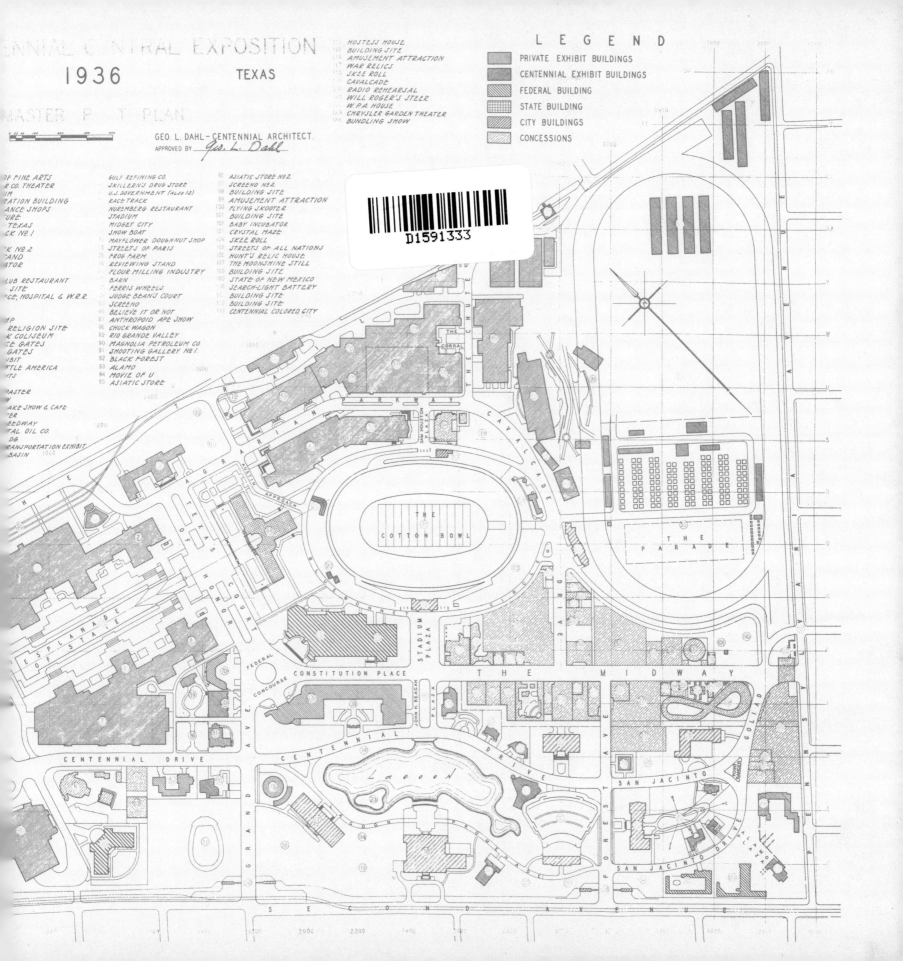

...NNIAL CENTRAL EXPOSITION

1936 TEXAS

MASTER P... T PLAN

GEO. L. DAHL — CENTENNIAL ARCHITECT.
APPROVED BY *Geo. L. Dahl*

LEGEND

- PRIVATE EXHIBIT BUILDINGS
- CENTENNIAL EXHIBIT BUILDINGS
- FEDERAL BUILDING
- STATE BUILDING
- CITY BUILDINGS
- CONCESSIONS


- OF FINE ARTS
- R CO. THEATER
- M
- RATION BUILDING
- ANCE SHOPS
- URE
- TEXAS
- CK Nº 1
- K Nº 2
- AND
- TOR
- LUB RESTAURANT
- SITE
- CE, HOSPITAL & W.R.R.
- MP
- RELIGION SITE
- K COLISEUM
- CE GATES
- GATES
- IBIT
- TLE AMERICA
- TS
- ASTER
- AKE SHOW & CAFE
- ER
- EEDWAY
- TAL OIL CO.
- DG.
- TRANSPORTATION EXHIBIT
- BASIN


- GULF REFINING CO.
- SKILLERN'S DRUG STORE
- U.S. GOVERNMENT (ALSO 12)
- RACE TRACK
- NUREMBERG RESTAURANT
- STADIUM
- MIDGET CITY
- SHOW BOAT
- MAYFLOWER DOUGHNUT SHOP
- STREETS OF PARIS
- FROG FARM
- REVIEWING STAND
- FLOUR MILLING INDUSTRY
- BARN
- FERRIS WHEELS
- JUDGE BEAN'S COURT
- SCREENO
- BELIEVE IT OR NOT
- ANTHROPOID APE SHOW
- CHUCK WAGON
- RIO GRANDE VALLEY
- MAGNOLIA PETROLEUM CO.
- SHOOTING GALLERY Nº 1.
- BLACK FOREST
- ALAMO
- MOVIE OF U
- ASIATIC STORE


- 96 ASIATIC STORE Nº 2.
- 97 SCREENO Nº 2.
- 98 BUILDING SITE
- 99 AMUSEMENT ATTRACTION
- 100 FLYING SKOOTER
- 101 BUILDING SITE
- 102 BABY INCUBATOR
- 103 CRYSTAL MAZE
- 104 SKEE ROLL
- 105 STREETS OF ALL NATIONS
- 106 HUNT'S RELIC HOUSE
- 107 THE MOONSHINE STILL
- 108 BUILDING SITE
- 109 STATE OF NEW MEXICO
- 110 SEARCH-LIGHT BATTERY
- 111 BUILDING SITE
- 112 BUILDING SITE
- 113 CENTENNIAL COLORED CITY


- HOSTESS HOUSE
- BUILDING SITE
- AMUSEMENT ATTRACTION
- WAR RELICS
- SKEE ROLL
- CAVALCADE
- RADIO REHEARSAL
- WILL ROGER'S STEER
- W.P.A. HOUSE
- CHRYSLER GARDEN THEATER
- BUNDLING SHOW

THE CORRAL

THE CHUTE

CAVALCADE

PARKWAY

AGRARIAN PARKWAY

AUSTIN APPROACH

COURT OF HONOR

TEXAS

SAN HOUSTON

THE COTTON BOWL

CIRCLE DRIVE

THE PARADE

ESPLANADE OF STATE

STADIUM PLAZA

BLUE BONNET

CONSTITUTION PLACE

FEDERAL CONCOURSE

JOHN H. REAGAN PLAZA

THE MIDWAY

GRAND AVE.

CENTENNIAL DRIVE

CENTENNIAL DRIVE

LAGOON

DRIVE

FOREST AVE.

SAN JACINTO

GOLIAD

L a g o o n

PENNS

ALAMO PLAZA

SAN JACINTO DRIVE

SECOND AVENUE

FAIR PARK DECO

ART AND ARCHITECTURE OF THE TEXAS CENTENNIAL EXPOSITION

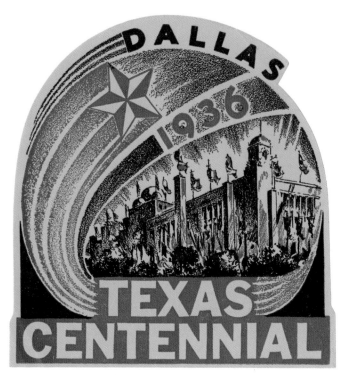

Texas Centennial decal, 1936

FAIR PARK DECO

ART AND ARCHITECTURE OF THE TEXAS CENTENNIAL EXPOSITION

JIM PARSONS AND DAVID BUSH

FOREWORD BY VIRGINIA SAVAGE McALESTER AND WILLIS CECIL WINTERS

Library of Congress Cataloging-in-Publication Data

Parsons, Jim, 1977-
 Fair Park deco : art and architecture of the
Texas Centennial Exposition / Jim Parsons and David Bush ;
foreword by Virginia McAlester.
 p. cm.
 Includes bibliographical references.
 ISBN 978-0-87565-501-7 (alk. paper)
1. Art deco--Texas--Dallas. 2. Art deco (Architecture)--Texas--Dallas. 3. Fair Park (Dallas, Tex.)--History. 4. Texas Centennial (1936 : Dallas, Tex.)
5. Historic buildings--Texas--Dallas. 6. Dallas (Tex.)--Buildings,structures, etc.--History. I. Bush, David, 1957- II. Title. III. Title: Art and architecture of the
Texas Centennial Exposition.
 N6494.A7P37 2012
 709.764'0747642812--dc23
 2012019449

This project was supported in part by a grant from
The Summerlee Foundation.

TCU Press
P.O. Box 298300
Fort Worth, Texas 76129
817.257.7822
www.prs.tcu.edu

To order books: 1.800.826.8911

Book design by Bill Brammer
www.fusion29.com

Printed in Canada

To Ramona Davis, without whose support
this book would not have been possible.

This project was funded in part by a grant
from The Summerlee Foundation.

VIII
FOREWORD

XI
INTRODUCTION

2
AN EMPIRE ON PARADE

12
ENTRANCE AND GRAND PLAZA

26
ESPLANADE OF STATE

58
STATE OF TEXAS BUILDING

90
AGRARIAN PARKWAY

114
FEDERAL CONCOURSE

138
CIVIC CENTER AND CENTENNIAL DRIVE

166
THE MIDWAY, COTTON BOWL STADIUM, AND SAN JACINTO DRIVE

182
FAIR PARK AFTER 1936

194
ARCHITECTS & ARTISTS

209
ACKNOWLEDGMENTS

211
NOTES

217
BIBLIOGRAPHY

219
ILLUSTRATION CREDITS

221
INDEX

FOREWORD

This handsome and well-researched book is filled with excellent photographs that capture the essence of the extraordinary legacy of architecture, art, and sculpture from the Texas Centennial Exposition. This internationally important collection remains essentially intact in Dallas's Fair Park, and a book about it is long overdue. Both of us writing this foreword have talked for years about this need, and how we might someday make such a project happen. Happily, David Bush and Jim Parsons have undertaken the work with a sense of mission—and a background in Art Deco from writing two previous books. The result is a visual, historical, and cultural treat that reminds us of a lifetime of memories of the park through good years and bad.

**Virginia Savage McAlester
and Willis Cecil Winters**

CHILDHOOD MEMORIES

VIRGINIA McALESTER: When I was a little girl growing up in Dallas, Fair Park was where my mother took me to learn and have fun. There was nothing I loved more than going with her for visits that generally began with feeding the ducks in the lagoon. This was often followed by visits to the natural history museum, the art museum, the health museum, and the dramatic Hall of State—or as many museums as I could cajole her into taking me to.

To me, Fair Park was a magical place, a beautiful park with incredible things to see and experience, including dioramas of native animals, paintings and sculpture, and the health museum's memorable "Invisible Man and Woman" exhibit. Sometimes the two of us would just walk around the park and look at the amazing buildings. The huge metal doors that led into many of these structures particularly intrigued me because they were all different. And the Tower Building, with its golden eagle, was wondrous.

WILLIS WINTERS: Like Virginia, I, too, grew up in Dallas and was a frequent visitor to Fair Park. Each fall, my friends and I eagerly anticipated "Fair Day," a different day reserved by various school districts for their students to attend the annual State Fair of Texas—one of the oldest and largest annual expositions in the United States. In addition to its fun and frivolity, Fair Park played a significant role in delivering culture and sports to the city and region. For many Dallas residents and visitors, it was the site of a diverse list of "firsts," including first museum, first aquarium, first garden center, first symphony performance, first opera, first musical, first college and professional football games, first livestock show, first automobile show, and first international Grand Prix race. In 1994, this list was further enhanced when Fair Park hosted World Cup soccer. There are very few places that have impacted the history and culture of a city and region as Fair Park has for Dallas.

FAIR PARK'S SIGNIFICANCE

VIRGINIA McALESTER: Oddly, well into my twenties, I assumed that most American cities and towns had grand places like Fair Park. In many places where I traveled, I would follow street signs to fairgrounds or museum centers, and invariably I was disappointed by what I found.

It was not until 1980 that I realized Fair Park truly was unique. While providing Russell Keune of the National Trust for Historic Preservation a tour of Dallas, I drove to the park and paused in front of the Hall of State. Russell, then in charge of the Trust's field services for the entire United States, leaped out of my car. He began dancing around, taking photographs, saying, "I didn't know there was anything like this left anywhere in the world. Why didn't I know this was here?"

I was speechless. It had never occurred to me that Fair Park was an unknown architectural treasure of national importance.

In 1985, I received an unexpected call from the National Park Service saying that its staff had just completed a survey of all the former world's fair sites in the country and that they believed Fair Park to be the most intact exposition site remaining. Later, Fair Park was designated a National Historic Landmark—a rare and prestigious honor. This survey and designation reaffirmed the park's extraordinary national value.

WILLIS WINTERS: As an architecture student at the University of Texas at Austin in the late 1970s, I was always surprised to learn that few people outside of Dallas knew about Fair Park and its architectural significance. The decade of the 1930s marked the great era of world's fairs and expositions in the United States, with major fairs staged by six American cities between 1933 and 1939. Very few of the Art Deco buildings and site features remain from these expositions with the exception of Fair Park, where most of the grand exhibit halls and museums built for the Texas Centennial Exposition in 1936 remain intact. Today, Fair Park provides an invaluable architectural snapshot of this era of hope and modernity.

ENDANGERED ERA

VIRGINIA McALESTER: By the late 1980s, it had become obvious that preservation activism was necessary to save Fair Park. The Dallas Park and Recreation Department (Fair Park is a Dallas city park) hired a planning firm to study Fair Park's future. The master plan prepared by the consultants called for the demolition of historic buildings to make way for a new conference center and parking lots in the heart of the park. Preservation Dallas became involved, and eventually the issues became so overwhelming that I, along with Lindalyn Adams and Joe Dealey, founded the Friends of Fair Park in 1986. The goals of this new civic organization were preserving Fair Park's historic architecture and art, supporting the museums located within the park, and making Fair Park a year-round visitor destination.

It was difficult to get a handle on the enormity of the problems involved in preserving the park. Some buildings had giant holes in their roofs. It was discovered that Fair Park had numerous historic murals that had vanished under layers of paint. In addition to these significant problems, there was no needs assessment or estimate of restoration costs, both of which were necessary to undertake a capital campaign. In 1994 and 1995, Fair Park landed on the National Trust's list of America's 11 Most Endangered Historic Places. The park desperately needed a savior—someone with intelligence, education and passion—to carefully assess its needs and properly oversee its restoration. The Dallas Park and Recreation Department assumed responsibility, and in 1993 director Paul Dyer asked Willis Cecil Winters, FAIA, to head up this project, assemble a team, and oversee the public-private effort to restore Fair Park.

RESTORATION

WILLIS WINTERS: Restoration of the historic fabric of Fair Park began in 1986, when the Dallas Park and Recreation Department undertook the reconstruction of three monumental porticoes flanking the Esplanade of State and the installation of missing centennial light fixtures throughout the park. A more concentrated preservation effort was initiated in the mid-1990s with funding approved by Dallas voters in the first of four consecutive bond referendums. Additional funding for building expansions, adaptive re-use of historic facilities, and art conservation was provided by individual museum institutions, the State Fair Association, the Friends of Fair Park, and various local, state, and federal grants.

The preservation strategy generally followed four stages. The first involved stabilizing the buildings by addressing water penetration, structural failures, and fire hazards. This work constituted the bulk of preservation activities for many years and was largely unseen by visitors to the park. During this period there were few outwardly visible signs of progress, and yet the buildings and structures were being prepared

for the next phase of the preservation program, which involved restoring the buildings' exterior plaster surfaces and historic paint schemes. The third stage in Fair Park's overall restoration was the discovery and conservation (or, in some cases, re-creation) of the monumental murals and bas-reliefs on the plaster walls of the exhibition halls. This was a painstaking process that involved the careful removal of the overpaint that had concealed the murals from view for more than fifty years, assessment of their newly uncovered condition, stabilization of the underlying plaster surface, and finally, the restrained application of infill paint in areas where no original mural image remained. The final priority of the preservation program encompassed reconstructing Fair Park's "missing" site features—the icing on the cake, so to speak. This work entailed recreating sculptures that mysteriously vanished from Fair Park following the Centennial Exposition, the reconstruction of the Esplanade Fountain, and the installation of interpretive signage.

These carefully prioritized and highly professional efforts have met the very highest standards of historic preservation practice. This hard work has been recognized with numerous honors including the prestigious National Trust for Historic Preservation's Honor Award.

CONTINUING CHALLENGES

VIRGINIA McALESTER: There are several ongoing challenges at Fair Park. The first is maintaining the buildings and art that have already been restored; the second is restoring the buildings not yet tackled; and the third is transforming this National Historic Landmark into a year-round destination—a task made more complex by the imminent departure of several of the park's venerable institutions in favor of locations in downtown Dallas.

WILLIS WINTERS: Preservation maintenance is a perpetual challenge at Fair Park. The restoration of "modern" Art Deco buildings and structures presents a unique set of issues that are compounded by the extremes of Dallas's harsh climate. Restored plaster walls begin cracking almost immediately after façade restoration is completed, and conserved murals fade under exposure to sunlight. The interminable process of decay begins again as soon as a restoration is completed. In addition, the buildings and landscapes at Fair Park take quite a beating from the millions of people who visit the park each year.

Maintaining Fair Park's economic viability and enhancing its attraction as a major visitor and tourist destination are often at odds with preserving its status as a National Historic Landmark. Preserving the park's historic integrity is paramount, given its status as the only remaining intact world's fair site from the 1930s. Achieving this requires a fine balance in preservation planning to prevent Fair Park from becoming a meaningless artifact.

■ ■ ■

Virginia Savage McAlester has been recognized with a Preservation Honor Award from the National Trust for Historic Preservation as coauthor of the classic architectural work A Field Guide to American Houses. *She is a founding member and past president of Friends of Fair Park and Preservation Dallas.*

Since 1993 Willis Cecil Winters has directed the ongoing revitalization of Fair Park, including restoration of its historic structures and conservation of its monumental public artwork, for the Dallas Park and Recreation Department. An architect and historian, Winters is the author and coauthor of several books on Dallas's architectural history, including 2010's Fair Park.

INTRODUCTION

When we started working on what became *Fair Park Deco*, we expected it to be a single chapter in a possible book on Art Deco architecture in Dallas and Fort Worth, a companion volume to our *Houston Deco* and *Hill Country Deco* books. We were probably more aware of Fair Park's significance than most people, but until we started exploring the fairgrounds and talking to people who cared about Fair Park, we didn't appreciate how much had survived from the 1936 Texas Centennial Exposition, the quality of the restoration work that has been carried out so far, and the commitment many exceptional people have made to preserving this unique historic site.

Fair Park Deco focuses specifically on the modernistic art and architecture of Fair Park—the public spaces, buildings, sculptures, and murals that were created to commemorate the one hundredth anniversary of Texas's independence from Mexico. Buildings that date to 1936 but are not modernistic are not included; however, some projects completed after 1936 are part of the book because they were later phases of centennial buildings, were designed by people who worked on the exposition, or were remodeled to resemble exposition buildings that no longer exist.

Most of the chapters in the book represent different areas of Fair Park, with buildings and artwork arranged in approximately the same order that a visitor to the Texas Centennial Exposition might have seen them. One challenge in putting together a book about exposition facilities that have been in continuous use for more than seventy-five years is that nearly all the buildings have gone through several name changes; few structures have the same names they carried during the exposition. Throughout the book, buildings are referred to principally by their 1936 names, but later names—as many as can be verified and are practical to list—are included as well. If there is any lingering confusion about a building's identity, referencing the map printed on the endpapers, which shows Fair Park as it was in 1936, should help to clear up any uncertainty.

The purpose of *Fair Park Deco* is not to recount the complete history of the Texas Centennial Exposition and how it came to be, or to give a comprehensive picture of Fair Park and how it has changed through the years. There are far better sources for that information, including three excellent books: Willis Cecil Winters's *Fair Park*, a pictorial history of the park since 1886; Kenneth Ragsdale's *The Year America Discovered Texas: Centennial '36*, which deals not only with the exposition but also tells the fascinating story of the evolution of the centennial movement statewide; and Patricia Evridge Hill's *Dallas: The Making of a Modern City*, a history of Dallas that includes an account of the wheeling and dealing required to make the exposition a reality.

We hope that *Fair Park Deco* is a worthy survey of a place that is extremely significant not only architecturally and artistically, but also culturally. Fair Park is one of the finest collections of Art Deco architecture in the country, to be sure, but it is so much more: the embodiment of Texan swagger, something impossibly bold and brash, a testament to the men and women who undertook the Texanic task of creating a dazzling spectacle in the darkest days of the Depression.

Jim Parsons and David Bush

AN EMPIRE ON PARADE

Every thought we have had has been for a big Centennial, Texanic in proportions and continental in scope. We think our history demands it.

Cullen F. Thomas
President, Texas Centennial Commission
May 21, 1935

Just before 8:30 p.m. on Saturday, June 6, 1936, nearly every light on the Texas Centennial Exposition grounds suddenly went out. It was opening day of the exposition, the first of its kind ever held in Texas. Earlier, a big parade and opening ceremonies had gone off without any major glitches, and though the heat of the afternoon had kept attendance low, tens of thousands of people flooded through the turnstiles as evening fell. There had been pageants, shows, and building dedications through the day, but now, with the exposition in darkness, only the silhouettes of its massive exhibit halls visible against the night sky, the real spectacle was about to begin.[1]

High overhead, an airplane began a power dive toward the heart of the exposition, a stream of fire shooting from its tail—a mechanical meteor. As the plane swooped toward the ground, the fiery trail disappeared and in its place a billion-candlepower electric star flashed on from the roof of the Ford Motor Company Building, triggering a wave of light that washed over the grounds. First came floodlights illuminating the exposition's gates, followed by spotlights, pylons, and modernistic light standards that lined the main avenues leading into the grounds. In the southwest corner of the park, lights were switched on at the Hall of Negro Life, and then the museums of the Civic Center lit up, one by one, along with the lagoon and nearby trees and shrubs. The Midway and exhibit buildings at the east end of the grounds came next, and then banks of floodlights turned the Esplanade of State into a riot of color mirrored in its seven-hundred-foot reflecting basin. As a grand finale, an array of two dozen high-powered searchlights flared from behind the State of Texas Building, a dramatic crown that would become one of the most photographed elements of the exposition.[2]

The opening night lighting spectacle was an appropriately theatrical kick-off to the Centennial Exposition's six-month run. It marked the beginning of an event that showed a largely rural, mostly poor state a future in which miracles were commonplace: instant long-distance communication, microwave cooking, television, robots—even bug zappers. Its broad esplanades and striking modern architecture promised a brighter future, too, that was a far cry from unpaved roads and tenant farms. "It was just like a fairyland," Betty Turner Rogers, who was twelve years old when the fair opened, remembered fifty years later. "You've got to remember that was the '30s, and we'd never had anything like that before."[3]

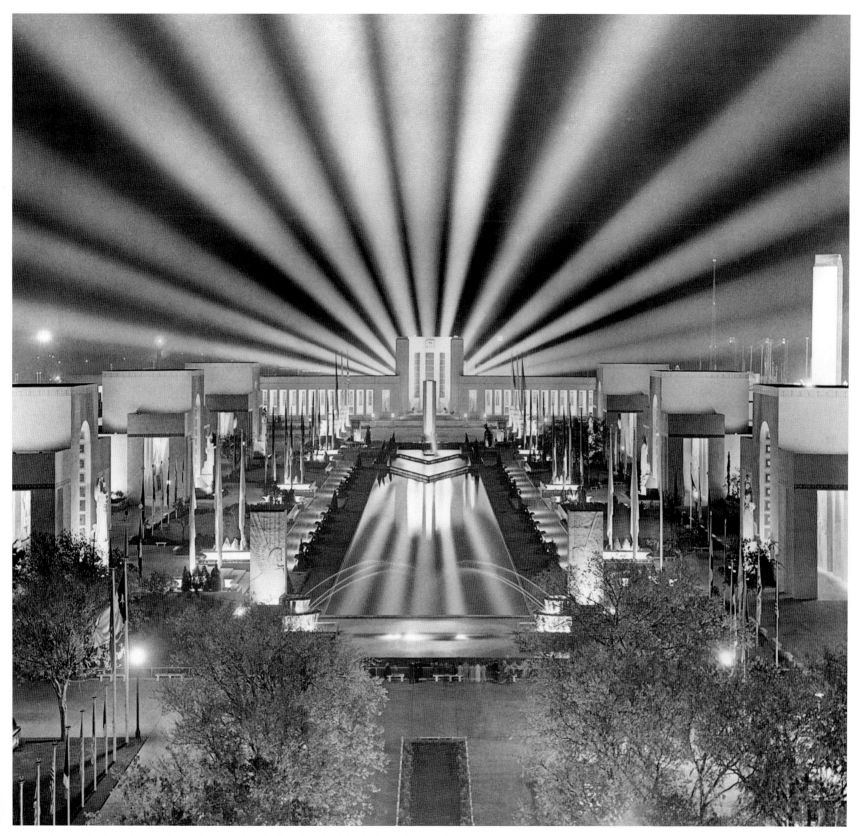

Esplanade of State at night, 1936. Exposition Technical Staff, architects. C. M. Cutler, lighting engineer.

Perhaps most important, the exposition proved to be exactly what its planners had hoped for. It pumped millions of dollars into the local economy, gave Depression-weary residents a point of pride, established Dallas as a center of opportunity and taste, and introduced the rest of the nation to a carefully edited, highly romanticized, and very appealing version of the Lone Star State. As a huge birthday party, the fair was a great success in 1936; as a slick piece of propaganda, its effects were much farther reaching.

The idea of a large-scale celebration marking the one hundredth anniversary of Texas's independence from Mexico had been discussed since early in the twentieth century, but it wasn't until the Great Depression hit that the idea really gained traction. At the time, half of Texas depended on cotton for its livelihood, and when the stock market crashed, so did cotton prices. Oil discoveries in East Texas offered a glimmer of hope, but rampant overproduction cut oil prices in half—and then came drought and the Dust Bowl. In a state where nearly sixty percent of residents lived on farms or in rural communities of less than twenty-five hundred people, things looked dismal as the 1930s dawned.[4]

Against that backdrop, the idea of a centennial celebration took on a new importance. Here was a chance to stimulate the economy through construction projects, encourage growth and development statewide, showcase Texas's history and resources, and, perhaps most significantly, attract millions of tourists—and their wallets. "If during the next six months the people of the State could become filled with the idea of holding a big celebration on the one hundredth anniversary of the establishment of Texas independence . . . it would have the effect of creating a general forward-looking spirit through the State," centennial planners said in 1934. "It would be more stimulating than anything we can think of, and this effect would be immediate."[5]

That year, the Texas Legislature took decisive action, creating the Texas Centennial Commission to oversee celebrations statewide and calling for a central exposition to be held in the city that

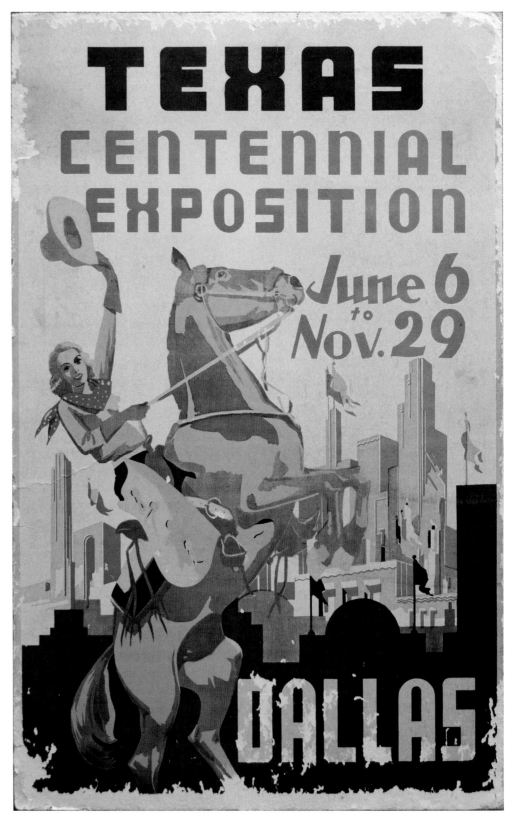

Texas Centennial Exposition poster, 1936

offered the largest financial incentive. The city that won the right to hold the Texas Centennial Central Exposition, as it was officially known, would have to provide at least two hundred acres of land and all utility services for the exposition site, and present its best monetary offer along with current appraisals of the property being offered. A call for proposals went out in June 1934 with a submission deadline of September 1.[6]

Five cities were in the running early on, but Austin and Fort Worth soon dropped out. That left San Antonio, Houston, and Dallas, Texas's three largest urban centers, to submit official proposals. Historical connections meant that San Antonio, home of the Alamo, and Houston, located near the San Jacinto Battleground where Texans won their independence, were considered the favored locations—at least by the residents of San Antonio and Houston. Dallas, by contrast, didn't exist at the time of the Texas Revolution, so it had no direct tie to the state's early history. But it did have the one thing that really mattered: money.[7]

When the cities' proposals were announced, San Antonio offered $4.8 million and Houston $6.5 million. The Dallas Centennial Commission, headed by banker Robert Lee Thornton, pledged $7.8 million. Dallas's bid included the city's trump card, the use and expansion of Fair Park, the city-owned state fairgrounds, then valued at $3.5 million. In addition, Thornton told the state Centennial Commission that Dallas's bid for the exposition would stand whether or not any state or federal funding was offered—a commitment neither San Antonio nor Houston was willing to make. And so Dallas, the second-largest city in the state with a population of two hundred and sixty thousand, was named host of the Texas Centennial Exposition.[8]

Although Dallas's bid was officially accepted in September 1934, and in spite of Thornton's pledge to forge ahead regardless of state and federal support, money from Austin and Washington was integral to the exposition's success. There was a promise of state funding, but political wrangling delayed that appropriation—which in-

cluded $1.2 million for a state exhibit building at the exposition and half a million dollars for advertising—until May 1935. On June 14, a few weeks after the state funding was finalized, the Dallas City Council approved a contract with the State Fair of Texas to turn Fair Park over to the Centennial Exposition, clearing the way at last for work on the exposition site to begin. (At the time, Texas was still waiting to hear how $3 million in federal centennial funds previously approved by Congress would be distributed. Details on the allocation, which included $1.2 million for the Dallas exposition, finally came in August 1935.)[9]

With government funding falling into place, the exposition's leaders could finally direct their attention toward the most difficult job yet: building the Texas Centennial Exposition. The project involved remodeling and enlarging a dozen existing State Fair buildings, designing and constructing more than fifty new ones, installing miles of utility lines, streets, and sidewalks, and landscaping Fair Park's 183 acres. The total price tag was estimated at $25 million, a huge amount in the middle of the Great Depression. As the fair's publicity staff noted, the materials required for the makeover would fill a three-thousand-car freight train long enough to stretch the thirty miles from Dallas to Fort Worth, and all the work had to be finished in less than a year. It was clearly meant to be a big undertaking—too big, in fact, for the English language to explain. Cullen F. Thomas, the president of the Texas Centennial Commission, told the US Congress in 1935 that he expected "Texanic," an invented word, to join "gigantic" and "titanic" in the dictionary within the year.[10]

Responsibility for the Texanic task of transforming Fair Park rested on the shoulders of forty-one-year-old Dallas architect George L. Dahl. In the ten years since he joined the firm of Herbert M. Greene (renamed Herbert M. Greene, LaRoche & Dahl in 1928), Dahl had made a name for himself by contributing to a number of buildings on the University of Texas campus in Austin and designing several prominent commercial buildings in Dallas, including large downtown

Texas Centennial Exposition medallion

department stores for Volk Brothers, Titche-Goettinger, and Neiman Marcus. He had also attended several expositions in the United States and Europe, giving him a perspective on what worked and what didn't when it came to fairs. As centennial architect and technical director of the Dallas exposition, Dahl was either directly or indirectly involved in every aspect of design, from approving plans for the main exhibit halls to keeping up with the number of paintbrushes that artists used. "From the largest towering building to the smallest hot dog or peanut stand, from the millions of feet of utilities buried underground to the smallest statue or decoration to be seen, all physical details have been subject to the approval or rejection of the architect in charge," *The Dallas Morning News* reported. As Dahl put it in an interview forty years after the exposition, "I *was* the authority."[11]

Given the scope of the work ahead and the tight time frame, Dahl recruited a small army of architects, designers, engineers, and artists. Many had worked at previous expositions, especially the 1933 Century of Progress International Exposition in Chicago. Dahl's chief designer, Donald Nelson, was an architect at the Century of Progress; lighting engineer C. M. Cutler had illuminated the Chicago exposition; and artists Carlo Ciampaglia, Raoul Josset, and Pierre Bourdelle had

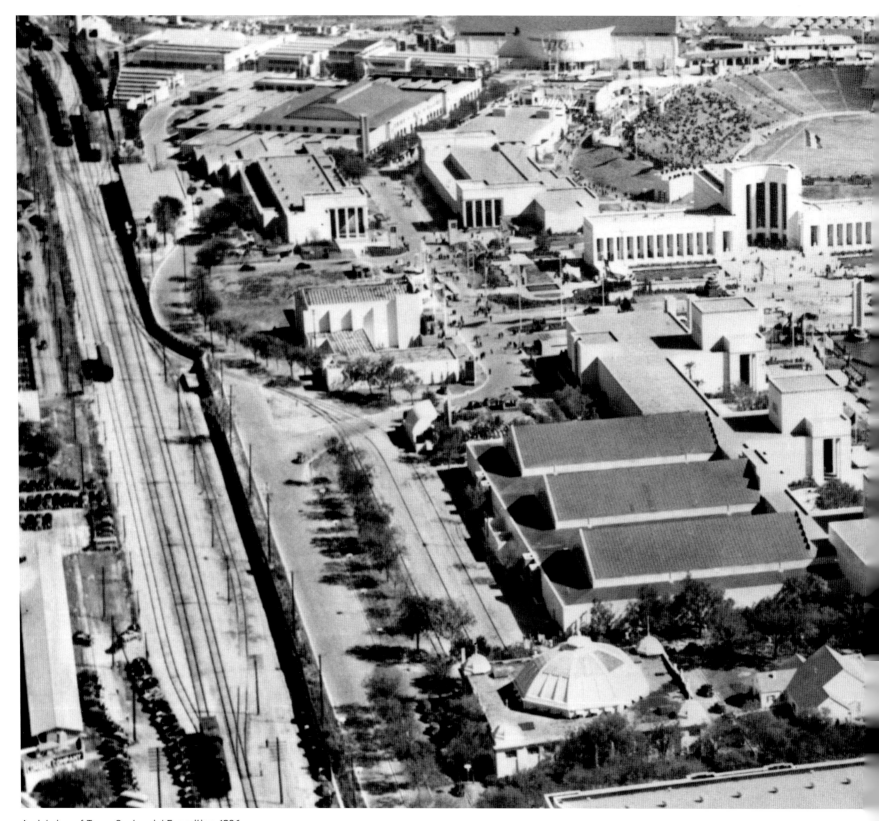

Aerial view of Texas Centennial Exposition, 1936

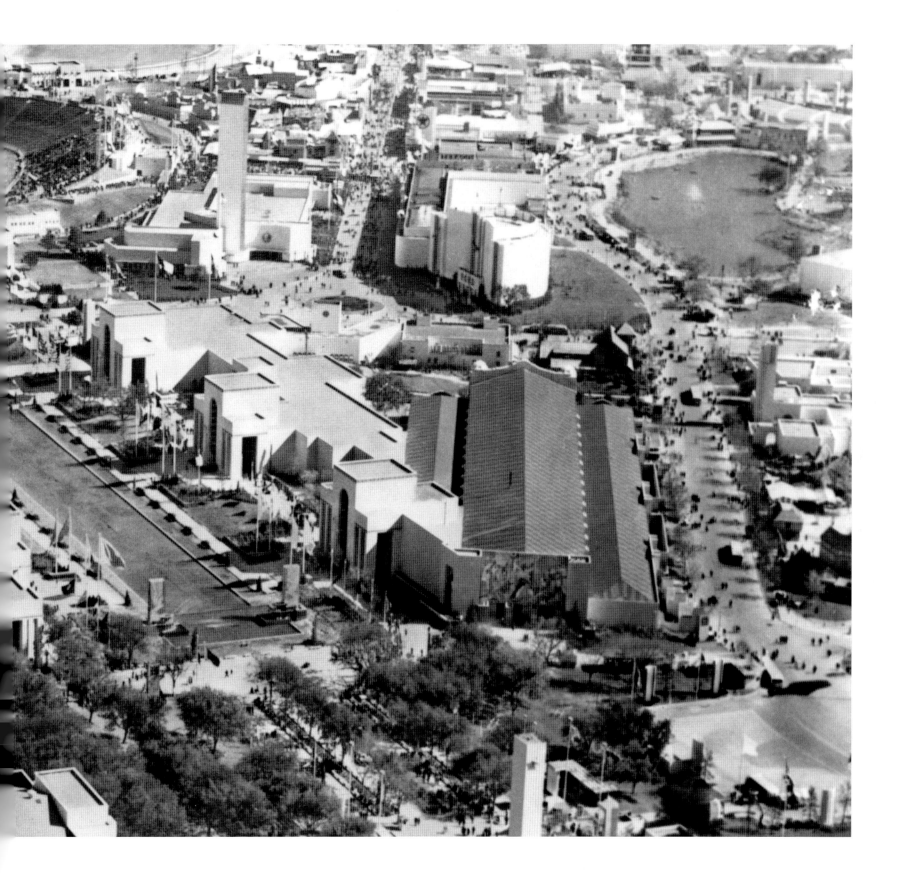

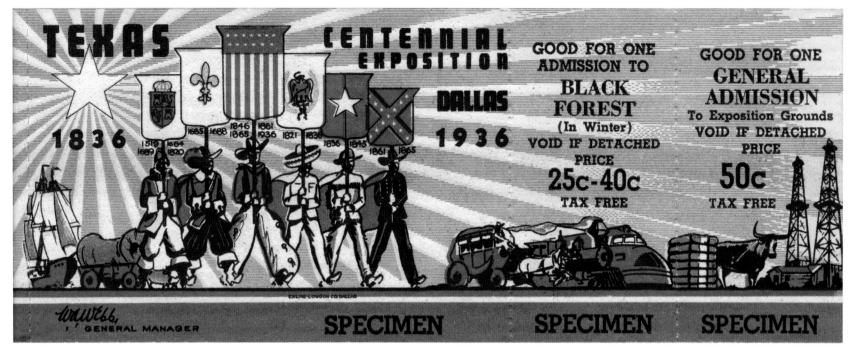

Texas Centennial Exposition admission ticket, 1936

all helped decorate the 1933 fair. Hare & Hare of Kansas City was brought in to design the Dallas exposition's landscaping, and local engineering firm Myers, Noyes & Forrest handled utilities and streets. High-profile national architects and designers came to work on specific projects—Detroit's Albert Kahn, for example, who designed the Ford Building, and William Lescaze of New York, who was commissioned to plan the Magnolia Petroleum Company hospitality building. For civic and service structures, Dahl encouraged the Dallas Park Board to offer design work to local firms. The commissions were very welcome for many of the Dallas architects; some, architecture critic David Dillon later wrote, "found themselves working on monumental civic buildings . . . for the only times in their careers."[12]

A flood of artists also came to Dallas to decorate the exposition's buildings and public spaces. Dahl and Nelson were both winners of the Prix de Rome, an art and architecture scholarship; they invited a fellow Rome scholar, Ciampaglia, to direct the exposition's staff of muralists. Bourdelle and Josset, both of whom had worked with Nelson in Chicago, came to oversee other mural-

ists and sculptors. Lawrence Tenney Stevens, a Prix de Rome-winning sculptor who specialized in monumental public art, joined the art staff, as did former Hollywood set designer Juan Larrinaga, who had helped decorate two expositions in California, and Jose Martin, who worked with Bourdelle and Josset at the Century of Progress. Another artist, Julian Garnsey, would go on to be a color designer at the 1939 New York World's Fair. Even though a group of local regionalist artists called the "Dallas Nine" was gaining respect for its work at the time of the exposition, Texans were mostly relegated to assisting the out-of-towners and to commissions in the exposition's Civic Center and the State of Texas Building. That rankled the locals, but there was a reason Dahl chose the men he did for the exposition's major artworks: they knew how to do exposition-scale work, and they knew how to do it quickly.

Construction work at Fair Park got under way in the summer of 1935 with the remodeling of the old Coliseum, which would house the exposition's administrative offices, and the demolition of several minor State Fair buildings. Planning and initial work on the park's major

structures continued into the fall; by year's end, tons of earth were being moved for utility lines, foundations, and lagoons as more and more exhibitors signed on for the fair. "The visitor who hasn't looked the exposition site over since the big push started may find himself completely lost," *The Dallas Morning News* reported on December 1, the day the grounds were first opened for public inspection. Tens of thousands of visitors crowded Fair Park on the next two open-house days in February and March; by that time, vast exhibit halls were taking form in steel and concrete, and it was obvious that the seemingly impossible task of creating a world's fair in a few short months was possible after all. "There is faith now where doubt lingered," the *News*'s Harry Benge Crozier wrote in March 1936. "For all of its glorious memories, the great State Fair of Texas appears a puny thing as it dissolves in the gigantic pattern that now clearly outlines the Texas Centennial Exposition."[13]

The pattern Crozier mentioned owed its form to a well-known architect who played an often-overlooked role in Fair Park's planning. In late February 1935, while Dallas was still waiting for

word on the state appropriation for the centennial, exposition directors hired Paul Cret of Philadelphia to develop a master plan for the grounds. Cret had experience with expositions, having served as a consulting architect for the Century of Progress in Chicago. He also had experience in Texas. In 1930, he had drawn up a master plan for the University of Texas campus in Austin, and he had consulted on several buildings that Dahl's firm designed there.

Although it is unclear how directly involved Cret was in the construction of the exposition, his master plan clearly laid out some of its signature features, including a grand central esplanade leading to the State of Texas Building, a park-like civic center arranged around a manmade lagoon, and an agricultural complex based on existing facilities. Whether it was the result of Cret's ideas or not, the rebuilt Fair Park's emphasis on axial planning and carefully composed vistas owed a great deal to the same Beaux Arts style of site planning that characterized another Chicago fair, the World's Columbian Exposition of 1893. For all its modernistic trappings, the Dallas exposition was laid out along very well-established lines.[14]

Of course, the classical axes and sight lines didn't cross the minds of most exposition visitors: they were overwhelmed by Fair Park's complete transformation into what came to be called the "Magic City." With its manicured lawns and massive buildings, soaring pylons, and heroic sculptures, the exposition grounds were unlike anything Dallas had ever seen—and for the scores of rural Texans who poured through the gates, the complex must have seemed the height of glamour.

Dahl said that he found inspiration for the main buildings' angular, planar design in the Spanish Colonial style, a nod to Texas's architectural heritage. "Without being dominated by the Spanish, you might say we have tried to suggest it gently, as sunshine and spice-laden wind would pleasantly and insistently call to mind a rich, tropic land," he told one reporter. The architecture reflected other historic sources, too. There

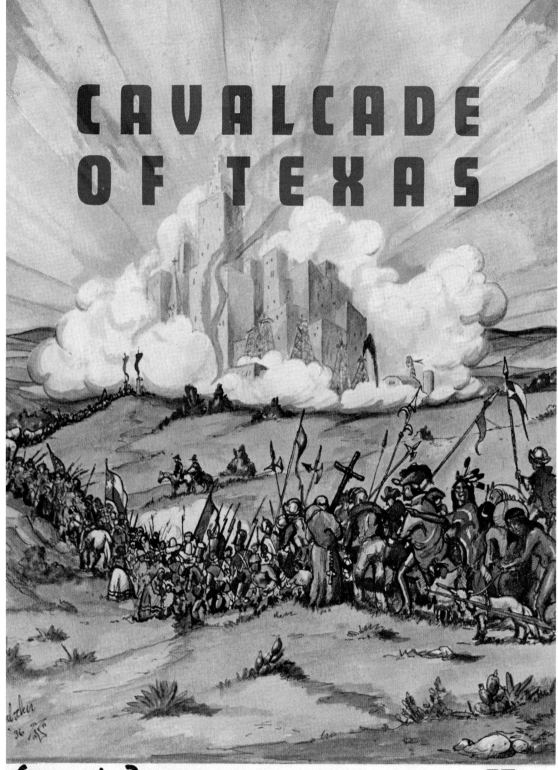

Cover, *Cavalcade of Texas* Souvenir Program, 1936

WELCOME TEXAS CENTENNIAL CELEBRATIONS 1936

Old man Texas invites you here
To share our blessings and good cheer
To see the wonders of our State
So come and help us celebrate!

TEXAS CENTENNIAL
1836 ★ 1936

Texas Centennial advertising pamphlet, 1936

was a touch of the ancient Greek and Egyptian in it, and Work Projects Administration writers compared the Esplanade of State to a Babylonian temple approach.[15] Despite the varied influences, designers meant the buildings to be something completely new. "Visitors have asked the style of [the exposition] architecture," architect Ralph Bryan noted. "It is easy to name a style when it is merely a revival of another era—as classic or Gothic revival. But this architecture is no revival. Years from now the critics will probably have named it, but for the time being it can only be called contemporary."[16]

In spite of the colorful appearance the elaborate lighting scheme gave exposition buildings at night, most of the structures were painted a buff color that gave them a modern, rather spartan look during the day. Dahl said the color was chosen to best complement the Texas light; the

publicity staff often referred to the buildings as "sunshine colored." This neutral color scheme combined with Dahl's clean-lined architectural style lent a further unity to the exposition grounds—a sharp contrast to Chicago's Century of Progress, dubbed the "Rainbow City," where buildings were painted in a palette of twenty-eight rich colors. "We have been careful never to lose sight of an organic sense of unity," Dahl said. "We have wanted [the exposition buildings] to suggest the simplicity of the country, divested of all superfluous ornamentation."[17]

That emphasis on simplicity meant that Fair Park did not turn out to be as fantastic as some other exposition grounds—its buildings didn't soar like many at the Century of Progress, nor did they have the wonderful swoops and spires that defined the 1939 New York World's Fair. The design differences between the Texas Centennial Exposition and other fairs of the 1930s were the result of one of the things that made the Dallas exposition unique: sixty percent of its buildings were meant to be permanent, used in future decades by the State Fair of Texas. "For this reason, in our planning we have held down the experimental aspect of things more than we would have done if the structures were to be used but a season," Dahl explained.[18]

Fair Park's new design also took the Dallas climate into consideration. The most heavily trafficked areas of the grounds were designed as fairly compact units to help visitors avoid walking long distances in the summer heat. In addition, the Centennial Exposition was heavily advertised as the first air-conditioned world's fair: two dozen of its exhibit halls were outfitted with air exchange systems, and some, including the Ford Building, Chrysler Hall, the Magnolia Lounge, the Hall of Religion, the Civic Center museums, and three-quarters of the attractions on the Midway, had full air conditioning systems. (The difference, newspapers noted, was that air-conditioned buildings maintained an average interior temperature of seventy-five degrees, while ventilated buildings ran ten to twenty degrees cooler than the outside temper-

ature—a blessing on most days, but little comfort when the mercury hit a record-breaking 109.6 degrees on August 10.) Journalists went so far as to claim that it was possible to walk five miles in air-cooled comfort at the fair, suggesting a complete circuit of the grounds with as little exposure to the outside air as possible. Even so, there was no way to totally avoid the Dallas heat: "On the north side of the grounds, [visitors] will be forced possibly to perspire slightly while making a hop of three hundred feet from the Humble Oil & Refining Company exhibit to the Foods Building," *The Dallas Morning News* observed.[19]

Building the exposition was a mammoth feat, but it was only part of the job. Centennial officials also had to advertise Texas to the world, partly to make sure that the exposition reached its attendance goals and partly to dispel myths about the state—or at least replace them with better myths.

In 1936, most of the United States knew little about Texas. If Americans thought of the state at all, they probably imagined it as a vast frontier filled with cowboys and oil wells. Centennial publicists, armed with a $500,000 allocation from Austin, were perfectly happy to use those misconceptions to their advantage, spinning them into decidedly sentimental symbols of the Lone Star State. "The entire state—with its wealth of history and romance—is the field from which our writers will draw their material," Robert Coulter, the man in charge of travel and advertising promotions, told a staff member in 1935. The images they drew upon would become forever linked to Texas in the popular imagination: not only wide-open spaces, sprawling ranches, and forests of oil derricks, but also Texas Rangers, ten-gallon hats, and endless fields of bluebonnets.[20]

Naturally, promoters threw in plenty of pretty girls for good measure. One of the publicity staff's most successful creations was the Rangerettes, a group of young women clad in cowboy hats, plaid shirts, bandanas, chaps, boots, and spurs who crisscrossed the country drumming up interest for the centennial. They seemed to be everywhere—in New York delivering the recipe

for barbecue to the Waldorf-Astoria Hotel; in Chicago (with a thousand Texas grapefruit in their luggage) encouraging aviators to visit the exposition; in Indianapolis riding in the pace car at the Indianapolis 500; in Washington delivering a centennial invitation to President Franklin D. Roosevelt—and, of course, cameras were never far behind. Smiling Rangerettes appeared in newspapers, magazines, and newsreels from coast to coast, becoming a prominent symbol of Texas in its centennial year.[21]

America clearly loved the centennial version of Texas, and Texans, in turn, loved the attention they got. But with increased visibility came increased opportunities for indignation, and Texas left no stone unturned searching for perceived slights. "I should like to enlist your help to stop the insidious use, current in your city, of the terms 'panhandle' and 'panhandling' for beggars and the act of begging," the state's attorney general, William McCraw, wrote the editors of *The New York Times* in April 1936. "The people of the Texas Panhandle decidedly are not beggars."[22]

The avalanche of Texana didn't stop when the Centennial Exposition opened. The state flower, the bluebonnet, appeared at fashion shows in New York and lent its color to products ranging from thread to General Motors automobiles. (There was even a suggestion to name the Fair Park stadium the Bluebonnet Bowl, which was the last straw for Dallas resident A. E. Zeiske. In a letter to *The Dallas Morning News*, Zeiske wrote that he and some friends thought Cotton Bowl was a more appropriate name for the facility— "much better than the overworked Bluebonnet.") The flags of the six nations that had ruled Texas were ubiquitous, too, represented in epic statues along the Esplanade of State, forming part of the exposition's seal and appearing beneath the rays of a lone star on every admission ticket.[23]

The exposition's theme, "An Empire on Parade," was perhaps best expressed in the *Cavalcade of Texas*, the fair's most elaborate show. The $250,000 pageant took audiences on a journey through four hundred years of Texas history with huge reversible sets, real livestock, and epic battles on a 300 x 170-foot stage that had artificial bluffs and mountains as its backdrop. There was so much to pack in the show that the *Cavalcade* ran four hours long during rehearsals; it was later slashed to seventy-five minutes. Despite minor criticism from the press (the *News* sniffed that the show "leaned heavily toward the romantic and the trivial" and "sorely lacked a unifying idea"), the *Cavalcade* was a huge success, with thousands of people in the audience every night and weekly receipts averaging $60,000.[24]

It was clear that the romance of Texas was worth its weight in gold in terms of publicity. And for Dallas, the exposition itself was equally valuable: thousands of people worked in its planning and creation, logging untold hours of labor and pumping much-needed dollars into the local economy—and that was before the first visitor stepped through the fair's gates. "It reminds one strongly of the days before the great crash in the stock market," one observer wrote. "In other words, the city itself is a hive of activity and ordinary business seems to be good." Fair Park continued to be an asset to the city and state even after the Centennial Exposition and its successor, the Greater Texas & Pan-American Exposition, closed, reverting to its roles as the site of the annual State Fair of Texas and one of the crown jewels in Dallas's park system.[25]

As writers for the Work Projects Administration put it, the Texas Centennial Exposition "found Fair Park a city of wood and left it a city of stone." More than that, the exposition left Dallas and Texas with a sense of focus and a pride of accomplishment that brightened, if temporarily, what were dark days indeed.[26]

Detail, Rio Grande Valley souvenir bag, 1936

ENTRANCE AND GRAND PLAZA

Ladies and gentlemen, the Texas Centennial Exposition at Dallas is opened to the world for 1936. America, here is Texas! Texas in the Centennial Year—an Empire on Parade!

From the script of the Official Opening Broadcast of the Texas Centennial Central Exposition
Columbia Broadcasting System
June 6, 1936

For the millions of people who attended the Texas Centennial Exposition during its six-month run, there was one chief entry point: Fair Park's main gate on Parry Avenue. It had served as the park's front door for fifty years, and the stout old gateposts, which dated from 1908, were familiar landmarks for Dallasites. When those gates came down in February 1936 to make way for a new, modernistic entrance to the exposition grounds, there was a swell of nostalgia in the city: "Between [the gates] have passed millions of State Fair visitors and vehicles from the days of horses and buggies until the era of the streamlined automobile," one newspaper account read. "Between these gate towers in 1918 many thousands of Texans marched on their first lap toward the war overseas."[1]

By the time the new gates swung open four months later, however, the past had been forgotten. As first-day visitors surged through the turnstiles, they entered a new world: nearly two hundred acres of ultra-modern plazas, museums, and exhibit halls, a vision of a better future for a state plagued by drought and economic depression. The Parry Avenue entrance helped set the stage for that world.[2]

Dallas architects Lang & Witchell designed the entry in the clean, modern style that was the hallmark of the Centennial Exposition, carrying out George Dahl's wishes for "a great deal of glamour, but still a monumental and dignified effect." The focus of the gate was an eighty-five-foot pylon centered on the axis created by Exposition Avenue outside the grounds and

Grand Plaza and the Esplanade of State inside; at its base was a relief band depicting pioneers entering Texas, and at its top, a five-pointed star outlined in tube lighting faced the Dallas skyline. Flanking the pylon were four low ticket and turnstile shelters bracketed at either end by twin pavilions inscribed with the years 1836 and 1936.[3]

Other than the decorations on the central pylon, ornamentation on the Parry Avenue Gate was limited to relatively restrained friezes and relief panels on the flanking pavilions. There was a reason for the austere look. During the day, the structures' simple lines were a dramatic contrast to older buildings facing Fair Park; after dark, the gates' blank surfaces were flooded with bright light—a beacon for fairgoers who alighted at the

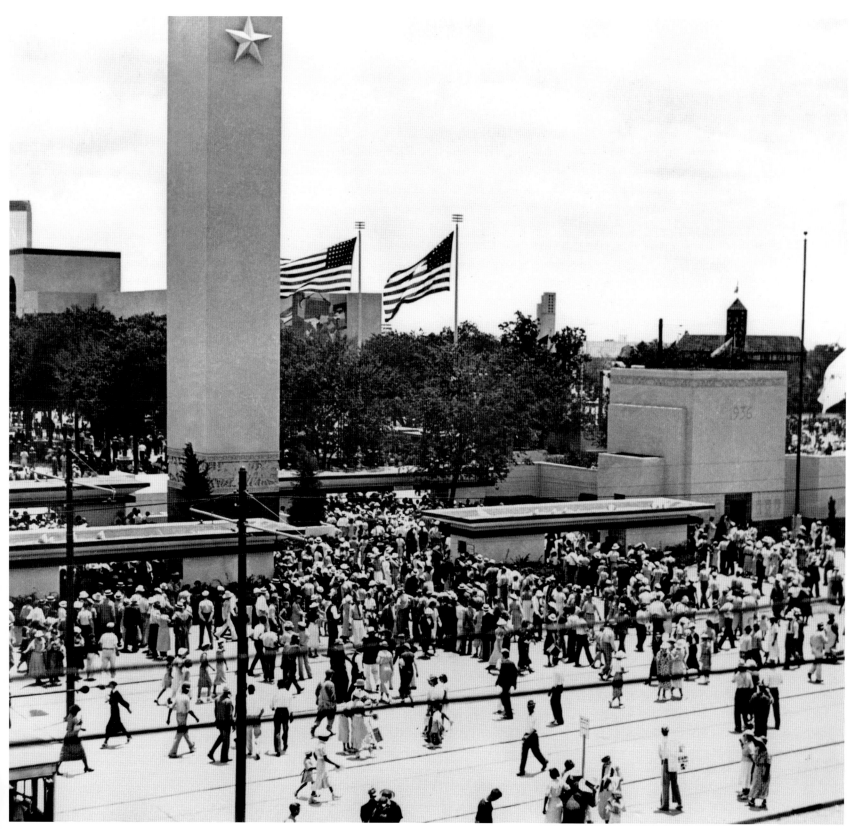

Parry Avenue Gate, 1936. Lang & Witchell, architects.

busy streetcar stop just outside the exposition grounds. "The attraction value of high brightness contrast was utilized to good effect and in addition provided a curtain to conceal the surprises awaiting within," C. M. Cutler, the exposition's lighting engineer, explained. Secondary gates along Second Avenue on the south side of the exposition grounds were designed along the same lines, though on a smaller scale.[4]

The main gate was at the center of the exposition's elaborate opening festivities on June 6, 1936. Most of the gates to Fair Park opened at nine o'clock that morning, but the Parry Avenue entrance remained closed, awaiting the arrival of a parade of dignitaries, marching bands, and historically themed floats that began making its way east from downtown at half past ten. When the parade arrived, Texas Governor James V Allred unlocked the Parry Avenue Gate with a $50,000 jewel-encrusted gold key, kicking off the official opening ceremony. (The key, made by the Arthur A. Everts Company of Dallas, was stolen from Everts's jewelry showroom in 1952 and was never seen again. By the time of the theft, most of the valuable gemstones had been replaced with imitations and the key's value had dropped considerably. "A smart thief would have picked up any of the other valuables in the case and left the key," Myron Everts, the store's president, mused.)[5]

Following a brief introduction from the governor, US Secretary of Commerce Daniel C. Roper stepped to a microphone connected to a live national radio broadcast and offered his greeting: "The State of Texas sends greetings to all the peoples of the world on the occasion of the celebration of her one hundredth anniversary, and invites you to join us here at the exposition in 1936." Roper's words were then supposed to circle the globe, telegraphed by way of San Francisco, Shanghai, Moscow, Leningrad, Stockholm, London, and New York. His words would return to Dallas in record time and activate oversized mechanical scissors that would cut through a rib-

bon, the final—and completely symbolic—barrier to the exposition grounds. It was a novel idea, but things didn't quite turn out as planned. "Somehow the message was lost somewhere over the steppes of Russia and we had to improvise and pretend the message had been received," Art Linkletter, one of the radio announcers that afternoon, said years later. Roper's missing message wasn't the only hiccup: Linkletter also recalled that the United States Marine Band, which marched near the head of the morning parade and should have arrived just ahead of Governor Allred, somehow took a wrong turn and wandered the streets of Dallas for an hour before finally finding its way to Fair Park.[6]

Inside the Parry Avenue Gate, visitors found themselves in a paved court called Grand Plaza, which served as a sort of forecourt for the Esplanade of State stretching away to the east. It also established a cross axis between the exposition's westernmost two buildings, the General Motors Auditorium and the Administration Building.

The Administration Building was one of a handful of buildings on the grounds that didn't offer exhibits, entertainment, or concessions during the Centennial Exposition; instead, it was headquarters for the exposition staff. The building was a modernistic makeover of the 1910 Fair Park Coliseum, which pulled double duty in its early days as a horse arena and livestock auction hall by day and theater for opera and symphony performances after dark. Its conversion to office space in the summer of 1935 was the first of the construction projects that transformed Fair Park into the Magic City—and the exposition staff, needing to establish an on-site presence, moved in as quickly as it could. "We were already in our offices before the renovation was complete," architect Donald Nelson remembered later. "The noise! I don't see how we worked. And the heat! No air conditioning. That came later. But it was a good working space." As a nod to the building's past—and almost certainly a wry reference to working conditions—the staff nicknamed the

Administration Building the "horse barn."[7]

Thanks to restoration work on the Parry Avenue Gate and nearby buildings, Fair Park's main entrance still looks much as it did in 1936. And for the millions of people who attend the State Fair of Texas each autumn, it remains a first glimpse of a magical place.

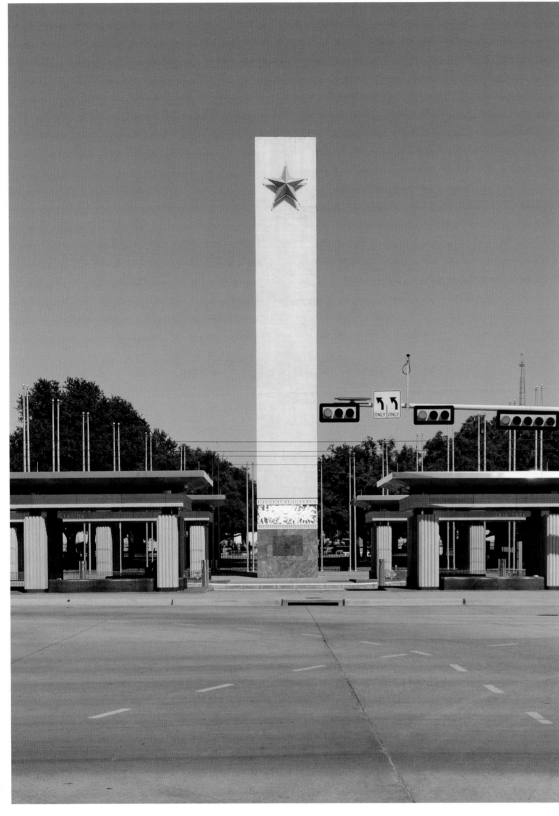

Parry Avenue Gate

The Parry Avenue Gate's four original ticket and turnstile structures, which flanked the central pylon, were removed during a 1963 remodeling project that also involved installing the flagpoles that form a semicircle just inside the gate.[8]

However, the Fair Park Station serving the Dallas Area Rapid Transit light rail system (visible in front of the gate) was designed to echo the lines of the old gate structures and of Fair Park in general. The station is located on the site of the park's streetcar stop in 1936. Dallas artists Brad and Diana Goldberg designed the station, which was completed in 2009.[9]

Quimby McCoy Preservation Architecture carried out a restoration of the Parry Avenue Gate that was also completed in 2009.[10]

The relief band at the base of the Parry Avenue Gate's central pylon depicts a buffalo hunt and a wagon train of Texan pioneers. In a later interview, artist Buck Winn explained that the relief was cast in cement and its background painted in afterward.

Winn also assisted artist Eugene Savage on his murals in the State of Texas Building.[11]

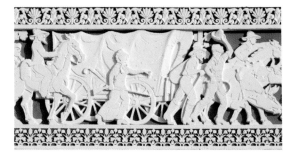

Relief details, central pylon, Parry Avenue Gate.
Buck Winn, sculptor.

Central pylon, Parry Avenue Gate

Frieze detail, 1836 Pavilion, Parry Avenue Gate

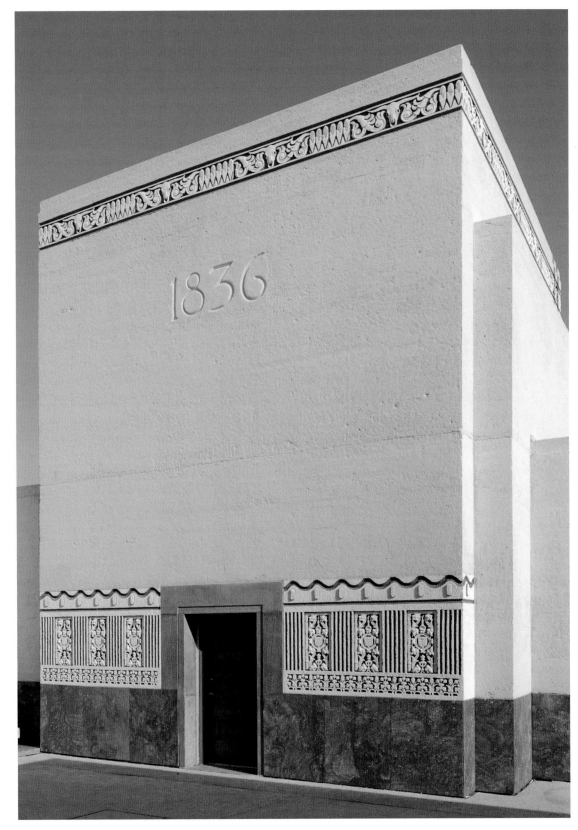

1836 Pavilion, Parry Avenue Gate

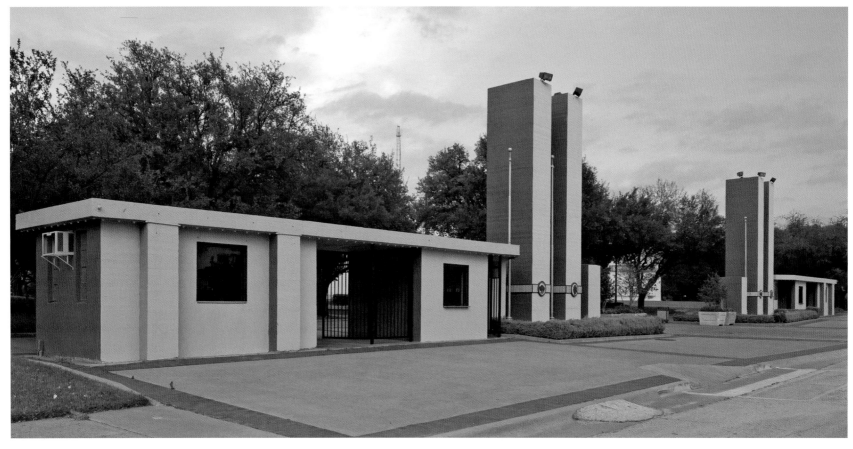

Grand Avenue Gate. Lang & Witchell, architects.

Lang & Witchell also designed two secondary gates on Second Avenue, at Grand Avenue and at Forest Avenue (renamed Martin Luther King Jr. Boulevard in 1981), along the south edge of the exposition grounds. Although these entrances were less elaborate than the one on Parry Avenue, their paired pylons are reminiscent of the grand tower at the main entrance.[12]

Glass-block pylons marking entrances along Robert B. Cullum Boulevard at Fair Park's present southern border were built after the park was expanded southward in the late 1970s.[13]

Relief medallions on the Second Avenue gates depicting a buffalo and a Native American are very similar to the design of the Buffalo nickel, the US five-cent piece that was in circulation at the time of the Centennial Exposition. Admission to the exposition cost fifty cents.

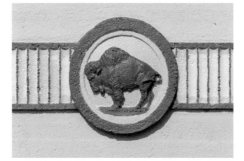 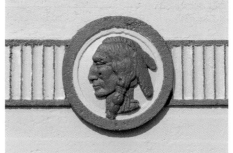

Details, Forest Avenue Gate/Martin Luther King Jr. Boulevard Gate

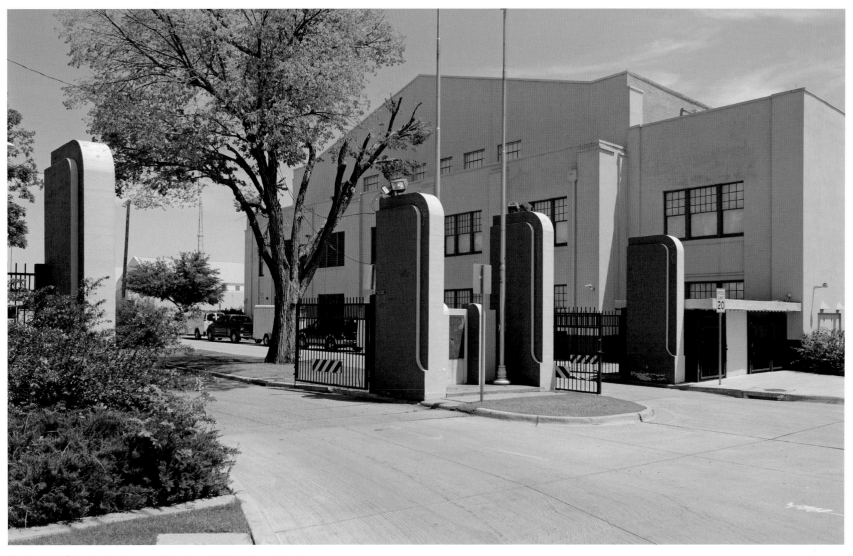

Service Gate/Washington Avenue Gate. Lang & Witchell, architects.

This gate, which led to a service drive at the north edge of the exposition grounds, had a simpler and more streamlined design than other entrances.

Conversion of the old Fair Park Coliseum into office space for the more than two hundred and fifty members of the Centennial Exposition's administrative staff involved flooring over a balcony area and dividing the interior into offices and corridors. Outside, the building's classically inspired detailing was replaced with a new modernistic façade that complemented the architecture of the rest of the exposition buildings. The exposition's publicity department noted that the building's walls were "very suggestive of the broad sunny plains so typical of the Texas landscape."[14]

The lobby had walls paneled in California redwood and a floor tiled in blue and gray linoleum with a map of Texas at its center. A portion of that space was restored when architect Wendy Evans Joseph converted the Administration Building into The Women's Museum in 2000. The museum closed in 2011.[15]

During the exposition's run, the Administration Building was also called John Garner Hall in honor of the vice president of the United States. The building may have been renamed for Garner, a native Texan, when he visited the exposition in early August 1936.[16]

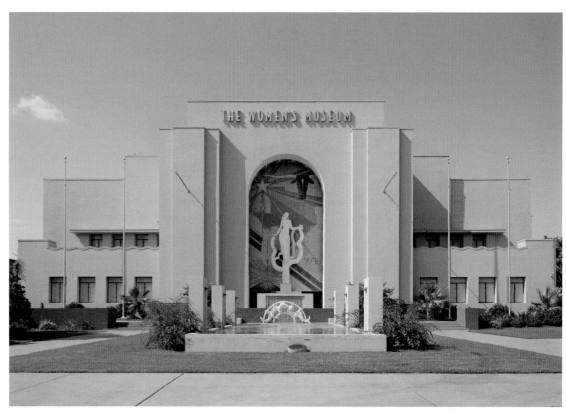

Administration Building. Exposition Technical Staff, architects.

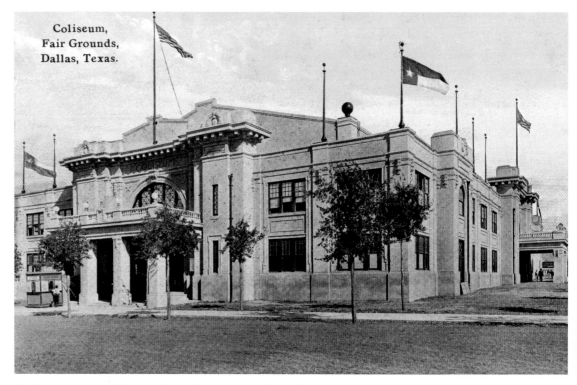

Fair Park Coliseum, c. 1910. C. D. Hill, architect. Shown before 1935 alterations.

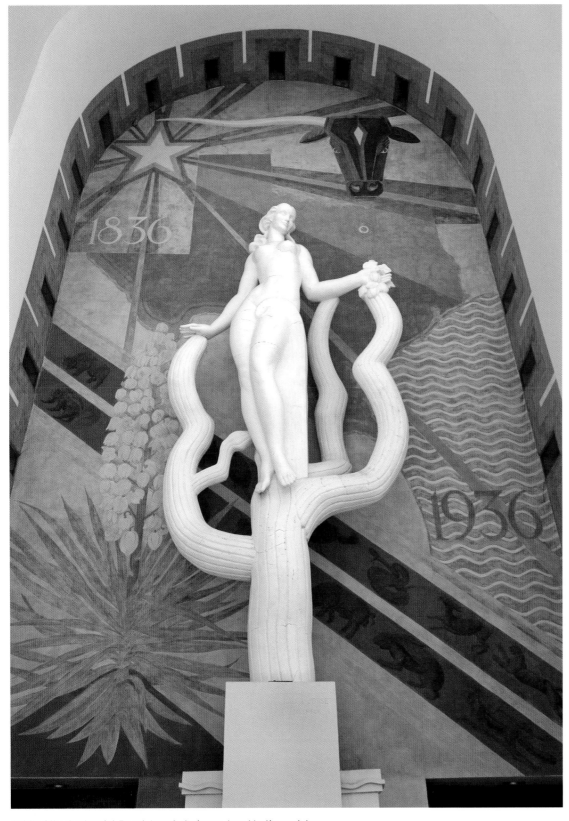

Spirit of the Centennial. Raoul Josset, designer. Jose Martin, sculptor.
Carlo Ciampaglia, muralist.

The statue at the Administration Building's entrance has drawn comparisons to Sandro Botticelli's 1486 painting *The Birth of Venus*. However, where Botticelli's Venus is shown aboard a seashell, Josset's figure stands on a saguaro cactus, a nod—albeit inaccurate—to Texas.

The model for the statue was Georgia Carroll, a sixteen-year-old from Blooming Grove, Texas, whom Josset discovered while judging a beauty contest in which she competed. Carroll said she refused to pose nude for Josset, so *Spirit of the Centennial* only reflects her from the neck up. (Architect Donald Nelson had a slightly different take: he remembered Carroll as having "not much of a figure, but a beautiful face.") Carroll went on to become a successful model in the 1930s and '40s; she joined Kay Kyser's big band as a vocalist in 1943, and she and Kyser married the next year.[17]

Jose Martin, who sculpted the statue, said *Spirit of the Centennial* was completed in ten days, and even then it was barely ready in time for the exposition's first day. Martin remembered that he was still putting the finishing touches on the piece when the gates opened that morning.[18]

The mural behind *Spirit of the Centennial*, which depicts Texas flora and fauna, was the work of Carlo Ciampaglia, who designed murals throughout the exposition grounds. Stashka Star restored the mural and statue in 1998.[19]

The playful sculpture of five flying fish at the head of the Administration Building's reflecting pool was severely deteriorated when restoration work began on the building. Conservator John Dennis oversaw the re-creation of the Fish Fountain and reflecting pool in 2000.[20]

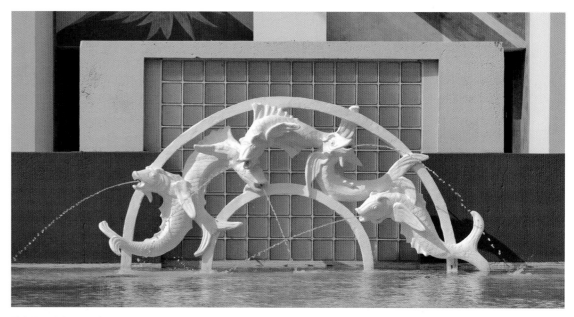

Fish Fountain. Raoul Josset and Jose Martin, sculptors.

Two modernistic fountains on the Parry Avenue side of the Administration Building feed small basins with scalloped enclosures.

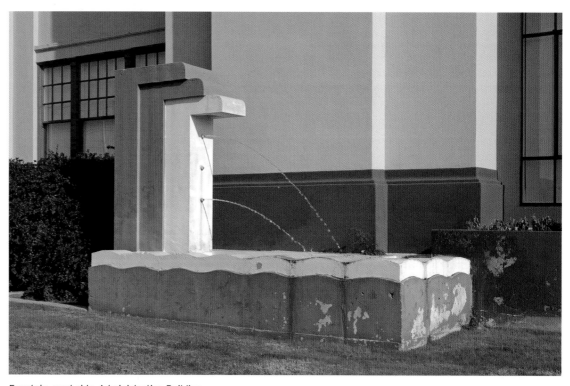

Fountain, west side, Administration Building

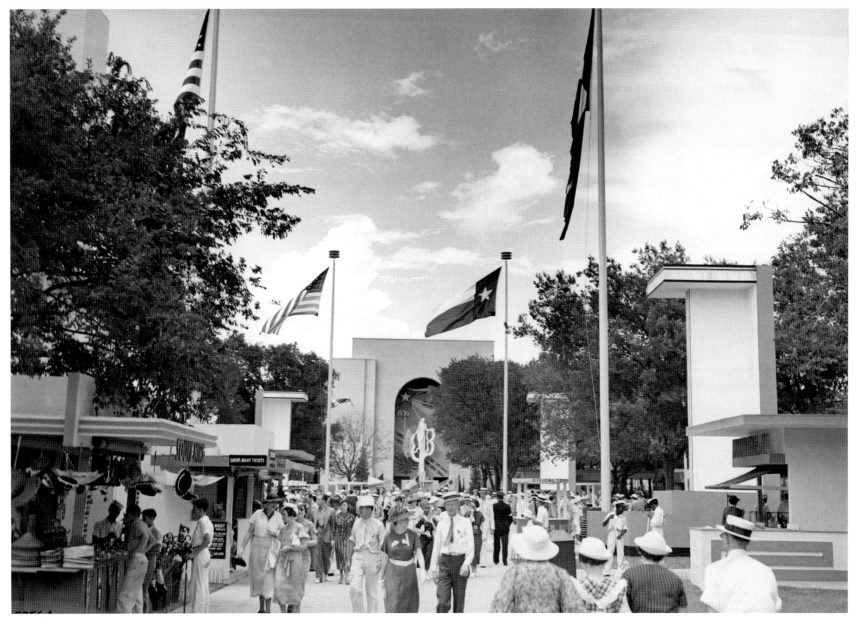

Grand Plaza looking toward Administration Building, 1936

Modernistic souvenir stands and some of the exposition grounds' distinctive lighting pylons line Grand Plaza in this 1936 view. There were nine different designs for the lighting pylons, none of which were built to be permanent.[21]

The Founders Statue was not a feature of the Centennial Exposition, but it is included here because it was the work of Josset, Martin, and Nelson, all of whom worked on the exposition, and it is in a style similar to the statues produced in 1936.[22]

The concrete sculpture honors the founders of the State Fair of Texas and the work of the Texas press in promoting it. The piece was dedicated in 1938 in honor of the State Fair's fiftieth anniversary, which was actually 1936; the celebration came two years late because the State Fair was not held in 1936 and 1937 to allow for the Texas Centennial Exposition and the Greater Texas & Pan-American Exposition.

At the base of the statue is an iron crypt into which were placed histories of the State Fair, the Texas Press Association, and *The Dallas Morning News* as well as three hundred newspapers from October 8, 1938, the day of the dedication ceremony. Otto Herold, the State Fair's president, was presented a key to the crypt which was to be passed from fair president to fair president until 1988, when the crypt would be opened. "I predict that the generation which opens this crypt will have opened the greatest iron field in the world in East Texas, as our generation has opened the greatest oil field," oilman Wallace Jenkins told the crowd at the dedication.[23]

What State Fair officials actually opened fifty years later was a crypt that had leaked over the years, damaging everything inside. The papers stored there crumbled to dust when they were touched, and the official reopening ceremony was canceled.[24]

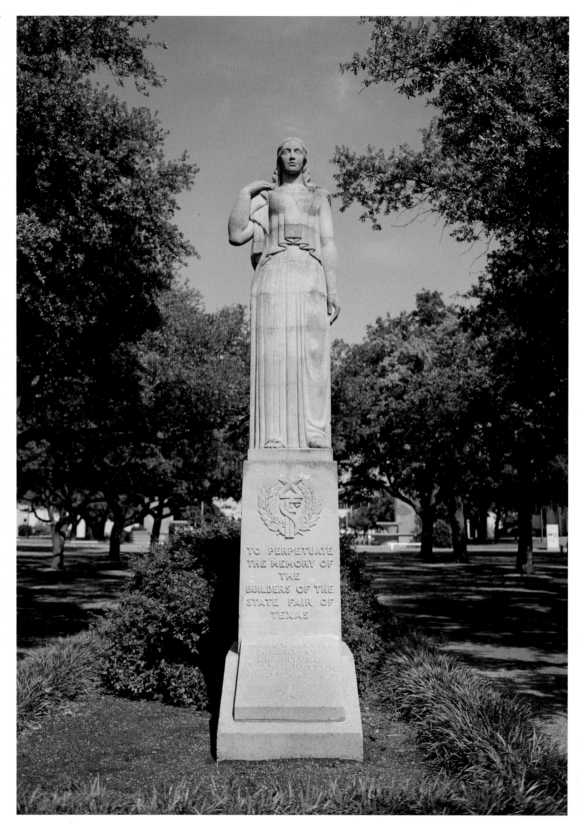

Founders Statue. Raoul Josset, Jose Martin, and Donald Nelson, designers. Jose Martin, sculptor.

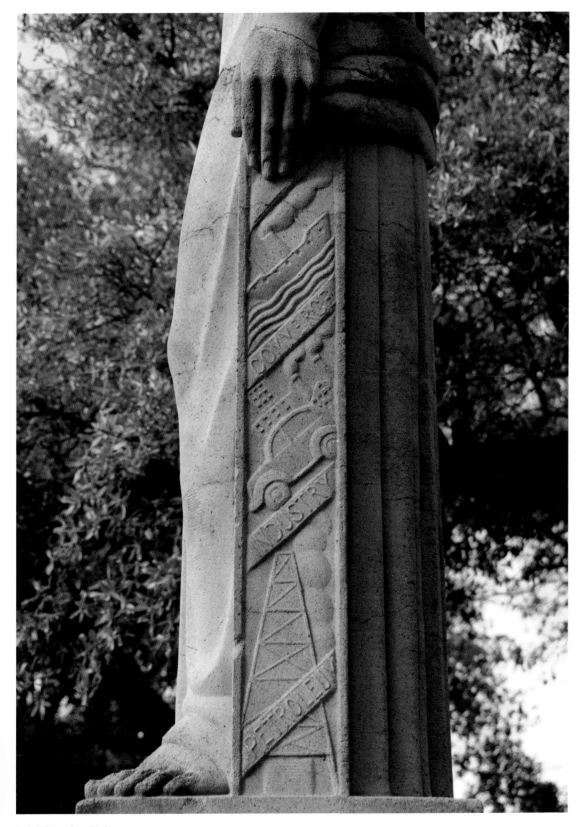

Detail, Founders Statue

ESPLANADE OF STATE

The most vivid picture of the exposition will always be that of the Esplanade with its ever changing colors on the walls of the flanking buildings, the flowing gold of the fountains, the high lights on the billowing flags, and at the end, the majestic State Building, with its crown of colored searchlights.

The Dallas Morning News
June 21, 1936

If the Parry Avenue gate didn't impress on Centennial Exposition visitors that something special was in store for them, then the Esplanade of State certainly did. The central axis of the exposition grounds, the Esplanade formed a quarter-mile promenade that led from Fair Park's main entrance to the Texas Court of Honor, its ceremonial heart. Flanked by massive exhibit halls and monumental statuary, studded with pylons and banners, a seven-hundred-foot reflecting basin at its center, the Esplanade was an imposing sight—the main street of the Magic City.[1]

As striking as it was by day, the Esplanade became something else entirely after dark. Banks of concealed floodlights bathed exhibit buildings in ever-changing shades of red, green, blue, and yellow, while spotlights picked out sculptures and bas-reliefs. In the reflecting basin, underwater lights turned glass-block weirs green while fountains were lighted in gold. And at the head of the Esplanade, the State of Texas Building was crowned with a fan of twenty-four colored searchlights that produced a total of a billion and a half candlepower, enough to be visible from twenty miles away.[2]

The lighting scheme definitely made an impression. As one newspaper reporter described it, "The walls seemed to change size under the touch of the varying colors and the sharp, modernistic lines of the exposition architectural theme seemed to become softer and more beautiful." C. M. Cutler, the exposition's lighting designer, was more succinct: "Other expositions are remembered for their architecture, color, and landscaping," he wrote, "but this one, it seems, will be remembered for its lighting."[3]

The Esplanade was another project designed by George Dahl's staff of exposition architects, but it was not a new idea: a broad pedestrian path had existed along the same alignment since at least 1890. When Centennial Exposition directors hired Philadelphia architect Paul Cret to develop a master plan for rebuilding Fair Park early in 1935, Cret proposed turning that old promenade into a broad court lined with enlarged and refaced exhibit buildings—which is exactly what Dahl's designers did. The three-hundred-foot-wide, thousand-foot-long mall featured two of the exposition's largest exhibit halls. On the north side was the Hall of Transportation, created by expanding and remodeling a 1905 auditorium

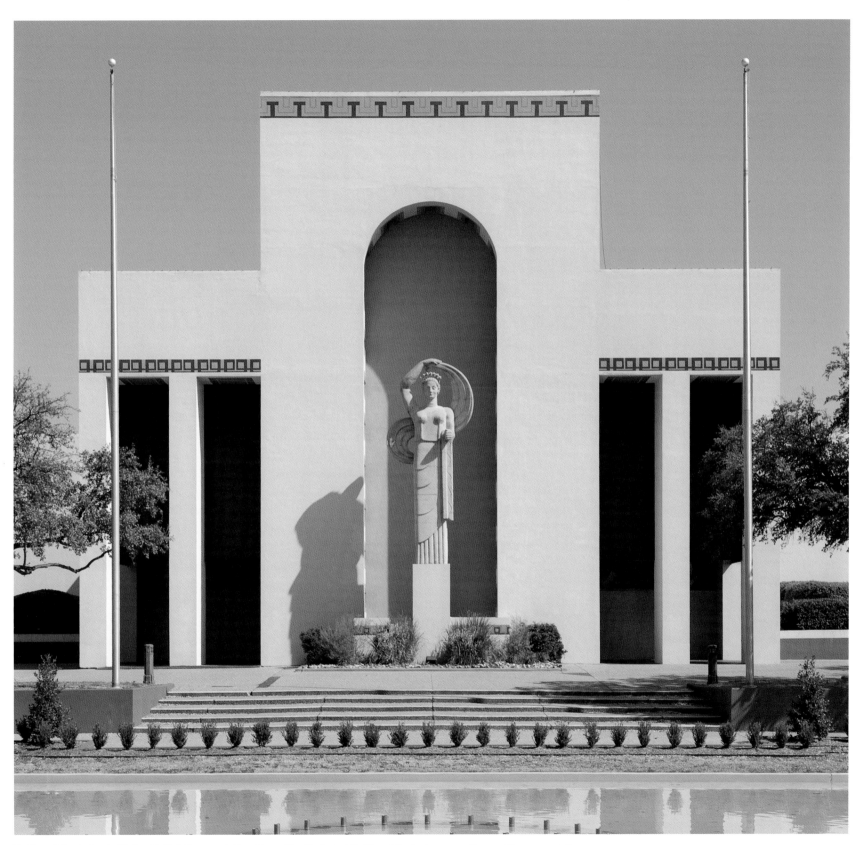

Portico of Confederate States, Hall of Transportation. Exposition Technical Staff, architects. Lawrence Tenney Stevens, sculptor.

and exhibit structure; on the south was the Hall of Varied Industries, Communications, and Electricity, which incorporated the 1922 Automobile and Manufacturers Building.[4]

Inside the Esplanade exhibit buildings, displays ran the gamut from farm machinery to high-speed trains, refrigerators to X-ray machines. Looking back, some of the exhibits that drew the most attention in 1936 appear quaint, but for fairgoers they must have seemed like glimpses of a future straight out of *Buck Rogers*.

At the Westinghouse exhibit in Varied Industries, visitors reached for stacks of coins in a model bank teller's cage, only to be thwarted by a security system triggered by the invisible beam of an electric eye. Western Union used the technology, too, demonstrating how telegrams could be sent simply by waving one's hand over a crystal ball equipped with a "magic eye." General Electric built a fully electric model home with pest-proof metal walls, a feature sure to be found in houses of the future; in GE's House of Magic theater, scientists demonstrated the beginnings of microwave cooking by using radio waves to pop corn. One of GE's biggest announcements was an invention so new that it wasn't yet available to consumers: a completely silent light switch that the company speculated would appeal to errant husbands. "There's nothing like being able to slip in late at night and turn the light on without waking up the wife and suffering the consequences," exhibit organizer W. O. Kyte told reporters.[5]

Other exhibits in Varied Industries were more prosaic, but still popular. Coca-Cola built a fully functional bottling plant that turned out one hundred bottles of Coke per minute to serve concession stands throughout Fair Park. The Owens-Illinois Glass Company showed off its new wonder product, Fiberglas, in an exhibit space built entirely of another new material, glass block. Eastman Kodak demonstrated its new color home movie film, Kodachrome, and the American Telephone & Telegraph Company let visitors place free long-distance calls to almost five hundred and fifty cities and towns across the country—as long as they didn't mind their fellow fairgoers listening in to check the quality of the connections. The sheer variety of Varied Industries exhibits was a wonder of the exposition in itself. As one journalist summed it up, "Visitors . . . can learn of such intangible things as life insurance and sound, of such delicate things as perfume and silk hose, or of such massive things as motors and electric ranges."[6]

There was less variety in the Hall of Transportation. The bulk of the exhibits focused on railroads, which pulled out all the stops to demonstrate their reach and luxury. Visitors could watch scenes of the journey between Dallas and St. Louis flash past the windows of an exact replica of a plush St. Louis-San Francisco Railroad lounge car or stroll through Missouri Pacific's mock-up of an ultra-modern train station complete with something most fairgoers had never seen: automatic doors. Burlington showed a full-sized model of sections of its famous streamlined Zephyr train, and the Atchison, Topeka, and Santa Fe and the Texas and Pacific celebrated the extent of their lines with elaborate model train sets. The models were popular with kids, as expected, but adults also proved to be big fans. "You can't see the trains for the old birds horning in in front of you," one young fairgoer grumbled.[7]

At the east end of the Transportation building was Chrysler Hall, an exhibit many visitors praised as the most beautiful on the grounds. Its main interior space was the Salon of Mirrors, an automobile showroom designed by Chrysler's David S. French and H. Ledyard Towle of the Pittsburgh Plate Glass Company. Towle's goal was to keep visitors thinking cool, so he floored the room in an icy gray with walls covered in silver tile wainscoting and forty-three tons of blue mirrored glass—even more, *The Dallas Morning News* noted, than in the Hall of Mirrors at Versailles. (If the cool color scheme proved too subtle, Chrysler also put the exhibit's air conditioning units on display in a glass case.) Entertainment was offered in the open-air Chrysler Gardens band shell, in a marionette and newsreel theater called Chrysler's Hall of Celebrities, and in the Salon of Mirrors itself, where regular concerts were given on the "marvel of modern musical instruments," the Hammond electric organ.

Women could have tea and write letters in the Chrysler Penthouse, a lounge that overlooked the Salon of Mirrors, while their husbands traded in their old cars for new Chryslers, Dodges, DeSotos, and Plymouths, getting appraisals from their hometown dealers by teletype. Overhead, a news ticker provided information on Chrysler automobiles, the day's exposition schedule, headlines, and sports scores. Unfortunately, none of Chrysler Hall's interiors have survived, and no photos showing the overall space were found in the archives of the centennial or the Chrysler Corporation.[8]

As modern as many of the inventions displayed along the Esplanade of State must have seemed, none would impact the future as much as one that was shown in the Varied Industries building: television, or as it was called at the time, the "television telephone." For a fee, visitors could speak to someone else in the exhibit by telephone, with each party able to see the other on small TV screens. The technology was hailed as the future of interstate law enforcement, but local newspapers really paid attention when it was used to marry Sylvia Wayt, an exposition employee, and taxi driver J. D. Hogue. Wayt and Hogue exchanged vows on stage at Chrysler Gardens connected by TV with the Rev. E. K. Dougherty, who was at the Varied Industries building. To provide the contrast necessary for the early black-and-white transmission, the groom wore a bright red shirt and the bride used green lipstick and rouge. The marriage attracted the attention of one South Texas farmer who showed up at the television exhibit asking to use the device to see a woman in New York with whom he had been corresponding—if she looked like movie star Joan Blondell, he said, he wanted to marry her. Exhibit officials told the disappointed farmer that he would have to wait

at least a decade before everyone in the country was linked by television telephone.[9]

Although the Esplanade of State appears intact today, only the Hall of Transportation (now called the Centennial Building) and the reflecting basin date from 1936. A smaller exhibit building at the east end of the Esplanade, the Hall of Petroleum, was demolished soon after the 1937

Greater Texas & Pan-American Exposition, and the Varied Industries building was destroyed by fire in 1942. The Automobile Building, as it is now known, is a 1948 structure built on part of the site of the old Varied Industries hall. Its Esplanade façade was remodeled in 1986 to complement that of the Transportation building, and its murals were re-created in 1999. The Transportation

building's murals and reliefs have been restored, as has the reflecting basin; missing pylons, statuary, and lighting features have been rebuilt based on 1936 plans.[10]

There is still work to be done, but even so, the Esplanade is once again the showpiece it was designed to be, a reflection of the grandeur of the Texas Centennial Exposition.

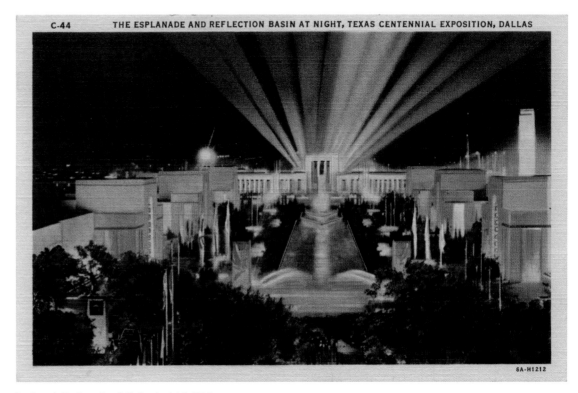

Postcard, Esplanade of State at night, 1936

Although the hues shown on this postcard are not entirely accurate, they give an idea of the Esplanade's colorful lighting scheme during the Centennial Exposition. "One can only speculate about the impression such a spectacle made on visitors from Ponder and Muleshoe," architecture critic David Dillon wrote. "Here was the county fair transformed into Oz."[11]

The reflecting basin was fed at its west end by a pair of twenty-seven-foot pylon fountains decorated with Pierre Bourdelle's reliefs depicting mythological figures.[12]

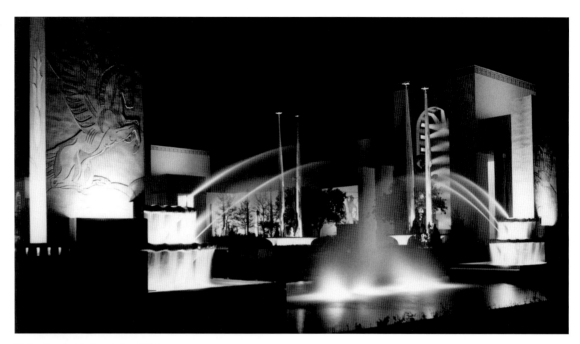

Reflecting basin fountains, 1936

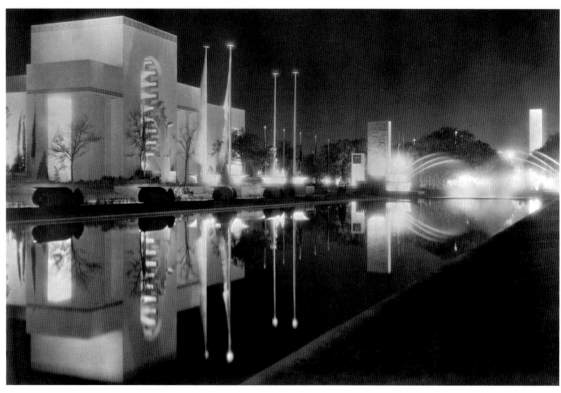

Reflecting basin with Portico of France, Hall of Varied Industries, Communications and Electricity, 1936

Siren. Pierre Bourdelle, sculptor.

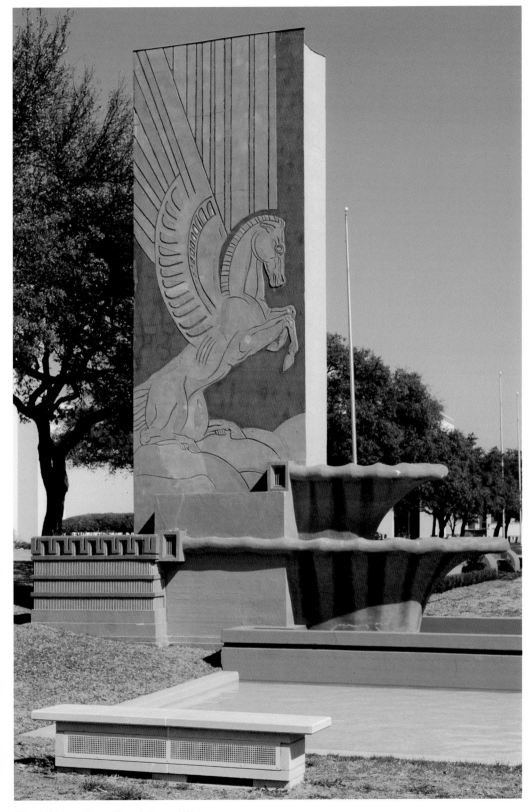

Winged Horse. Pierre Bourdelle, sculptor.

By day, the dominant features of the Esplanade were the porticoes of its two major exhibit buildings, the Hall of Transportation (left) and the Hall of Varied Industries, Communications, and Electricity. Oversized banners in front of each portico represented the six nations whose flags have flown over Texas.

The Esplanade's symmetry, scale, and sheer size were meant to amaze visitors to the exposition grounds, drawing them toward the State of Texas Building at its center—"a manipulative and highly effective arrangement," architecture critic David Dillon wrote.[13]

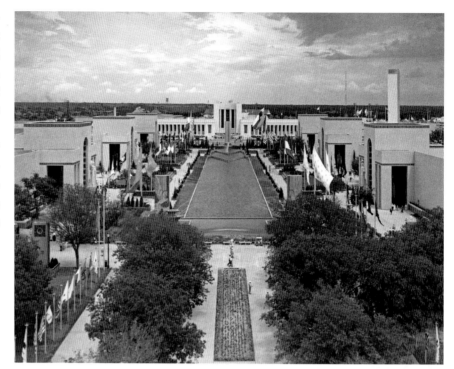

Esplanade of State by day, 1936

The 1905 Auditorium and Exposition Building, the first steel-and-masonry building at Fair Park, was enlarged and remodeled in 1936 to become the Hall of Transportation. The peaked roofs of the 1905 structure are still visible on the north side of the remodeled building.[14]

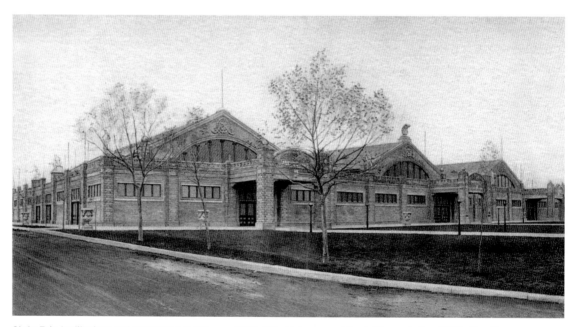

State Fair Auditorium and Exposition Building, c. 1905. Otto H. Lang, architect. Shown before 1936 alterations.

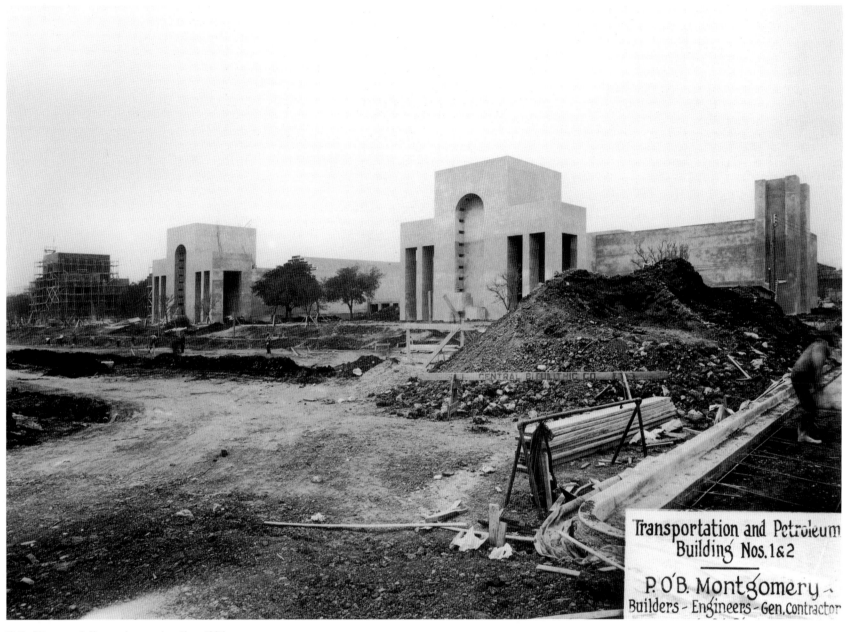

Transportation and Petroleum
Building Nos. 1 & 2
———
P. O'B. Montgomery
Builders - Engineers - Gen. Contractor

Hall of Transportation under construction, 1936

Construction of the Hall of Transportation is nearing completion in this photo, which looks west from the Texas Court of Honor. The Esplanade's reflecting basin would be built in the open area in front of the building.

As the label indicates, the complex was initially referred to as the Transportation and Petroleum Building. Exposition officials planned for major oil companies to exhibit here, but each decided to build its own pavilion. Oil-related businesses ended up in the Hall of Petroleum, which was built east of the Transportation building.[15]

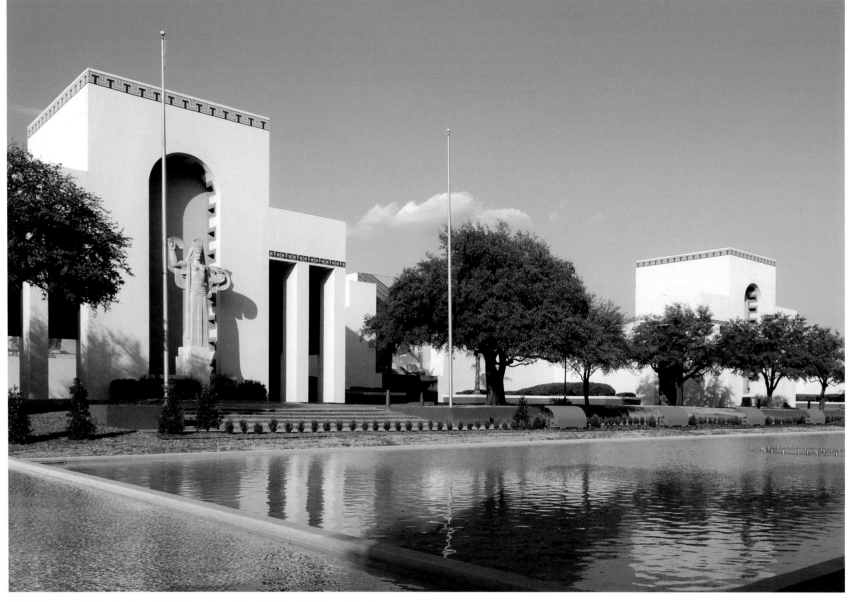

Hall of Transportation/Centennial Building. Exposition Technical Staff, architects.

The Hall of Transportation was known in later years as the General Exhibits Building and Hall of Gold and the World Exhibits Building before being renamed the Centennial Building. It underwent a thorough exterior restoration in 2000-2001 under the direction of ARCHITEXAS.[16]

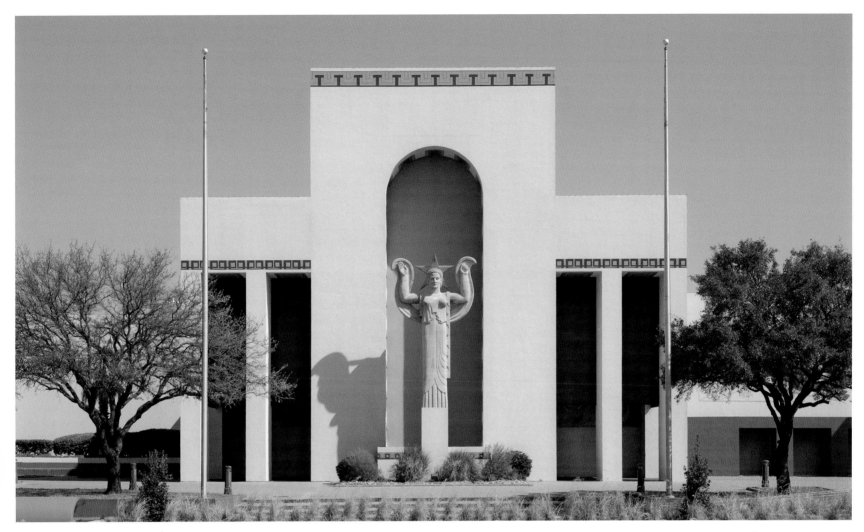

Portico of Texas, Hall of Transportation

The signature architectural features of the Transportation and Varied Industries buildings were the six massive porticoes that ran along the Esplanade façades, each dedicated to one of the six nations whose flags have flown over Texas: Spain, France, Mexico, the Republic of Texas, the Confederate States of America, and the United States of America.

Sculptors Lawrence Tenney Stevens and Raoul Josset designed the monumental twenty-foot cast-stone statues that stand on twelve-foot pedestals in each portico's niche. Each statue is a stylized female figure bearing symbols of one of the six nations—*France*, for example, holds a bunch of grapes representing the country's winemaking, while *Spain* wears a lace mantilla and holds

castanets and a castle, an element of the Spanish coat of arms. Though the sculptures weren't the work of George Dahl, he did dictate their style, suggesting early in 1936 that the figures "be delineated with a vertical expression, draped, executed in a style which might be a concoction of a little of the flavoring of Egypt tempered by the Archaic Greek, and finally breathed over with some of the condiments of the Southern sunshine."[17]

The porticoes also featured some of Fair Park's most outstanding murals. Behind each niche, a painted seal represented one of the six nations, and flanking the entrances under each portico was a pair of monumental scenes related to exhibits inside the building. For the Hall

of Transportation, Carlo Ciampaglia designed murals that depicted the history of transportation and its various modes; at the Hall of Varied Industries, Pierre Bourdelle's paintings dealt with industry, labor, science, and technology. Bourdelle was also responsible for a series of allegorical bas-reliefs on both buildings' exteriors.[18]

The murals and reliefs on the Transportation building have been restored. Today the murals are protected by retractable sunscreens, which are visible in the photo. The original Bourdelle murals on Varied Industries were lost when the building burned in 1942, but they have been re-created; however, reliefs on the building have not.[19]

Lawrence Tenney Stevens (left) supervises sculptor Jose Martin (second from left) and two unidentified assistants as they add finishing touches to *Confederacy*, the first of the Esplanade statues to be completed.[20]

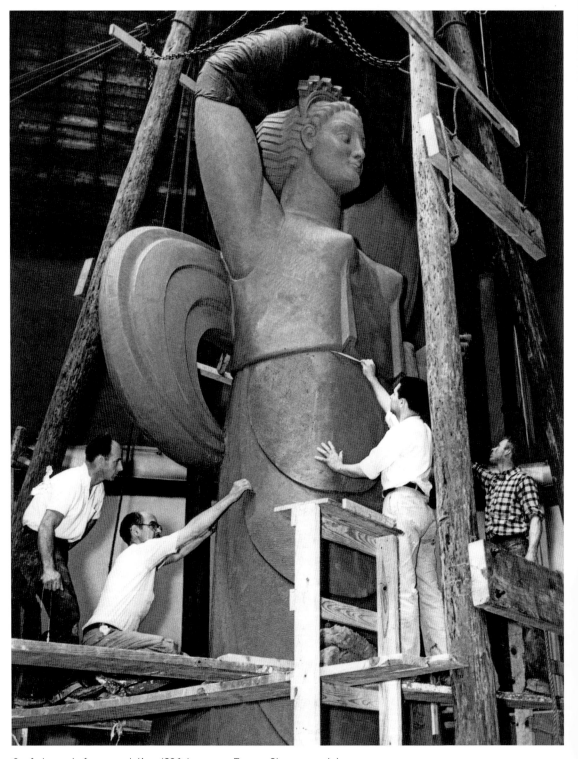

Confederacy before completion, 1936. Lawrence Tenney Stevens, sculptor.

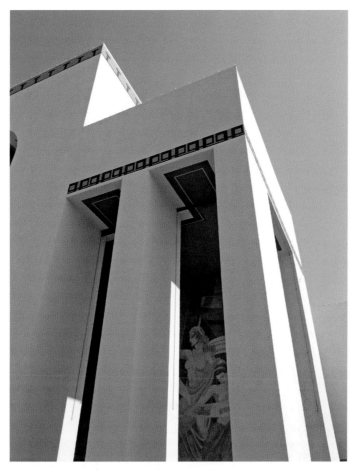

Ceiling detail, Portico of Spain, Hall of Transportation

The porticoes' simple lines and lack of ornamentation, combined with bold colors on their ceilings and in the murals, made them all the more striking. "It is an architecture of mass and proportion rather than one of ornamental detail," architect Ralph Bryan noted.[21]

Juan Larrinaga, a former Hollywood set designer who had served as art director for the 1935 California Pacific International Exposition in San Diego, designed the Mesoamerican-influenced ornamental bands near the porticoes' rooflines as well as similar features on buildings throughout the exposition grounds.[22]

Ceiling detail, Portico of Spain, Hall of Transportation

Lawrence Tenney Stevens was responsible for the design of the statues representing Spain, the Confederacy, and Texas in front of the Hall of Transportation, while Raoul Josset designed those for France, Mexico, and the United States at the Hall of Varied Industries, Communications, and Electricity. Although the statues complement each other, their subtle stylistic differences distinguish the two artists' work.

Likewise, the accompanying seals reflect the styles of the murals they face. The seals for Spain, the Confederacy, and Texas have a look that fits Carlo Ciampaglia's classically inspired work, but those for France, Mexico, and the United States are executed in a much more abstract style reminiscent of Mesoamerican art. The artists of the seals are not known.[23]

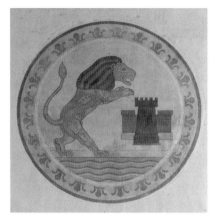

Seal, Spain

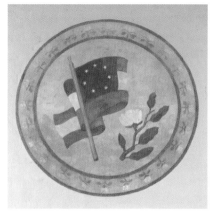

Seal, Confederate States of America

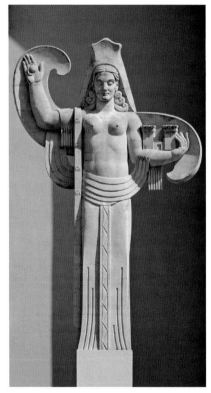

Spain
Lawrence Tenney Stevens, sculptor.

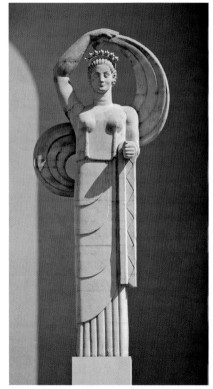

Confederacy
Lawrence Tenney Stevens, sculptor.

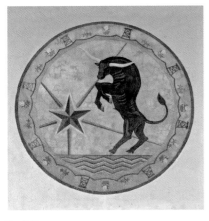

Seal, Texas

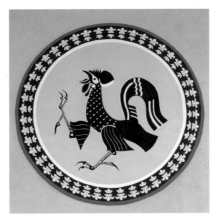

Seal, France

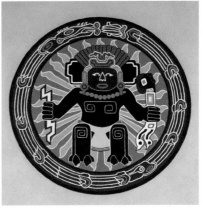

Seal, Mexico

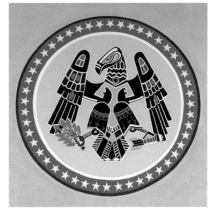

Seal, United States of America

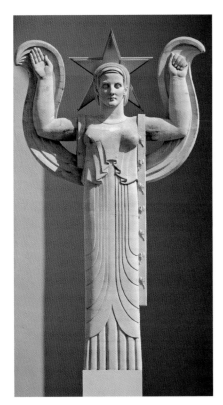

Texas
Lawrence Tenney Stevens, sculptor.

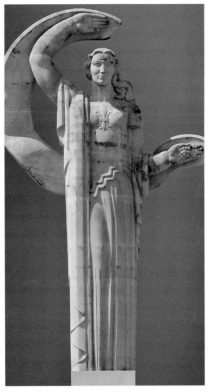

France
Raoul Josset, sculptor.

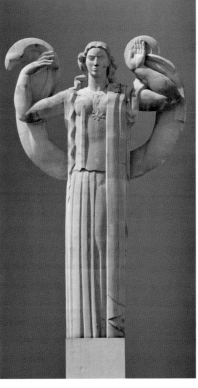

Mexico
Raoul Josset, sculptor.

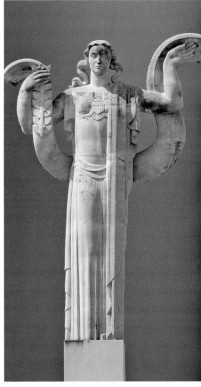

United States
Raoul Josset, sculptor.

Ciampaglia's murals *Motion* and *Traction* are located at the west entrance to the Hall of Transportation, which led directly into the exhibit of the International Harvester Company. International Harvester displayed its reapers, tractors, trucks, and school buses along with other farm equipment and a mechanical Holstein cow that chewed its cud, moved its eyes, head, and tail, mooed, and even gave milk.[24]

Motion
Carlo Ciampaglia, artist.

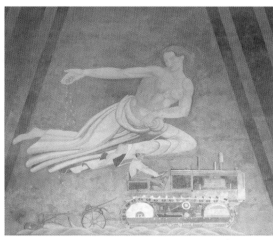

Traction
Carlo Ciampaglia, artist.

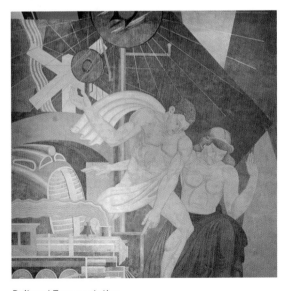

Railroad Transportation
Carlo Ciampaglia, artist.

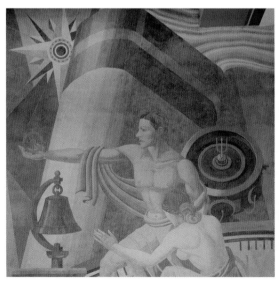

Navigation
Carlo Ciampaglia, artist.

Transportation of the Future, which shows a pair of figures escorting a rocket ship into outer space, is believed to be among the earliest depictions of space travel in American public art.[25]

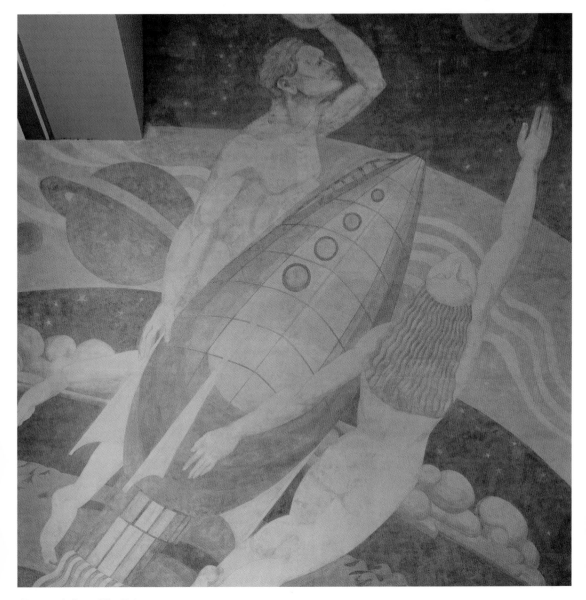

Transportation of the Future
Carlo Ciampaglia, artist.

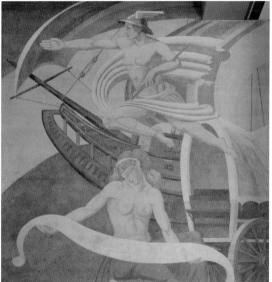

Old Methods of Transportation
Carlo Ciampaglia, artist.

Ciampaglia's Hall of Transportation murals were all painted over after the Centennial Exposition; the first coat of overpaint may have been applied as early as 1942, with more coats added in every decade that followed. The national seal medallions under the Transportation porticoes were rediscovered in the late 1970s, but most of the murals were thought to be lost until sandblasting revealed part of *Motion*. At that time, Ciampaglia's work was buried beneath as many as eight layers of overpaint.[26]

Fine Art Conservation Laboratories of Santa Barbara, California, uncovered and restored the murals in 2000. Because each mural had aged and weathered differently, conservators decided not to attempt to match color and saturation across the entire series.[27]

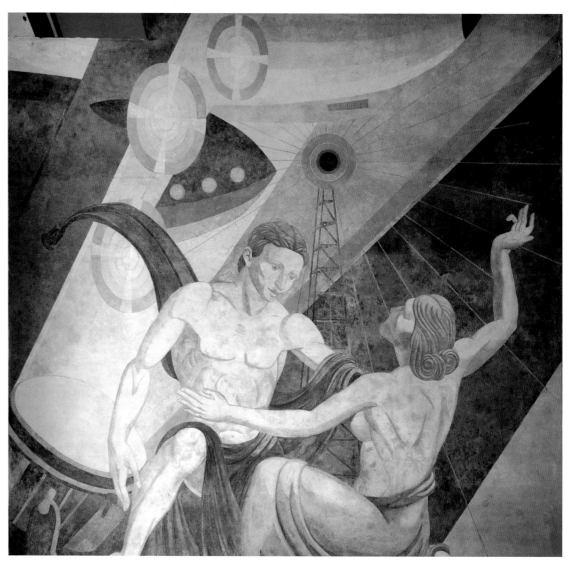

Aeroplane Transportation
Carlo Ciampaglia, artist.

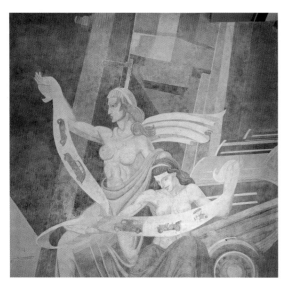

Automobile Transportation
Carlo Ciampaglia, artist.

A set of bas-reliefs on the Hall of Transportation symbolized transportation by rail, air, land, and sea. The reliefs had been damaged and painted over through the years; they were restored in 2000 by Laboratory for Conservation of Fine Arts of Englewood, New Jersey.[28]

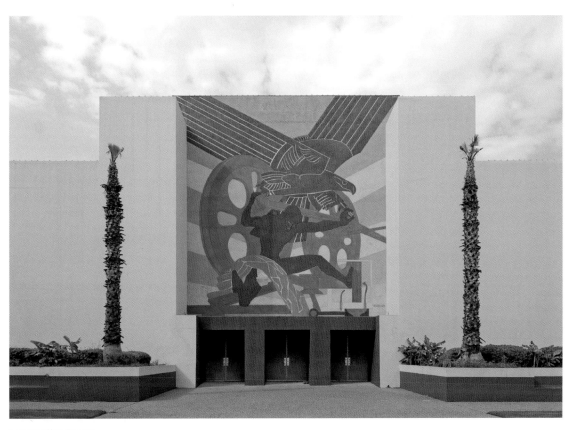

Locomotive Power
Pierre Bourdelle, sculptor.

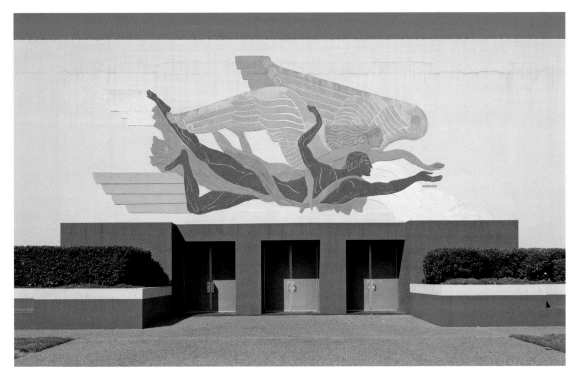

Speed
Pierre Bourdelle, sculptor.

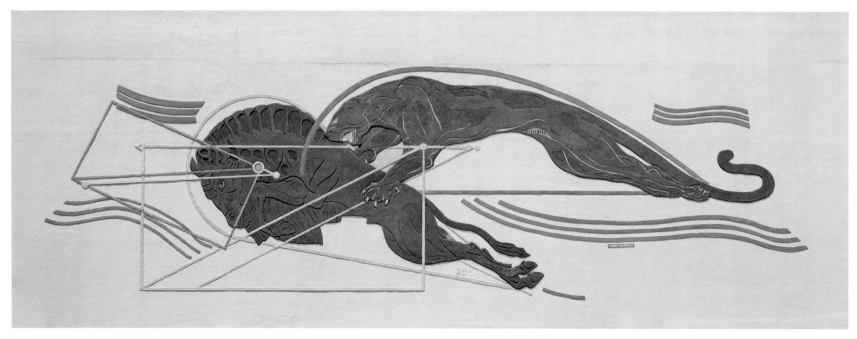

Streamline
Pierre Bourdelle, sculptor.

Bourdelle's bas-relief of a cougar and bison on the Chrysler Hall wing of the Hall of Transportation was said to represent the design of Chrysler's Airflow automobile, which was billed as the first streamlined car when it was introduced in 1934. It is unclear whether that was actually Bourdelle's intention or simply an example of clever publicity from Chrysler.[29]

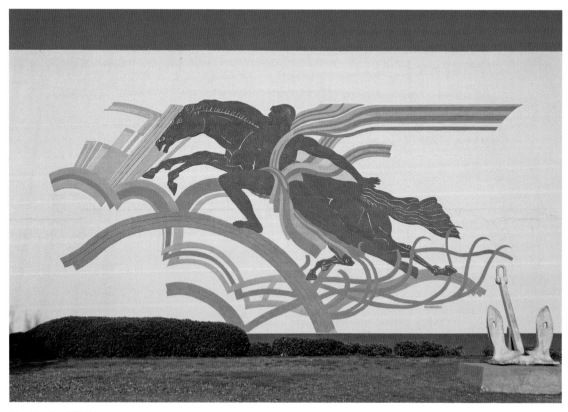

Man Taming Wild Horse
Pierre Bourdelle, sculptor.

Iron Workers
Pierre Bourdelle, artist.

Miners
Pierre Bourdelle, artist.

X-Rays
Pierre Bourdelle, artist.

Power Dam
Pierre Bourdelle, artist.

Bourdelle's six portico murals on the Varied Industries building were re-created in 1999 based on the artist's drawings and black-and-white photos of the murals from 1936. The $192,000 project was funded by proceeds from the 1998 State Fair of Texas.[30]

Although the colors seem bold today in comparison to Ciampaglia's murals at the Hall of Transportation, newspapers in 1936 reported that all the Esplanade murals were originally painted in "full rich colors that are associated with Italian art."[31]

Lens Makers
Pierre Bourdelle, artist.

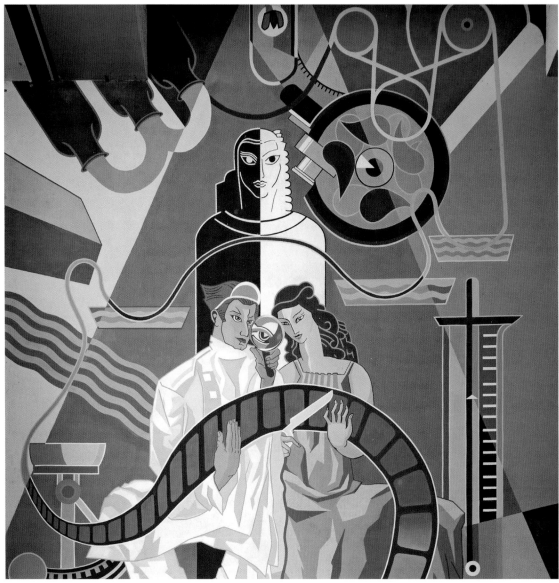

Photographic Process
Pierre Bourdelle, artist.

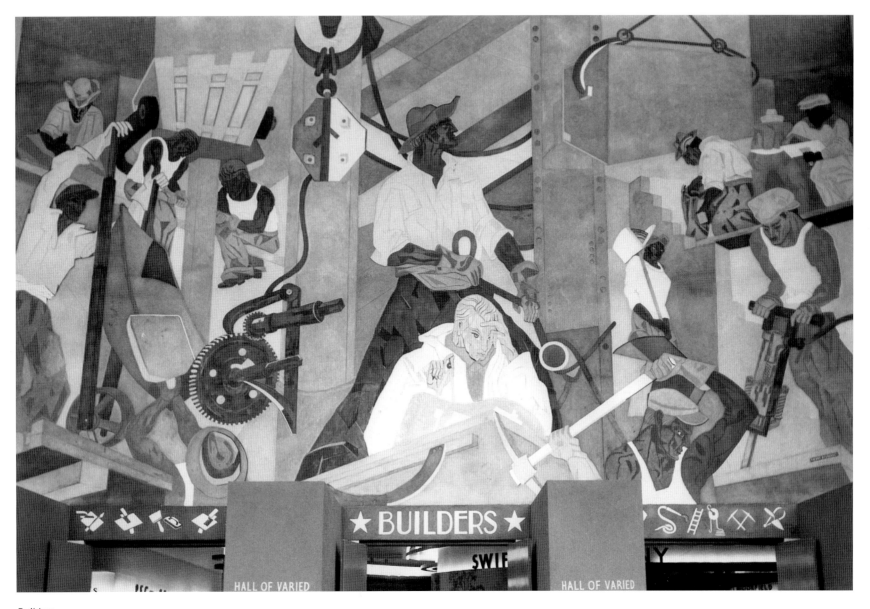

Builders
Pierre Bourdelle, artist.

Bourdelle's works lost when the Hall of Varied Industries, Communications, and Electricity burned in 1942 included murals symbolizing the construction trades and electric power and a bas-relief of a cowboy.

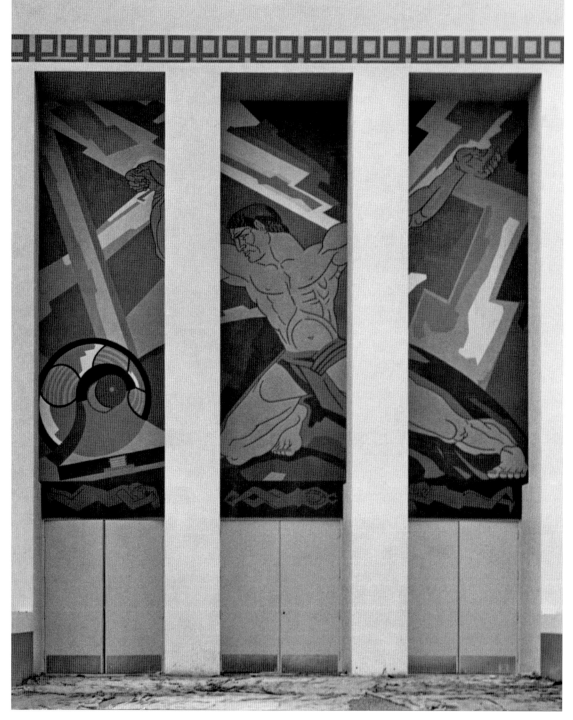

Texan Youth
Pierre Bourdelle, sculptor.

Prometheus
Pierre Bourdelle, artist.

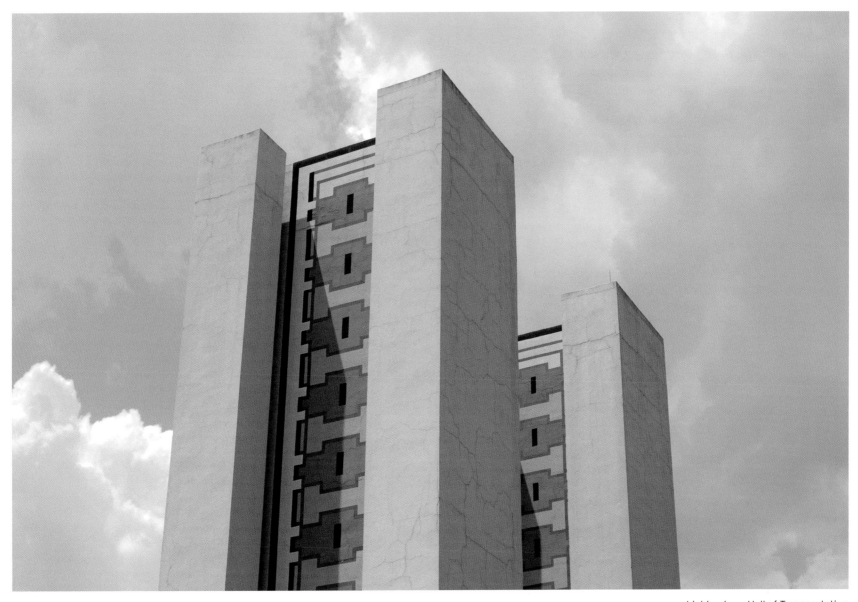

Light pylons, Hall of Transportation

Part of the Esplanade lighting scheme was two pairs of illuminated pylons at the east end of the Transportation and Varied Industries buildings. They have been restored as part of the Esplanade rehabilitation projects.

Low concrete reflectors supplied indirect lighting to the walkways flanking the Esplanade's reflecting basin in 1936. They were removed after the Centennial Exposition, but were reconstructed in 2008-2009 as part of the restoration of the basin and fountains.[32]

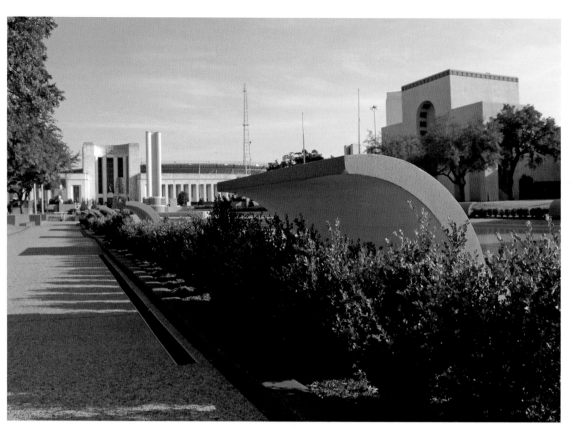

Light reflectors, Esplanade of State

A highlight of the railroad exhibits in the Hall of Transportation was the elaborate model railroad built by the Texas and Pacific Railway, which cost $30,000 and covered more than two thousand square feet. Scaled-down passenger and freight trains ran on three hundred and twenty feet of track through models of major cities including New Orleans, Dallas, Fort Worth, and El Paso. In the countryside, the trains passed miniature gushing oil wells, moving tractors, flowing rivers, grazing cattle, and cotton fields under harvest.[33]

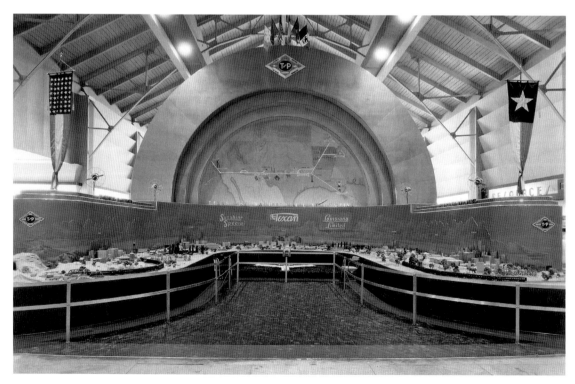

Texas and Pacific Railway Company exhibit, Hall of Transportation, 1936

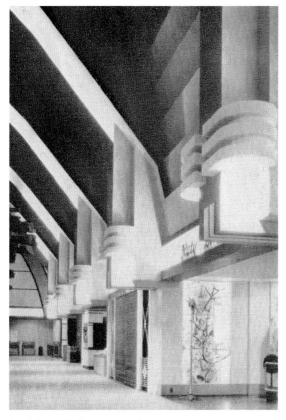

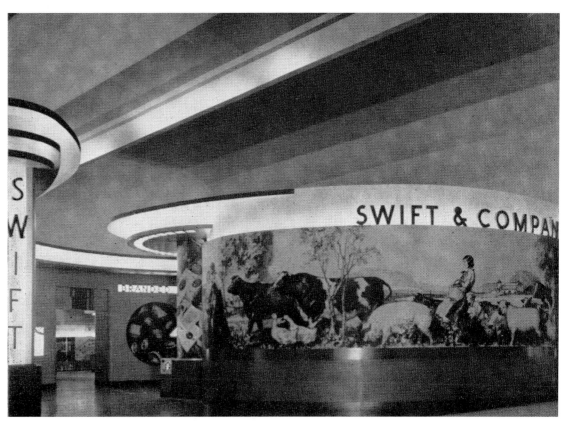

Corridor, Hall of Transportation, 1936

Swift & Company exhibit, Hall of Varied Industries, Communications, and Electricity, 1936

During the exposition, structural elements inside the 1905 section of the Hall of Transportation were concealed behind modernistic wall treatments, as shown above. None of the 1936 work has survived.

Every exhibit in the Hall of Varied Industries had its own distinctive look, but they were all designed along the same modernistic lines as the rest of the exposition. Some elements, such as the indirect lighting on the General Electric exhibit at right and the backlit shelf signage on the Swift & Company exhibit, above right, were required by the exposition's architectural staff.[34]

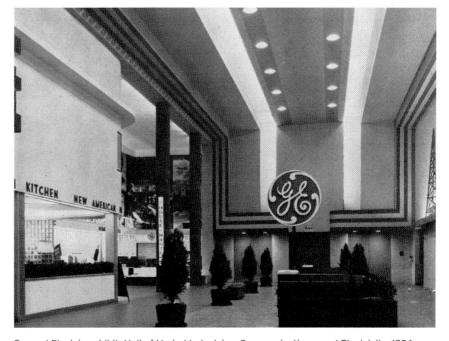

General Electric exhibit, Hall of Varied Industries, Communications, and Electricity, 1936

The Automobile Building opened on the site of the Hall of Varied Industries, Communications, and Electricity in 1948, six years after the original building burned. Although an effort was made to address Raoul Josset's statues *France*, *Mexico*, and *United States*, which survived the blaze, the new building's bands of windows and squat, curved entrances were not in keeping with the Hall of Transportation across the Esplanade.

The footbridge in the foreground, which crossed the Esplanade reflecting basin, was built for the 1952 State Fair of Texas. The bridge was later removed. [35]

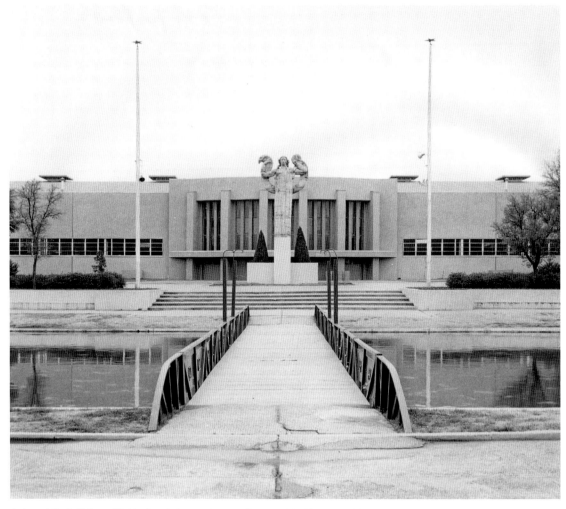

Automobile Building with *Mexico* statue, c. 1952. Walter W. Ahlschlager, architect (1948).

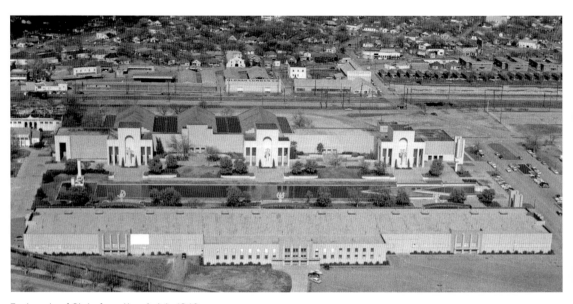

Esplanade of State from the air, late 1940s

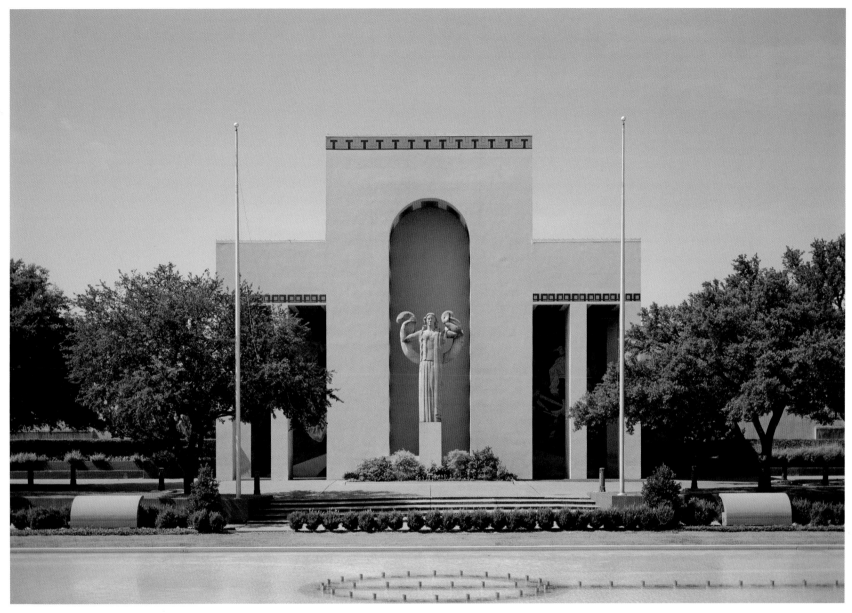

Portico of Mexico, Automobile Building. Bogard, Guthrie & Partners, architects (reconstruction), 1986.

The Esplanade façade of the Automobile Building was remodeled to mirror that of the Hall of Transportation in 1986.[36]

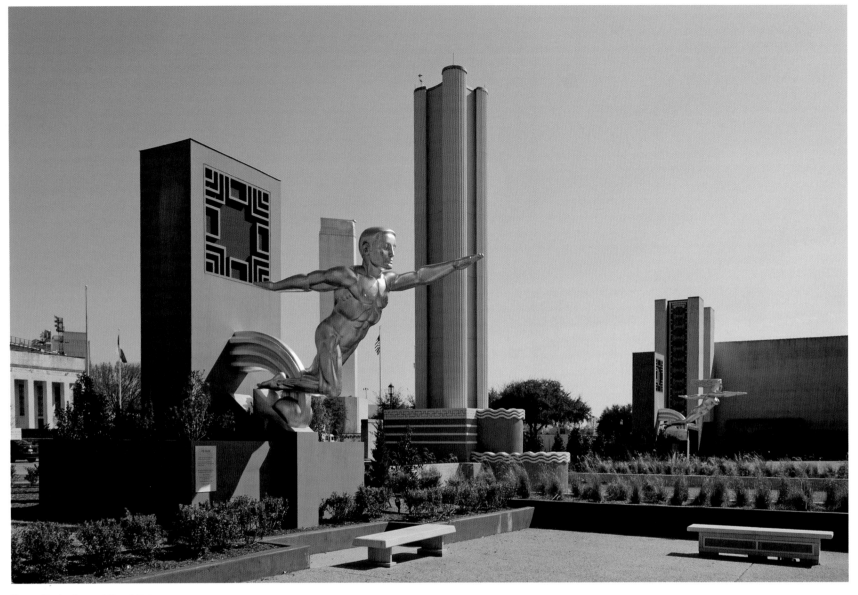

Tenor, Contralto, and Great Pylon

At the east end of the Esplanade reflecting basin stood the fifty-foot Great Pylon and *Tenor* and *Contralto*, a pair of statues by Lawrence Tenney Stevens.

The Great Pylon was designed to be an Esplanade landmark and a visual anchor for the head of the reflecting basin. It was also a fountain, with a seventy-five-foot jet of water arcing from its base into the reflecting pool. At night, the jet was lighted in amber to give it the look of flowing molten metal; during the Centennial Exposition it was known as the "Stream of Gold."[37]

Tenor and *Contralto* were sculptures of silver-painted plaster attached to two "Singing Towers," the loudspeaker pylons that dotted Fair Park in 1936; the statues represented sound and were meant to celebrate the exposition's state-of-the-art broadcasting system. The originals were damaged after the exposition closed and the Gulf Refining Company, which had sponsored the speaker system, declined to pay the $100 necessary to repair them. They were removed at some point after 1938.[38]

Sculptor David Newton created new versions of *Tenor* and *Contralto* using historic photographs as a guide. His reproductions were cast in bronze, and the speaker towers that accompanied them were re-created in cast concrete. The new *Tenor* and *Contralto* were set in place in 2009.[39]

Great Pylon
Exposition Technical Staff, architects, 1936.
Quimby McCoy Preservation Architecture
(reconstruction), 2009.

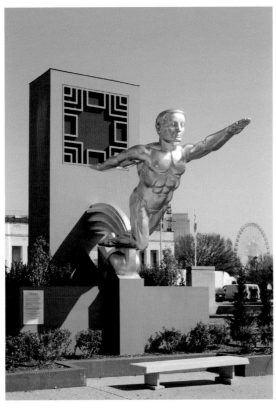

Tenor
Lawrence Tenney Stevens, sculptor, 1936.
David Newton, sculptor (reproduction), 2009.

The fifty-foot Great Pylon played a part in the Esplanade's dramatic lighting plan. Its three curved faces were illuminated in green to match the lighted glass blocks in the reflecting basin; coupled with the "Stream of Gold" fountain, it must have produced a striking effect. Lighting engineer C. M. Cutler pointed out that the steady colors illuminating the basin fountains provided a needed contrast to the changing hues of floodlights on the Esplanade exhibit halls: "Too many parts of the picture changing are likely to destroy its unity," he said.[40]

The pylon was demolished after the exposition closed, but was re-created in 2009 as part of the restoration of the reflecting basin.[41]

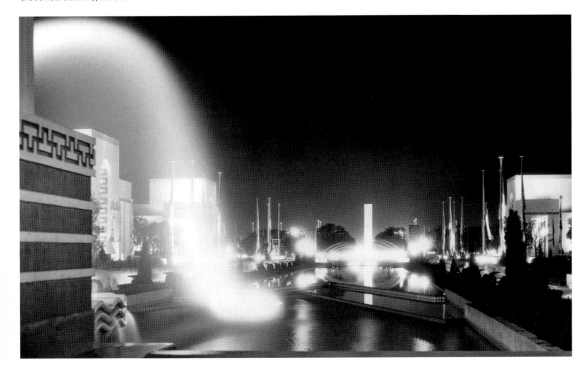

Reflecting basin looking west from Great Pylon, 1936

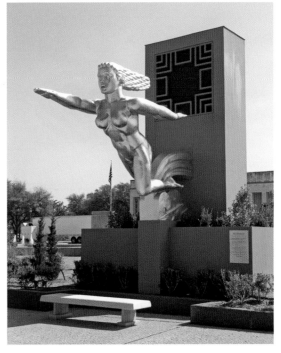

Contralto
Lawrence Tenney Stevens, sculptor, 1936.
David Newton, sculptor (reproduction), 2009.

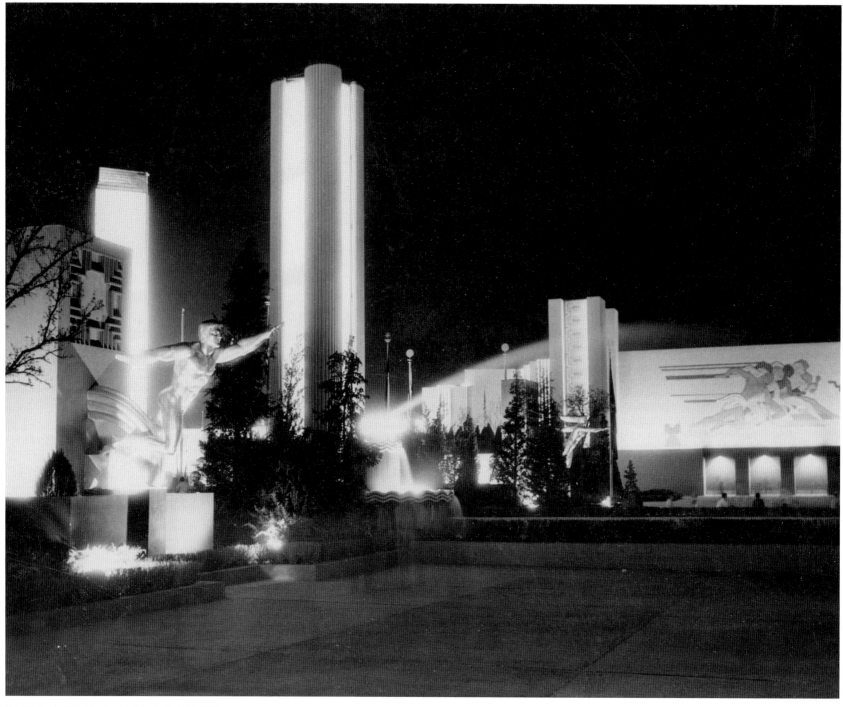

Tenor, Contralto, and Great Pylon at night, 1936

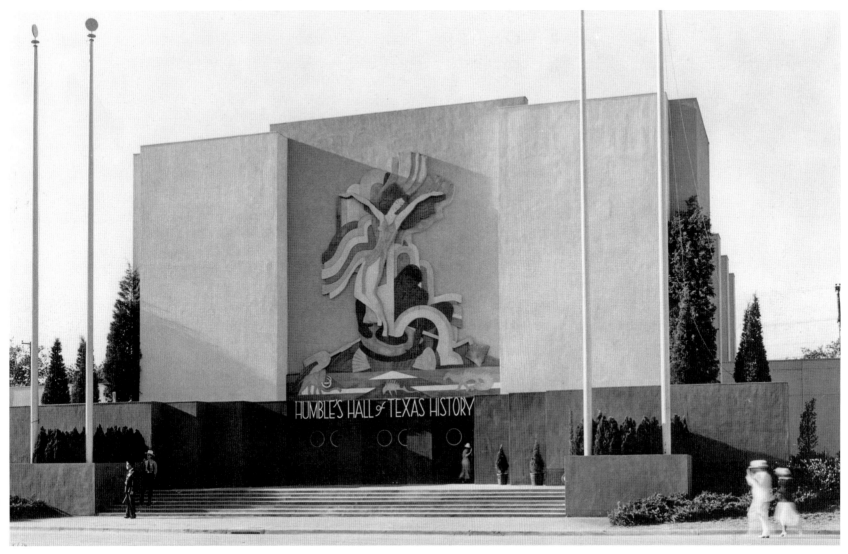

Hall of Petroleum, 1936 (demolished). Exposition Technical Staff, architects.

As the Centennial Exposition was being planned, officials expected oil companies to exhibit in what was then called the Transportation and Petroleum Building. When Chrysler leased an entire wing of the Transportation building and several major oil companies announced that they would build their own structures, the official plans changed. The result was the Hall of Petroleum, a freestanding building located just northeast of the Hall of Transportation.[42]

Humble Oil & Refining Co. was the major exhibitor in the Hall of Petroleum. Humble's Hall of Texas History, which occupied the central portion of the building, covered the state's history and geology through scale models, relief maps, photomurals, and a series of historical dioramas equipped with "robophones" that played recorded descriptions when visitors picked up telephone handsets. Above the main entrance was a bas-relief representing an oil gusher.[43]

A handful of other exhibitors had space in the Hall of Petroleum as well, including Pennzoil, which screened a film about the struggle between industry and natural forces in a scaled-down version of a modern movie theater. The Hall of Petroleum—which was always intended to be a temporary building—was demolished after the 1937 Greater Texas & Pan-American Exposition.[44]

STATE OF TEXAS BUILDING

Like the Alamo, San Jacinto Battlefield, and other sacred spots, this is not the property of the Centennial or of Dallas, but is held in trust by them for all the people of Texas. Let us charge that its halls never be tainted with commercialism and that it always be held as a sacred source of inspiration for our youth.

Pat M. Neff
Governor of Texas, 1921-1925
September 6, 1936

Pat Neff's dedicatory appeal to hold the State of Texas Building up as a sacred place was exactly the kind of oratory for which the former governor was known. But more than that, it reflected state officials' plans for a great monument to the Texas centennial, a shrine to the state's history, and a quiet place of reflection that would be open to future generations. To Texas Centennial Exposition directors, there was no better place for such a monument than the fairgrounds in Dallas.

A state monument of some kind was at the center of Centennial Exposition plans from the beginning. In Paul Cret's master plan of early 1935, the architect called for a wide central esplanade terminating in a ceremonial court—the outlines of what would become the State of Texas Building site. "The formal area is concentrated so as to achieve an impressive picture," Cret explained. "It forms an impressive Court of Honor when seen from the principal entrance." At that time, the state building was envisioned as being dedicated to Texas education and natural resources, but its intended form was still vague.[1]

Two months later, when the Texas Legislature appropriated $3 million for centennial celebrations statewide, $1.2 million was specifically directed to the state monument at the Centennial Exposition—a million dollars for construction and $200,000 for finishes and furnishings. Centennial architect George Dahl's staff began making plans for the building, with designer Donald Nelson taking the lead; by that time, the structure was described as "an enduring monument to the heroes and builders of Texas . . . a forceful symbol of the past and present glories and future greatness of all Texas." According to exposition records, Dahl's team had finished floor plans and elevations for the building and was moving on to working drawings in early June 1935, apparently with the blessing of state officials. Then everything changed.[2]

The State Board of Control, which was overseeing the project, suddenly announced that it was taking the State of Texas Building commission away from the exposition technical staff and giving it to a group made up of ten Dallas architects and architecture firms and Adams & Adams of San Antonio. The reasons behind the

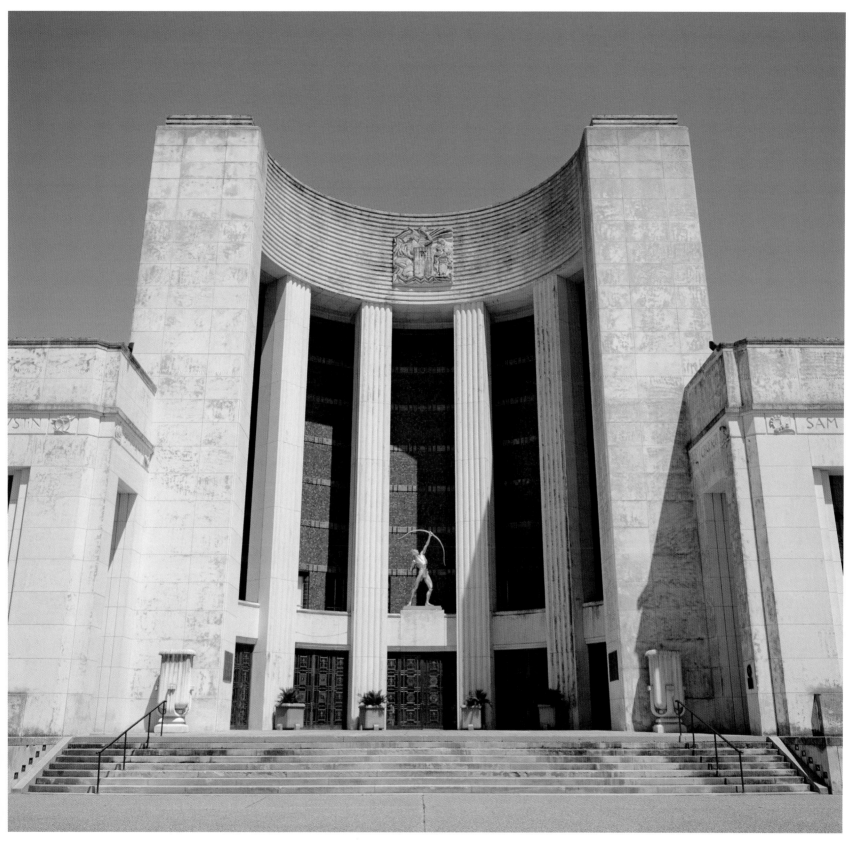

State of Texas Building/Hall of State. Texas Centennial Architects, Associated/Donald Barthelme Sr., architects. Adams & Adams, interiors.

change were never fully explained. In later interviews, Carleton Adams of Adams & Adams said that Dahl's staff was only making a proposal to the state for the building's design and that the group of locals, jealous that Dahl was overseeing the architecture of the rest of the exposition, went to state officials and convinced them that they should get the job. Adams said the Board of Control brought his firm in because it had prior experience with state commissions and was in contact with artists who would likely decorate the building. "We didn't make this solicitation," Adams said, stressing that his firm only became part of the design team "because we were already in there working with this type of thing with the Board of Control."[3]

Nelson, however, was convinced that Adams used his connections in Austin to get the State of Texas Building job by persuading the Board of Control that an Adams & Adams-led consortium would produce a better building than Dahl's designers would. "The odd thing about it is, not one of [the local architects] . . . felt they could do it," Nelson recalled. (Dahl himself, reflecting in 1984 on his work at the exposition, was a bit more magnanimous. "Several men, Adams from San Antonio and a number of others, they got together and said, 'Hey, we're left out,'" Dahl explained. "And so they went down to the legislature . . . and said if the state is going to spend any money . . . we want something to do with this thing. So that's how they got in.")[4]

Whatever the exact circumstances behind the turn of events, Dahl seems to have taken it in stride, offering the consortium—which called itself Texas Centennial Architects, Associated—Nelson's sketches for the state building. The group declined to take them, instead choosing to plunge ahead on its own. Its first four designs were rejected by the Board of Control, and by late summer 1935, the group found itself at an impasse. Faced with architectural gridlock and a quickly approaching deadline, after which the job would likely revert to Dahl's team, architect Mark Lemmon sought help from young Houston architect Donald Barthelme. The clock was ticking, Lemmon said; if Barthelme could come to Dallas at once, he could take on the task of designing the State of Texas Building.[6]

When Barthelme arrived, he was presented with site plans and briefed on what was expected from the building. After a couple days of intense work, Barthelme produced plans for the building as it stands today: a T-shaped structure centered on a semicircular entrance, with exhibit rooms in its north and south wings and a vast ceremonial hall to the east. His design also included a pair of pavilions projecting from either end of the west façade, which were to be used as museum galleries; although foundations were laid for the museum wings, they were never built. The Board of Control accepted Barthelme's design in late summer 1935, and as he described it, "there was joy, un-confined, all around. . . . As I remember, I was taken to lunch every day the next week."[7]

Approval of the design didn't mean that there was a smooth road ahead for the State of Texas Building. The state's appropriation required that the building be constructed on land to which the state held title, but until plans were approved, it was unclear exactly how much land that would be. An agreement was finally reached in mid-September 1935, and ground was broken a month later. As foundation work began, bids were accepted for construction of the building itself, but they came in higher than expected, and then state officials got word that the federal Works Progress Administration had turned down a request for $700,000 in funding for the project. Work on the structure, minus the museum pavilions, didn't get under way until December 30, just over five months before the exposition's opening day. It looked as if the showpiece of the Magic City wouldn't be finished in time for the start of the exposition after all. [8]

When the gates of the Texas Centennial Exposition finally swung open on June 6, 1936, the State of Texas Building at least *appeared* complete. Exterior work was almost totally finished, and though the doors remained locked, the building served as an appropriately dramatic anchor for the Esplanade of State. Most visitors probably did not realize that things weren't nearly as finished as they seemed: interior work had ground to a halt a few days earlier when members of the

bricklayers' union went on strike over extra pay for work they had done on weekends, triggering a sympathetic strike involving the electrical, plumbing, heating, and heat control unions. Most interior work resumed on June 9, and thanks in part to a $50,000 bonus from Dallas business leaders, construction proceeded apace through the late summer. Even so, the building did not open until September 5, halfway through the exposition's run.[9]

In the end, it was worth the wait.

The completed State of Texas Building was immediately hailed as an architectural marvel and a fitting tribute to Texas itself. Former Texas Governor Pat Neff, who spoke at the dedication ceremony, declared it "the Westminster Abbey of the New World," and journalists praised the building's design in column after column. "The beauty and glory of the famed Parthenon of Athens appears to hover over the magnificent State hall," one wrote; another noted that visitors to the building "instinctively remove their hats [and] lower their voices as if they were within the walls of some great cathedral." Mary Carter Toomey of *The Dallas Morning News* even imagined the statues of Texas heroes inside the building stepping from their pedestals one midnight to explore. "Sam Houston, most venerated of all, might blush at the references to himself," she wrote. "Mirabeau B. Lamar, father of education in Texas . . . would slip into the auditorium and nod approvingly at the provisions there for classes and lectures." Fairgoers were a bit less wordy: "Gosh, honey, ain't you glad we're Texans?" one woman asked her friend as the pair stood in the soaring Hall of State, the building's main interior space.[10]

To be fair, the enthusiasm was well-founded. The State of Texas Building was splendid, from its three hundred and sixty-foot limestone façade to the granite, marble, and wood that decorated the interior—almost all Texas materials, the exposition's publicity staff made sure to note (even the cement, which was made in North Texas).[11]

During the exposition, the building's four regional halls were filled with exhibits that traced the history of Texas: the north wing covered the story of Spanish and French colonization and Mexican rule from 1492 to 1836, while in the south wing, items on display related to Texas as an independent nation and state from 1836 to 1900. The artifacts, which included a Spanish suit of armor, relics of the Battle of San Jacinto, antique toys and clothes, and historical documents including William Barrett Travis's letter calling for reinforcements during the siege of the Alamo, were assembled by Dallas Historical Society Director Herbert Gambrell. Many items were on loan from institutions across the state, but some came from private collections—and Gambrell shrewdly made sure that some of those artifacts stayed with the Historical Society even after the exhibits were removed from the building.[12]

Today, the State of Texas Building not only represents one of the best unions of architecture and art in Texas; it is also one of the premier Art Deco buildings in the United States. There have been few major changes to the building, and restoration projects have returned parts of its interior to their original luster, enabling visitors to experience these spaces much as they would have during the Centennial Exposition. As Dallas Hotel Association President George Scott told *The Dallas Morning News* in 1937, "Even if empty of displays of an historical nature . . . it is an architectural gem and a visit to it cannot but impress a person with the historical past of this great state and at the same time give one a vision of the inspiring future of Texas."[13]

A pair of museum pavilions at the north and south ends of the building—called the Hall of 1836 and the Hall of 1936 on blueprints—are shown in this rendering based on Donald Barthelme's original design.

As they were planned, the projecting wings would have defined the State of Texas Building's forecourt, which in turn would have opened onto the Texas Court of Honor at the head of the Esplanade of State. At its northern end, the Court of Honor originally ended at the Hall of Petroleum and led into the agrarian area; to the south, the court opened onto the Federal Concourse.

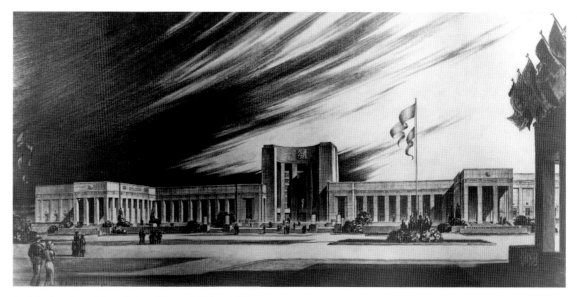

Architectural rendering, State of Texas Building, 1935

Although the State of Texas Building's forecourt has remained much as it was in 1936, the Court of Honor's original planters and pylons have been replaced with fountains.

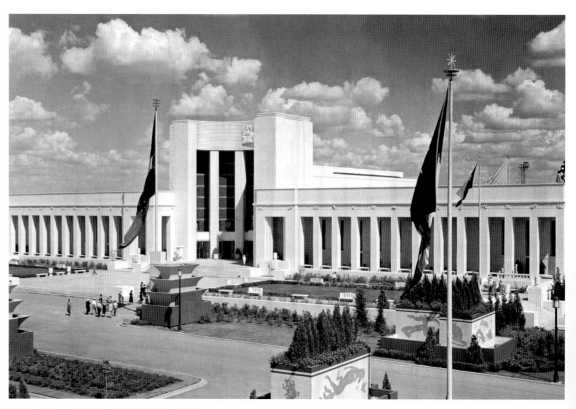

State of Texas Building/Hall of State, 1936

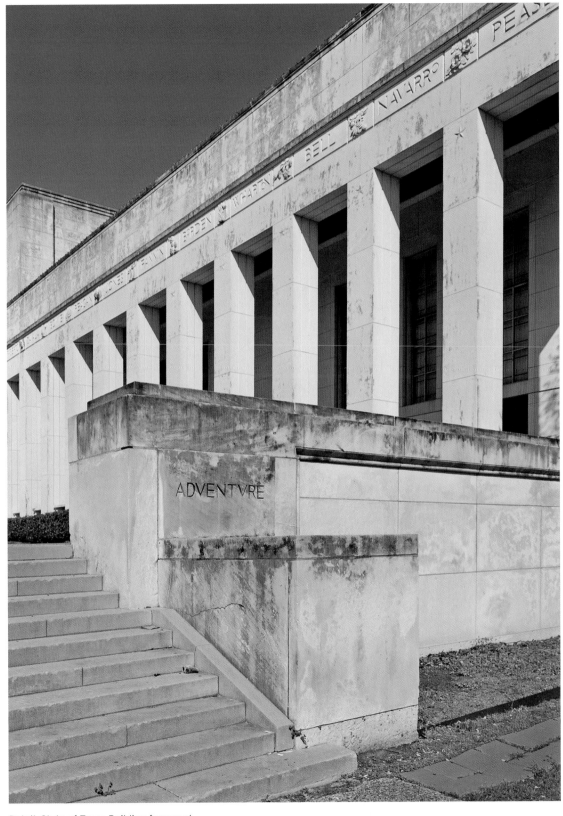

Steps at the north and south ends of the State of Texas Building's forecourt are flanked by buttresses carved with the words "Adventure," "Fortune," "Romance," and "Honor," terms the building's architects deemed most representative of Texas's history and future.[14]

Detail, State of Texas Building forecourt

A set of four bronze lanterns in front of the State of Texas Building features soldiers from each of the nations whose flags have flown over Texas: Spain, France, Mexico, the Republic of Texas, the Confederate States of America, and the United States of America.

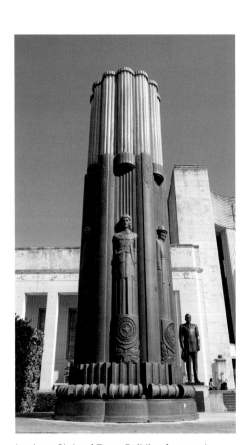

Lantern, State of Texas Building forecourt

Detail, lantern, State of Texas Building forecourt

Planters, Texas Court of Honor, 1936

Large planter boxes decorated with Texas wildlife adorned the Texas Court of Honor during the Centennial Exposition. These temporary structures were removed after the fair closed.

Harry Lee Gibson sculpted bas-reliefs of century plants at the bases of porticoes on either side of the State of Texas Building's main entrance. Texas flora also appears in smaller reliefs, the work of Fanita Lanier, along a frieze near the building's roofline.

The frieze is also carved with the names of Texas heroes, statesmen, and early explorers. Because Donald Barthelme was brought in to design the building at the last minute, the story goes, the plaque at the main entrance had already been cast without his name. To be sure that his contribution to the design was recognized, Barthelme arranged the names in the frieze on the Court of Honor façade so that their first letters spell his last name when read left to right starting at the north end of the building. (It is more accurate to say that the first letters of the name *almost* spell Barthelme's last name: they actually form the word "Barthelm." In a later interview, Barthelme claimed he couldn't think of a second Texas hero whose last name began with an E to complete the set.)[15]

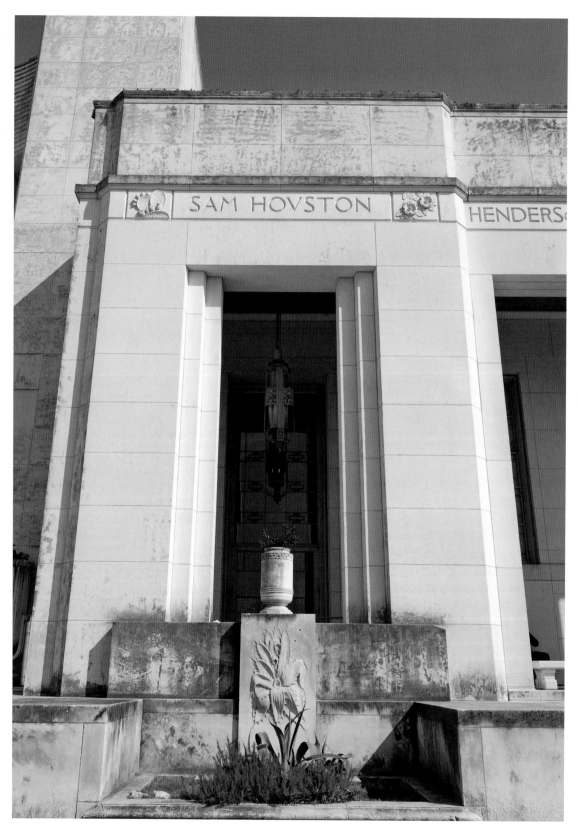

Portico, State of Texas Building

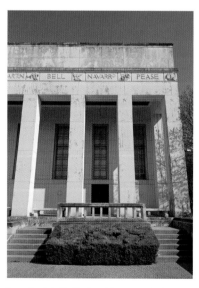

Loggia detail, State of Texas Building

Loggia benches, State of Texas Building

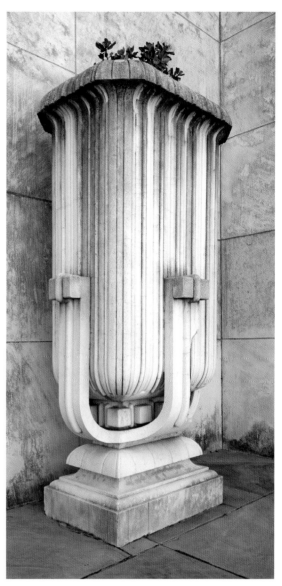

Urn, State of Texas Building

Loggia doors, State of Texas Building

Doors lead from the Hall of the Heroes to a pair of porches at the rear of the building. In 1936, these porches were described as overlooking gardens located between the State of Texas Building and Cotton Bowl Stadium; those gardens no longer exist.[16]

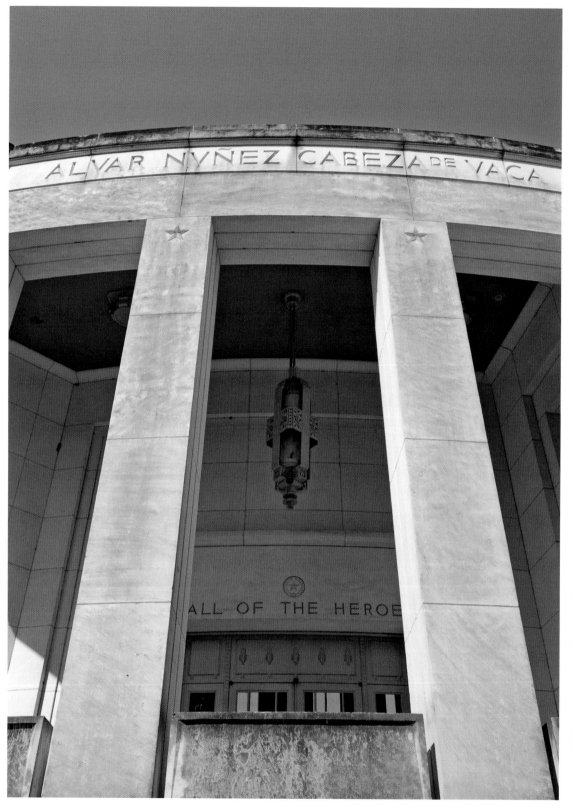

Sconce, northeast entrance,
State of Texas Building

Northeast porch, State of Texas Building

Sculptor Harry Lee Gibson was also responsible for the plaques representing five Texas animals over the balcony doors on the exterior of the Hall of State wing. Although the Hall of State's interior is one of the most celebrated features of the State of Texas Building, its exterior at the rear of the building is rarely visited, and some detailing (including the stone balcony railing) has fallen into disrepair.[17]

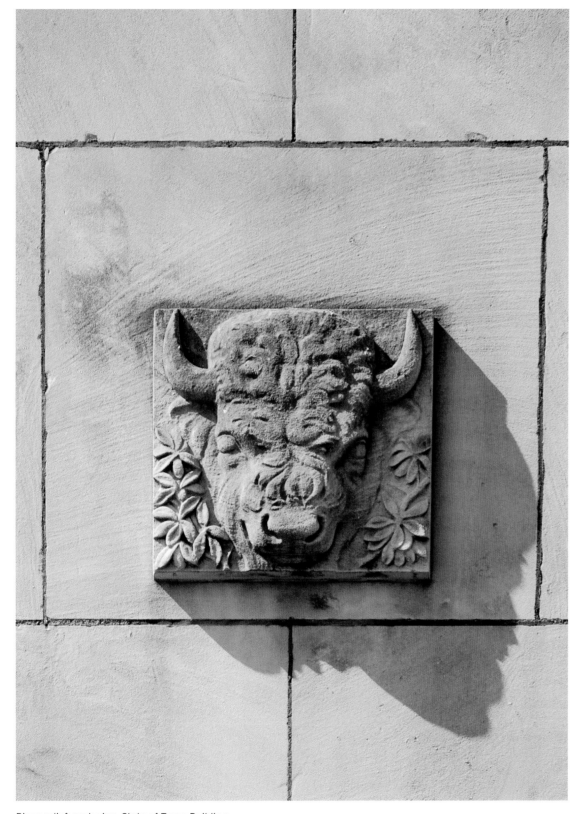

Bison relief, east wing, State of Texas Building
Harry Lee Gibson, sculptor.

Balcony, east wing, State of Texas Building

The semicircular Niche of Heroes, with its four eighty-foot limestone columns, marks the main entrance to the State of Texas Building. The limestone used on the building's exterior is Texas Cordova Cream, a smooth stone quarried in central Texas.[18]

The decision to use the limestone facing provides a glimpse into the building's often convoluted design process. Carleton Adams, one of the architects who worked on the project, recalled a meeting in which twenty or twenty-five people were debating exterior materials. One architect proposed using shell limestone, but Adams objected, pointing out that the stone was porous. "I took it and put it over in the lavatory . . . I took the thing out and it dripped all over the floor. I said, 'First time you get a freeze, it's all going to fall off,'" he remembered. "Things like that were very controversial . . . when we got into some of those details, nobody could agree to anything."[19]

At the top of the Niche of Heroes is a relief by Harry Lee Gibson depicting a female figure symbolizing Texas kneeling behind a shield bearing the pattern of the state flag. Beside her is an owl, symbolizing wisdom, wreathed by branches from from the state tree, the pecan.[20]

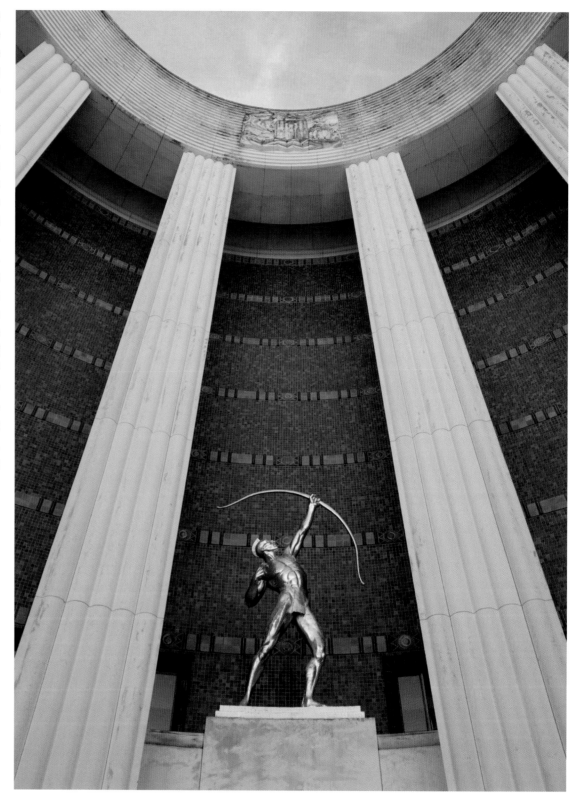

Niche of Heroes, State of Texas Building

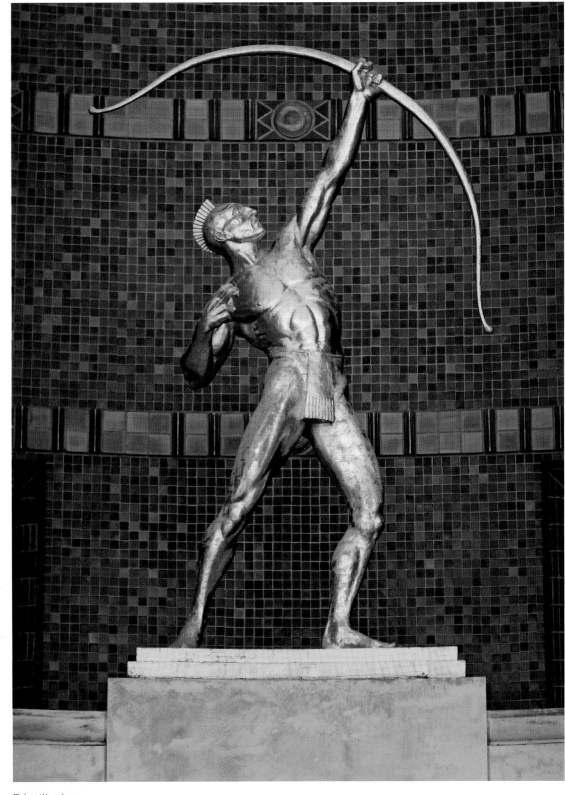

Tejas Warrior
Allie V. Tennant, sculptor.

Allie V. Tennant intended her eleven-foot sculpture of a Native American warrior to symbolize the various indigenous tribes of Texas. "The treatment is stylized rather than realistic, as that fits better into the architectural demands of the location, and also because no particular Indian or tribe should be featured," she explained.[21]

The title, *Tejas Warrior*, refers to the word "tejas" or "texas," which was used by the Hasinai Indians of what is now East Texas to mean "friend" or "ally"—the term that gave Texas its name.[22]

Local athlete Austin Barbosa was Tennant's model for the statue.[23]

Five pairs of plate glass doors with bronze screens lead into the State of Texas Building from the Niche of Heroes. Patterns in the screens represent the state's agriculture and industry: the four central medallions are formed from coiled rope, oil derricks, stylized stalks of wheat, and a circular saw blade, while surrounding cow and horse heads are paired with spurs and snakes.

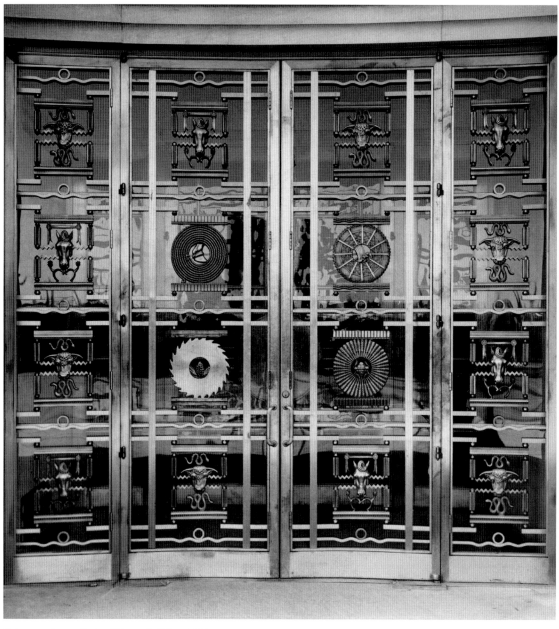

Entrance doors, State of Texas Building, 1936

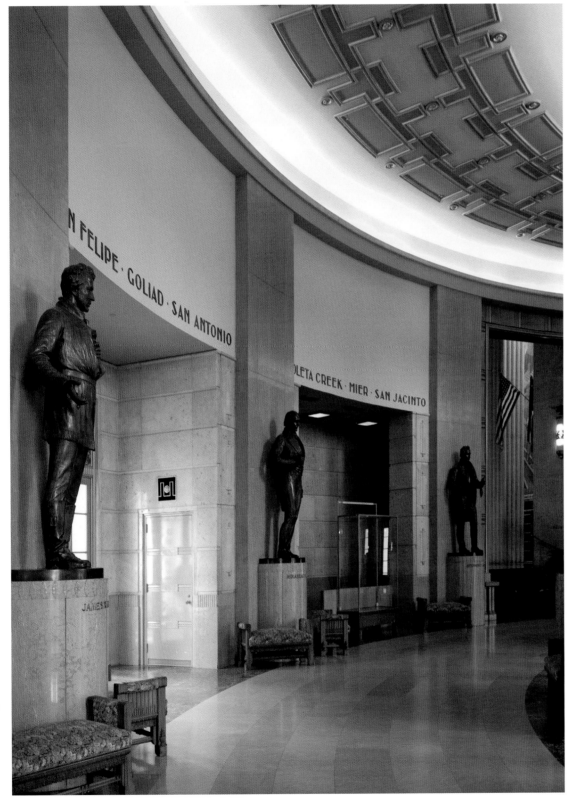

The semicircular Hall of the Heroes serves as the State of Texas Building's entry hall, connecting the four regional exhibit rooms with the Hall of State. The one hundred and forty-foot hall is ringed with the names of battles in the Texas Revolution and contains bronze portrait statues of six Texas revolutionary figures: Stephen F. Austin, Sam Houston, David Crockett, Mirabeau B. Lamar, Thomas Jefferson Rusk, and James Walker Fannin. Pompeo Coppini of San Antonio was the sculptor.

Coppini's commission did not sit well with some Dallas artists who accused the sculptor of "[maintaining] a San Antonio mailing address just for such occasions as this so that he can claim to be a Texan." (In fact, though Coppini was based in New York at the time the statues were done, he had been involved in Texas art since 1901 and lived in San Antonio on and off for thirty-six years.) According to Coppini, however, the job of sculpting the six statues was virtually forced upon him. In his autobiography, Coppini wrote that he had designed a statuary group for the east end of the Hall of State—where the Great Medallion of Texas is located—but Donald Barthelme, the building's designer, did not like it, so the plan was scrapped. Coppini claimed the state Board of Control insisted he take on the Hall of the Heroes statues instead.[24]

As favorable as that story might have been for Coppini, it must be noted that many of the tales in his autobiography do not match anything in the historical record. As a note in the archives of the Dallas Historical Society puts it, Coppini's recollections "must be taken with more than a little salt."[25]

Hall of the Heroes, State of Texas Building

At 94 x 68 feet, with a forty-six-foot ceiling, the Hall of State (which lent its name to the entire State of Texas Building virtually from opening day) brings to mind Pat Neff's comparison of the building to Westminster Abbey. "The atmosphere in the [hall] with its immense supporting columns framing the largest of mural decorations is definitely that of a great cathedral," one observer wrote. "There is perhaps no room in America more impressive."[26]

The floor is of green marble from Vermont with inlays and mosaics of white Texas marble. The walls are polished Texas shell limestone with a wainscot of black Pyrenees marble. On the side walls, huge murals deal with Texas history and culture, while a gilded medallion at the hall's east end represents the six governments that have ruled Texas. Furnishings—stone urns, bronze consoles, lanterns, and flagpoles, and carved wooden chairs—were designed for the Hall of State and date from 1936.[27]

Everything about the room was designed to make an impression on visitors, and as one of the outstanding Art Deco spaces in the nation, its design still awes. "If the visitor walks directly to the Hall of State, as majestic as the throne room of an emperor and more enthralling because simplicity and contrast lend it charm instead of rococo adornment, he must be calloused, indeed, not to feel a breathtaking thrill," wrote John Terry Hooks of *The Dallas Morning News*.[28]

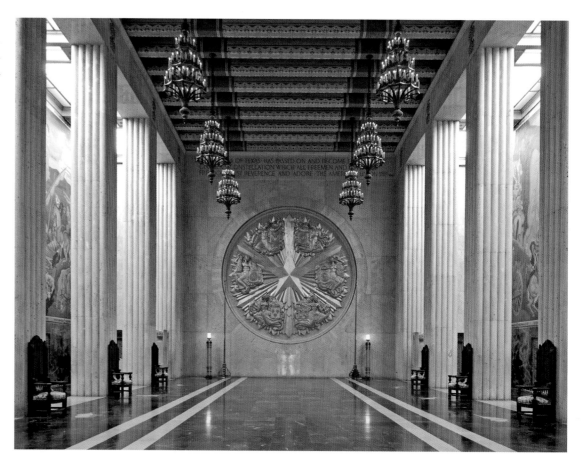

Hall of State, State of Texas Building

Detail, Hall of the Heroes

Detail, Hall of the Heroes

Drinking fountain, Hall of the Heroes

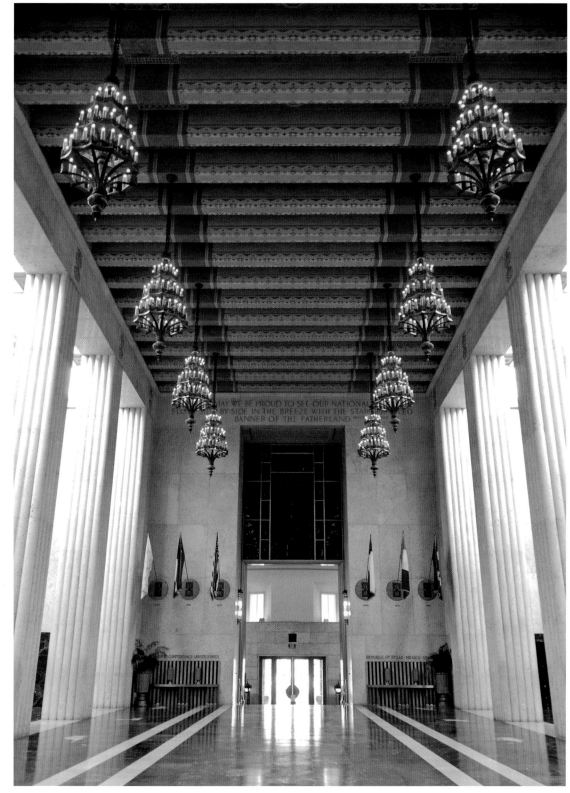

Hall of State

The twenty-five-foot *Great Medallion of Texas* dominates the east wall of the Hall of State. Finished with three colors of gold leaf, the medallion features figures representing the six nations that have governed Texas grouped around a central star (clockwise from top right, Texas, Mexico, Spain, France, the Confederacy, and the United States). "A star, which is in itself a perfect geometrical design, is well adapted to represent a great state," the medallion's sculptor, Joseph E. Renier, said.

Adams & Adams, the architects responsible for the building's interiors, came up with the basic design of the medallion. Carleton Adams later remembered the trouble his firm had placing six figures around a five-pointed star—a challenge finally resolved when the Spain and France figures were positioned at the bottom two points of the star. "We tried . . . doing all kinds of stuff," Adams said. "You'd be surprised."[29]

Great Medallion of Texas, Hall of State
Adams & Adams, designers.
Joseph E. Renier, sculptor.

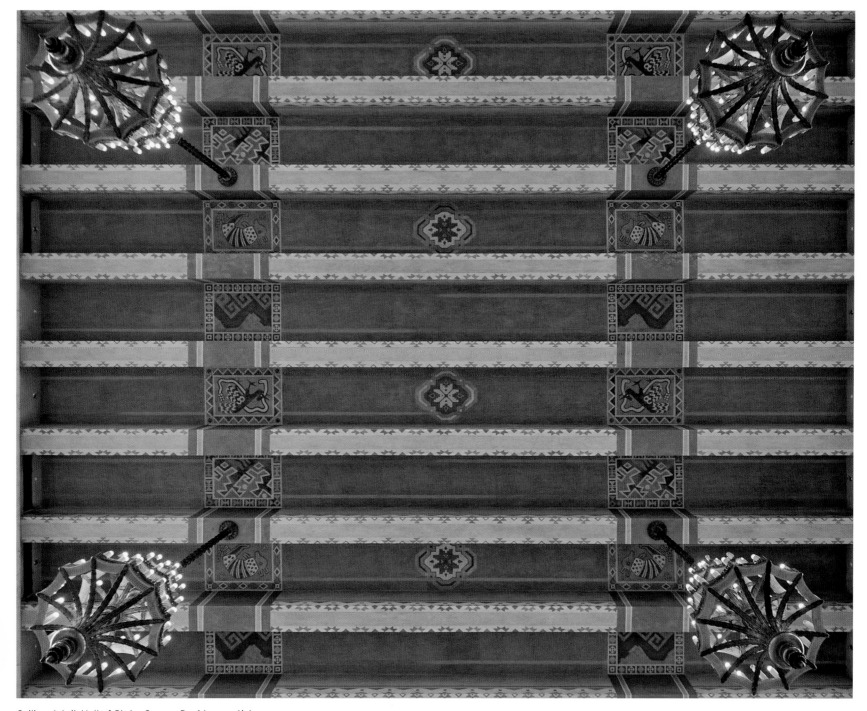

Ceiling detail, Hall of State. George Davidson, artist.

George Davidson designed the hand-stenciled Hall of State ceiling around four stylized figures: an armadillo, a roadrunner holding a snake in its beak, and abstract designs representing land and sea. Surrounding details were influenced by Aztec art.[30]

Carleton Adams attributed the design of the wooden chairs in the Hall of State to the American Seating Company, the same firm that supplied the seats in the State of Texas Building's basement Lecture Hall.[31]

Side doors, Hall of State

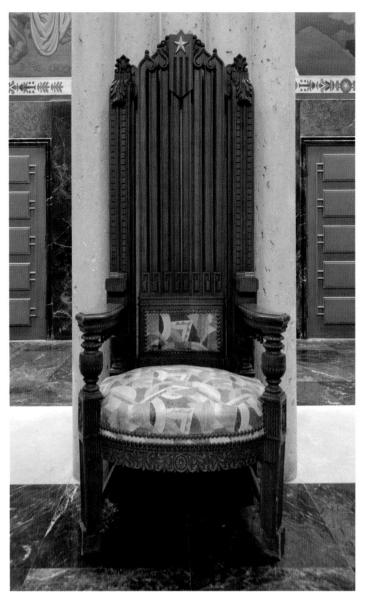

Chair, Hall of State

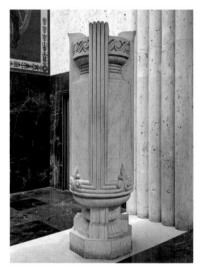

Urn, Hall of State

Among the more delightful design touches in the Hall of State is a series of white marble animal mosaics inlaid in the room's floor. The mosaics depict typically Texan fauna such as the jackrabbit and rattlesnake.

Floor detail, Hall of State

Floor detail, Hall of State

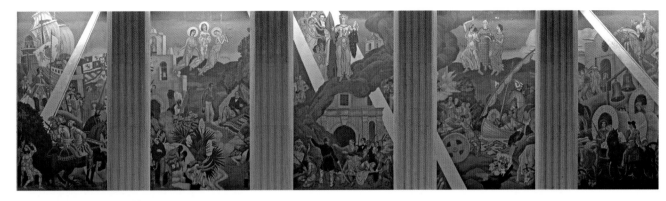

Texas of History, Hall of State. Eugene Savage, artist.

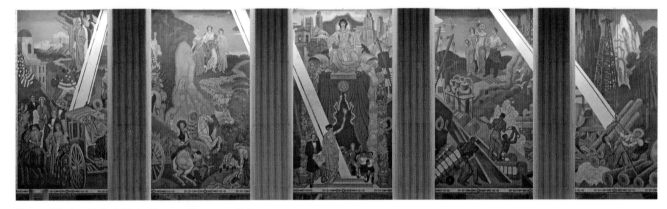

Texas of Today, Hall of State. Eugene Savage, artist.

A pair of 90 x 30-foot murals on the walls of the Hall of State depict the story of Texas in a textbook's worth of historical vignettes and allegorical scenes. *Texas of History*, on the north wall, centers on the Battle of the Alamo. A group of Texan heroes is shown in the foreground, while to the left, smoke rises from the funeral pyre of fallen Texans; a central female figure representing the Republic of Texas stands on the plume of black smoke. Groups of European explorers and American settlers bookend a variety of other historical scenes.

On the south wall, *Texas of Today* deals with the cultural progress of the state on the left and commercial interests on the right. Cowboys, lumbermen, and stevedores labor across the bottom of the mural as the Civil War, a cattle drive, and the development of the arts take place above. The central figure represents the State of Texas; beneath her pedestal, Texas President Mirabeau B. Lamar establishes the state's educational system as Education leads Texan youth into the light of knowledge.[32]

The Hall of State murals were considered one of the prize commissions of the Centennial Exposition. A group of local artists called the "Dallas Nine," led by Jerry Bywaters, spent six months researching Texas history and preparing sketches of their ideas for the murals, but Bywaters said state officials refused to see the group's work, choosing the better-known Eugene Savage of Yale University as muralist instead.[33]

Although Texan artists ended up assisting Savage on the murals, the works didn't turn out to be entirely accurate. When Dallas Historical Society Director Herbert Gambrell viewed *Texas of Today* shortly before the State of Texas building opened, he noticed that Anson Jones, last president of the Republic of Texas, was left out of the scene showing the annexation of Texas into the United States—even though Jones had presided over the ceremony depicted. "Well, I never heard of [Jones]," Savage retorted. Gambrell gave Savage a picture of Jones and the artist made an eleventh-hour addition to the mural. "If you look at it closely," Gambrell later said, "he has Anson Jones right in front of this group of people—painted him in just the night before it was finished."[34]

The columns in front of the murals were a point of contention between architects and artists: Savage and his assistants reportedly didn't like them, but because of cost concerns, architect Donald Barthelme decided they were necessary. Barthelme also liked the columns for aesthetic reasons. "I enjoyed putting the columns in front of the murals in the Great Hall, preferring to let people visiting the hall to catch glimpses of the murals, and go behind the columns if they wanted to see them as a whole," he said. "The length of the hall is such that a mural on either side, of that height, would have been overwhelming."[35]

The detail below from *Texas of History* depicts victims of a battle that took place in August 1813 near San Antonio. Spanish Royalist troops defeated the Republican Army of the North, a group of Tejano Mexican and Tejano American revolutionaries fighting for Mexican independence from Spain. Fewer than one hundred of the fourteen hundred Republican Army members survived.[36]

Greenish figures representing the victims of battles and massacres, like the ones in the depictions of the battles of Medina and the Alamo, show up several times in Savage's Hall of State murals.

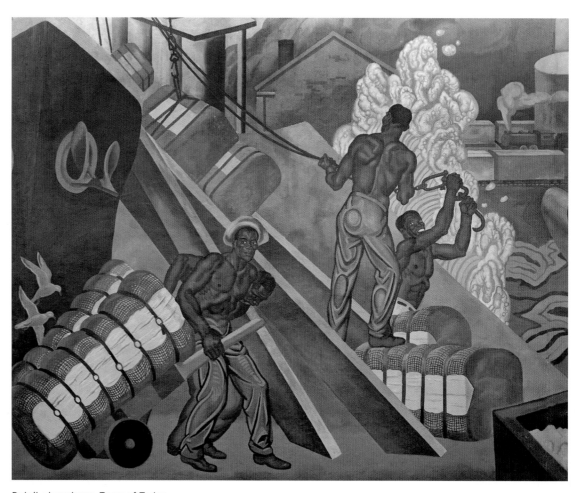

Detail, stevedores, *Texas of Today*

Detail, Battle of Medina, *Texas of History*

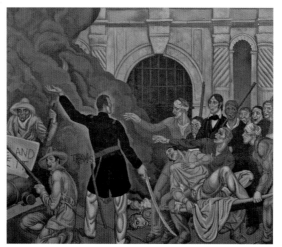

Detail, Battle of the Alamo, *Texas of History*

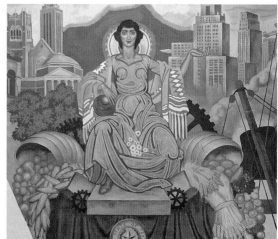

Detail, *The State and Education, Texas of Today*

The room dedicated to East Texas pays tribute to the region's two main products in the 1930s: lumber and oil. The walls are paneled in East Texas gum wood, the same material used in the tall carved doors at either end of the hall. Photographs of East Texas scenes, the work of Polly Smith, are set into the side walls. Even the light fixtures are in keeping with the theme, with panels depicting oil derricks, cotton bolls, stalks of wheat, corn, oak leaves, and pine boughs.[37]

East Texas Room, State of Texas Building

Door, East Texas Room

Light fixture, East Texas Room

The East Texas Room's murals depict the region before and after oil was discovered. The mural at the north end of the room deals with East Texas agriculture and lumber; artist Olin Travis painted the cotton gin, sawmill, and cotton wagon from examples in East and North Texas. (An early description of the mural notes that Travis "had some difficulty, indeed, finding the cotton wagon, as most farmers and planters now use trucks for hauling.") Untapped oil reserves are represented by prone male figures whose backs create the contours of the ground.

In the south mural, the human figures rise from an oil gusher framed by oil refineries, highways, railroads, and skyscrapers. Again, Travis modeled the refineries and oilfield equipment on the real things: an obsolete refinery is shown at right and a modern one at left, with a "spider," a piece of machinery used to pump several oil wells at once, in the left foreground.[38]

The discovery of the vast East Texas oilfield —the largest in the continental United States— in 1930 was important not only for East Texas, but also for Dallas, which became the financial center for oil operations in East and West Texas, the Texas Panhandle, Oklahoma, and much of the Gulf Coast.[39]

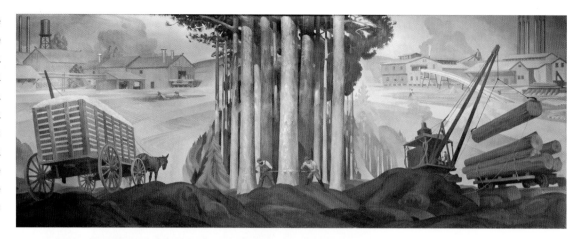

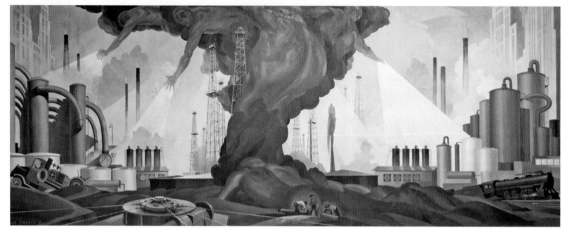

East Texas of Today, Before and After the Discovery of Oil, East Texas Room. Olin Travis, artist.

Detail, *East Texas of Today, After the Discovery of Oil*

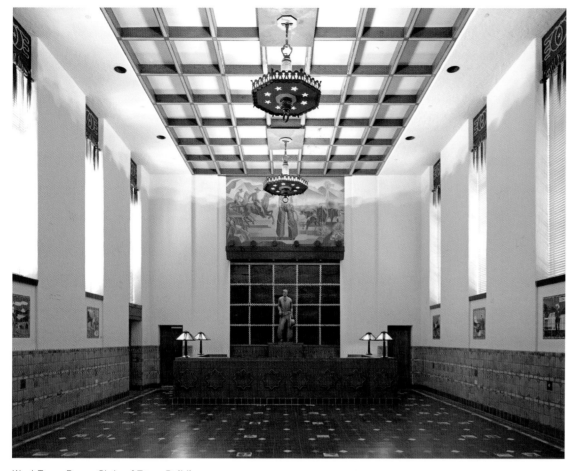

West Texas Room, State of Texas Building

Detailing in the West Texas Room is the most rustic of that in any regional room. The walls (which feature West Texas cattle brands) are textured to suggest adobe, while the tile floors and wainscoting and crossed-beamed ceiling are reminiscent of Spanish Colonial architecture. "The poetry of the West is hard and sharp and clear like the straight talk of the cowhand, and the artists and architects have caught this note in the murals and the detail of decoration," an early description of the room declared.[40]

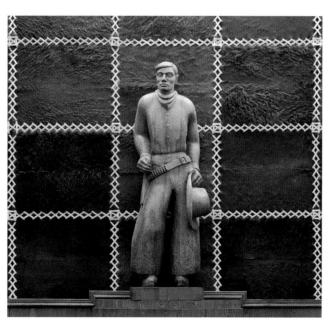

Cowboy, West Texas Room. Dorothy Austin, sculptor.

Dorothy Austin's model for this wooden statue of a West Texas cowboy, which stands against a wall of cowhide squares laced together with rawhide, was a contestant in the State Fair Rodeo.[41]

Ethel Wilson Harris, a San Antonio tile artist, designed the eight tile murals depicting figures and scenes from West Texas history along the side walls of the West Texas Room. Each mural bears the mark of Harris's Mexican Arts and Crafts workshop in its lower right corner.[42]

The Horse Wrangler, West Texas Room.
Ethel Wilson Harris, designer.

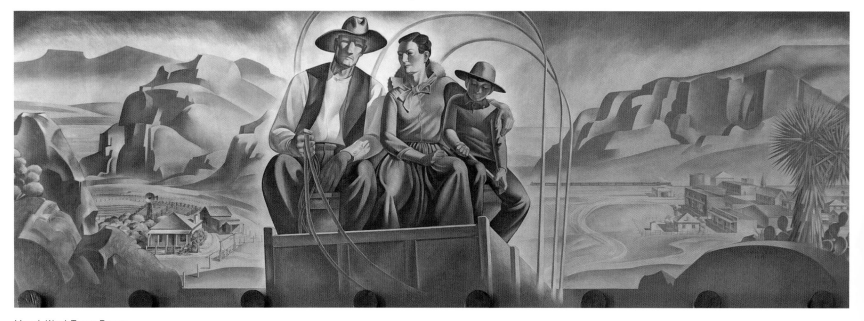

Mural, West Texas Room.
Tom Lea, artist.

El Paso native Tom Lea painted three pioneer West Texans against a stylized desert landscape at the south end of the West Texas Room. "The three West Texans in a wagon offered themselves as symbols of mankind's courage and enterprise in the midst of a huge and inimical world of nature," one observer wrote.[43]

North Texas Room, State of Texas Building

The North Texas Room, with its cream-colored walls and marble wainscot, may be the least detailed of the State of Texas Building's regional rooms. Ornamentation is limited to the fresco over the north door and pairs of carved wooden figures by Dallas artist Lynn Ford representing cotton and wheat set over the main entrances. Photographic scenes of North Texas by Polly Smith are set into the side walls.[44]

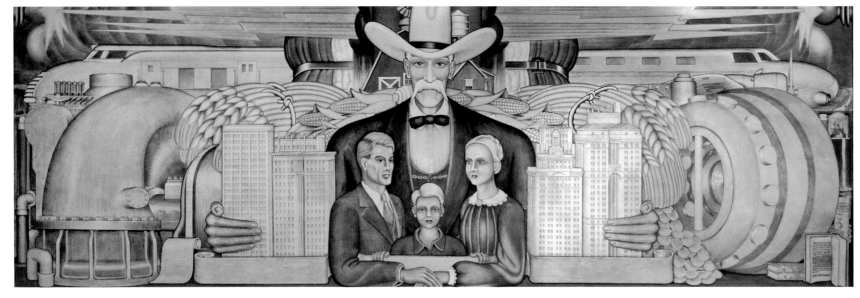

Fresco, North Texas Room. Arthur Starr Niendorff, artist.

Arthur Starr Niendorff learned the fresco technique as one of Diego Rivera's assistants; his work in the North Texas Room is the only true fresco in the State of Texas Building. It reportedly took five months to complete.[45]

The central figure in the fresco is based on Old Man Texas, a character created in 1906 by *Dallas Morning News* cartoonist John Knott. Niendorff said he meant Old Man Texas to represent North Texas farmers: "I have given him the background of the farm of which he is a part, and placed him between the city and the farm because out of him and his farms have grown the cities, sprouting like wheat," Niendorff explained.[46]

Various symbols of North Texas business, agriculture, and even weather fill the rest of the frame: a giant cotton bale, cascades of wheat and corn, a modern airplane and streamlined train, a turbine, a bank vault (complete with gold coins), the skylines of Dallas and Fort Worth, and a raincloud from which lightning crackles, striking positive and negative poles that represent the harnessing of the elements. "I have tried to present North Texas as it is today in its beauty, its strength, power, wealth, and modernity; the heritage of one hundred years from the lonely rolling prairie," Niendorff said.[47]

In the bottom right corner of the fresco is painted a rolled copy of the October 1, 1935, issue of *The Dallas Morning News*, which featured an article about Knott and his creation Old Man Texas. Below it is an open book in which artist Niendorff thanks his parents; his assistant Perry Nichols; Carleton Adams and other State of Texas Building architects and artists; and French art historian Élie Faure, whose book *The History of Art* sits nearby.[48]

Detail, fresco, North Texas Room

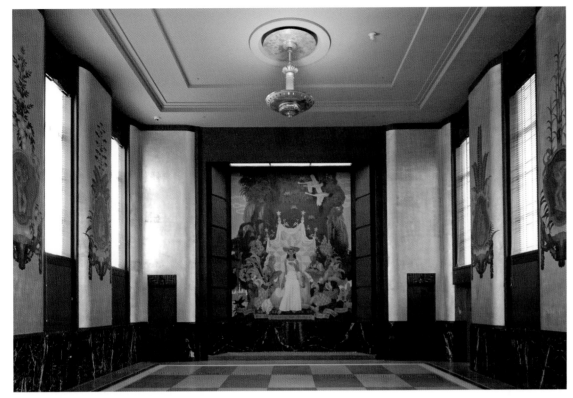

South Texas Room, State of Texas Building

Black marble wainscoting, white gold wall panels, and aluminum light fixtures give the South Texas Room a distinctive look. Between the windows, artist James Owen Mahoney painted cameos representing the history, industries, flora, and livestock of South Texas. Each is enclosed in a Spanish Baroque-influenced frame Mahoney said was "calculated to recall something of the elegance with which South Texas was not unacquainted in colonial times."[49]

Light fixture, South Texas Room

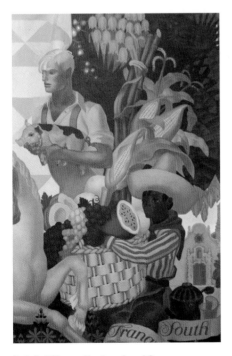

Detail, *Witness the Land and Sea*

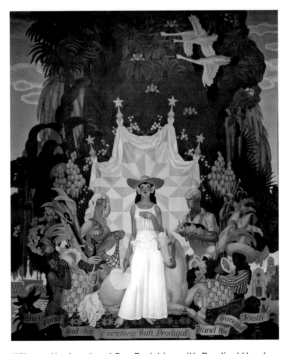

Witness the Land and Sea Enriching with Prodigal Hand the Tranquil South, South Texas Room.
James Owen Mahoney Jr., artist.

Mahoney's mural for the South Texas Room depicts South Texas as a female standing amid figures representing the land and sea, all against a backdrop of oleanders, magnolias, palms, and Spanish moss. "'South Texas' is a state of mind, not an actual place. Hence the imagery was generalized, romanticized, or idealized," Mahoney said.[50]

The mural contains several details that Mahoney intended to represent aspects of life in South Texas. "The oil can at the right, stopped with a potato, represents the extensive oil industry to the south; a small blue pennant on the left, the sport of yachting; and the small sand bucket represents the beaches along the coast. The mosaic canopy over the central figure suggests the colorful patchwork quilts for which women of the country are famous," he said.[51]

The metal side doors of the four regional rooms, which lead to the State of Texas Building's front loggia, feature bulls in bas-relief.

Detail, door, South Texas Room

Marble and aluminum staircases lead from the Hall of the Heroes to the foyer of the basement Lecture Hall, a space paneled almost entirely in polished gum wood. Although a large information desk has been added, the room otherwise looks much as it did when the photo at right was taken in 1936.[52]

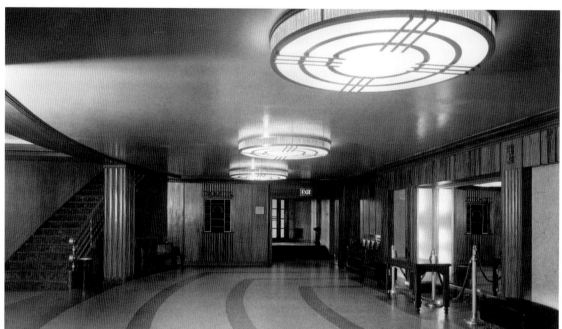

Lecture Hall foyer, State of Texas Building, 1936

Stairway, Lecture Hall foyer

Lecture Hall, State of Texas Building

The Lecture Hall itself was designed to seat five hundred and included a full stage and dressing room facilities. Quimby McCoy Preservation Architecture oversaw a restoration of the hall's finishes and its original blue and gray color scheme in 2009.[53]

Aisle, Lecture Hall

AGRARIAN PARKWAY

Other World's Fairs have stressed Science, the Arts, or other major phases of progress, but the first World's Fair of the Southwest . . . will offer livestock and agriculture, two enterprises on which that section of America was built, as principal features.

Press release
Exposition Publicity Department
1935

By 1936, farm families in Texas had contended with plunging income, drought, and the Dust Bowl. If they were fortunate enough to visit the Magic City, it must have been akin to leaving sepia-toned Kansas for the Emerald City.

On entering the agricultural group from the Texas Court of Honor, visitors faced two colonnaded buildings flanking a central thoroughfare called Agrarian Parkway. Paul Cret's master plan positioned the Hall of Foods to screen the embankment around the Cotton Bowl; the Hall of Agriculture hid the railroad tracks where livestock was brought in. Behind the Hall of Agriculture was Livestock Building No. 1, which encompassed the Poultry Building, Livestock Arena, and the horse, dairy cow, and beef cattle exhibition areas in 1936. A roadway called The

Chute separated it from Livestock Building No. 2, which housed swine, goats, and sheep during the exposition.

At a time when more than half of Texas farmers were tenants or sharecroppers and less than three percent of the state's farms had electricity, the exposition's livestock and poultry buildings were wired to play soothing music in the pens, stalls, and coops, used "violet ray" (ultraviolet) lamps to kill bacteria, and displayed mechanical milking machines. Most farm families did not have the benefit of running water or indoor plumbing, but at the exposition they saw more than twenty-five hundred chickens housed in self-cleaning coops with bottoms of galvanized wire netting above a trough that was flushed continuously with flowing water.[1]

The buildings along Agrarian Parkway were designed in the classic modern style in keeping with the exposition's overall architectural theme. The area was intended to be an integral part of the State Fair of Texas for years to come, so all of the buildings were of permanent construction. None of the exhibit halls or livestock arenas were air conditioned, but all of the agrarian buildings had continuous air-exchange ventilation systems when most Texas farmhouses lacked electric fans. Dallas endured an unusually hot summer in 1936, with a record twenty-two consecutive days of triple-digit temperatures. Having the air changed every four to six minutes must have been a godsend when visiting the 196 swine pens or sitting among six thousand sweaty spectators in the livestock arena.[2]

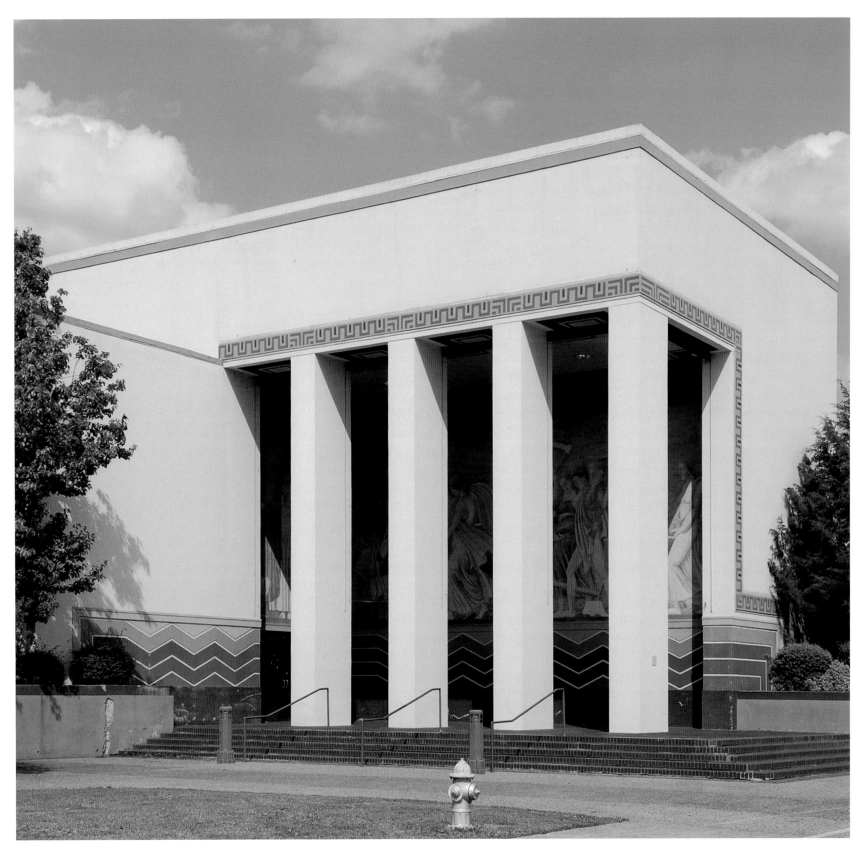

Hall of Agriculture/Food & Fiber Building. Exposition Technical Staff, architects.

The livestock buildings also saw the introduction of a new invention described as "an electric chair for insects" consisting "chiefly of a hollow tube of glass that holds an electric bulb. The tube is sheathed with steel grids charged with electricity . . . [insects] are burned to death by the grids while trying to reach the light." A less complex device, "The Roast-Meat Thermometer," also attracted attention. Displayed under a giant meat thermometer in the livestock building, the "new kitchen contrivance in perfecting the preparation of meat" was designed by scientific experts with the National Live Stock and Meat Board so that even husbands could prepare the Sunday roast successfully.[3]

Mechanical innovations were not the only new developments on display at the Centennial. The exposition hosted the King Ranch's official debut of its new breed of cattle, the Santa Gertrudis. The result of seventeen years of selective breeding between Brahma bulls from India and Texas Shorthorn cows, the hardy Santa Gertrudis would change the beef cattle industry around the world. Another years-long project literally bore fruit at the exposition, where South Texas nurserymen introduced a new type of grapefruit with distinctive red meat, later marketed as the Ruby Red.[4]

Despite the architecture and amenities, the activities along Agrarian Parkway were typical of any state fair. The Future Farmers of Texas and 4-H Clubs held contests for poultry, pigs, and cattle. Texas farmers of Italian descent showed their produce in the Hall of Agriculture along with the Gilmer, Texas, Yamboree's sixty bushels of "glorified yams" and the Oliver Farm Sales Equipment Company's new streamlined tractors.[5]

The calendar of events featured a number of livestock shows, including the All-American Swine Show and the National Dairy Show: Supreme Court of the Milky Way. Guest of honor at the dairy show was Carnation Ormsby Butter King, the Carnation Company's record-setting cow, who produced fifty-seven quarts of milk in twenty-four hours and had to be milked every six hours. While the cow was in Dallas, the Carnation Company donated her output to the Scottish Rite Hospital for Crippled Children.[6]

In the Hall of Foods, Dr Pepper operated an air-conditioned soda fountain to dispense the company's product, and Kraft-Phenix Cheese (later Kraft Foods) ran a sandwich counter that served toasted Old English and Philadelphia Cream Cheese sandwiches and Kraft malted milk. The Beech-Nut Company presented one of the more elaborate displays, a miniature circus assembled at a cost of $15,000; visitors received free samples of Beech-Nut chewing gum when they stopped to see the "small top." The model circus competed for the visitors' attention with a miniature factory exhibited by Mrs. Tucker's Shortening Company—period accounts do not mention free samples of shortening.[7]

Companies mounted massive displays of food to impress Depression-era consumers. Although the exhibits may sound old-fashioned today, they emphasized the message of abundance that was even part of the Hall of Foods' architectural ornamentation.

H. J. Heinz showed more than four thousand packages of its various products; every day the company would offer free samples of another nine of its famous 57 Varieties. Ball Brothers, which made glass jars for home canning, displayed almost three thousand examples of foods preserved in Ball products, many canned by Texas homemakers and home economics students. The standout, according to the company, was a jar of preserved mushrooms from Estonia. The Ball Brothers exhibit, the company said, "represented the most complete and diversified collections of preserved foods in existence. Some are three to seven years old and are as edible today as the day they were put into the air-sealed jars." There is no record of that claim being tested.[8]

The Hall of Foods also hosted entertainers. Kellogg's air-conditioned lounge offered respite from the heat and free performances by singing cowboys from the company's popular radio program "Riding With the Texas Rangers." Among the more unusual entertainment were the ritualistic dances performed three times a night by members of the Yanyego voodoo cult in the Artists' Auditorium in the Hall of Foods. Exposition officials specifically encouraged clergymen, students of sociology, and dance instructors to attend the performances, emphasizing that it was the first time these rituals had been seen outside of Cuba and the Congo. Officials did not explain why the performances were held in the Hall of Foods, although *The Dallas Morning News* did publish an article on the Yanyegos' generally negative response to the American diet. At the time, exposition officials were trying to find black beans and bay leaves for the Cubans' meals.[9]

The agrarian group is the most intact section remaining from the Texas Centennial Exposition. Although the Agriculture and Foods buildings have changed names and undergone some alterations over the years, this is the only area of Fair Park in which all the 1936 structures survive and are still used for their original purposes. It is a testament to the quality of the design and construction that these buildings have endured decades of wear and tear from meandering herds of fairgoers, farm families, and livestock.

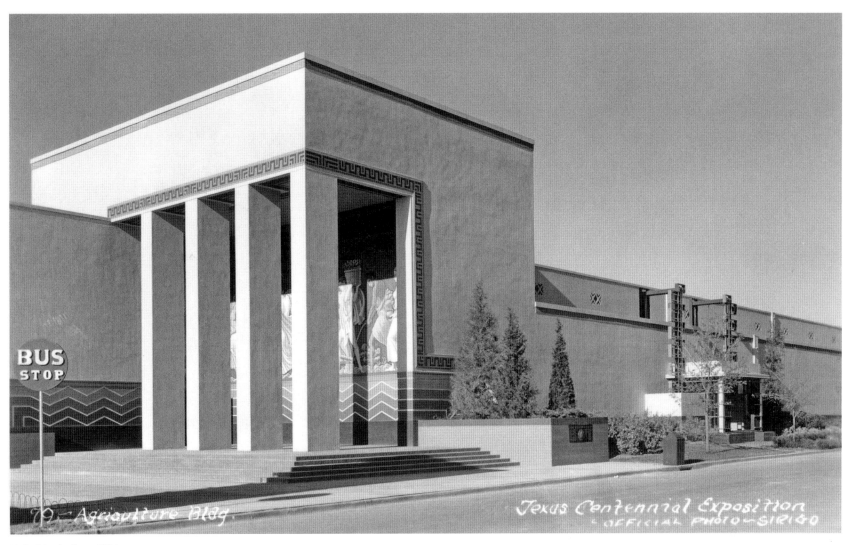

Hall of Agriculture. 1936

Historic photos like this one helped guide the restoration of the Hall of Agriculture to its 1936 appearance. Good Fulton & Farrell were the architects for the preservation project, which was completed in 2001.[10]

During the restoration of the Hall of Agriculture, layers of paint were removed to reveal the murals *Fecundity* and *Wheat Harvesters*, which were restored along with the building's historic color scheme. ARCHITEXAS was the consultant for the mural restoration and FACL, Inc. of Santa Barbara, California, was the art conservator.[11]

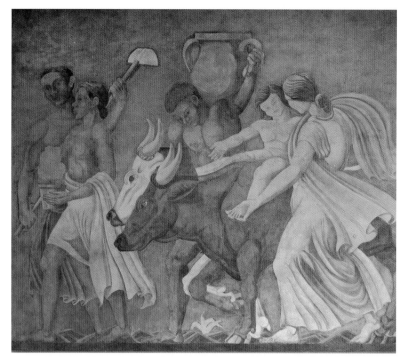

Detail, *Wheat Harvesters*, Hall of Agriculture.
Carlo Ciampaglia, designer.
Hector Serbaroli, painter.

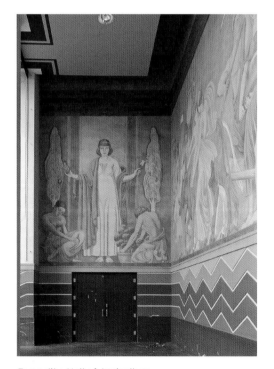

Fecundity, Hall of Agriculture.
Carlo Ciampaglia, designer.
Hector Serbaroli, painter.

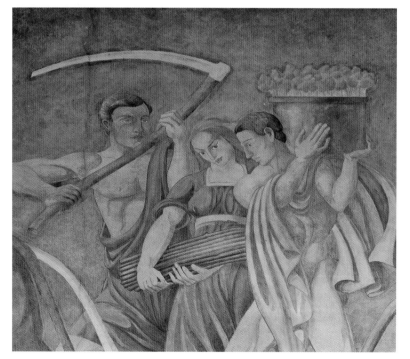

Detail, *Wheat Harvesters*, Hall of Agriculture

Exhibits of Texas produce, Hall of Agriculture, 1936

Interior, Hall of Agriculture

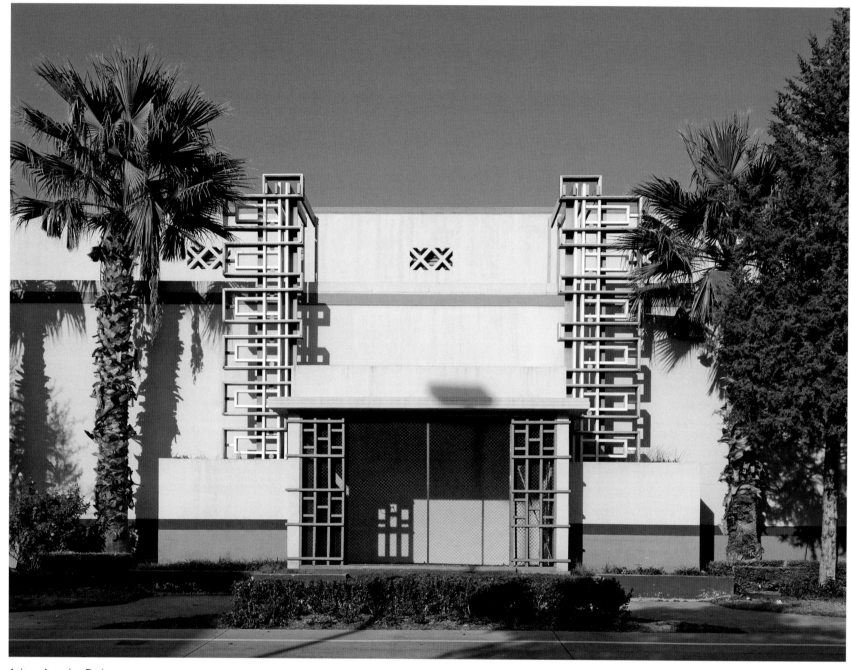

Aviary, Agrarian Parkway

During the exposition, rare birds and exotic
fowl were displayed in two aviaries on the south
wall of the Hall of Agriculture.

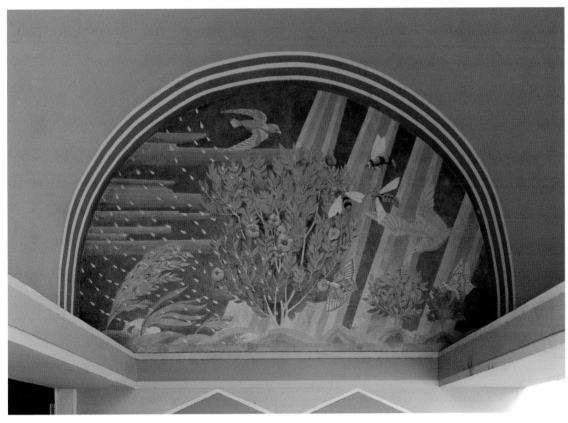

Pollination of Nature was the first mural to be uncovered that was signed by Carlo Ciampaglia. The painting was restored in 2000. ARCHITEXAS was the consultant for the mural restoration and FACL, Inc. was the art conservator.[12]

Pollination of Nature, rear entrance, Hall of Agriculture.
Carlo Ciampaglia, artist.

The technique used to paint the sheaf of wheat, sickle, and scythe led art conservators to believe the small mural was not the work of Carlo Ciampaglia.[13]

Untitled mural, lunette opposite *Pollination of Nature*.
Artist unknown.

Peacock and Fowl was over one of the entrances to the Poultry Building, which is part of Livestock Building No. 1. This mural was painted over, but evidence indicates it survives under several layers of paint.

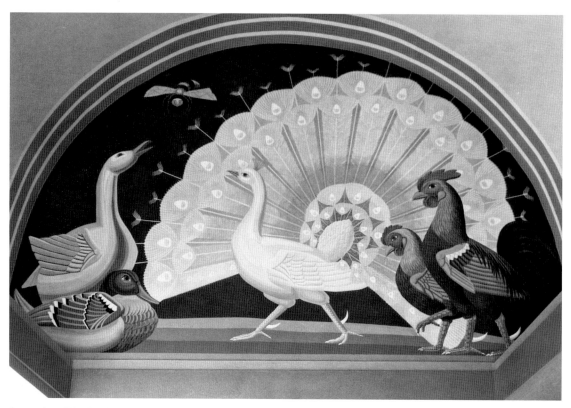

Peacock and Fowl, entrance, Livestock Building No. 1, 1936.
Carlo Ciampaglia, artist.

Like most of the buildings in Fair Park, the Hall of Foods has been known by other names. At different points in its history, this exhibit hall has been called the Varied Industries Building, the Science Building, and the Embarcadero Building.

Phase II of the Hall of Foods' restoration was completed in 2005. Good Fulton & Farrell were the project architects.[14]

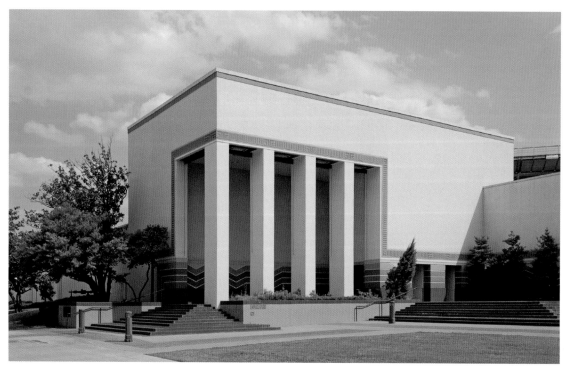

Hall of Foods/Embarcadero Building. Exposition Technical Staff, architects.

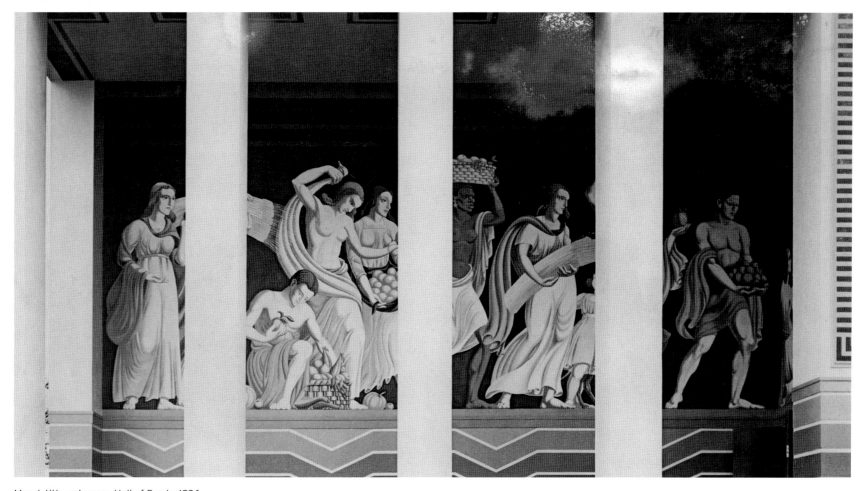

Mural, title unknown, Hall of Foods, 1936.
Carlo Ciampaglia, artist.

Ciampaglia's murals on the Hall of Foods may have been painted over as early as 1942. They will be uncovered and restored when funding is available.

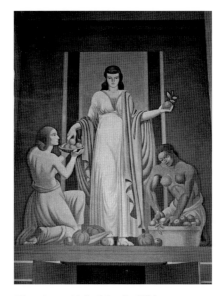

Abundance, Hall of Foods, 1936.
Carlo Ciampaglia, artist.

Jerry Bywaters, Otis Dozier, and Alexandre Hogue were part of a group of regionalist artists known as the "Dallas Nine" who looked to the land and people of Texas for their inspiration. The artists prepared studies for murals in the agricultural group, hoping the Centennial Exposition would use local talent to decorate the exhibit buildings, but their proposals were rejected in favor of Ciampaglia's classically inspired designs.

Most of the Dallas Nine were employed at the exposition assisting the European-trained artists brought in to decorate the buildings. The studies by Bywaters and Dozier foreshadow the post office murals they would paint for the Works Progress Administration.[15]

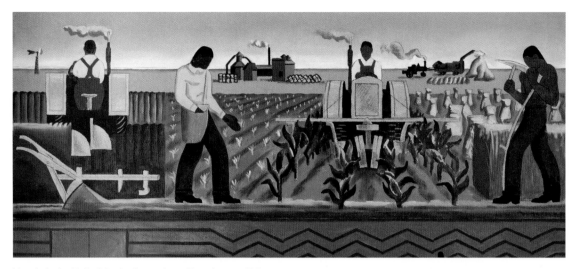

Mural study, Hall of Agriculture. Jerry Bywaters, artist

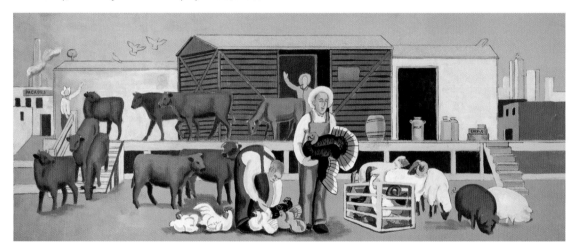

Mural study, Hall of Foods. Otis Dozier, artist.

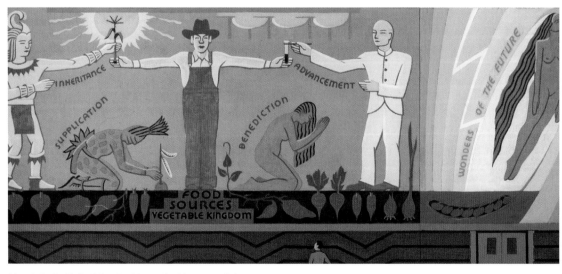

Mural study, Hall of Foods. Alexandre Hogue, artist.

PHOTO COURTESY OF MARK KNIGHT

Gebhardt Chili Powder Company exhibit, Hall of Foods

The Gebhardt Chili Powder Company display is the only original booth that survives from the Centennial Exposition; it is still used during the State Fair of Texas. In 1936, the display was described as a replica of a sixteenth-century kitchen and pantry in Toledo, Spain.[16]

The Gebhardt exhibit was restored as part of the larger rehabilitation of the Hall of Foods. Good Fulton & Farrell were the project architects.

Vestibule, Hall of Foods

Evidence of a mural is visible where paint has been removed from the curved south wall in the Hall of Foods lobby, but no historic photographs or record of the mural's title or artist have been found.

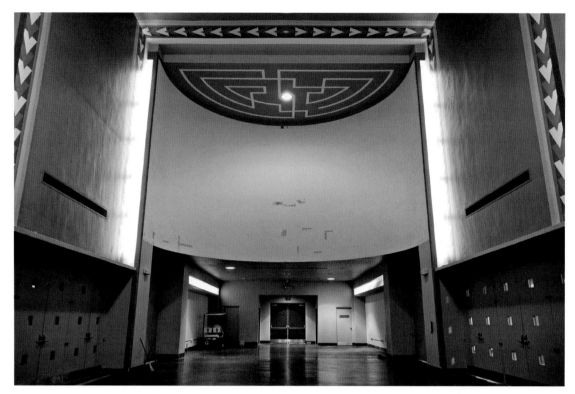

Lobby, Hall of Foods, toward south entrance

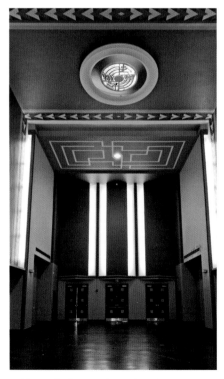

Lobby, Hall of Foods, toward north entrance

Lobby ceiling, Hall of Foods

The north portico opens from Agrarian Parkway into the lobby of the Hall of Foods.

North portico, Hall of Foods

This mural filled the niche within the north portico of the Hall of Foods. The giant woman staring out through the arch must have been striking—or perhaps disturbing.

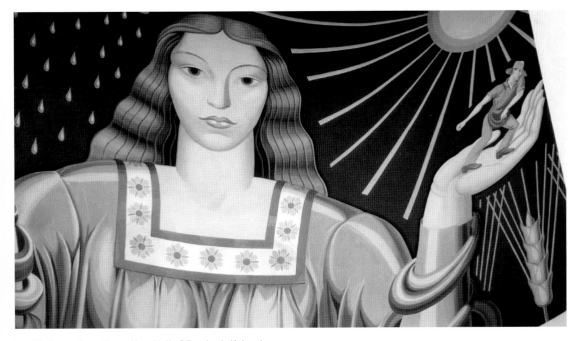

Untitled mural, north portico, Hall of Foods. Artist unknown.

Interior, north portico, Hall of Foods

Plaques, north portico, Hall of Foods

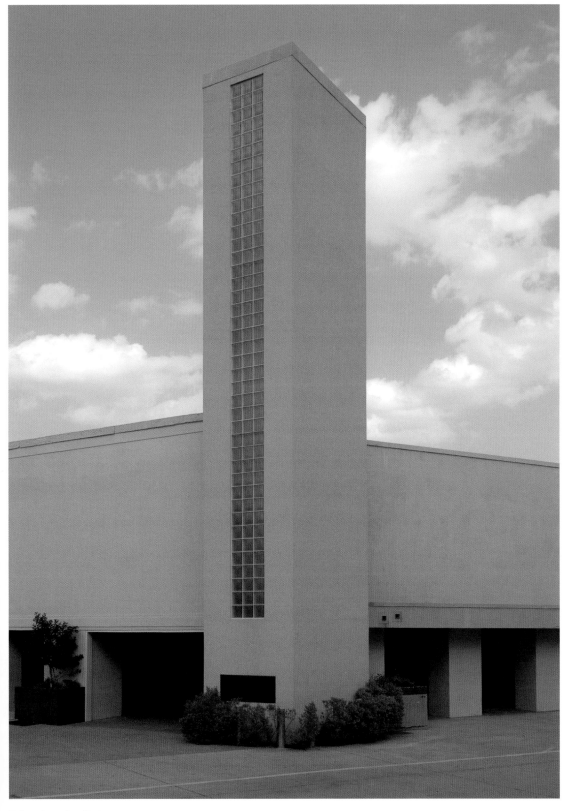

This fifty-foot pylon is centered between the Hall of Agriculture and the Hall of Foods as the focal point of the vista down Agrarian Parkway. The pylon marked the entrance to the poultry exhibits and the point where the parkway turned to accommodate the existing State Fair Livestock Arena (1929). Red, green, and blue lights inside the pylon originally illuminated the glass blocks; an automatic controller flashed the lights in varying patterns.[17]

Pylon, Agrarian Parkway

Livestock Building No. 1 was constructed around the State Fair Livestock Arena (1929), which was updated with streamlined design features. Most of the elements from the 1936 interior remodeling have been removed. During the exposition, the arena hosted free demonstrations of rough riding and musical drills by Troop F of the Fifth United States Cavalry stationed at Fort Clark, Texas.

The Livestock Arena was renamed the Pan-American Arena for the 1937 Greater Texas & Pan-American Exposition; the structure encompassing the arena, the Poultry Building, and the horse and cattle areas became the Pan-American Complex.[18]

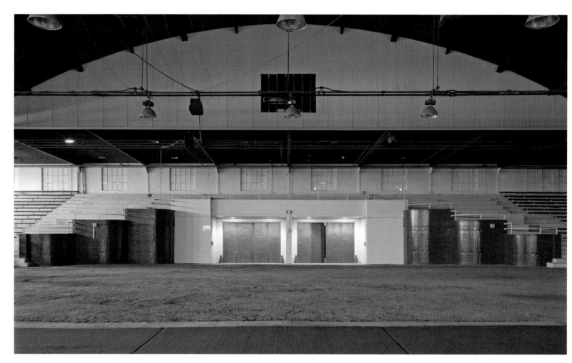

Livestock Arena/Pan-American Arena

Pierre Bourdelle painted the head of a different domesticated animal over each of the six entrances on the east end of Livestock Building No. 1 facing the avenue called The Chute. The images had been covered with paint, but were rediscovered when the building was being restored. All six had been severely damaged by sandblasting in the past and could not be salvaged. FACL, Inc., the art conservator, re-created Bourdelle's designs using historic photographs and analysis of the remaining paint.

During the Centennial Exposition, this section of Livestock Building No. 1 housed horses, dairy cows, and beef cattle; after the sheep and goat sections were moved here, it became known as the Sheep and Goat Building. Conley Design Group planned the building's restoration, which was completed in 2002.[19]

Livestock Building No. 1/Sheep and Goat Building.
Exposition Technical Staff, architects.

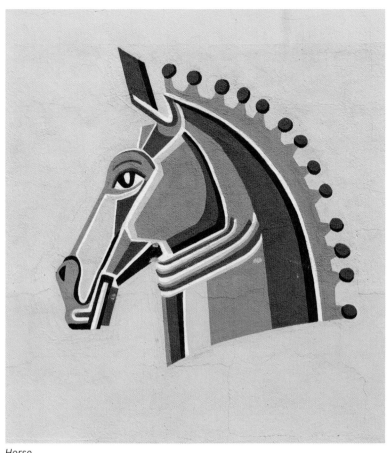

Horse
Pierre Bourdelle, artist.

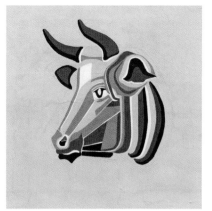

Cow

Pig

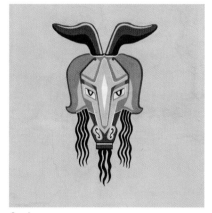

Goat

Ram

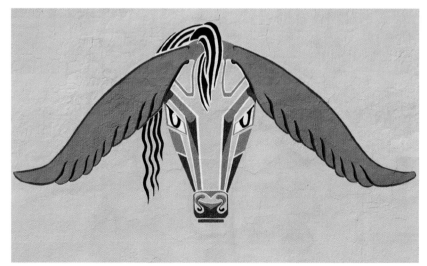

Donkey

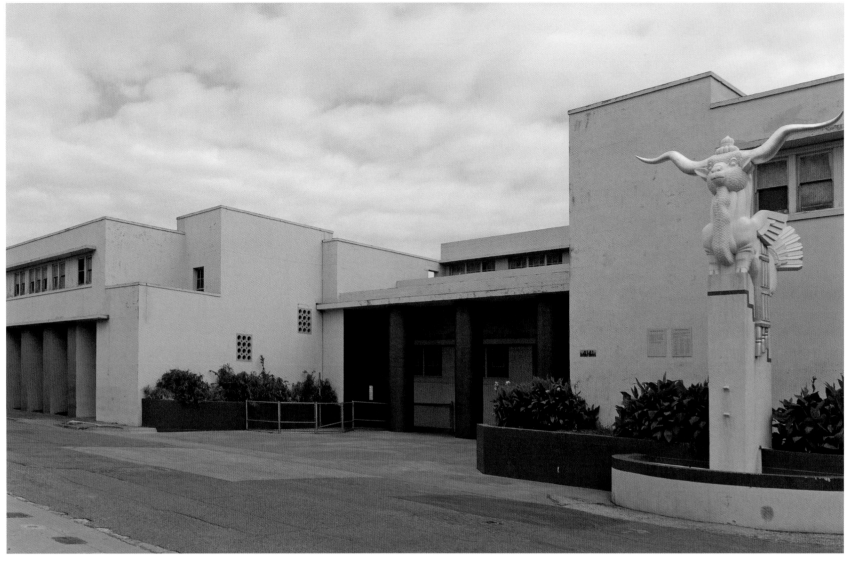

Livestock Building No. 2/Swine Building.
Exposition Technical Staff, architects.

Livestock Building No. 2 is the only exhibit hall in Fair Park that has remained largely untouched since 1936. The exposition's technical staff designed the building, which reflects the influence of industrial design in its straight lines and stripped-down ornamentation.

Light fixture, steer head with brands,
Livestock Building No. 1. Pierre Bourdelle, artist.

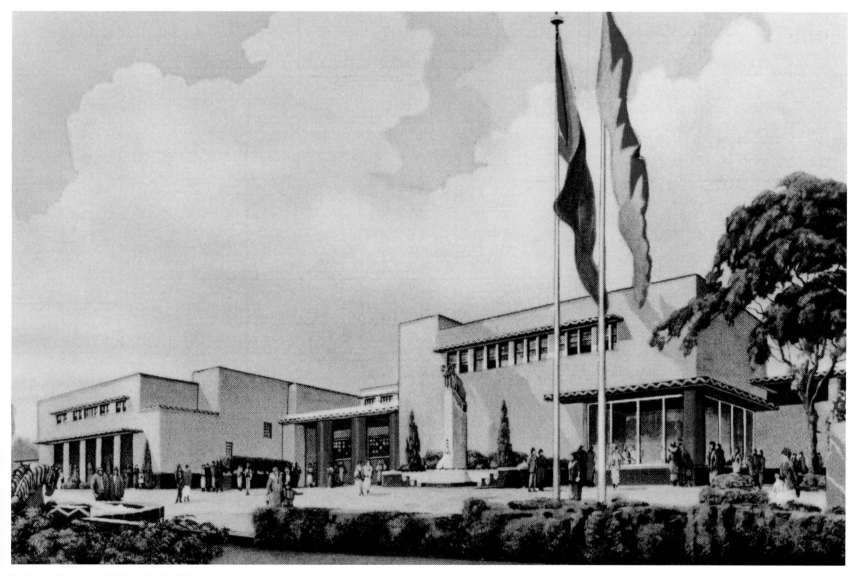

Postcard, Livestock Building No. 2, 1936

Grille, Livestock Building No. 2

Press releases describing the proposed Livestock Building No. 2 mentioned that it would be decorated with painted murals and multicolored, Aztec-inspired stenciling on the coping. The columns were to be Chinese red lacquer. It is not clear if the murals were ever painted. The stenciled coping is visible on the color postcard, but cannot be seen today; the artist may have added those details or the building might have been sandblasted after the exposition, as was Livestock Building No. 1.[20]

The nine-foot-tall *Texas Woofus* stands in front of Livestock Building No. 2. Lawrence Tenney Stevens's monument to animal husbandry gone horribly wrong incorporates body parts from different types of farm animals shown at the Centennial Exposition. The figure includes a horse's neck and mane, hog's body, turkey's tail, the wings of a duck, and a sheep's head with ten-foot-wide, chromium-plated Texas longhorns. The origins of the statue's name are not known.

In 1941, construction workers broke off the sculpture's nose while placing beams for a new livestock arena. The original Woofus was removed and never seen again, to the apparent relief of many. Architect Donald Nelson later stated, "To me, it was a sin to do anything like [the *Woofus*]." As for the statue's creator, Nelson said, "I think Stevens was a complete ass."

Sixty-one years after the statue's disappearance, the Friends of Fair Park succeeded in recreating the Woofus and returning the sculpture to its original location.[21]

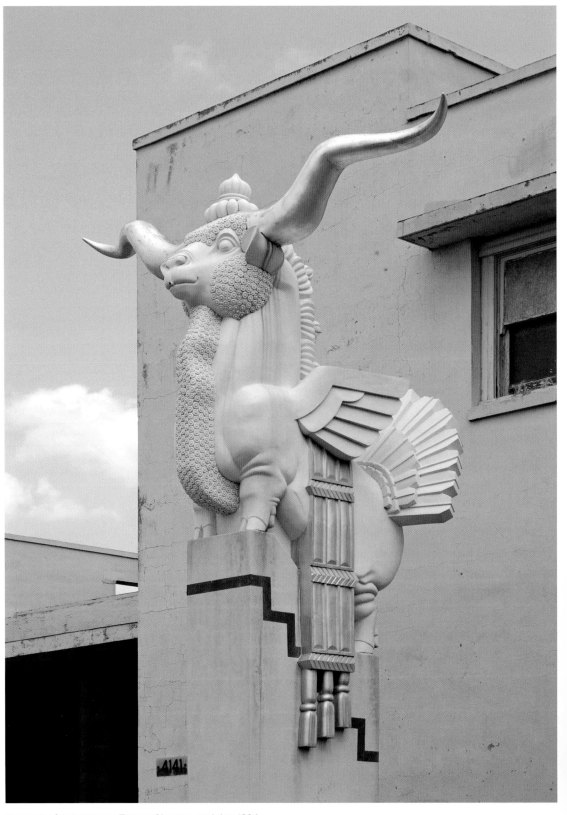

Texas Woofus. Lawrence Tenney Stevens, sculptor, 1936.
David Newton, sculptor (reproduction), 2002.

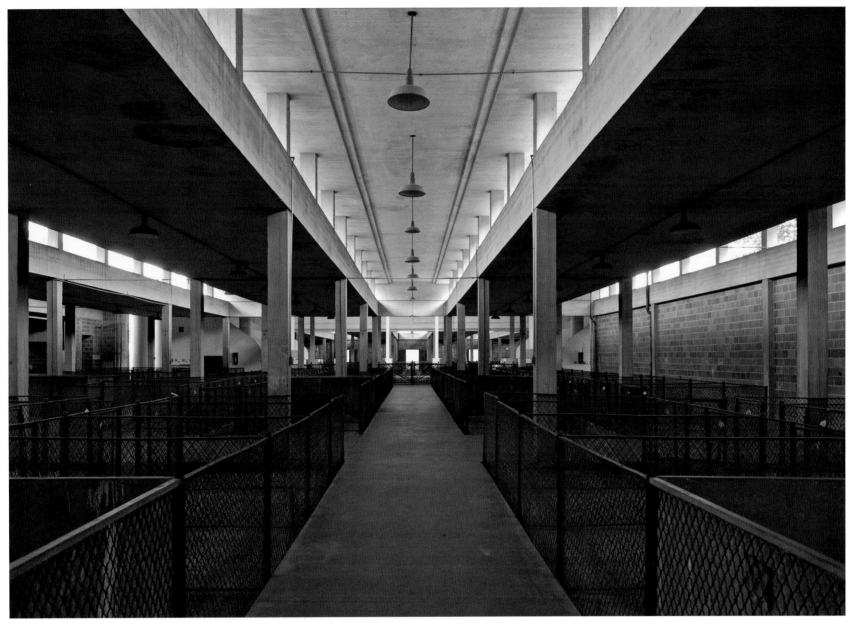

Sheep and goat pens, Livestock Building No. 2

Livestock Building No. 2 was originally divided into four sections: swine pens, the judging arena, sheep and goat pens, and an exhibition room that contained a goat-milking parlor and exhibits from the mohair industry. The exhibition room no longer exists.[22]

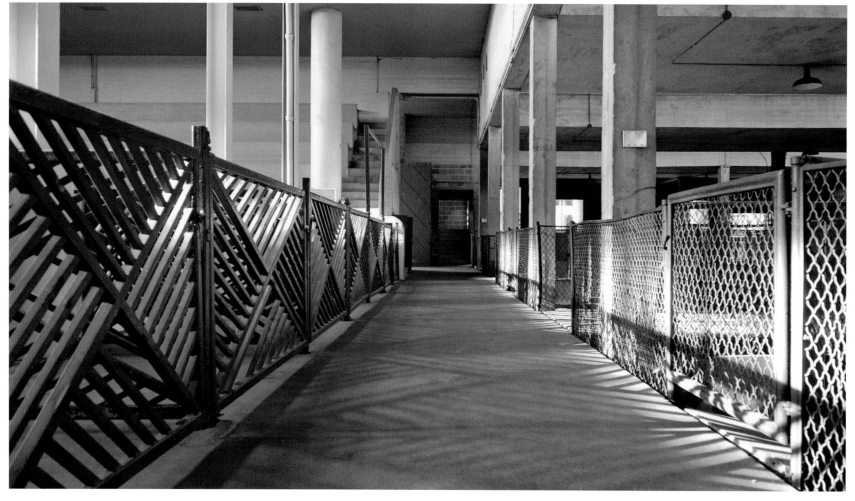

Holding pens and swine pens, Livestock Building No. 2

Heavy metal gates in a Chippendale pattern distinguish the holding pens from the livestock pens. Animals were placed in the holding pens before being taken into the judging arena.

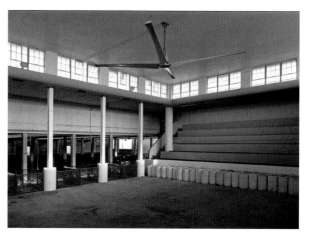

Judging arena, Livestock Building No. 2

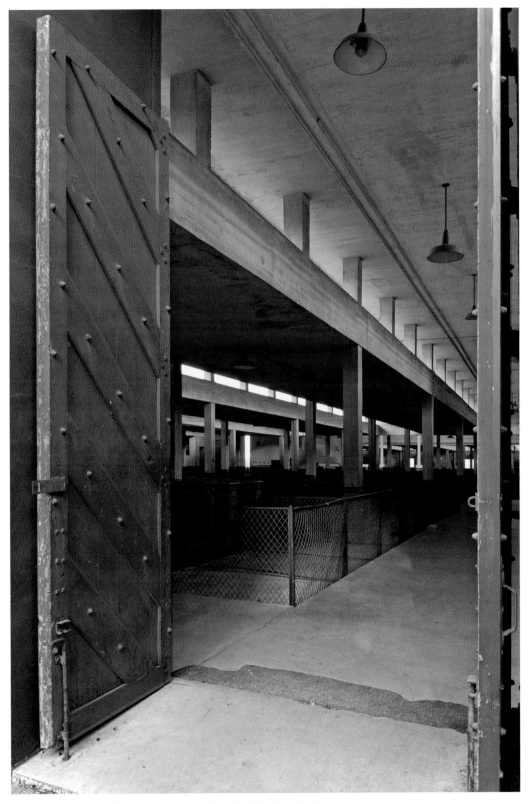

Outdoor entrance to sheep and goat pens, Livestock Building No. 2

FEDERAL CONCOURSE

There has been considerable concern expressed by Mr. Frankenstein as to the grounding of the steel tower of the Federal Building and flag poles as to lightning striking this tower and poles.

Interoffice communication
from George Dahl, Centennial Architect, to R. L. Rolfe, Structural Engineer
March 17, 1936

It only seems sensible to pay attention when someone named Frankenstein is worried about lightning striking a tower—especially when the tower in question is going to be an iconic structure that will be seen for miles around. H. A. Frankenstein was the exposition's assistant director of works, so he had a legitimate interest in the Federal Building and its 175-foot tower, the tallest structure at Fair Park in 1936.

Located near the center of the wedge-shaped fairgrounds, the structure marked the spot where the Texas Court of Honor, Grand Avenue, and Constitution Place (the entrance to the Midway) joined to form the Federal Concourse, the only plaza on the exposition grounds at the intersection of three major thoroughfares.

The tower was designed to be a landmark during the day, when the gilded eagle at its peak caught the sun, and at night, when it was one of the most brightly illuminated structures in Fair Park. It was also meant to symbolize the US government's strength and supremacy, but exposition publicists couldn't resist noting that if every six-ounce hamburger patty sold on the fairgrounds in an average day were placed one on top the other, the stack would be as tall as the Federal Building's tower.[1]

Given the structure's size and complexity, the pace of construction was impressive, even by the exposition's standards. The US government did not formally commit to participating in the Texas fair until early 1936, when Congress appropriated funds to construct two exhibit halls at the exposition: $825,000 (eventually $850,000) for the semi-permanent Federal Building and $50,000 for the temporary Hall of Negro Life. Exposition staff in Dallas designed the federal exhibit building, but approval had to come from Washington. Changes required multiple copies of typewritten specifications and hand-drawn plans and renderings, along with letters, telegrams, and meetings in the nation's capital. After final authorization, the Federal Building's cornerstone was laid on February 29, slightly more than three months before the exposition's opening day. Despite the abbreviated construction schedule, the building survived well past its projected useful life of ten to fifteen years.[2]

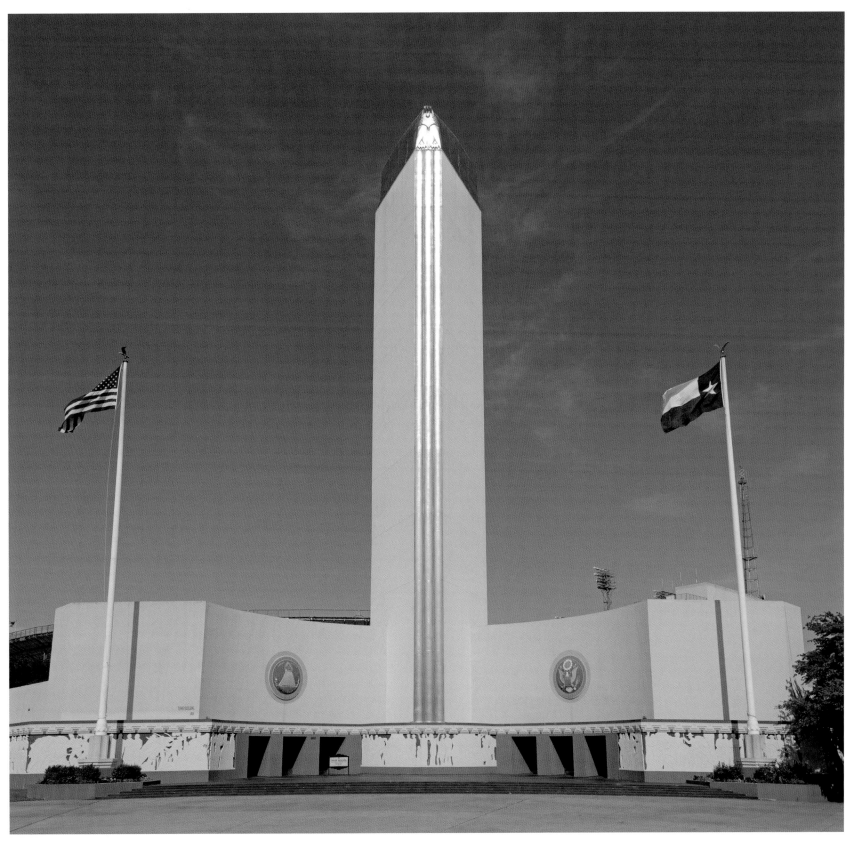

Federal Building/Tower Building. Donald Nelson, architect.

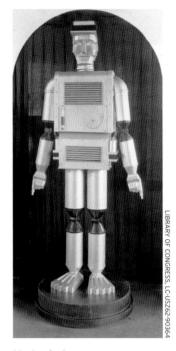

Mechanical man,
US Department of Labor exhibit, 1936

The Federal Building's exhibit hall was probably the most densely packed at the exposition, containing displays from more than thirty-five governmental departments, bureaus, and agencies. Lines on the floor and ceiling helped visitors navigate the maze of exhibits that began with the Department of State and wound its way to the Public Health Service before depositing fairgoers at the foot of the Midway.

The exhibits were as varied as the responsibilities of the federal government. The Post Office Department displayed a stamp collection valued at $10 million, which contained specimens of every US postage stamp ever issued. Fairgoers could watch scientists from the Smithsonian Institution assemble the skeletons of prehistoric animals or track births and deaths across the United States at the Census Bureau's mechanical display, which also provided hourly updates of the country's total population.[3]

Nautical exhibits were popular with inland residents, particularly the Navy Department's array of realistically detailed model ships, each about seventeen feet long. The Bureau of Navigation and Steamboat Inspection presented a full-sized, working replica of the bridge of a ship; when visitors steered the vessel, the ocean ahead would move and the deck would tilt in response to the turn.[4]

In the midst of it all, the Department of Labor attracted a great deal of attention with its seven-foot-tall mechanical man. After a greeting of, "How do you do, friends?" followed by a bow, the robot acknowledged that many people feared and disliked technology because it had replaced humans in the workforce. He went on to explain that machines were making workplaces safer by handling dangerous jobs and, in the long run, would create more employment opportunities for men and women by increasing productivity. After

completing his four-minute talk, the mechanical man would take a fifteen-minute break before his next performance. When *The New York Times* reported on the robot's speech, the newspaper noted that his accent was neither Southern nor Western; the writer described it as a New York accent, but the government would not say who had recorded the voice.[5]

The Labor Department's mechanical man got the most press, but there was no shortage of robots at the exposition, especially among automakers. At Chrysler Hall, a robot made of auto parts would overhear visitors talking and join in their conversation with wisecracks, while a mechanical Chief Pontiac answered questions about his namesake automobiles in the General Motors Auditorium. Of Detroit's Big Three, the Ford Motor Company alone presented exhibits that told a cohesive story with an overall theme and minimum gimmickry.

US Department of Labor exhibit with mechanical man, Federal Building, 1936

The Ford Building, the other major exhibit hall on the Federal Concourse, was a tour de force by Walter Dorwin Teague, the country's most influential industrial designer. Working with architect Albert Kahn, Teague used the lessons he learned creating Ford's innovative exhibits at Chicago's Century of Progress Exposition and San Diego's California Pacific International Exposition to design the fifty-five thousand square foot, air-conditioned Ford Building in Dallas, the largest and most expensive privately constructed exhibit hall at the Texas Centennial Exposition. (Teague also designed the Texaco and National Cash Register buildings and the DuPont exhibit in Dallas.)

In contrast to the adjacent Federal Building, with its prominent vertical component, curving lines and strong sculptural elements, the Ford Building was strictly horizontal with plain, smooth walls. An angled main entrance façade was the designer's primary concession to the Ford Building's site, positioning the automaker's pavilion as the focal point for the vista looking south along the Texas Court of Honor; the Hall of Petroleum served the same function at the north end of the court, making these two modernistic buildings integral components of the fairground's classic Beaux-Arts arrangement of axes and vistas.

Inside the Ford Building, there was no need for a zigzag path painted on the floor and ceiling to help visitors find their way. Teague wanted people to move through the exhibits naturally without realizing they were being guided on a definite course, so he created a design that encouraged fairgoers to flow through the building. Teague also understood the factors that can influence whether an exhibitor's message has the desired impact. "[The exhibit designer] must always bear in mind the low IQ of fair visitors," he wrote. "No matter how brilliant a man may be when he pays his admission fee, by the time he has tramped around the fair for a few hours his mental receptivity has probably declined to a twelve-year-old level."[6]

Despite the significant investment in the building and the positive response it received, the Ford exhibit did not last very long. The automaker did not return for the Greater Texas & Pan-American Exposition, so the building was repainted and repurposed as the Pan-American Palace. It was demolished before the 1938 State Fair of Texas.

Donald Nelson is credited with designing the Federal Building, although George Dahl also played a crucial role in the project. Raoul Josset designed and Jose Martin sculpted the stylized eagle that crowned the tower. The eagle and the tower's fluting were covered in gold leaf that gleamed in the intense summer sun and the exposition's extensive artificial lighting.[7]

The Federal Building was designed to be semi-permanent, lasting only ten to fifteen years, but it saw decades of active use as the State Fair Education Building, the Foods Building, the Electric Building, and the Better Living Center before being renamed the Tower Building and becoming home to the City of Dallas Fair Park Administration offices. The structure stood largely untouched until 1975, when cracking plaster began falling from the tower. Stopgap repairs were made for several years before ARCHITEXAS oversaw a complete exterior restoration. The work was finished in 2000.[8]

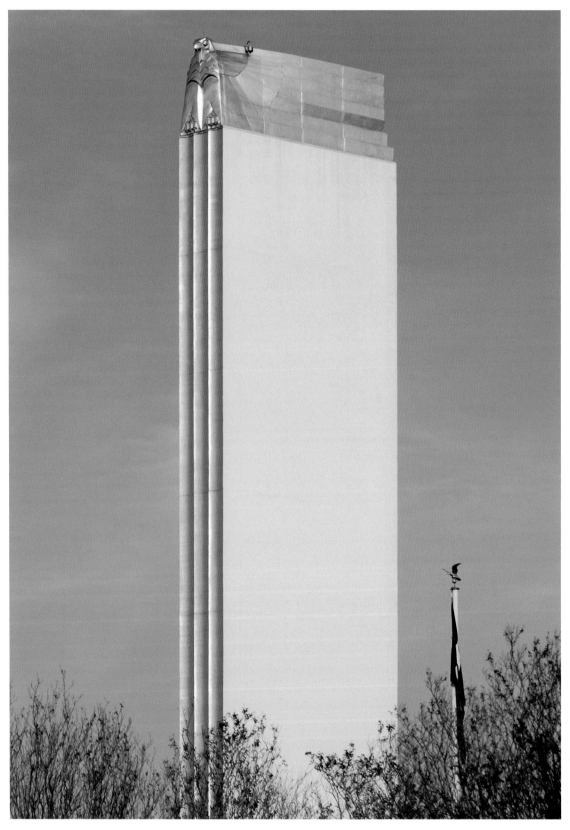

Tower and eagle, Federal Building

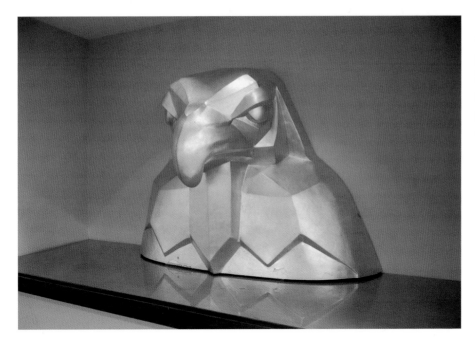

Plaster positive, Federal Building

The original eagle was disintegrating when exterior restoration of the Federal Building began in 1997. R. Alden Marshall & Associates of La Grange, Texas, created this plaster positive of the eagle's head to duplicate the original. The plaster head is on display in the lobby of the Federal Building.[9]

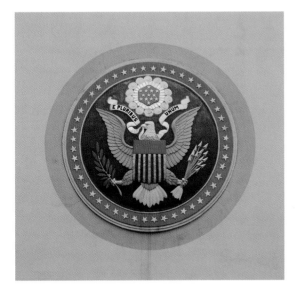

Great Seal of the United States, obverse

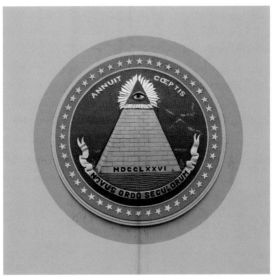

Great Seal of the United States, reverse

Sandblasting had heavily damaged both sides of the Great Seal when planning for the Federal Building's restoration began. R. Alden Marshall & Associates was responsible for repairing the reliefs.[10]

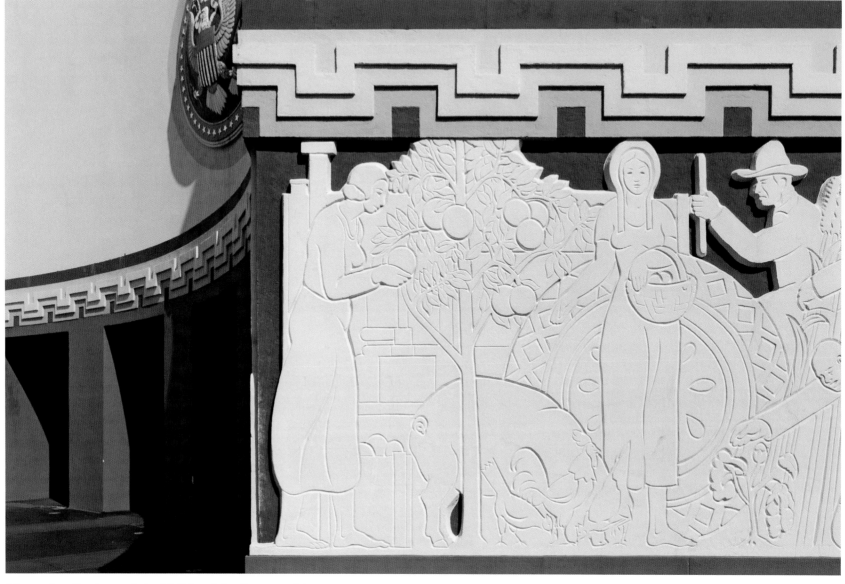

Frieze and south entrance, Federal Building. Julian Garnsey, artist.

The frieze across the front of the Federal Building depicts the history of Texas from the 1500s to 1936. It is one hundred seventy feet long, seven feet two inches tall and contains more than one hundred individual figures. The work presented a series of challenges, the most notable recorded in a letter from George Dahl to Julian Garnsey stating that the frieze was flaking and "looks like it is small-pox marked all over."

The frieze had to be scraped and repainted during the exposition.[11]

Jeff Greer, Duke Russell, and W. Stuart Wood assisted Garnsey in designing and executing the frieze. The end panel next to the building's south entrance represents the development of agriculture, including animal husbandry and the cultivation of citrus fruits.[12]

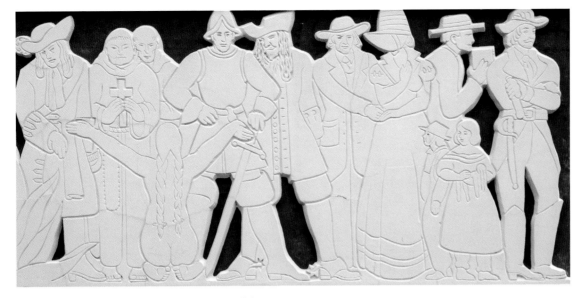

From left are the French explorer René-Robert Cavelier, Sieur de La Salle; Father Francisco Hidalgo, who established Spanish missions in East Texas, presenting a cross to a Native American woman while another Franciscan monk looks on; Commander Diego Ramón and Louis Juchereau de St. Denis, who accompanied the missionaries and marked the Old San Antonio Road; and Dr. James Long, his wife Jane, and their two children. Jane Long was revered as "The Mother of Texas" for the claim (later disproved) that she was the first English-speaking woman to give birth in Texas. The final two figures are the Reverend Henry Stephenson, representing the early influence of Protestant churches, and the pirate Jean Lafitte.[15]

Frieze panel, Federal Building. Julian Garnsey, artist.

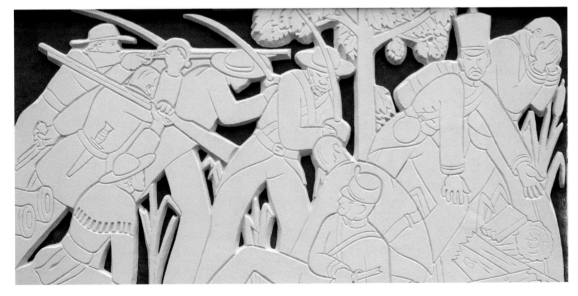

This panel represents the Battle of San Jacinto where Texans won their independence from Mexican rule. The figure on the left, rising on one arm and raising his rifle, represents the Texan revival after the massacres at the Alamo and Goliad. The barrels of the famous Twin Sisters cannons are also visible on the left. In the rest of the panel, the Texans sweep down on the defeated Mexican army; note the shattered saber in the hand of the Mexican soldier. The broken timbers at the bottom right represent Vince's Bridge, which the Texans had destroyed, thus preventing the Mexican army's retreat and Mexican General Antonio López de Santa Anna's escape.[16]

Frieze panel, Federal Building

Plans for decorating the private reception area in the Federal Building were still being discussed less than four weeks before the fair opened, when Centennial Architect George Dahl sent this message to William Yeager, executive director of the United States Texas Centennial Commission: "I am dumbfounded with the lay-out! What an opportunity has been missed in not making this room a fine dignified chamber." Dahl specifically objected to a blue neon star that was part of the original interior design. The star was not installed in the room.[17]

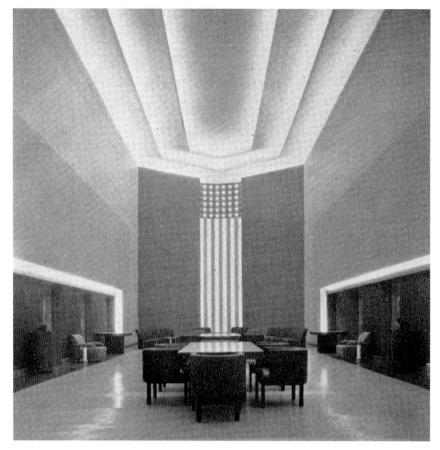

Reception room, Federal Building, 1936

The reception room looks much as it did during the Centennial Exposition and still contains its original Herman Miller furnishings. Note the tiered ceiling and recessed lighting.

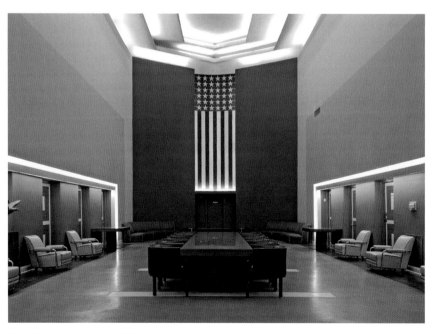

Reception room, Federal Building

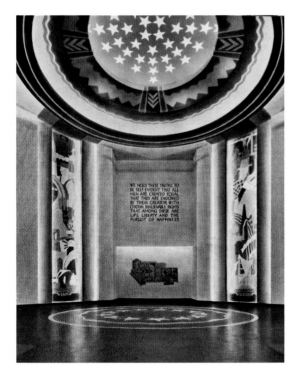

Rotunda, Federal Building, 1936.
Julian Garnsey, artist.

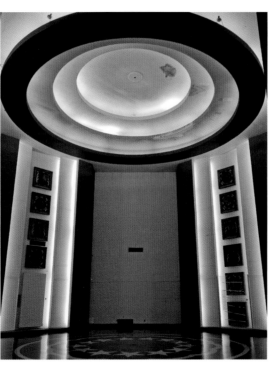

Rotunda, Federal Building

The colorized photograph from 1936 at far left suggests the vibrancy of Julian Garnsey's plans for the Federal Building interiors. His design for the rotunda featured inscriptions from the Declaration of Independence and from the inaugural address of Mirabeau B. Lamar, second president of the Republic of Texas. The largest works in the room were four murals depicting the northern, southern, eastern, and western United States.[18]

Garnsey also had definite ideas about lighting the space. He suggested yellow light bulbs for the rotunda; the corridors leading out from the rotunda would have orange tube lighting that gradually turned to red. The colorized photograph suggests that Garnsey's plan was at least partially carried out, even though the artist noted, "This may be a crazy idea."[19]

Jerry Bywaters, Thomas Stell, and G. Henry Richer were Garnsey's assistants on the Federal Building interiors.

Remnants of decoration, rotunda ceiling

For the rotunda murals, Garnsey selected iconic images that he felt depicted the character of each section of the United States.

North: The central figure is a woodsman. From the top, the mural depicts a moose, the Aurora Borealis, snow-capped mountains, evergreen trees, a beaver, a canoe, a bear, a barn and silo, corn, agricultural implements, a totem pole, an automobile motor block and tire, a log and saw, wheat shocks, a grain elevator, and a Great Lakes steamer.[20]

South: The central figure is a cotton weigher. From the top, the mural depicts a cotton compress and gin, Southern pine, a Bessemer converter, a blast furnace, a cotton bale, textile machinery, oil wells, the Mississippi River, palm trees, a mockingbird, a swordfish, an armadillo, a seashell, and a steamboat.[21]

East: The central figure is an industrial worker. From the top, the mural depicts an American eagle, Independence Hall, the Washington Monument, the Liberty Bell, manufacturing machinery, a coal mine, a steel mill, the Statue of Liberty, the Brooklyn Bridge, a lighthouse, skyscrapers, a bank, wharves, an ocean liner, a clipper ship, and codfish.[22]

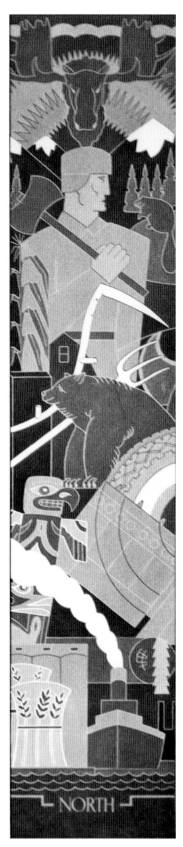

North, 1936. Julian Garnsey, artist.

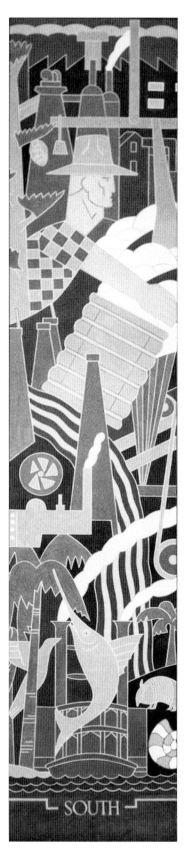

South, 1936

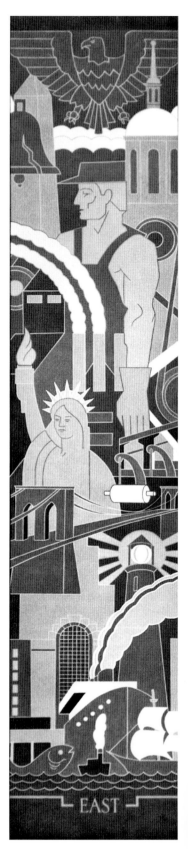

East, 1936

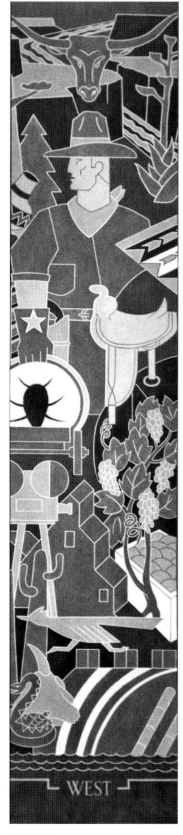

West, 1936

Remnant, *West*

Remnant, *North*

West: The central figure is a cowboy. From the top, the mural depicts a longhorn steer, the Grand Canyon, a redwood tree, a century plant, Native American pottery and blanket, a corral fence, a saddle, a covered wagon, a grapevine, citrus fruit, a motion picture camera, a gold mine, a saguaro cactus, a roadrunner, a buffalo skull, a rattlesnake, and a dam.[23]

It is not clear when the four murals in the Federal Building rotunda were painted over, but they were still visible when the exhibit hall was used as the State Fair Education Building before World War II. The square plaques covering parts of the murals came from the Baker Hotel in downtown Dallas. The hotel's fixtures were sold in 1979 and the building was demolished in 1980. Remnants of the 1936 murals and painted decoration on the rotunda ceiling have been uncovered.[24]

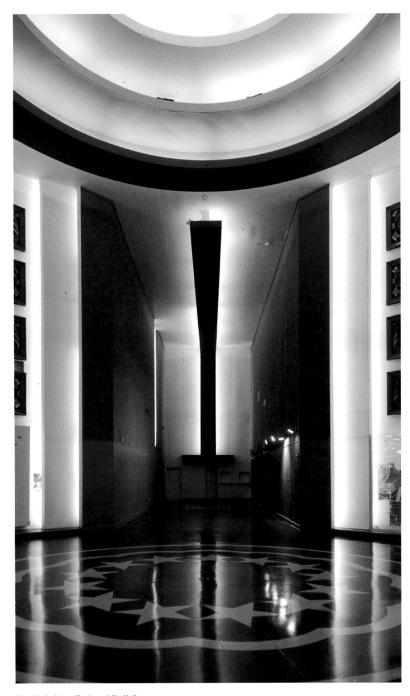

South lobby, Federal Building

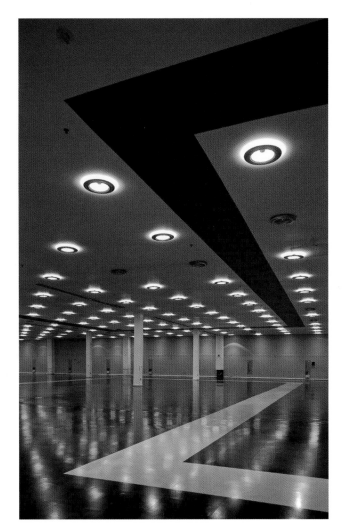

Exhibit hall, Federal Building

Every department of the federal government was represented in the exhibit hall during the exposition. The white line on the floor mirrored the blue line on the ceiling to guide visitors through the government displays. The exhibit hall was rebuilt in 2002.[26]

Cameo reliefs representing war and peace were originally above the entrance doors in the south lobby. The ceiling featured a mural with three figures representing the executive, legislative, and judicial branches of the federal government.[25]

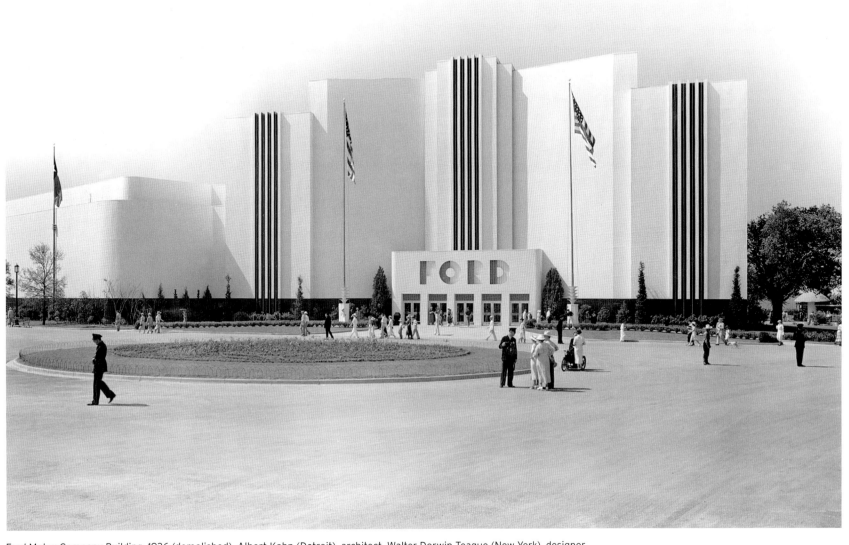

Ford Motor Company Building, 1936 (demolished). Albert Kahn (Detroit), architect. Walter Dorwin Teague (New York), designer.

Walter Dorwin Teague was one of the first designers to tailor his clients' exhibits to appeal to specific audiences. In Dallas, Ford's overall theme was "Raw Materials from Soil to Finished Car Parts." Teague placed particular emphasis on Texas agricultural products used to manufacture Ford automobiles: cotton, wool, mohair, soybeans, corn, cattle, and sugar cane.[27]

"When planning the story of an exhibit you must put it in terms of the spectator and relate it to his interests," Teague wrote. "In this case it was a revelation to farmers that thousands of cows contributed to the making of Ford cars ev-ery year and that it requires the cooperation of ninety million bees to produce a million of these automobiles."[28]

Although Albert Kahn's name is on the architectural drawings for the Ford Building at the Centennial Exposition, Teague claimed credit for designing both the building and the exhibits. It is not clear what roles Kahn and Teague played in planning the building, but Teague alone was responsible for Ford's exhibits at the Texas fair.[29]

Teague wrote extensively about his designs for the Centennial Exposition in his article "Ex-hibition Technique" in the September 1937 issue of *American Architect and Architecture*. He explained much of his work in terms of drama and entertainment, casting the exhibit designer in the role of storyteller; wherever possible, Teague's own words from the article will serve as a guide to the Ford Building here.

The Ford sign was illuminated with concealed red and yellow tube lighting; vertical elements were accentuated with blue tube lights.[30]

"We have learned to avoid flat floodlighting of buildings. Light should be used as accents, since areas in shadow by contrast give great value to illuminated areas," Teague wrote. "In Dallas we kept the word 'Ford' down low over the entrance because we had found that in San Diego, where the building name was about eighty feet above the ground, some people who walked up to the building were too tired to lift their eyes to see what it housed."

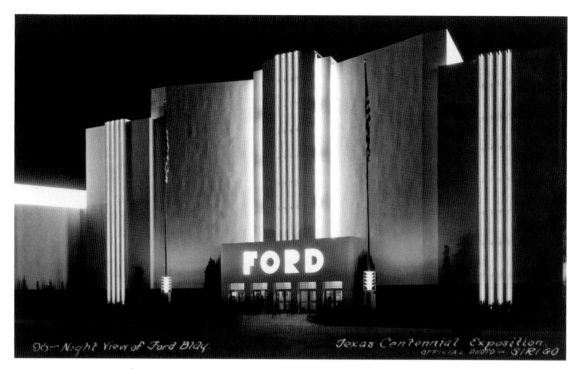

Ford Building at night, 1936

The semicircular entrance hall featured an exhibit tracing the development of transportation with vehicles brought from the Edison Institute Museum (now the Henry Ford Museum) in Dearborn, Michigan. In addition to a variety of carriages and buggies, the display included the first Ford automobile, the first Model T, the first Model A, and the first Ford V-Eight.[31]

According to Teague, "People must flow in an exhibit. Audiences follow the line of least resistance just as water does, and it is much easier to take them around a slow curve than to make them turn an abrupt corner."

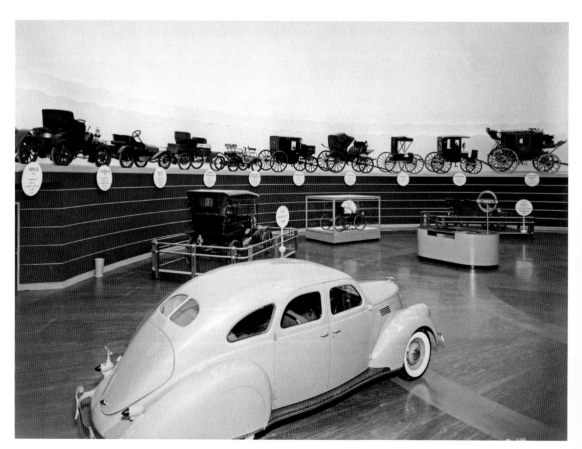

Entrance Hall and "Pageant of Transportation," Ford Building, 1936

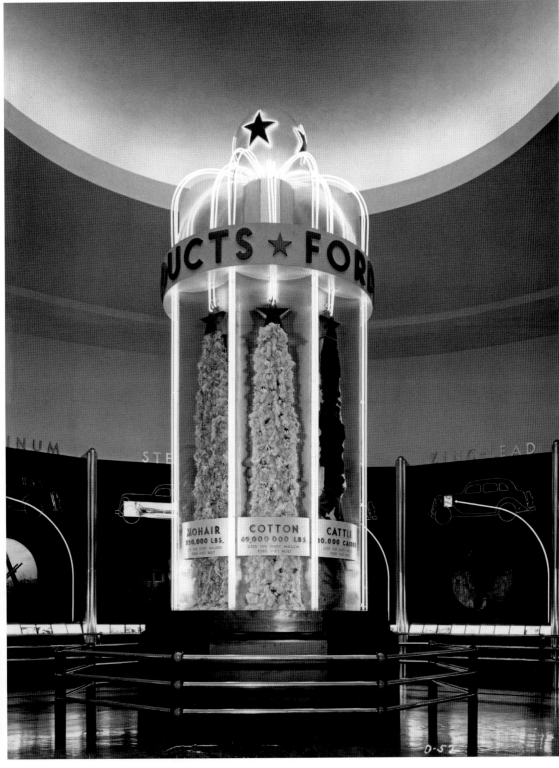

Diorama Hall and Fountain of Texas Products, Ford Building, 1936

Visitors left the entry hall and came into a smaller, circular gallery that had lower ceilings and was not as brightly lit. Around the walls were twelve large photomurals describing the natural resources used in automobile manufacturing. The centerpiece was the Fountain of Texas Products, a striking display containing samples of the state's major agricultural products that were used in Ford cars.[32]

"We had [in Diorama Hall] the pause that comes sometimes in a big production, the suspension of interest before you give your spectators another big smash. This was a prelude to the big exhibit hall," Teague wrote.

The main exhibit hall was 337 feet long and housed fifteen separate exhibits demonstrating Ford's manufacturing process.[33]

"People can be entertained by a multitude of things not ordinarily classified as amusements—such as scientific demonstrations, mechanical operations, etc.," Teague pointed out. "It is necessary, however, to entertain them actively . . . you must have events, must have things happening in your exhibit," Teague wrote.

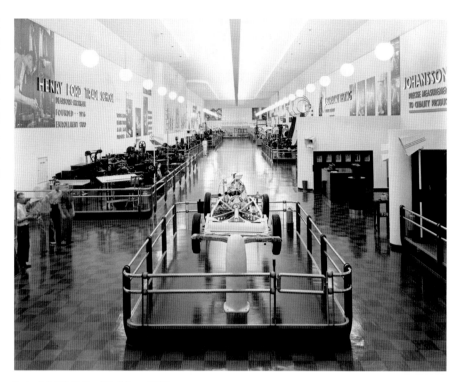

Industrial Hall, Ford Building, 1936

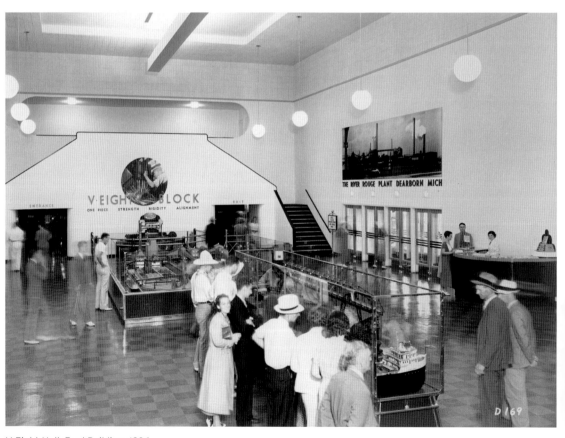

V-Eight Hall, Ford Building, 1936

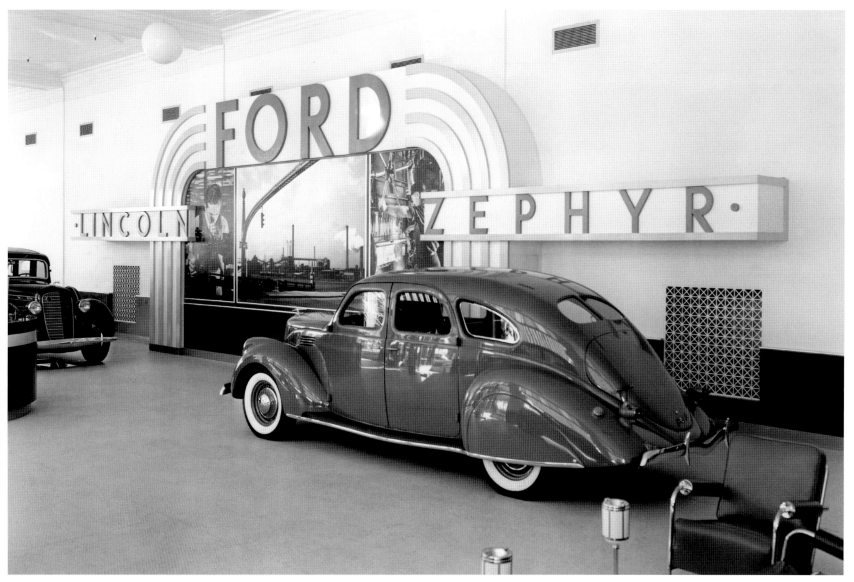

Showroom, Ford Building, 1936

The showroom complemented Ford's "Roads of the Southwest" attraction, which circled the Civic Center lagoon. Fairgoers were chauffeured in new Ford V-Eights over a variety of road surfaces. While the driver explained the history of the re-created trails, the passengers were, presumably, impressed with the quality of the car's suspension system and ride. The nine historic routes were the San Antonio Road, Fort Worth Pike, Chisholm Trail, Butterfield Stage Road, Santa Fe Trail, Yuma Road, Pan-American Highway, Magazine Street in New Orleans, and Main Street in Dallas.[34]

"The executive lounge in the Ford building at Dallas was air-conditioned and decorated in cool tones of turquoise blue, white, yellow, and emerald green. As a refuge from the summer climate of Texas it was both psychologically and actually cool," Teague wrote.

Executive Lounge, Ford Building, 1936

Gulf Broadcasting Studios, 1936 (demolished). Donald Nelson, architect. E. K. Smith, construction engineer.

Gulf Refining Company sponsored the Gulf Broadcasting Studios, state-of-the-art radio facilities where both on-site programming and broadcasts from the exposition were produced. E. K. Smith, the oil company's construction engineer, helped design the exposition's broadcasting and public address systems.

A large studio was located in each wing of the roughly U-shaped broadcasting center, with control rooms located between the studios in the middle of the building. Sixty-eight feet of sound-proof glass on the front of each studio allowed fairgoers outside the building to watch performers in the studio while listening to the program on the outdoor sound system. The court in front of the studios could accommodate an audience of seven hundred and fifty for what exposition promoters called "visual broadcasts."[35]

The radio system also aired programs live from six remote locations around the fairgrounds. Exposition staff transmitted President Franklin D. Roosevelt's speech from the Cotton Bowl on June 13, 1936, to national radio networks and provided performances by leading entertainers to local stations, the regional Gulf Centennial Network, and national networks throughout the six months of the fair.

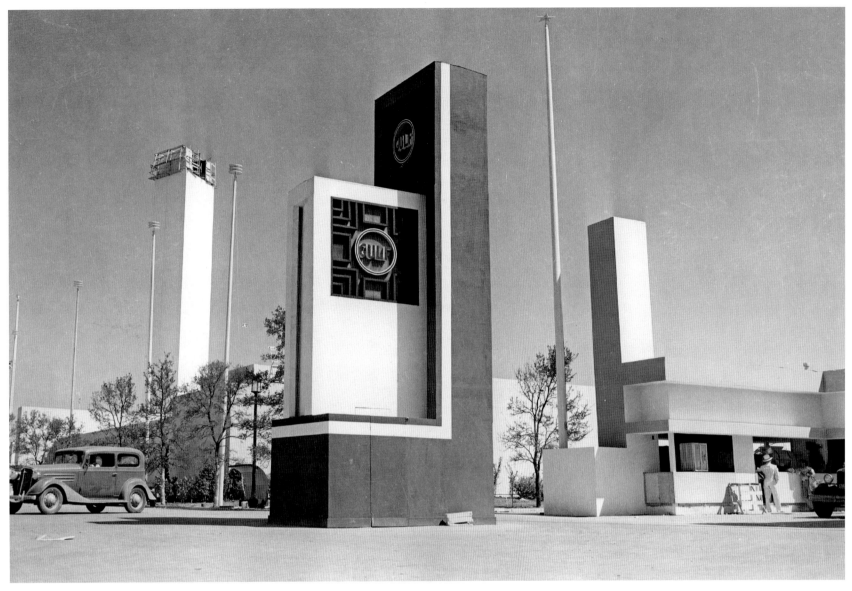

Singing Tower loudspeaker pylon, 1936 (demolished)

The Gulf Refining Company also sponsored the nineteen outdoor sound pylons (dubbed "Singing Towers") and countless indoor loudspeakers which were divided into six circuits so that appropriate music and announcements could be provided to distinct sections of the fairgrounds. A staff of twenty-four produced the programming for the exposition's public address system.

Art Linkletter, a young broadcaster who had been radio director at the 1935 San Diego world's fair, was responsible for all the exposition's radio programming. Linkletter also wrote the scripts for the CBS and NBC national broadcasts of the exposition's opening.

Years later, Al Harting, a journalist with the *Dallas Times Herald,* recalled that the Singing Towers would play "Tumbling Tumbleweeds" every night at midnight when the fairgrounds officially closed. The song was a huge hit for the Sons of the Pioneers, a very popular cowboy band that appeared at the exposition. At the time, founding member Leonard Slye was still with the group; the band would soon leave for Hollywood and Slye would take a new name: Roy Rogers.[36]

The only other building on the Federal Concourse was Skillern's Better Service Drugstore, an eight thousand-square-foot facility of restrained modernistic design in keeping with the adjacent Gulf Broadcasting Studios. The Skillern company, which operated a chain of pharmacies in Dallas and Fort Worth, built a $75,000 state-of-the-art drug store centered on four forty-foot soda fountain units surrounded by a two hundred and ten-foot serving counter. Sunken floors behind the counter allowed for table-height counter service.

The fully equipped store featured drug, sundry, and notions departments, a souvenir shop, and a complete prescription department with pharmacists on duty. Another highlight was the fifty-foot candy and cigar counter. In trumpeting the exposition's economic benefits, fair officials noted that Skillern's hired fifty people to staff the store's retail departments alone.[37]

A portion of the original Spanish Colonial Revival façade of the State Fair's Automobile & Manufacturers Building (1922) is visible above Skillern's roofline. Although it was part of the Hall of Varied Industries, Communications, and Electricity, the rear section of the Automobile & Manufacturers Building was not remodeled in modernistic style. During the exposition, the Spanish-inspired façade provided an appropriate backdrop for the subtropical garden that was the setting for the Rio Grande Valley's outdoor exhibits.[38]

118. Skillern's

Skillern's Better Service Drugstore, 1936 (demolished). Exposition Technical Staff, architects.

CIVIC CENTER AND CENTENNIAL DRIVE

Whoopee-hunting Texans set a giddy pace today in arraying big time entertainment for the Lone Star State's gayest birthday party.

The Associated Press
June 2, 1936

If anything exemplifies the multiple personalities of the Texas Centennial Exposition, it's the hit songs associated with two big-name dance orchestras that performed during the first weeks of the fair. In the General Motors Auditorium, audiences could listen to the sweet Guy Lombardo-inspired music of Jan Garber, the Idol of the Air Lanes, and his rendition of the popular "Lookie, Lookie, Lookie, Here Comes Cookie," while at the opposite end of Centennial Drive fairgoers at the Band Shell were swinging to Cab Calloway, Mr. Hi-De-Ho, and his classic "Minnie the Moocher."

Centennial Drive itself illustrated some of the challenges facing exposition planners. While the Esplanade of State and Centennial Drive were the only two east-west corridors leading from the main gate into the exposition grounds, Centennial Drive lacked the Esplanade's cohesive design and monumental scale. Visitors strolling down Centennial Drive would pass Spanish Colonial Revival buildings built for the State Fair, modernistic designs by the exposition's technical staff, and private exhibit structures that defied categorization. On just one side of the street between the General Motors Auditorium and Grand Avenue, fairgoers encountered a replica of Shakespeare's Globe Theatre, life-sized mechanical dinosaurs battling atop the Sinclair Refining Company pavilion, a gigantic mushroom housing a marionette theater, and the Magnolia Lounge, one of Texas's first International Style buildings.

The hodgepodge was even more striking when compared to the Civic Center at the east end of Centennial Drive. In his master plan for the exposition, Paul Cret recommended that the Civic Center be developed with winding walkways to create park space and separate the cultural institutions from the commercial aspects of the fair. Cret's proposal succeeded: the museum buildings were related in architectural style, but their informal arrangement amid lawns around an irregularly shaped lagoon made each institution a distinct entity. By contrast, the linear placement of buildings along the east-west axis of Centennial Drive contributed to the impression that they were random, unrelated structures.[1]

Bolstered by predictions that the city would become the center of cultural progress for the Southwest, Dallas voters approved a $3.5 million municipal bond issue to fund the Civic Center in

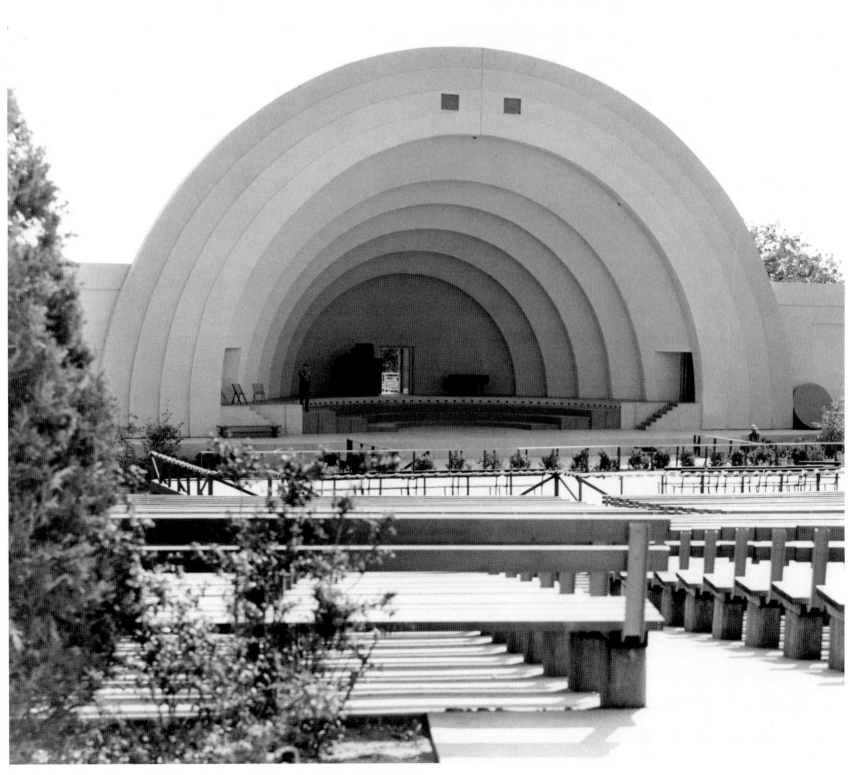

Band Shell and Amphitheater, 1936. W. Scott Dunne; Christensen & Christensen, architects.

Fair Park. The project included six permanent facilities: the Dallas Museum of Fine Arts, the Dallas Museum of Natural History, a horticultural museum, an aquarium, a museum of domestic arts, and a band shell with amphitheater. The bond money was controlled by the Dallas Park Board, which spread the work of designing the Civic Center among as many local architects as possible; the Park Board's consulting architect, W. Brown Fowler, supervised the overall project and coordinated the efforts of the various firms.[2]

Despite all the publicity surrounding the Civic Center's construction, culture was a hard sell at the Centennial. As Richard Foster Howard, director of the new Dallas Museum of Fine Arts, said, "It was only a little while ago that many Texans considered anything associated with art 'sissy.'" The museum's attendance dropped significantly after its grand opening due in part to the delayed delivery of its air conditioning system, which wasn't installed until late July, and partly because of the separate fee required to visit the museum. When the Museum of Fine Arts offered free admission on its first air-conditioned day, the promise of a constant temperature of seventy-two degrees and no entry charge brought in 4,254 visitors—more than ten times the usual daily attendance.[3]

Still, the museum had to support itself, and it was up to the director to figure out how. The Art Institute of Chicago's director suggested printing small signs leading to the art museum à la Burma-Shave, but desperate times called for desperate measures, and Howard knew what was selling at the exposition.[5]

Howard collaborated with Peggy Hahn, a.k.a. Paris Peggy, who worked at the Streets of Paris concession as a spieler (the carnival barkers' preferred term for their profession). On the Midway, Hahn's spiel attracted paying customers to an artistic peep show featuring a live model portraying Édouard Manet's *Olympia*. Howard believed Hahn could use her talents to attract fairgoers to view the nudes in the museum's collection; in exchange, the museum director would advise Hahn on the authenticity of the Streets of Paris's *Olympia*. On the day of her first foray into high culture, one hundred and sixty-five patrons followed Paris Peggy through the museum to hear her spiel on two nude paintings and a reclining nude statue that was "titillatingly described."[6]

Next door to the Museum of Fine Arts, the Fair Park Band Shell had no trouble attracting crowds. The Civic Center's most distinctive structure was among the more elaborate outdoor theaters inspired by the Hollywood Bowl (1929). W. Scott Dunne, Texas's leading movie theater designer and primary architect for the band shell, visited the amphitheater in Hollywood as well as similar facilities in Oakland, San Francisco, Sioux City, and Kansas City, incorporating the best features from each into his plans for the Dallas venue.[7]

The band shell hosted some of the exposition's most notable entertainment. Cab Calloway and his Cotton Club Orchestra performed on Emancipation Day, June 19—Juneteenth, the date in 1865 traditionally celebrated as the end of slavery in Texas. One newspaper reported, "Friskier members of the race whooped it up while dancing to the ho-di-ho rhythm of Calloway's band . . . having a great time of it, entirely oblivious to the stares of hundreds of white onlookers."[8]

The Federal Theater, a project of the Works Progress Administration, presented Orson Welles's production of *Macbeth* in the amphitheater. The young, largely unknown director had made a name for himself on Broadway by changing the setting of Shakespeare's classic Scottish play to nineteenth-century Haiti and casting black actors in all the roles. The play was, for the most part, well received in Dallas. Jesse O. Thomas, general manager of the Hall of Negro Life at the exposition, later wrote, "We had the play 'Macbeth' with a Negro cast in the Band Shell. Whites and Negroes sat on the same floor. This was not true of any theatre in the City of Dallas in which Negroes and whites both attend."[9]

Although it was a relatively modest structure, the Hall of Negro Life broke new ground as the first exhibit building officially dedicated to African American culture at a major US exposition, but it did not come about easily. Led by A. Maceo Smith of the Dallas Negro Chamber of Commerce, local African American leaders secured a commitment of $100,000 from state officials for an exhibit building showcasing the contributions black Texans had made to the state's development. When Smith endorsed a black candidate against a white incumbent in a race for state district judge, the city's political elite told Smith to withdraw his support and pull the black candidate from the race or Smith would lose the funding for the exposition building. Smith refused, the

black candidate remained on the ballot, and the Negro building was dropped from the Centennial appropriations package.

At the time, Texas's Congressional delegation was trying to convince the federal government to appropriate $3 million for the state's centennial celebrations, including $1.2 million for the exposition. Local African American leaders contacted members of the "Black Brain Trust," an informal group of policy advisors to President Franklin D. Roosevelt, and asked them to intervene, but the project still faced stiff opposition from Dallas politicians and exposition officials.

As a show of good faith, Smith sold $50,000 worth of exposition bonds in the black community, which helped persuade white leaders to stop opposing federal funding for the project. Congress eventually approved the appropriations bill with an important stipulation: $50,000 was designated for the construction of a temporary federal Negro building at the exposition, with an additional $50,000 for assembling exhibits and operating the hall. (Whenever exposition news releases and local media later referred to the Hall of Negro Life, there was always a statement that Washington had paid for the "federal Negro exhibit" and that no money was provided by the State of Texas or the exposition corporation.)[10]

The facility was to be curated, managed, staffed, and, if feasible, built by African Americans "to show the progress and achievements of the Negro race in America." The Negro Advisory Committee for the Texas Centennial Celebration wanted African American architect John Blount

of Houston to design the building, but Centennial Architect George Dahl overruled the wishes of the committee and assigned the project to his assistant Donald Nelson.[11]

Exposition management tried to put the best face possible on the situation, noting that eight hundred and fifty-five thousand black Texans could provide significant income for the world's fair if they were encouraged to attend. Not everyone was enthusiastic, as the May 14, 1936, headline in The Dallas Morning News suggests: "History of Negro From Jungles to Now to Be Shown." (A subhead added fuel to the fire: "Centennial to Be Turned Over to Darkies Juneteenth.") After black newspapers in the rest of the country denounced the Dallas media and wrote of possible boycotts of the exposition, local coverage became less demeaning. Nevertheless, editors didn't seem to recognize the irony in their reports, as the News demonstrated on June 18, 1936: "The Centennial is the first world's fair that has accorded recognition to the negro race on a comprehensive scale and the Juneteenth celebration is expected to show not only the progress of this people but also the degree of interracial goodwill and understanding evidenced in Texas. Special sections have been reserved for white people at all attractions."[12]

Even with a federally endorsed Negro presence, segregation was still the law in the Magic City. African Americans were welcome in exhibit buildings any day or time the exposition was open, a significant improvement over many state and county fairs, but they could only dine at Little

Harlem, the restaurant in the Centennial Negro Village. They could ride the trams that provided transportation around the fairgrounds, but were only allowed to sit in designated rows. The Midway's games, rides, and attractions were open to black customers, but the nightclubs and girlie shows were not.

In light of all the restrictions, sometimes the exposition provided glimpses of a future that was in many ways harder to imagine than a world with television telephones and electric eyes. After lengthy negotiations, the managers of the Hall of Negro Life convinced exposition officials to remove the "Colored" signs from the restrooms in the building. (The exhibit hall had only one set of restrooms.) "White men and women who came to the Hall of Negro Life used freely the men and women's restrooms," Thomas wrote. "There was no hesitation on the part of either group as they mingled together in these places without hitch or hinder."[13]

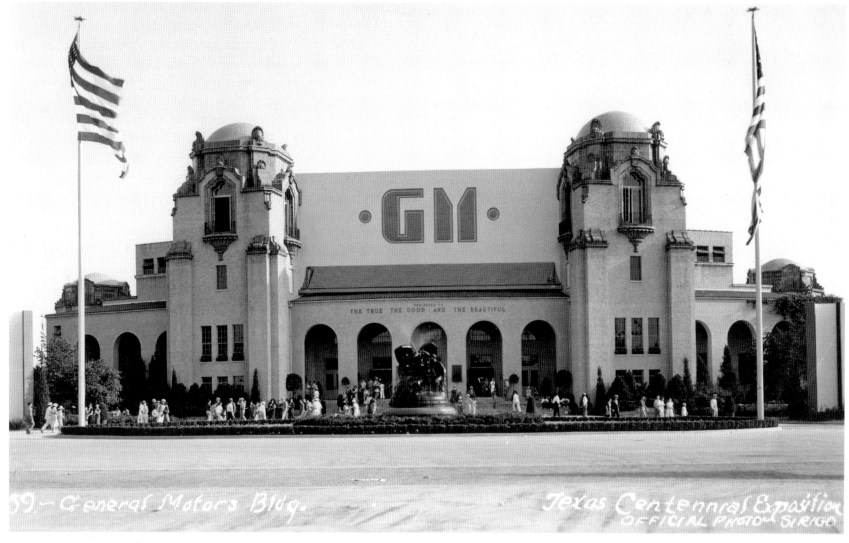

General Motors Auditorium/The Music Hall at Fair Park, 1936. Lang & Witchell, architects (1925).

The General Motors exhibit was the first building on Centennial Drive encountered by fairgoers entering from the main gates. Most visitors would have recognized it as the Fair Park Auditorium built in 1925. The only significant change the automaker made to the building's exterior was the installation of the illuminated "GM" sign.[14]

The company had proposed spending $50,000 to construct a shell over the auditorium to conform to the exposition's architectural standards. The plan for the temporary cover was announced at a luncheon for local officials less than a month before opening day and was never mentioned again in the media.[15]

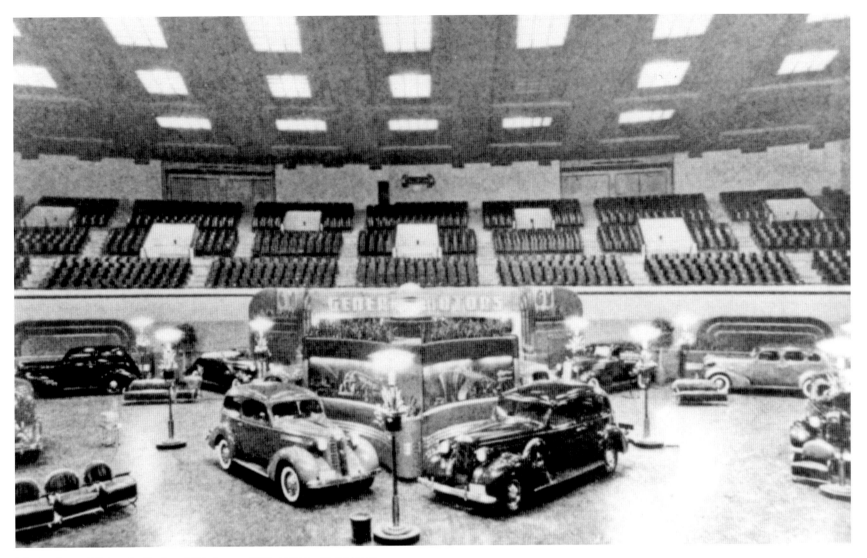

Interior, General Motors Auditorium, 1936. George Wittbold (Detroit), designer.

Creating GM's exhibit required removing all of the seats on the main floor of the Fair Park Auditorium and installing a level display floor to show automobiles manufactured by Chevrolet, Pontiac, Oldsmobile, Buick, LaSalle, and Cadillac. The lighter cars in the photo were probably those painted GM's special Bluebonnet Blue, the color of Texas's state flower.

The walls of the auditorium were covered in Fabrikoid, imitation leather used for upholstery. The bottom four feet of the walls were covered in brown Fabrikoid and the upper portions in three shades of blue. Fairgoers sat in the balcony to watch dance orchestras perform on a stage on the far side of the automobile exhibit. No dancing was allowed.[16]

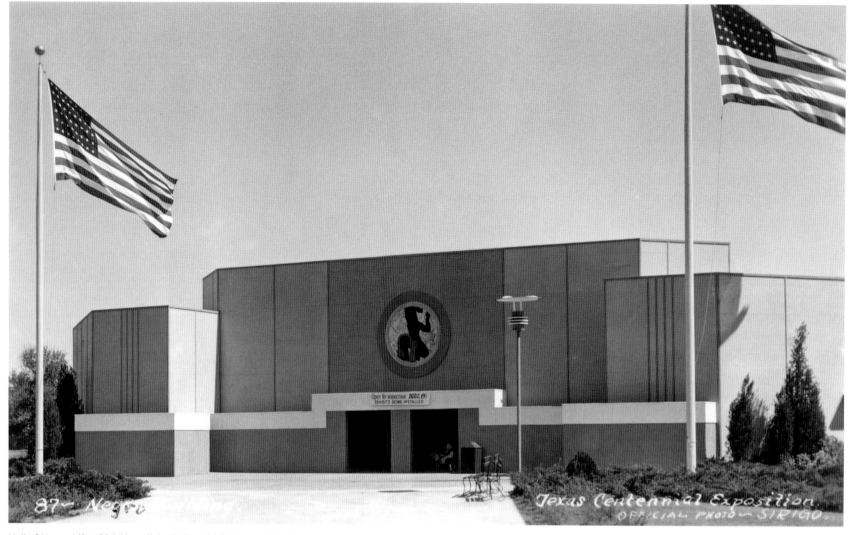

Hall of Negro Life, 1936 (demolished). Donald Nelson, architect.

The Hall of Negro Life was located between the General Motors Auditorium and Shakespeare's Globe Theatre. The fourteen thousand-square-foot exhibit building carried out the fair's modernistic theme and color scheme. The body of the building was painted two shades of cream above a three-foot base of reddish brown, with the terrace in front paved in bands of black and red. The building had an L-shaped floor plan, with the crook of the "L" containing an open-air amphitheater that hosted free programs of music and drama.

Sculptor Raoul Josset created the large relief over the entrance, which the building's manager described as "a heroic figure of a Negro with broken chains from slavery, ignorance, and superstition" surrounded by symbols of music, industry, agriculture, literature, and art. Like the exposition's other exhibit buildings, the Hall of Negro Life was illuminated every night.[17]

Into Bondage, oil on canvas, 1936. Aaron Douglas, artist.
60 3/8 x 60 1/2 inches. Corcoran Gallery of Art, Washington, DC.
Museum purchase and partial gift from Thurlow Evans Tibbs, Jr.,
The Evans-Tibbs Collection
1996.9

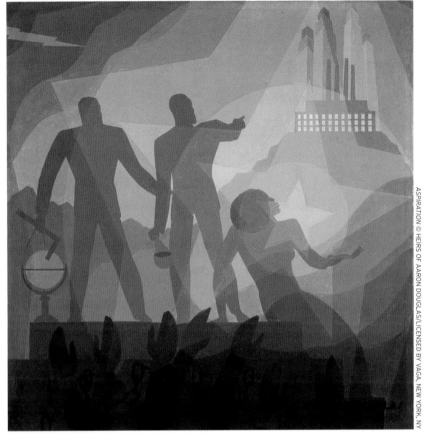

Aspiration, oil on canvas, 1936. Aaron Douglas, artist.
60 x 60 inches. Fine Arts Museums of San Francisco Museum purchase, the estate of Thurlow E. Tibbs,
Jr., the Museum Society Auxiliary, American Art Trust Fund, Unrestricted Art Trust Fund, partial
gift of Dr. Ernest A. Bates, Sharon Bell, Jo-Ann Beverly, Barbara Carleton, Dr. and Mrs. Arthur H.
Coleman, Dr. and Mrs. Coyness Ennix, Jr., Nicole Y. Ennix, Mr. and Mrs. Gary Francois, Dennis
L. Franklin, Mr. and Mrs. Maxwell C. Gillette, Mr. and Mrs. Richard Goodyear, Zuretti L. Goosby,
Marion E. Greene, Mrs. Vivian S. W. Hambrick, Laurie Gibbs Harris, Arlene Hollis, Louis A. and
Letha Jeanpierre, Daniel and Jackie Johnson, Jr., Stephen L. Johnson, Mr. and Mrs. Arthur Lathan,
Lewis & Ribbs Mortuary Garden Chapel, Mr. and Mrs. Gary Love, Glenn R. Nance, Mr. and Mrs.
Harry S. Parker III, Mr. and Mrs. Carr T. Preston, Fannie Preston, Pamela R. Ransom, Dr. and Mrs.
Benjamin F. Reed, San Francisco Black Chamber of Commerce, San Francisco Chapter of Links, Inc.,
San Francisco Chapter of the NAACP

Aaron Douglas, one of the leading artists of the Harlem Renaissance, painted four murals for the lobby in the Hall of Negro Life. The panels dealt with the African American experience from enslavement through 1936.

On entering the building, the first mural visitors encountered featured Estevanico, the first known African slave to reach Texas; he arrived as a castaway with Cabeza de Vaca in 1528. The remaining panels traced "the dramatic story of the race up from slavery."[18] The first in the series, *Into Bondage,* showed the beginnings of forced servitude; the second mural, *The Negro's Gifts to America,* featured agricultural and industrial workers and their contributions to the country's music, art, and religion, while the third, *Aspiration,* illustrated the motivation for a better life.

The Harmon Foundation of New York, which acted as a patron for many African American artists, commissioned Douglas's work for the Hall of Negro Life. Although the artist's modernist style was in marked contrast to the classically inspired murals of the other exposition buildings, even the normally dismissive *Dallas Morning News* responded favorably to Douglas's work: "Executed in boldly patterned color with many figures in active poses, the murals are dramatic versions of Negro life by perhaps the most capable and versatile American Negro working in art today."[19]

The two murals shown here survive in American museums. The whereabouts of the other two murals are not known; no images were found in archival collections.

Leading black institutions and businesses from thirty-two states and the District of Columbia were represented in the Hall of Negro Life. Exhibits were divided among six sections: Education, Health, Agriculture, Fine Arts, Mechanic Arts, and Business and Industry.[20]

Tuskegee Institute exhibit, Education Section, Hall of Negro Life, 1936

Lone Star Gas Company financed the Hall of Religion and donated it to the Centennial for use by the state's religious bodies. The building housed exhibits from major Protestant denominations, the Jewish exhibit from the 1933 Chicago World's Fair, and a chapel/meeting room where organ recitals were held. The Catholic Church constructed its own building in the Civic Center: a replica of the Mission Socorro in El Paso.[21]

Lone Star Gas stipulated that there were to be no commercial exhibits in the hall—except, of course, its own. On entering, visitors saw a model gas kitchen and the gas-powered air conditioning equipment that cooled the building.[22]

Pierre Bourdelle designed and Emile Guidroz painted abstracted religious symbols on seven lunettes in the Hall of Religion. The lunettes were probably destroyed when a misunderstanding over ownership led Lone Star Gas to demolish most of the building, which had served as the company's State Fair pavilion from the 1940s into the 1970s.[23]

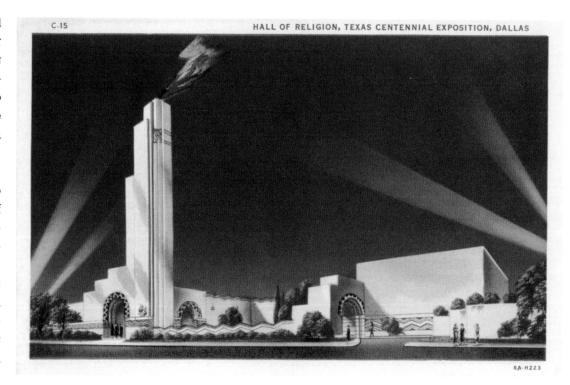

Postcard, Hall of Religion, 1936 (partly demolished). Exposition Technical Staff, architects.

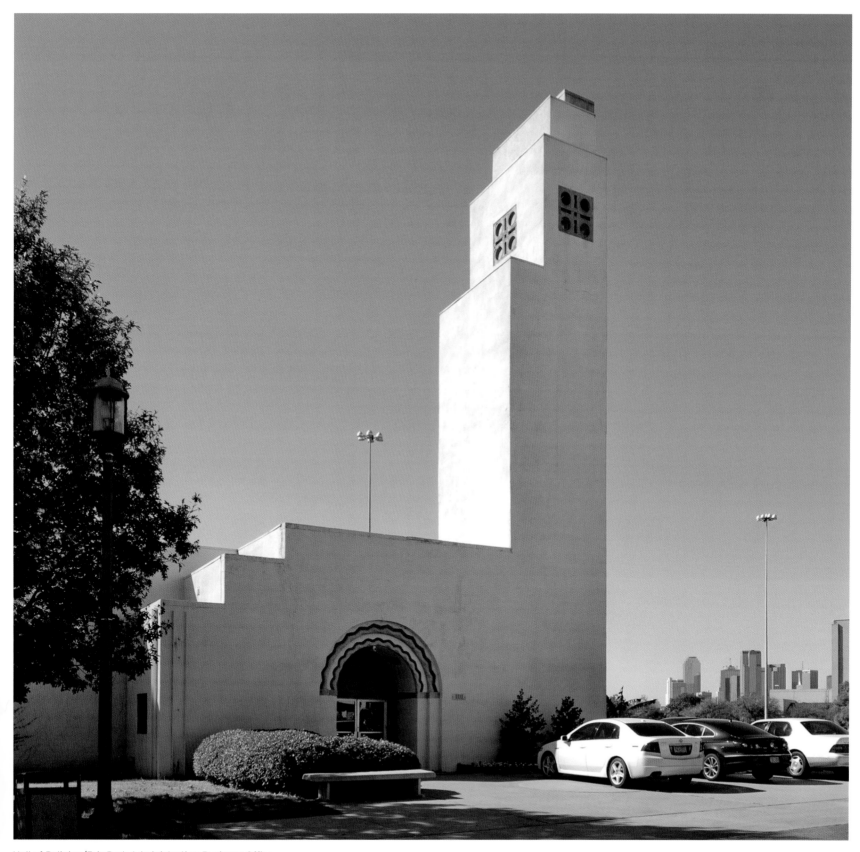

Hall of Religion/Fair Park Administration Business Office

The seventy-foot tower contained twenty-five chimes attached to a keyboard at ground level. When the chimes were played, the performances were broadcast throughout Fair Park.[24] Renderings of the building show the tower topped with a flame or torch, presumably fueled by natural gas, but descriptions of the Hall of Religion during the exposition do not mention a fire feature.

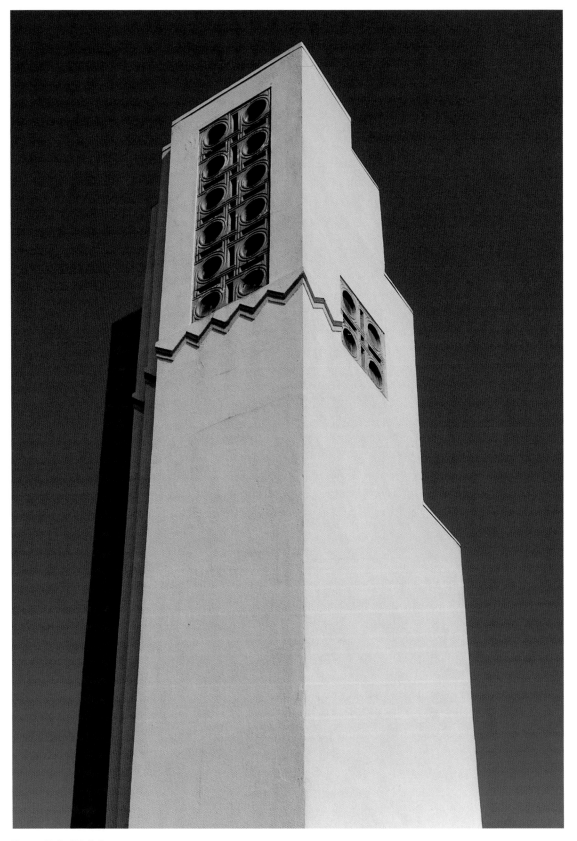

Tower, Hall of Religion

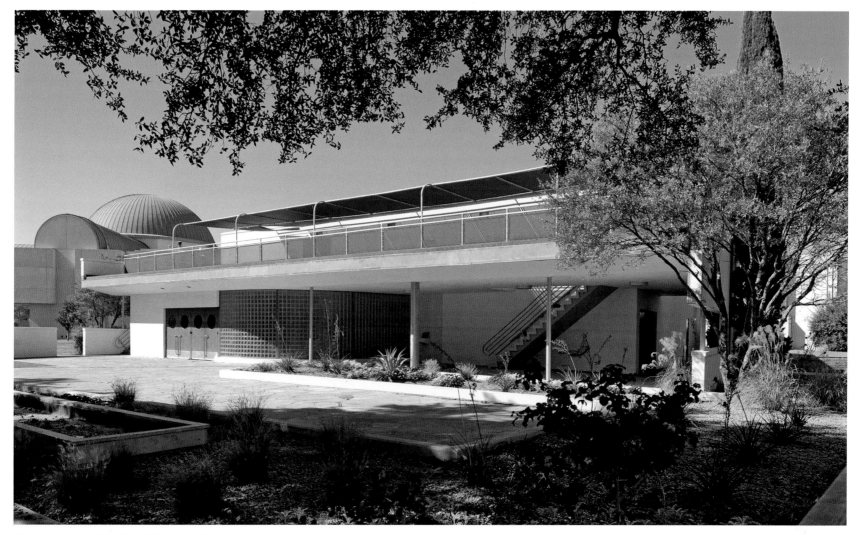

Magnolia Lounge/Friends of Fair Park. William Lescaze (New York), architect.

Prominent Dallas merchant and modern architecture aficionado Stanley Marcus was interviewing architects to design his new home when he met the Swiss American architect William Lescaze. Although Frank Lloyd Wright won the commission for the house, Marcus later recommended that Lescaze design the hospitality building that Dallas-based Magnolia Petroleum Company had proposed for the exposition.[25]

The resulting design is usually cited as being the first true European Modern building in Texas. It was not constructed without controversy; exposition officials did not like Lescaze's building, calling it "extremely modernistic." Lescaze responded, "What they mistook for 'modernistic'

is really simply good modern architecture." Because Magnolia Petroleum was paying for the $75,000 building, the project eventually went forward. The Neiman Marcus department store decorated and furnished the lounge.[26]

The completed building did not contain any corporate exhibits; its motto was, "Be our guests and rest at the Magnolia Lounge." The company provided tables and chairs on the second floor's canopied deck and in the shaded area below. The building was air conditioned and featured marble restrooms. The lounge room itself seated one hundred. Travelogues of the five States of Magnolialand, where Magnolia Petroleum operated, were projected on a translucent screen that

allowed the images to be visible even though the lounge remained lit.[27]

In 1947, the Magnolia Lounge became home to the country's first professional regional theater company and first professional theater-in-the-round. Producer/director Margo Jones founded and operated the company as Theatre '47, then Theatre '48, with annual name changes through Theatre '53. The company was then dubbed Margo Jones Theatre '54 and continued to update its name annually after Jones's untimely death in 1955. The company disbanded at the end of the 1959 season.[28]

The building constructed for the Dallas Museum of Natural History was the most ornate in the Civic Center. The museum originally contained four exhibit halls on the first floor, with the second floor reserved for paleontology labs and exhibit assembly. Wildlife dioramas with backgrounds painted by Dallas artists Reveau Bassett, J. D. Figgins, and Walter Stevens in 1936 are displayed in the building.

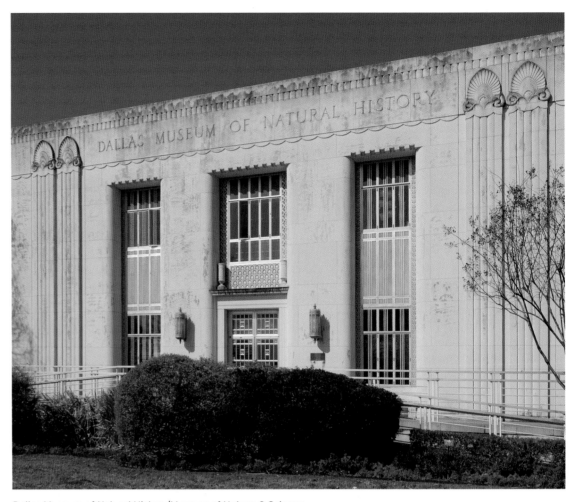

Dallas Museum of Natural History/Museum of Nature & Science. Clyde Griesenbeck, Mark Lemmon, John B. Danna, Frank D. Kean, architects.

Exterior stair, Magnolia Lounge

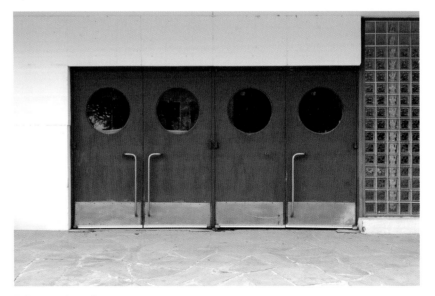

Entrance, Magnolia Lounge

Detail, Grand Avenue façade, Dallas Museum of Natural History

Lantern, Dallas Museum of Natural History

Doorknob, Dallas Museum of Natural History

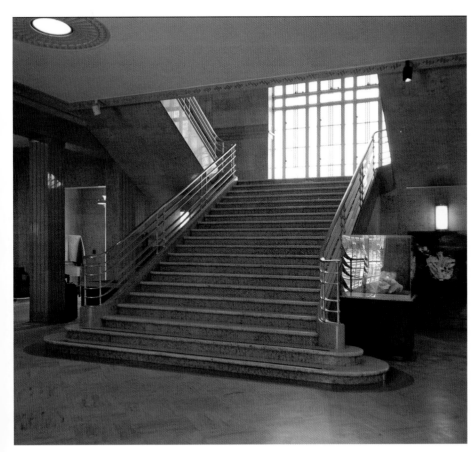

Staircase, Dallas Museum of Natural History

Doors, Dallas Museum of Natural History

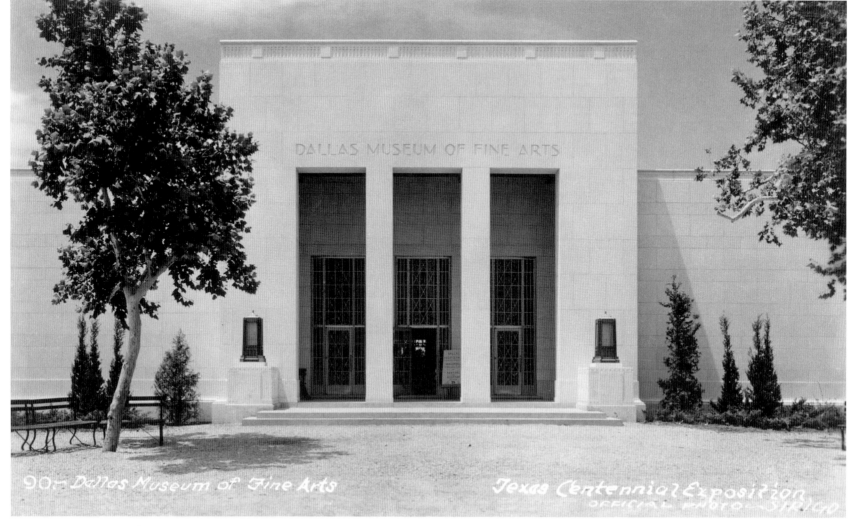

Dallas Museum of Fine Arts/Museum of Nature & Science, 1936.
DeWitt & Washburn; Herbert M. Greene, LaRoche & Dahl; Henry Coke White; Ralph Bryan, architects.

The Dallas Park Board's effort to spread the Civic Center design work among as many architects as possible backfired badly with the Museum of Fine Arts. According to George Dahl, the night before plans were supposed to be presented, he received a call from Park Board member Robert Shields, who told Dahl that the local architects couldn't agree on a plan for the museum and drawings were due the following day. Dahl said he stayed up all night and gave Shields the plans at seven the next morning. "It may not be any great achievement, but this is it," Dahl told Shields.

The building housed The Science Place after the renamed Dallas Museum of Art moved to its new downtown facility in 1983. The Science Place later merged with the Dallas Museum of Natural History and the Dallas Children's Museum to form the Museum of Nature & Science.

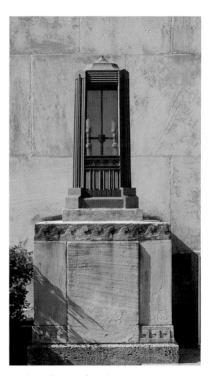

Lantern, lagoon façade,
Dallas Museum of Fine Arts

Entrance grille, lagoon façade, Dallas Museum of Fine Arts.
Dorothy Austin, sculptor.

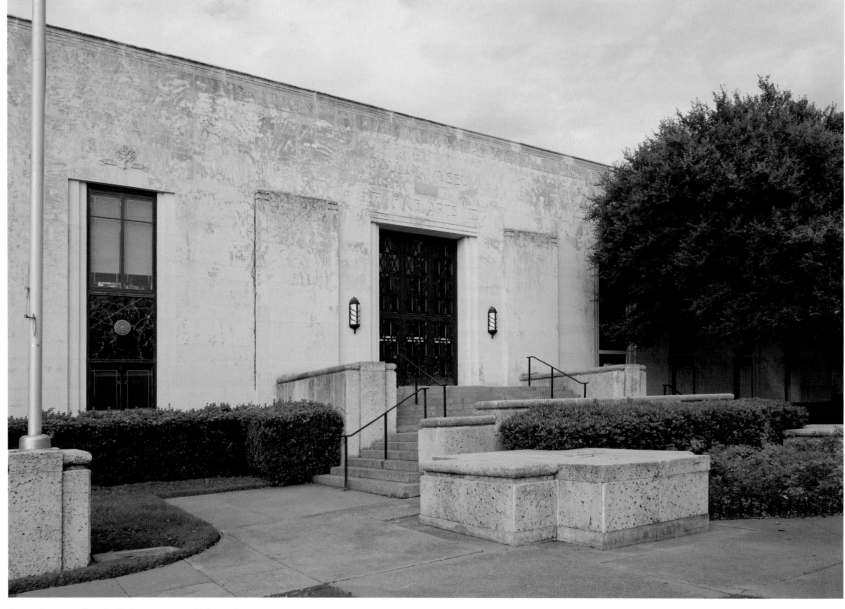

Second Avenue façade, Dallas Museum of Fine Arts

Sculptor Madelyn Miller created the screen on the Second Avenue entrance, which includes figures representing the arts.

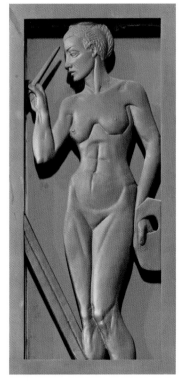

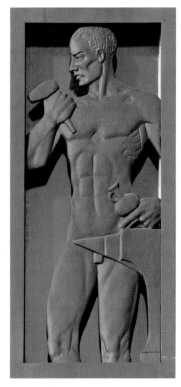

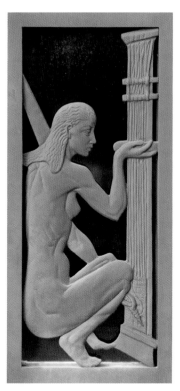

Painting
Madelyn Miller, sculptor

Metalwork

Textiles

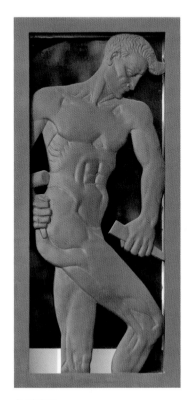

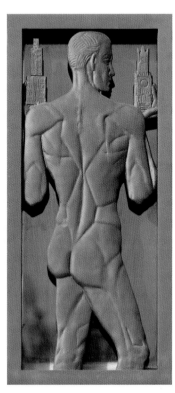

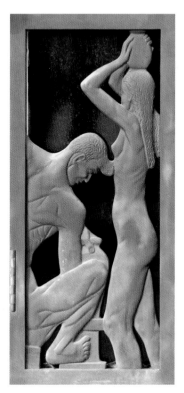

Sculpture

Architecture

Pottery

The museum was built with nine galleries, an auditorium, offices, and classrooms. A two-story wing was added to the building in 1965.[29]

Exhibit gallery, Dallas Museum of Fine Arts, 1936

Lantern, Second Avenue façade, Dallas Museum of Fine Arts

Given his reputation as the state's leading theater designer, it is not surprising that exposition officials commissioned W. Scott Dunne to lead the work on the Band Shell. It would be one of Dunne's last major projects before his death in 1937. Although the fifty-five hundred-seat amphitheater was planned with a box office and restrooms, those facilities were not built for the exposition.[30]

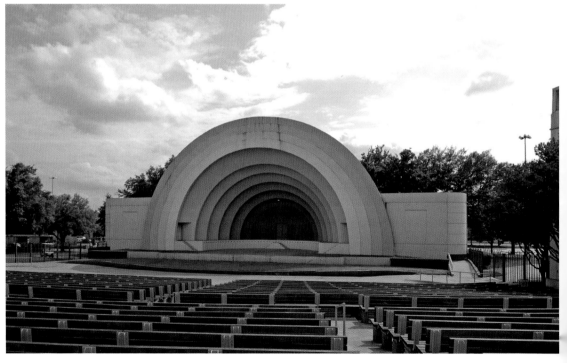
Band Shell

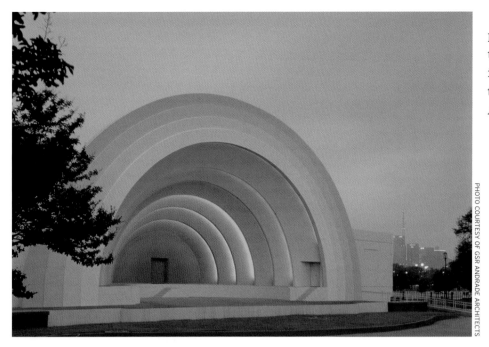

The Band Shell was disassembled and completely refurbished during a two-year project that was completed in 2002. The rehabilitation included recreating the elaborate lighting effects that had been in place during the exposition. GSR Andrade Architects designed the restoration.

Band Shell at night

Railing detail, backstage, Band Shell

Backstage, Band Shell

The Band Shell's backstage was designed with storage rooms for instruments and props, a music library, and an office for the orchestra leader. The plans called for dressing rooms for four stars and one hundred performers beneath the amphitheater's stage.[31]

In 1938, Christensen & Christensen joined W. Scott Dunne's widow in suing the City of Dallas for fees owed them for designing the Band Shell. The suit apparently did not affect the Christensens' standing with the municipal government, which hired the firm to design the 1941 addition that completed the amphitheater.[32]

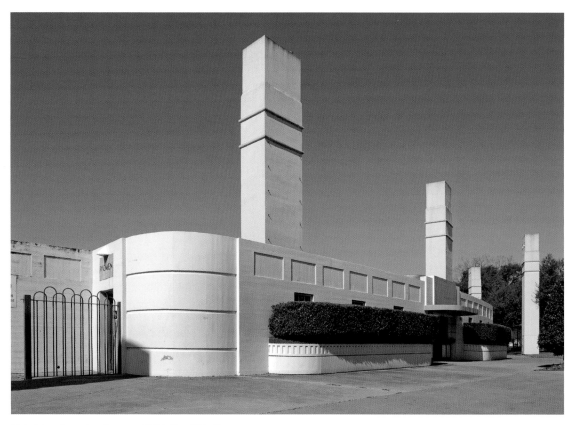

Ticket booth and restrooms (1941), Band Shell. Christensen & Christensen, architects.

Restroom sign (1941), Band Shell

Gate (1941), Band Shell

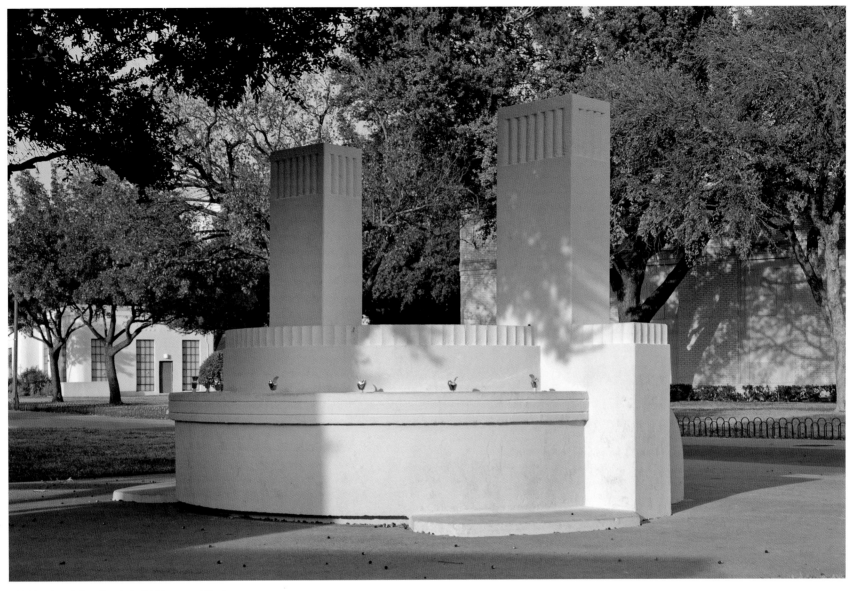

Drinking fountains. Goodwin & Tatum, architects.

As a result of the bond issue that funded the Civic Center, the City of Dallas Park Board was responsible for designing and paying for many improvements to the exposition grounds, including drinking fountains. This did not prevent Centennial Architect George Dahl from voicing his objections to the proposed plans.

"These fountains are designed from the standpoint of becoming a terminal feature rather than an accessible fountain located near the walk," Dahl wrote. "These fountains do not justify as monumental a treatment as indicated."

Dahl's authority did not prevent Ray A. Foley, the Director of Works, from stating his position in a short, stern, handwritten reply: "It is <u>March 12th</u>. The rule is on. <u>NO MORE CHANGES</u>" (emphasis Foley's). The drinking fountains were built as designed.[33]

Although it was built with high expectations, the Hall of Horticulture proved to be one of the less successful attractions at the exposition. The Dallas Park Board called a meeting one week before the fair opened because exposition managers still had not offered a plan for using the building.

Crews finally started planting indigenous trees, flowers, and shrubs around the Hall of Horticulture when fairgoers expressed disappointment that the building's greenhouse and surrounding grounds did not contain Texas flora as the fair's publicity promised. In August, the third month of the exposition, fair officials offered Texas nurserymen free exhibit space in the building in hopes of attracting visitors.[34]

The building has had a varied history since 1936. It was the headquarters of the War Rationing Board from 1942 to 1945 and returned to State Fair use as the Women's Building before opening as the Dallas Garden Center, later Texas Discovery Gardens.

Hall of Horticulture/Texas Discovery Gardens, c. 1950. Arthur E. Thomas, M. C. Kleuser, architects.

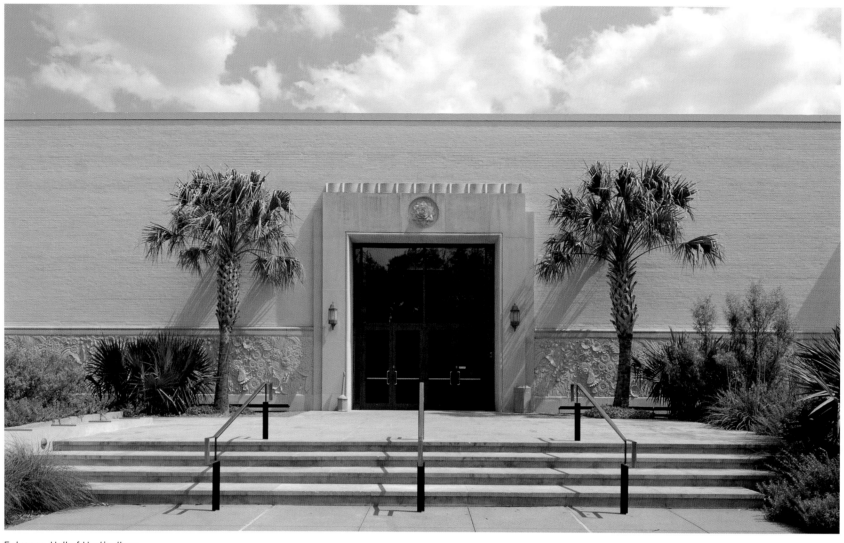
Entrance, Hall of Horticulture

The original reliefs on the Hall of Horticulture were removed at some point in its history. When the building was renovated in 2007, Oglesby Greene created new reliefs depicting native North Texas plants and insects based on historic photos of the Hall of Horticulture.[35]

Relief detail, Hall of Horticulture

Hall of Domestic Arts/Museum of Nature & Science Planetarium.
Anton F. Korn, J. A. Pitzinger, architects.

The architects attempted to give the Hall of Domestic Arts a residential flavor while maintaining the modernistic character of the Civic Center. They were not completely successful. The semicircular portico supported by columns with Egyptian Revival-style palm capitals suggests the Old South.

The Hall of Domestic Arts was another attraction that did not meet expectations. In fact, it is difficult to determine what was in the building during the world's fair. When exposition management suggested leasing the hall for a furniture auction, the Dallas Park Board rejected the proposal in keeping with its policy of not allowing commercial concessions in the Civic Center. Even before the exposition started, the Hall of Domestic Arts was being suggested as a possible location for the Dallas Park Department's offices and later as a branch of the public library.[36]

Immediately after the exposition, the Texas Institute of Natural Resources moved into the building; later it housed the Dallas Health & Science Museum, one of the predecessors of the Museum of Nature & Science.

Staircase, Hall of Domestic Arts

The streamlined banister on this staircase, one of two in the building, contrasts sharply with the neoclassical portico outside.

Exposition management reported that one in every five fairgoers toured the aquarium, which means approximately one and a quarter million visitors went through this comparatively small building in just six months. Despite being the most popular and heavily trafficked facility in the Civic Center, the aquarium building has survived with its original architectural character intact. It is particularly notable for its reliefs by sculptor Allie V. Tennant.[37]

When it opened, the aquarium had the distinction of being the only inland institution of its kind in the United States; all of the nation's other aquariums were located on the seacoasts or on the shores of the Great Lakes. With forty-six freshwater and four saltwater tanks, the Dallas aquarium compared favorably with those in Detroit, New Orleans, and San Francisco.[38]

Exacting copies of Tennant's seahorse relief were created when the aquarium was expanded in 1964. James B. Cheek, one of the building's original architects, designed the addition.[39]

The reliefs were restored in 2001 as part of a project planned by Conley Design Group.[40]

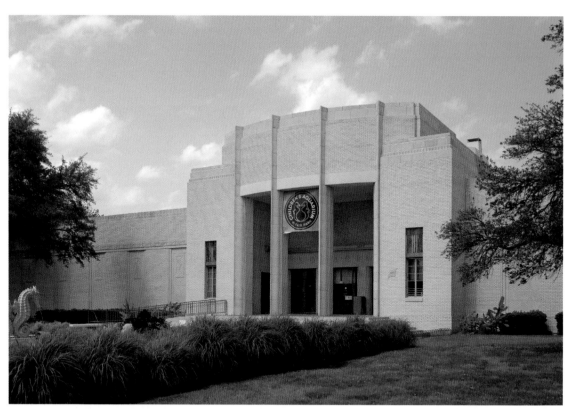

Aquarium/Children's Aquarium at Fair Park.
H. B. Thomson; Flint & Broad; Fooshee & Cheek, architects.

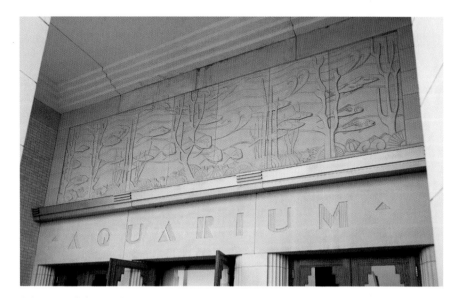

Entrance relief, Aquarium.
Allie V. Tennant, sculptor.

Entry door, Aquarium

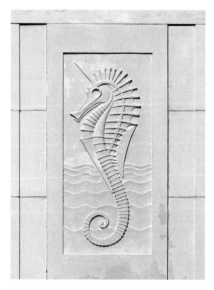

Seahorse relief, Aquarium.
Allie V. Tennant, sculptor.

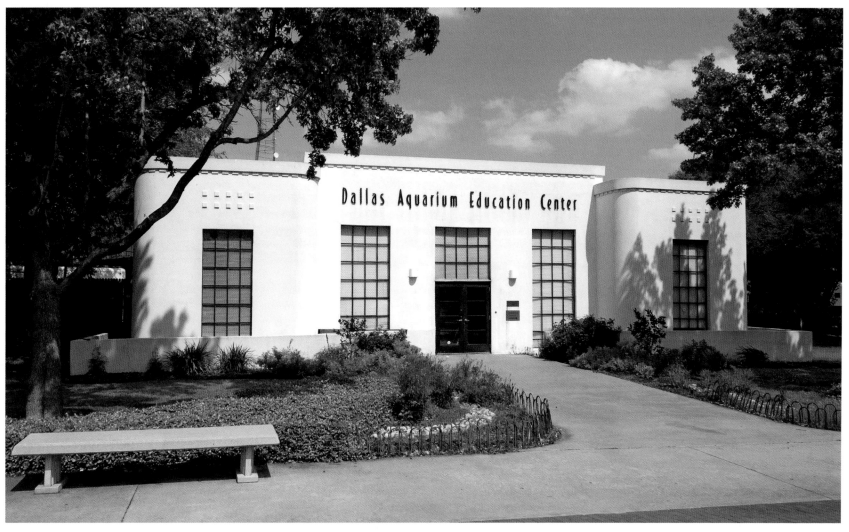

Christian Science Monitor Building/Dallas Aquarium Education Center. Luther Sadler, architect.

The streamlined styling of the Christian Science Monitor Building was in keeping with Luther Sadler's designs for modernistic houses throughout Dallas. Sweeping lines distinguished this pavilion from the angular museum buildings in the Civic Center.

Sadler's design featured a large central room for "displays in motion" explaining how the *Christian Science Monitor* was produced. The Boston-based international daily newspaper was creative in illustrating abstract concepts through its exhibits: it was reported that "a grist mill will demonstrate the separating of the chaff from the wheat for the news columns of the paper."[41]

The building was described as a temporary structure in 1936, but the newspaper continued to use the exhibit hall during the State Fair of Texas in the years before World War II. The building underwent a complete restoration in 1999; GSR Andrade Architects planned the project.[42]

THE MIDWAY, COTTON BOWL STADIUM, AND SAN JACINTO DRIVE

**It's Coney Island . . . Monte Carlo . . . the Mardi Gras . . .
all rolled up into one—It's the MIDWAY of the Texas Centennial!**

From the script of the Official Opening Broadcast for the Texas Centennial Central Exposition
Columbia Broadcasting System
June 6, 1936

One of the definitions of the phrase "back forty" is "remote, usually uncultivated acreage." The Midway was definitely the back forty of the exposition. Removed from the showpiece buildings along the Esplanade of State and Texas Court of Honor, the Midway was home to thrill rides, peep shows, some surprisingly elaborate nightclubs, and one extremely unusual barker, Flaming Fanny, whose disembodied head beckoned visitors into the Streets of Paris concession. Remote? Yes. Uncultivated? Definitely—but also very popular and profitable.[1]

Aside from reading George Dahl's interoffice memos about signage, building placement, and lighting, there is no way of knowing what the centennial architect really thought of the Midway. Although he maintained final design approval over all the concessions, the nature of many of the attractions meant Dahl had less control here than in other parts of the exposition grounds. Each concessionaire was free to hire his own architect. Even if the exposition staff designed a concession, in the end, the Black Forest's shops, beer hall, and ice rink had to look like a German village and the Texas Queen music hall had to look like a showboat.

In those areas of the Midway where Dahl could enforce the fair's architectural standards, he could not hide the fact that behind the Art Deco façades and futuristic light fixtures was a traditional carnival. Midget City was a case in point. The attraction hewed closely to the exposition's design standards, but the scaled-down modernistic skyscrapers only gave a new look to a concept that dated at least as far back as 1904 when Lilliputia, populated by three hundred little people, opened at Coney Island's Dreamland amusement park. Similar attractions were successful at the world's fairs in Chicago in 1933 and San Diego in 1935, although San Diego upped the ante by adding a farm with miniature animals and diminutive farmers.[2]

The premise of these shows was that the audience was viewing little people going about

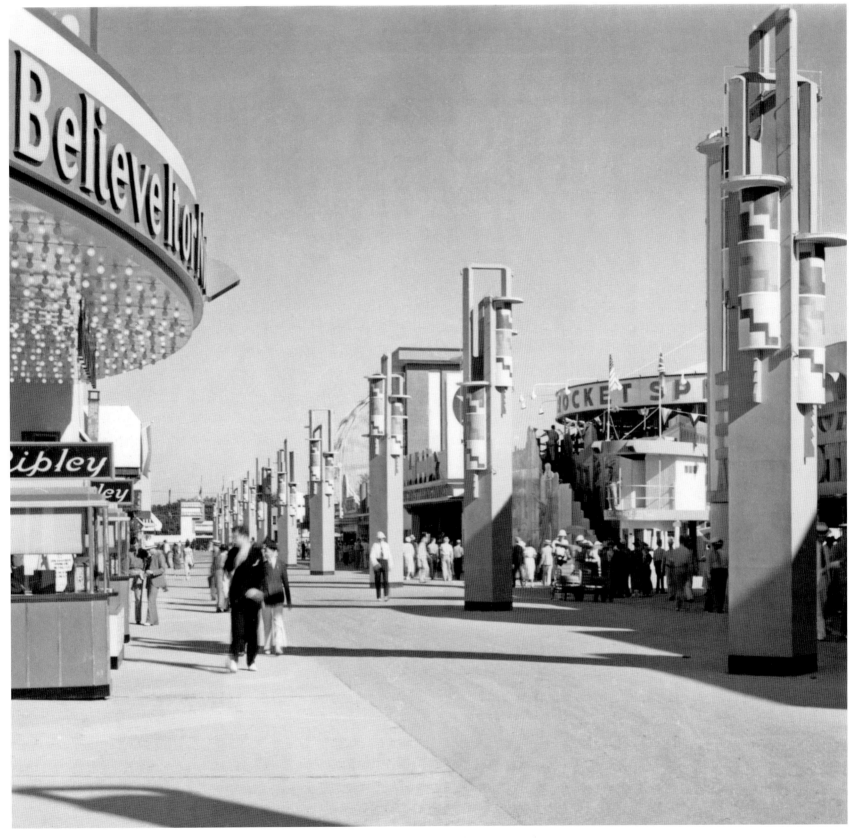

The Midway, 1936

their everyday lives at home and at work, but in a world built to their size. In Dallas, the main attraction was a revue featuring Dolly Kramer, "The Midget Sophie Tucker." Later in the season, the show added Eleanor Stubitz, "The Miniature Mae West," who had headlined Midget Village at the San Diego fair.[3]

Another longstanding carnival draw was very much in evidence in Dallas: female nudity. Although the amount of flesh on display was shocking to some, the Texas Centennial Exposition was continuing a midway tradition that first attracted national attention with Little Egypt's belly dancing on A Street in Cairo at the 1893 World's Columbian Exposition in Chicago. It was carried on by fan dancer Sally Rand in the Streets of Paris at the 1933 Century of Progress Exposition. In fact, the Parisian concept was so successful in Chicago that the producers re-created the entire attraction, sans Rand, in Dallas.[4]

The featured performer in the Streets of Paris centennial floorshow was Mona Lleslie, the Diving Venus, whose costume consisted of "a pint of pure olive oil." During her act, the lights would dim and Lleslie would appear atop a diving platform, pose as multicolored lights played off the olive oil glistening on her skin, then dive into a tank of water.

Less coquettish and more controversial was the Life Class at the Streets of Paris. In an attempt to give the popular nude revue some redeeming artistic value, audience members were given paper and crayons to sketch the women.

A committee of local ministers convinced the exposition manager to shut down the show—temporarily. One month later, the Dallas welfare board complained to the mayor about "unnecessary displays of feminine anatomy" at the fair and the Life Class was closed again.

The city's overall commitment to cleaning up the Midway should probably be taken with a grain of salt. On July 24, *The Dallas Morning News* ran the headline "Shows at Fair Comply With Morals Laws," and the accompanying article mentioned that the city's Baptist ministers had passed a resolution condemning nudity at the exposition. The same day, the newspaper also carried an interview with Della Carroll of the Midway's new Hollywood Nights revue, who was billed as "America's most beautiful nude dancer." The twenty-year-old platinum blonde talked about a parachute jump she had made "clad in her working clothes, which consists of a pair of shoes." The publicity stunt had taken place two days earlier at Dallas's municipal airport: Love Field.[5]

The one real breakout performer at the exposition worked in the last concession at the far end of the Midway, but that did not stop the crowds from finding her. Mademoiselle Corinne's famous Apple Dance was the star attraction at the Streets of All Nations. A hit during the second season of the Chicago World's Fair, Corinne danced with a large "apple" (actually a gilded balloon the size of a medicine ball) that she moved to artfully conceal her nudity. Although originally promoted

as a danseuse who had studied with a master from the Imperial Russian Ballet, Mlle. Corinne's popularity was only enhanced by the revelation that she was, in reality, born Corinne Boese in Kaufman, Texas. Her act was popular enough that 24,534 South Texas residents purportedly signed a petition requesting that Mlle. Corinne substitute a grapefruit for her apple, noting that apples were not grown commercially in the Lone Star State. The dancer demurred, having already turned down similar requests from Texas's peach growers and watermelon farmers. Corinne also inspired at least one imitator: Tony Sarg's Marionette Theater at the exposition introduced Mlle. Chlorine in its shows. After her dance, a puppet William Tell would shoot the marionette Chlorine's apple with an arrow.[6]

Apple dancers weren't the only performers who attracted attention: Warden Lewis E. Lawes's Crime Prevention Exposition produced the Midway's most unusual heartthrob. When the well-known warden of New York's Sing Sing State Prison lent his name to this concession, it was nominally an educational attraction. In a special column for *The Dallas Morning News,* Lawes explained how visitors would be enlightened by lectures on investigative techniques and demonstrations of lie detectors, fingerprinting, and handwriting analysis. This may have been heady stuff for the warden, but the show's producers realized early on that they had to offer something more than a crime lab and two-way radio demonstrations to justify the additional forty-cent ticket

price. After all, admission to the entire exposition was only fifty cents.[7]

The exhibit needed an electrifying finale, and the producers created one: a mock execution staged every half hour at least twenty times a day. A "condemned killer" would be taken from his cell in Sing Sing's Death House, strapped into the electric chair, and "executed" in full view of the ticketholders. The standout among the three actors who went to the chair was Floyd Woolsey, who imitated electrocution convincingly enough that some audience members believed they had witnessed an actual execution. Woolsey reportedly received a dozen letters a day from female fans, enough for the fair's publicity department to dub him "the Warner Baxter of the Midway." (At the time, Baxter was one of Hollywood's highest paid actors.) *The Dallas Morning News* attributed Woolsey's popularity to "the freakish turns of the feminine mind."[8]

Cotton Bowl Stadium, adjacent to the Midway, hosted both history and hype during the exposition. On June 12, 1936, a capacity crowd of forty-six thousand cheered President Franklin D. Roosevelt as he congratulated Texans on the one-hundredth anniversary of their independence and praised the state for enacting groundbreaking legislation to regulate corporations, contain monopolies, and protect farmers and small businessmen. Seven days later, an audience of four thousand five hundred came to the Cotton Bowl to witness the wedding of one of the famous Hilton sisters, conjoined twins who performed in vaudeville and nightclubs. Violet Hilton was the bride; her sister Daisy served as bridesmaid. The groom was James Moore, variously described as a dancer in the Hiltons' act or a slide trombone player. Despite such an auspicious beginning, Violet and James filed suit to have their marriage annulled less than four months later.[9]

The back of the fairgrounds was not all hoopla and ballyhoo. Walter Dorwin Teague designed the modernistic Texas Company (Texaco) Building, which marked the transition point between the Midway and the rest of the exposition. But even an important designer like Teague could show his playful side at a fair, as his colossal version of the National Cash Register Company's newest model proved. Teague created the look of the original cash register and planned its mammoth replica to track and display the exposition's daily attendance.[10]

The giant cash register anchored the back forty's other thoroughfare. San Jacinto Drive looped behind the Hall of Horticulture and, like the Midway, contained a hodgepodge of architectural styles, including the Texas Rangers' log compound (Dallas's drivers license bureau after the exposition), a replica of the Alamo, the modernistic Works Progress Administration Building, and the four Centennial Model Homes. Although remote, the attractions here were definitely cultivated, but *The San Antonio Light*'s description of the Streets of All Nations could also apply to San Jacinto Drive: "[It] looked like a bit of Hollywood had gotten its stages jumbled."[11]

The Midway and San Jacinto Drive remained basically intact through the 1937 Greater Texas & Pan-American Exposition. Several of the buildings along San Jacinto Drive were used by government agencies and non-profit organizations during and after World War II, but almost all were demolished by the late 1950s. The Midway managed to hang on longer than expected, even though it contained some of the most ephemeral buildings in the Magic City. Although piecemeal demolitions occurred, most of the buildings on the south side of the 1936 Midway appear to be in place in photos from the 1950s. Based on historic photos and newspaper accounts, parts of the Centennial Midway survived into the 1970s, when its last remnants were demolished.[12]

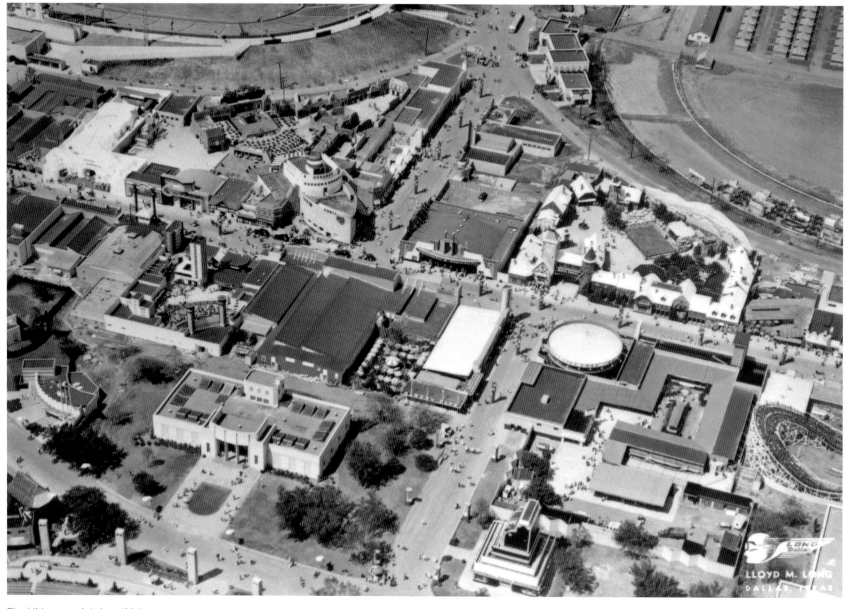

The Midway, aerial view, 1936

The *SS Normandie* at the entrance to the Streets of Paris is near the center of the photo. Ripley's Believe It or Not Odditorium is on the opposite corner next to the clock tower and snow-covered roofs of the Black Forest, a Bavarian-themed attraction. Midget City's skyscrapers are across the street to the left of the *Normandie*. The National Cash Register Company Building and the Aquarium in the Civic Center are visible at the bottom of the photo.

Midget City, 1936 (demolished)

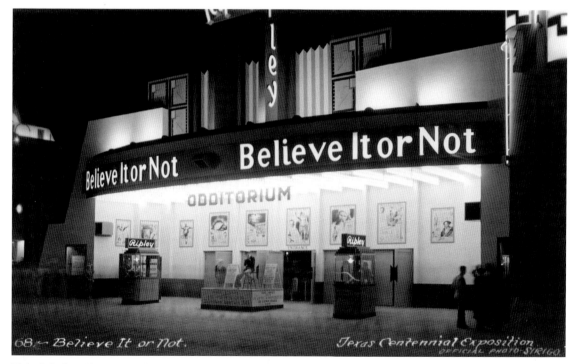

Ripley's Believe It or Not Odditorium, 1936 (demolished)

Although the sign suggests otherwise, Hollywood was primarily a trained animal show. The star power of the performers featured is questionable; ads for the attraction describe the animals as famous and even world famous, but do not mention any of their movies. Hollywood was most popular with children who attended during the day; to bring in adult audiences who flocked to the Midway in the evening, the concessionaire subdivided the building and offered a floorshow, "Hollywood Nights."[13]

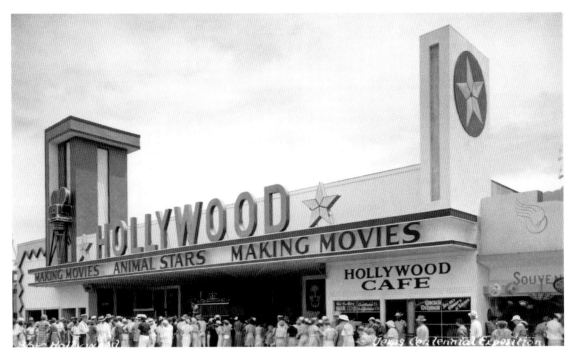

Hollywood, 1936 (demolished)

The Midway was the hub of Dallas's nightlife during the exposition. The last of the exhibit buildings closed at 11:00 p.m., but the fair's ticket booths were open until midnight collecting admissions from visitors headed to the Midway's nightclubs, restaurants, and attractions.[14]

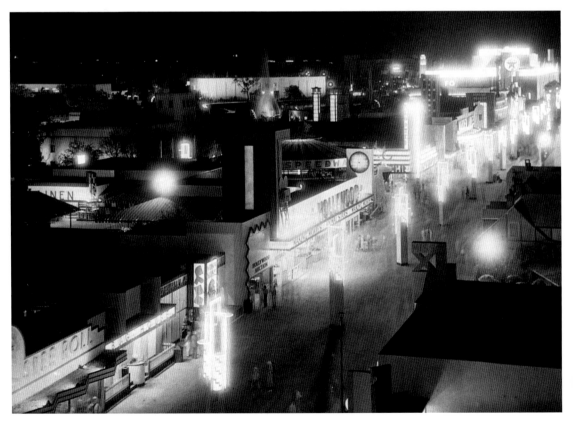

The Midway at night, 1936

The Streets of Paris featured French-themed shopping, dining, and entertainment. Its defining element was the stylized replica of the prow of the French liner *Normandie,* a benchmark in Art Deco design that had completed her maiden voyage in 1935. At the exposition, the ship housed the private Centennial Club, which advertised "a closed membership list composed of social and business leaders of Dallas."

The ship's three decks included fully air-conditioned dining rooms, the main clubroom, a lounge, and a dancing pavilion, while the poop deck provided a clear view of the nightly floorshows. Architect Francis Dittrich had designed the popular Streets of Paris concession at the 1933 Chicago World's Fair and produced the controversial Life Class at the Streets of Paris in Dallas.[15]

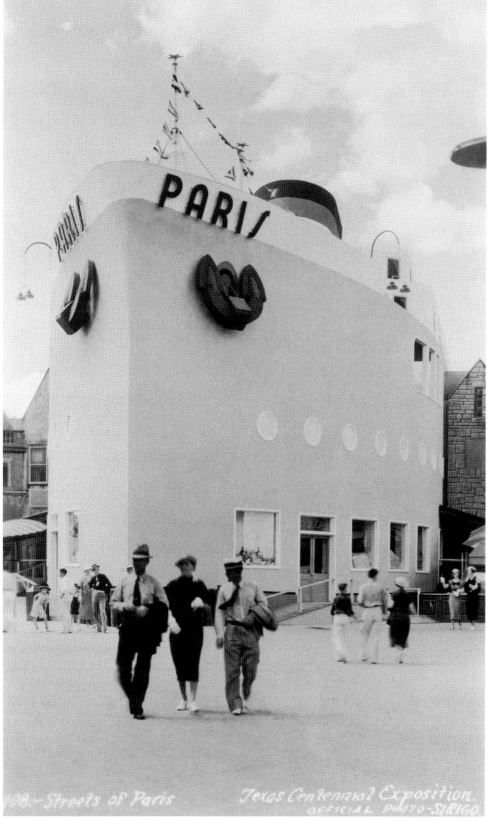

SS Normandie, Streets of Paris, 1936 (demolished). Francis Dittrich, architect.

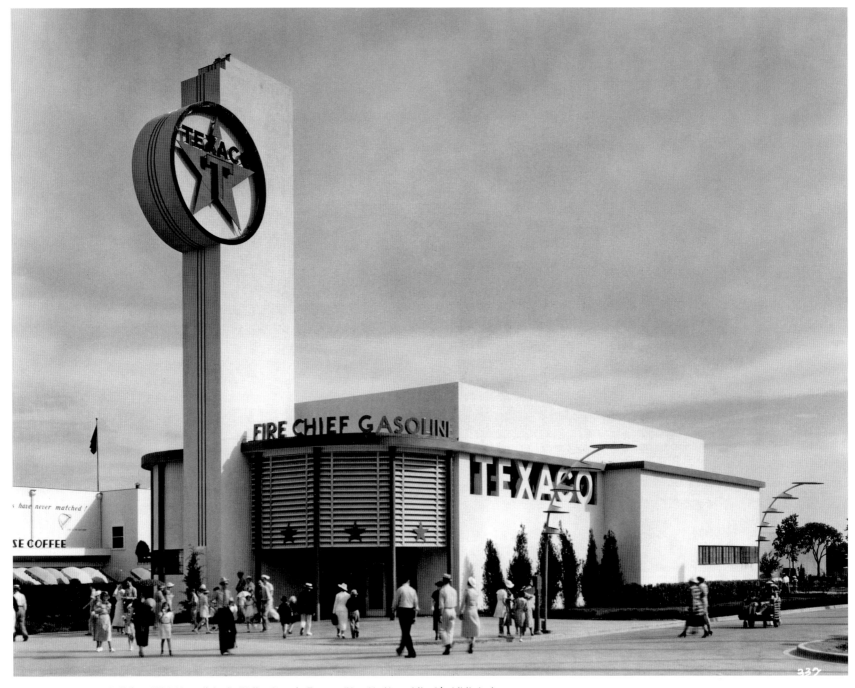

The Texas Company Building, 1936 (demolished). Walter Dorwin Teague (New York), architect/exhibit designer.

Walter Dorwin Teague was responsible for designing the Texas Company's building and exhibits. The oil company had hired the industrial designer to create the prototype for Texaco service stations across the country; the exposition building exhibits elements of those stations, par-ticularly Teague's redesigned Texaco Star logo and word mark.[16]

The Texas Company Building was listed among the exhibit halls on the visitor map for the 1947 State Fair of Texas. The building was visible in photos of the Midway from the 1950s, but the Texaco signs and logos had been removed and the building appeared to have been leased by a concessionaire.

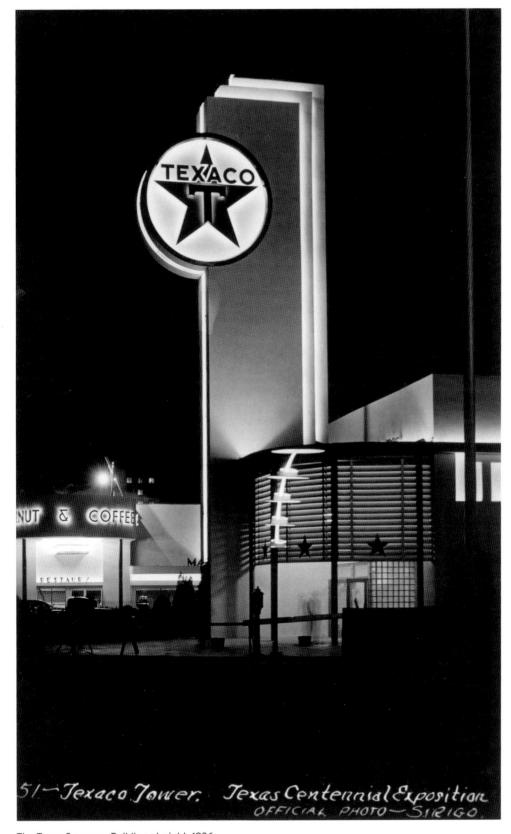

The Texas Company Building at night, 1936

Exhibit hall, The Texas Company Building, 1936

For the Texaco exhibits, Walter Dorwin Teague used the same design principles that shaped his work in the Ford Building at the Centennial Exposition.

When Walter Dorwin Teague sent a telegram to exposition officials in February 1936 requesting a prominent location for a possible National Cash Register exhibit, he was told that no suitable locations were available and it was not possible to move other concessions to create the space the company desired. Accompanying notes in the Dallas Historical Society files suggest George Dahl was concerned that a giant cash register would not be an appropriate addition to the fairgrounds. The exhibit was eventually approved for a more remote location.[17]

The cash register itself was forty feet tall; it rested atop an exhibit building that was twenty-five feet tall and fifty feet square. The color scheme for the entire structure was chromium and black.

The National Cash Register Building was electrically connected to the exposition gates, where turnstiles recorded the number of ticket holders entering the fairgrounds. A company representative totaled the gate numbers every hour and displayed the updated daily attendance on the giant cash register. One of the building's exhibit windows featured a huge version of the company's traditional account statement book where the public could track the exposition's total attendance starting with opening day.[18]

Teague would design a similar building for National Cash Register at the 1939 New York World's Fair.

National Cash Register Company Building, 1936 (demolished).
Walter Dorwin Teague (New York), architect/exhibit designer.

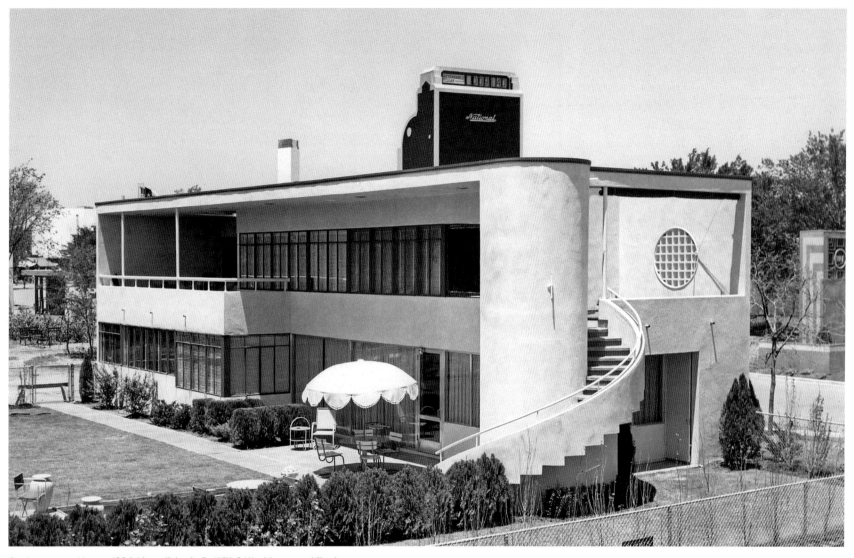

Contemporary House, 1936 (demolished). DeWitt & Washburn, architects.

DeWitt & Washburn planned the Contemporary House to suit Dallas's weather. Although the model house was air conditioned, the architects used the home's design to mitigate the extremes of the North Texas climate. The architects wrote of the building, "If Contemporary House differs from the traditional manner, it was not just to be different. Nor has it been cut to the pattern of any of the so-called modernists. It represents our sincere effort to solve the problems presented by trying to live pleasantly and graciously within our peculiar scene."[19]

The interior design by the Neiman Marcus department store was in sharp contrast to the stark white exterior. The color scheme for the living room included reseda green, clear yellow, and cocoa brown. The downstairs lavatory had a black tile floor with lime green borders, lime green ceiling, and black glass walls "relieved by the fresh whiteness of the fixtures."[20]

The Contemporary House was open through the 1937 Greater Texas & Pan-American Exposition. In May 1938, DeWitt & Washburn, which owned the house, announced it was donating the building to the Girl Scouts. The building served as the Girl Scout Little House until 1949.[21]

It is often stated that the Contemporary House was moved to 6851 Gaston Avenue in the Lakewood section of Dallas. The house at that address looks very similar to the Contemporary House, but research revealed that local architect Reynolds Fischer designed the Gaston Avenue residence for the Mayflower Investment Company, which built it in 1936.[22]

Ralph Cameron won the Masonite Corporation's competition to design its model home. The company wanted to demonstrate that its product, which was made of pressed wood fiber, was a suitable, inexpensive alternative to traditional building materials. At the time, the company claimed a seven-room house like the one at the exposition could be built for $7,500; in comparison, the Contemporary House cost $15,000.

Decorators with the Anderson Furniture Studio of Dallas designed the interiors. The color scheme for the living room featured a maroon rug that blended with the color of the drapes and venetian blinds. The walls were turquoise and the ceiling brown. The loveseats were eggshell and the chairs were brown curly mohair and white leather with brown satin.[23]

The Masonite House was moved to 6901 Gaston Avenue after the Greater Texas & Pan-American Exposition and has been covered in stucco. Another of the Centennial Model Homes, the traditionally styled Southern Pine House, was moved to 3003 Kinmore Street without any major alterations.

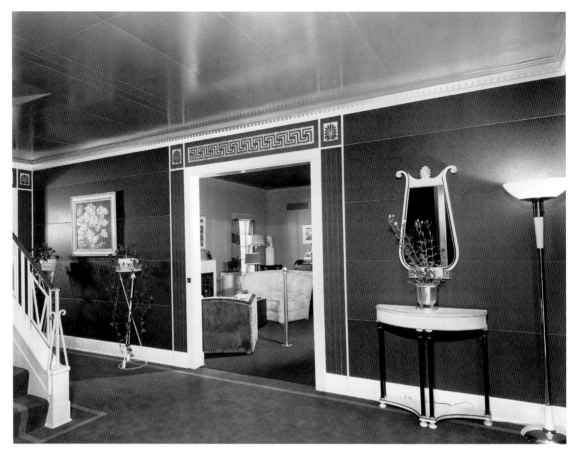

Entry hall and living room, Masonite House, 1936 (relocated). Ralph Cameron (San Antonio), architect.

Harold "Bubi" Jessen won a contest held by the Portland Cement Association to design its house at the exposition. It is the only Centennial Model Home still on its original site behind the former Hall of Horticulture. Interior designers from the Sanger Bros. department store decorated the house.[24]

Portland Cement House. Harold "Bubi" Jessen (Austin), architect.

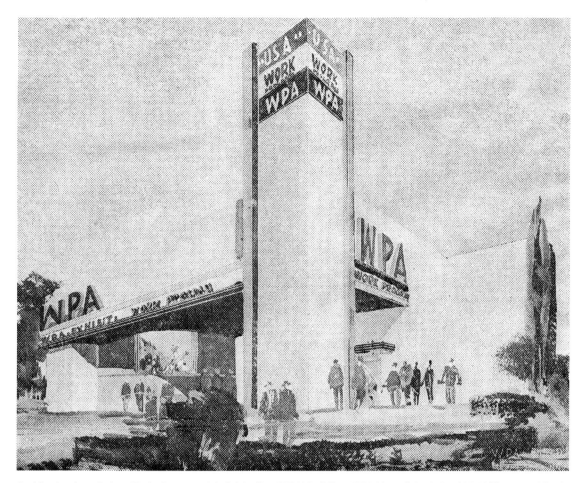

Architectural rendering, Works Progress Administration (WPA) Building, 1936 (demolished). David R. Williams, architect.

What must be the least-photographed building on the fairgrounds was on San Jacinto Drive across from the Centennial Model Homes. The T-shaped Works Progress Administration (WPA) Building housed a one hundred-seat lecture hall, dioramas, pictorial displays, and demonstrations highlighting the federal relief agency's efforts to find meaningful work for the unemployed. Artist Julia Eckel painted murals of industrial scenes on the building's exterior, which also featured an outdoor theater with seating for seven hundred and fifty. The WPA hired unemployed professional entertainers to present performances including a Punch & Judy show in which Punch went on the dole.[25]

This building was not included in the appropriations bill that authorized funding for the Federal Building and the Hall of Negro Life; the WPA paid for the building out of its annual budget. The WPA Building was to be covered with brick veneer before it was turned over to the Dallas Park Board for use as a community center. After the Pan-American Exposition, the Park Board leased the building to the Naval Reserve Association of Dallas to house a permanent naval exhibit. In 1942, the building was turned over to the 29th Battalion of the Texas Defense Guard for use as its headquarters, training facility, and armory. The WPA Building was damaged by fire in 1946 and demolished in early 1948.[26]

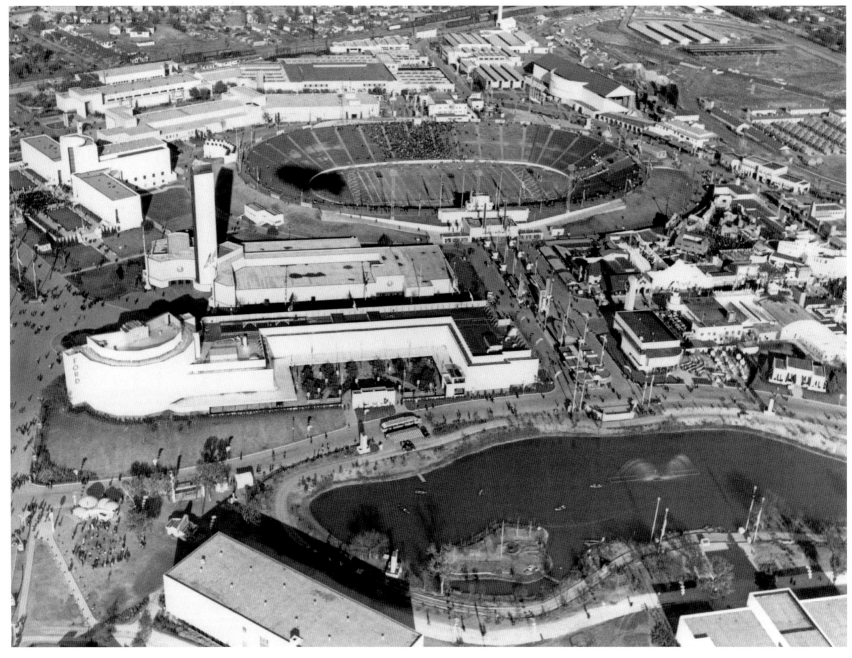

Cotton Bowl Stadium, 1936 (altered). Mark Lemmon, architect (1930).

The arena that came to be called the Cotton Bowl was just that: an excavated bowl sided in concrete with the field below grade level and an embankment around the perimeter. Its capacity was forty-six thousand. Opened as Fair Park Stadium in 1930, it was rechristened Cotton Bowl Stadium in January 1936. Because the facility was relatively new, little work was required to prepare the stadium for the Centennial.

Cotton Bowl Stadium has been greatly expanded over the years, but segments of the embankment are still visible.

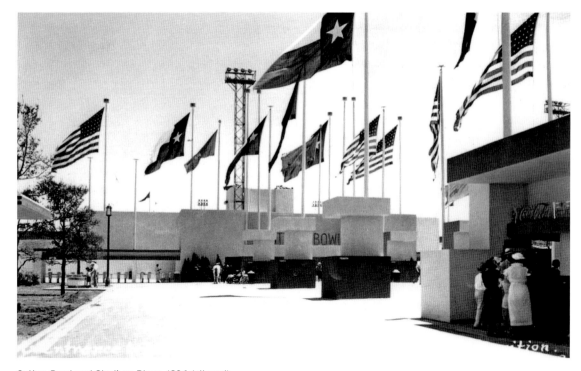

Cotton Bowl and Stadium Plaza, 1936 (altered)

The exposition staff designed new concession stands, ticket booths, and restrooms for Stadium Plaza, the main entrance to the Cotton Bowl. In April 1936, Dallas City Council began accepting bids for a $30,000 comfort station to be built at the stadium's entrance. The contract noted half of the toilets would be "of the pay type" with income going to the exposition corporation for maintenance. This conflicted with the fair's later claims that everything in the restrooms was provided free of charge except for paper towels, which cost two cents, and linen towels, which cost ten cents. Uniformed porters and maids staffed all of the exposition's 137 restrooms.[27]

The emergency services center for the exposition was located behind the Cotton Bowl. In this facility, the City of Dallas operated a police station with three cellblocks, a fire station with dormitory, and the municipal radio station, WRR, the first licensed broadcast station in Texas. The building also included a fully equipped ten-bed hospital with an emergency operating room.[28]

Municipal Services Building/State Fair of Texas Administrative Offices. Bertram C. Hill, architect.

FAIR PARK AFTER 1936

It is paradoxical that the most heavily patronized park in Texas is the least understood and appreciated.

Sam Acheson
The Dallas Morning News
August 21, 1941

When Sam Acheson called Fair Park misunderstood and underappreciated a few months before the attack on Pearl Harbor, he was unhappy with a plan to cut what he called "a high speed traffic artery" through the heart of the park. Acheson noted that it wasn't the first time the City of Dallas had proposed routing traffic through Fair Park and that it probably wouldn't be the last. He was right.

If there was a recurring theme in Fair Park's history after the Texas Centennial Exposition, it was one of grandiose plans announced, but unfulfilled, followed by years of benign neglect until the next grandiose plan was proposed. As most Dallas residents only visited the area for football games at the Cotton Bowl or during the State Fair of Texas, the adage "out of sight, out of mind" helped preserve Fair Park.

By the time the giant cash register at the Centennial Exposition had tallied attendance for the last time on November 29, 1936, more than six million people had passed through the turnstiles, a number equal to Texas's entire population, but well short of the ten million visitors predicted during the heady opening days. Like almost every world's fair, the Centennial Exposition lost money, but the event had an immense positive impact on the local economy. During construction, the weekly payroll for the exposition corporation and its contractors was almost $300,000, with an additional $374,000 being spent on materials each week. The exposition directly created fifteen thousand jobs ranging from highly paid architects and craftsmen to low-wage laborers. Exposition officials estimated one million out-of-state visitors came to Dallas for the fair, and

Texas Comptroller George H. Sheppard released statistics showing that increased tax income from higher gasoline sales would allow the state government to turn a profit on its $3 million appropriation for all the Centennial celebrations. As would be expected, officials in Dallas credited the fair's drawing power with the exponential increases in gasoline sales in Texas during June and July 1936.[1]

Before the Centennial Exposition closed, Dallas officials had decided to reopen the fair in 1937 as the Greater Texas & Pan-American Exposition. As the bulk of the capital expenses were incurred building the Centennial Exposition, the second year was more likely to turn a profit—or so the thinking went. Exposition architect George Dahl and his staff were already working on plans, and demolitions began imme-

Hall of Agriculture/Texas Food & Fiber Pavilion, late 1970s

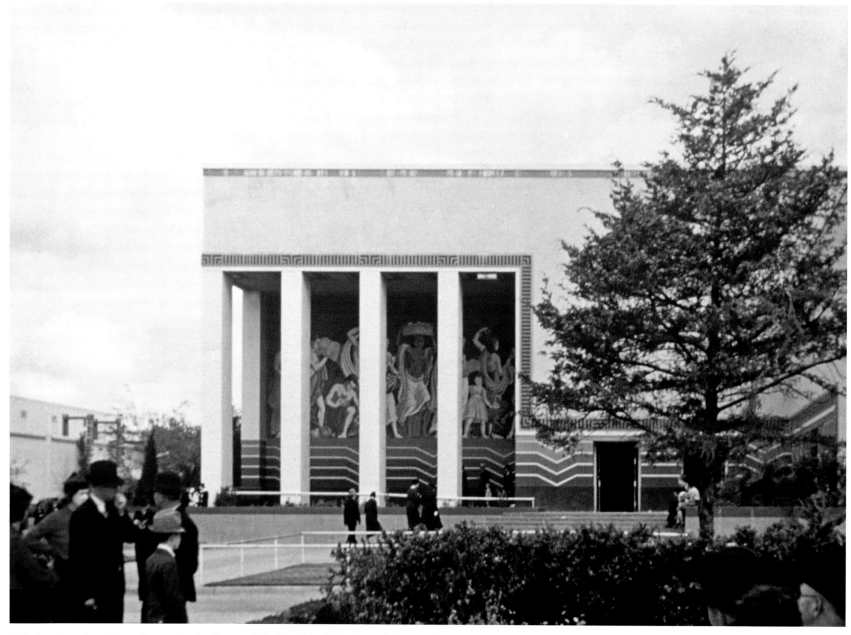

Hall of Foods, c. 1938, shows the weather's effect on its painted trim. Note the still-vibrant colors of Carlo Ciampaglia's murals.

diately after November 29. Temporary concessions were the first structures to be removed. National Cash Register did not renew its contract and its building came down as well. After visiting Fair Park in early December 1936, *Dallas Morning News* reporter Barry Bishop noted, "[T]here was no mistake that the Texas Centennial Exposition had closed, for the wrinkles and faded cheeks of old age were showing up rapidly after one week of neglect."[2]

The most controversial loss was the Hall of Negro Life. African American leaders were aware the building was temporary, but they did not think the exhibit hall would be demolished until after the Pan-American Exposition. In November 1936, Texas Governor James V Allred appointed a goodwill committee of black community leaders to assist in securing continued federal funding for the exhibit's second year. Dallas Mayor George Sergeant sent a telegram to US Senator Morris Sheppard asking for his aid in retaining the Hall of Negro Life; many residents, black and white, sent letters of support. However, in February 1937, Vice President John Garner wrote the chairman of the Federal Negro Advisory Committee stating that it would be "impractical and uneconomical" to adapt the Negro exhibits to the exposition's new Latin American theme (the government's exhibits in the Federal Building, on the other hand, remained substantially unchanged despite the new theme). Noting that he was acting on the advice of unnamed authorities in Dallas, Garner ordered that the Hall of Negro Life be dismantled as soon as possible. The following month, Congress approved the transfer of $325,000 to the Pan-American Exposition; the money was left over from the federal government's original $3 million appropriation for the Texas Centennial celebrations. In December 1937, the exposition returned to the US government $50,000 that had not been spent—an amount equal to Washington's total 1936 allotment for the Hall of Negro Life's exhibits and staffing.[3]

Even with federal dollars, money would remain a concern throughout the exposition's second year. Pan-American officials requested $300,000 from the City of Dallas for improvements to Fair Park; they received $42,000. Maintenance had become an issue almost as soon as the Centennial Exposition opened. Dallas Historical Society's collection of exposition papers contains files full of letters exchanged between recalcitrant contractors and fair officials demanding repairs of leaking roofs, cracking stucco, and buckling asphalt. Cultural groups were upset that the City of Dallas had only budgeted $4,500 for the upkeep of all of the museum buildings in the Civic Center; in the meantime, the Dallas City Council was insisting the exposition corporation should continue covering operating expenses for the Civic Center because the buildings were going to be part of the 1937 fair.[4]

The State of Texas Building (renamed the Hall of State after the Centennial Exposition) was proving an even bigger challenge. The State of Texas proposed leasing the building to the Dallas Park Board for $100 a year for twenty years, after which the Park Board would own the building. The proposal was accepted in principle, but the City of Dallas insisted the state repair the building before it signed any contracts; drainage problems had allowed water to seep into the structure causing parts of the massive building to settle, which damaged walls and the plumbing system. The state refused to make any further repairs and announced that it would not open the building during the Pan-American Exposition. Later, the state government proposed converting the Hall of State into an office building and, adding insult to injury, announced that it was considering transferring the exhibits, furniture, fixtures, and any movable works of art to the San Jacinto Monument then under construction outside Houston.[5]

In the midst of this turmoil, George Dahl released designs showing substantial alterations to the exposition structures, including plans to convert the former Ford Building into a Mayan temple complete with smoking volcano. With money tight, Dahl scrapped the Mayan motif;

instead of being remodeled, the Ford Building got a new paint job, a new sign, and a new name: the Pan-American Palace. Given the financial constraints, renaming came to have as big a role as remodeling at the 1937 exposition: the Esplanade of State became the Esplanade of the Americas, the Texas Court of Honor was called the Patio de Honor, the Hall of Religion became the Pan-American Hostess House, and the Midway was now La Rambla. The Spanish Colonial architecture of the Fair Park Auditorium suited its new use as the Pan-American Casino better than its previous incarnation as the General Motors Auditorium. The Streets of Paris was remodeled as a Spanish fortress and rechristened the Road to Rio, while the infamous Apple Dance morphed into the scandalous Sombrero Dance, yet another variation on the fan dance.[6]

The Greater Texas & Pan-American Exposition was a tough sell from the start; publicists had to counter the general impression that all the big exhibitors had left and the commonly held belief that attractions that had been free at the Centennial Exposition were going to charge admission at the Pan-American Exposition. Promoters were able to capitalize on the fact that the 1937 event had more claim to the world's fair title than had the Centennial Exposition; no foreign governments exhibited in Dallas in 1936, but several Latin American countries had an official presence at the Pan-American Exposition. Even the Republic of Mexico sent an exhibit after American officials assured the Mexican government that the 1937 fair was a completely separate event celebrating President Roosevelt's Good Neighbor Policy and not just a continuation of the 1936 commemoration of the Texas Revolution.[7]

At the end of its twenty-week run, the Pan-American Exposition went out with more of a whimper than a bang. Officials closed the exhibit buildings at 6:00 p.m. on the last two nights of the fair, October 30 and 31, to deter what were alternately described as "destructively playful Halloween crowds" and "Halloween toughs." Final tallies showed the exposition attracted more than two million visitors; when the State

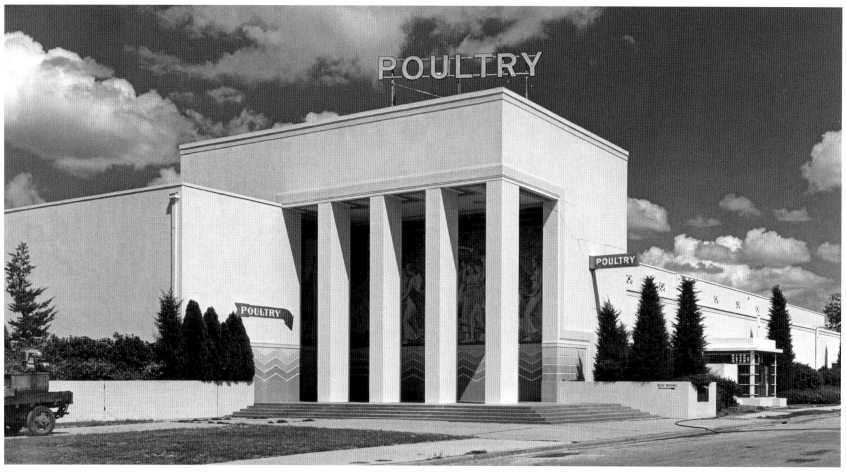

Hall of Agriculture, c. 1940, renamed the Poultry Building. The structure housed a training school for defense plant workers through the summer of 1941.

Automobile Building from the Hall of State, 1948.
The corner pylons survived the 1942 fire that destroyed the Hall of Varied Industries.

Ciampaglia's mural *Traction* before restoration, Hall of Transportation

Fair of Texas returned to Fair Park the following year, it brought in almost a million ticket buyers during its two-week run. Fifteen years later, one Dallas columnist would remember the Greater Texas & Pan-American Exposition as having had "a name which was larger than the attendance at that fair."[8]

Significant demolitions followed the 1937 exposition. The Ford Building and the Hall of Petroleum were the biggest losses; the vacant sites were used to show farm equipment during the 1938 State Fair. Research indicates that the Gulf Broadcasting Studios and Skillern's Better Service Drugstore were also razed after the Pan-American Exposition. In December 1937, Vice President Garner signed an order transferring ownership of the Federal Building to the City of Dallas, and the federal exhibit hall became the State Fair's Education Building. In 1938, the City of Dallas and the State Board of Control finally came to terms over the Hall of State; the city signed the lease for the building and the state repaired the structure. The city then contracted with the Dallas Historical Society to operate the Hall of State as a museum to be open year-round; however, the agreement with the state stipulated that the public could not be charged admission to enter the building. The lack of income caused financial headaches for the historical society and the city within two years of the transfer.[9]

Late in 1941, workers damaged Lawrence Tenney Stevens's *Woofus* statue in the agrarian area and the artwork was removed and either lost or destroyed. Less than three months later, a fire engulfed the former Hall of Varied Industries, Communications, and Electricity, which housed a basketball court and roller skating rink during the State Fair's off season. Low water pressure hampered firefighters and the building was destroyed. Raoul Josset's statues *France, Mexico,* and *United States* survived the blaze along with one set of light pylons, but the building's three porticoes and all of Pierre Bourdelle's murals and bas-reliefs were lost. Wartime rationing of construction materials prevented the exhibit hall from being replaced until after World War II.[10]

It was also around this time that art conservators believe the murals created for the Centennial Exposition were first painted over. Studies indicate that the paints muralist Carlo Ciampaglia used in 1936 faded or turned to powder within a few years; the new coat was a very hard lead-based paint, probably chosen for its covering power. The Esplanade murals were painted over with light yellow, while the Hall of Agriculture and Hall of Foods murals were painted over with brown. Bourdelle's reliefs on the Hall of Transportation were also eventually covered with several layers of paint.[11]

Although the State Fair was cancelled for the duration, Fair Park was still a busy place during the Second World War. The Band Shell hosted defense rallies and scrap metal drives; the Hall of Horticulture was the headquarters for the War Rationing Board; and the Texas Defense Guard occupied the WPA Building.[12]

When the State Fair resumed in 1946, issues that had been set aside during the war came up for debate again. The Park Board wanted to find a permanent use for the former Hall of Domestic Arts, and proposals for a new Cotton Bowl Stadium were considered. A recommendation was made to fill in the basin around the Esplanade reflecting pool to create more beds for plantings. Hare & Hare, which had designed the landscape plan for the Centennial Exposition, was also brought back to create a new master plan for Fair Park; there would be several more such plans in the decades ahead.[13]

A new exhibit hall was still to be constructed on the site of the burned Hall of Varied Industries. Initial recommendations were for a semi-permanent building designed to last ten years; the high cost of building materials kept the State Fair Association from beginning construction until 1948. The replacement exhibit hall, named the Automobile Building, did not maintain the symmetry of the Esplanade. Although Josset's surviving statues remained in place in front of the low-slung structure, it lacked porticoes. It is not clear how the replacement building's color scheme (white concrete with coral doors) related to the surviving historic buildings.[14]

During the next two decades, proposals

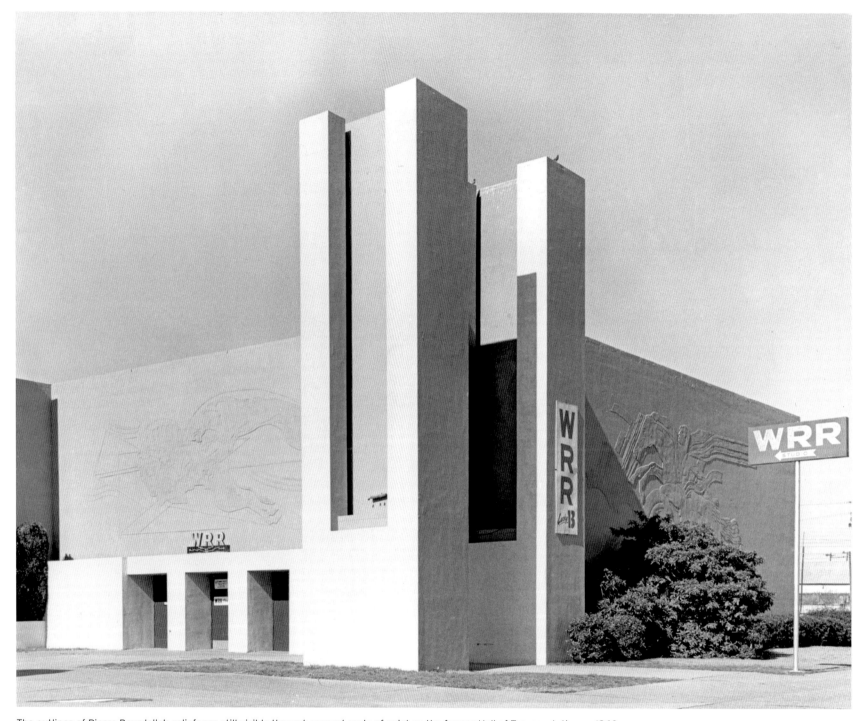

The outlines of Pierre Bourdelle's reliefs are still visible through several coats of paint on the former Hall of Transportation, c. 1960.

Ciampaglia's mural *Aeroplane Transportation* before restoration, Hall of Transportation

would be made and plans drafted for improving Fair Park, but they were only partially carried out or simply forgotten. The City of Dallas frequently revisited the possibility of cutting streets through the park to improve the flow of traffic in the surrounding neighborhood. Another regular suggestion was the creation of a major parkway from downtown to the fairgrounds or a freeway extension to the edge of Fair Park. Upgrading the Midway to a year-round amusement park became a common suggestion after Six Flags Over Texas, the state's first theme park, opened in Arlington in 1961. The portions of the plans that were funded usually included additional sandblasting and new paint jobs for the existing buildings.

A slate of proposals for Fair Park during the 1960s would have left little to preserve if they had been carried out. A twenty-five-year master plan created in 1963 called for a freeway-type thoroughfare leading to an imposing new park entrance and new treatments for all of the exhibit buildings. In 1966, Dallas Cowboys owner Clint Murchison Jr. floated the idea of demolishing the Cotton Bowl in favor of a new football stadium near downtown. State Fair officials responded the next year with a proposal to enlarge Fair Park by five hundred acres and build a new Cotton Bowl on the north side of the bigger park. After a few years of attempting to combine the State Fair with an international trade exposition, proponents of the trade fair blamed their lack of success on Fair Park's aging facilities and suggested replacing the Esplanade exhibit halls with up to twenty-five pavilions clustered by subject, as was the style at major European trade fairs. In 1968, the State Fair released a long-range pro-

posal that also called for the demolition of the Esplanade buildings. An updated plan released the next year deemed the Hall of State and the Civic Center museums worthy of preservation, but called for replacing Fair Park's other buildings over the next five to ten years.[15]

As Dallas debated Fair Park's future, the world began taking another look at modernistic architecture. In 1968, English art historian and author Bevis Hillier coined the term "Art Deco" and published the first major work examining modernistic design of the 1920s and 1930s; Hillier also helped organize a highly regarded exhibition on Art Deco at the Minneapolis Institute of Art that helped spur a resurgence of interest in the Art Deco movement.[16]

Eight years later, celebrated architectural historian and *New York Times* architecture critic

Raoul Josset and Jose Martin's
Spirit of the Centennial
before and after restoration,
Administration Building

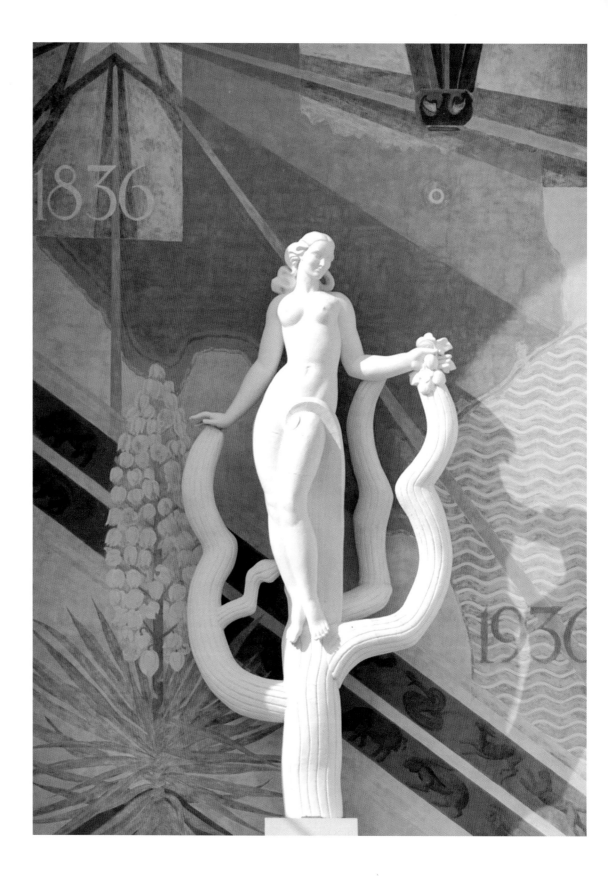

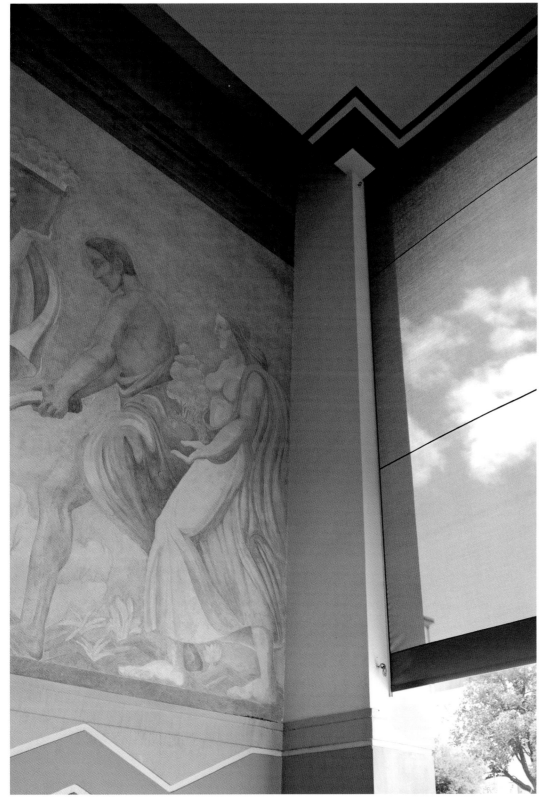

Sunscreens on the former Hall of Agriculture help protect Ciampaglia's *Wheat Harvesters*.

Ada Louise Huxtable visited Dallas and commented on the significance of Fair Park. "I see Fair Park as a quite fabulous concentration of 1936 Art Deco, Art Moderne buildings. Unfortunately some are mutilated at this point," she said. "I don't know how people feel about them locally, but I suspect they are somewhat underappreciated.

"I loved Fair Park," Huxtable continued. "I guess because of my basic training as an architectural historian I've always been sort of at the cutting edge of what is currently unpopular or unnoticed."[17]

Yet Fair Park did not go completely unnoticed in the 1970s. A 1974 plan included enlarging the Dallas Garden Center in the former Hall of Horticulture, rebuilding the plaza in front of the Cotton Bowl, and sandblasting the older buildings on the grounds—again. The following year, Fair Park's tallest structure, the tower of the former Federal Building, had to be stripped to its superstructure when chunks of its exterior facing started falling off; temporary panels were installed as a stopgap measure. The "semipermanent" Federal Building was by then thirty-nine years old, well past its predicted fifteen-year lifespan.[18]

The next time the exhibit buildings were sandblasted, in 1978, the work revealed remnants of some of the 1936 murals under the porticoes on the former Hall of Transportation. The first work to be discovered, the seal on the Portico of Texas, was "restored" by a young artist whose previous experience was painting murals in two San Antonio bars. He planned to airbrush acrylic paints onto the 1936 work. "You blow the acrylics right into the plaster and there's no layer that tends to peel," he said. It was not preservation at its finest, but it was a start.[19]

The biggest impetus for renovating Fair Park turned out to be another commemoration of the Texas Revolution. In 1986, the state would mark the 150th anniversary of Texas's independence from Mexico. Although Dallas officials did not believe they could produce an event on the scale of the Centennial Exposition for the sesquicentennial, they wanted Fair Park to play a prominent role in the statewide celebrations. In 1981, Dallas Park Board members approved a $51 million plan for Fair Park improvements; the board promised that initial work would start within three years and be finished in time for the sesquicentennial, but board members expressed doubts that all the projects would ever be funded. The Park Board also recommended that the next city bond election include $15 million for the first of the proposed improvements.[20]

When the election was called in 1982, Dallas voters were asked to approve the sale of $18 million in bonds for Fair Park. The proposition would provide funds to improve the general appearance of the fairgrounds and renovate at least half a dozen buildings; $3.3 million would be used to rehabilitate the former Hall of Transportation, and $750,000 would go to interior renovations for the Hall of State. The Dallas Historic Preservation League (later Preservation Dallas) actively supported the bond issue, and a new group, the Friends of Fair Park Committee, was formed to raise money to buy advertising encouraging Dallas residents to vote for the bonds. Before the election, the Friends committee reported it had raised $10,846 and spent $15,227; all but $1,500 came from the State Fair of Texas.[21]

Voters approved the funding, but there was still a rocky road to implementation. The Park Board objected when the Dallas Landmark Committee (later Dallas Landmark Commission) and the Texas Antiquities Committee (later Texas Historical Commission) moved to designate Fair Park's buildings as historic landmarks, arguing that securing the required approvals for altering designated landmarks would delay the work. The Park Board again raised preservationists' hackles by asking City Council to approve using $322,000 of the bond money to hire a consultant to recommend how to spend the rest of the $18 million. Fair Park supporters objected loudly, claiming the city was obligated to spend the money exactly as stated in the bond package. City Council approved the request from the Park Board, which signed a contract with Management Resources, a company founded by former Walt Disney employees—a move that further alarmed preservationists because the firm had no experience working with historic buildings. In response to pressure from the Historic Preservation League and the Landmark Committee, two prominent architectural historians, Russell Keune and Blake Alexander, were added to the consulting team. When Management Resources' report came back, it included an unexpected bonus: the new plan recommended rebuilding the Fair Park Band Shell rather than demolishing it as previously suggested (the project would eventually be completed in 2000). The Park Board passed the plan unanimously.[22]

The Friends of Fair Park incorporated as a not-for-profit organization in 1985 and took the lead among the private groups supporting the park's preservation. The Friends restored the former Magnolia Lounge, which had been slated for demolition, as its headquarters. The group also successfully supported a second bond issue that provided $9.5 million for restoring and expanding the historic museum buildings in the Civic Center; the Friends would go on to raise millions of dollars for continuing preservation projects.[23]

Fair Park presented a new face—or, more precisely, a re-creation of its original face—in time for the Texas Sesquicentennial. At the 1948 Automobile Building, porticoes were built to match those on the original Hall of Transportation across the Esplanade. At the same time, Fair Park was designated a National Historic Landmark, the highest level of historical significance granted by the United States government.

On January 1, 1988, the Dallas Park and Recreation Department assumed responsibility for the upkeep of Fair Park from the State Fair Association and embarked on an evaluation and planning process that led to an unprecedented restoration effort. With local, state, and federal funds, private donations, and grants, almost every historic building from the Texas Centennial Exposition has received some level of renovation or rehabilitation.

A complete exterior restoration of the former Federal Building began in 1997. The work would eventually include replicating Raoul Josset's distinctive eagle sculpture and placing the thirty-three thousand-pound piece atop the building's one hundred and seventy-foot tower, recreating the reliefs of the Great Seal of the United States on the front of the building that had been sandblasted flat, and rebuilding the exhibit hall. The restoration was completed in 2002.[24]

In 1999, the Clinton administration approved a $3 million matching grant through the Save America's Treasures program to restore the former Administration Building as The Women's

Museum. At the time of the grant, the building where George Dahl and his staff planned the Centennial Exposition was described as being in a "controlled state of collapse." Private funding paid for art conservator Stashka Star to restore the *Spirit of the Centennial* sculpture and its background mural on the building. Unlike the cast stone statues along the Esplanade, *Spirit* was made of plaster over a metal armature and had deteriorated severely over the years. Conservator John Dennis re-created the Fish Fountain in front of the Administration Building. At the same time, EverGreene Architectural Arts of New York used historic photographs to re-create six of Pierre Bourdelle's murals on the remodeled Automobile Building, a project funded by proceeds from the State Fair of Texas.[25]

One of the most exciting projects at Fair Park began in 1999: revealing and restoring the murals on the former Hall of Transportation and Hall of Agriculture. Art conservators had to carefully remove up to eight layers of paint and varnish applied to the murals over six decades. Exposure to the elements probably caused the initial damage to the murals; later, sandblasting and overpainting took a heavy toll. Even with the extreme care taken during the cleaning process, remnants of the original colors could come off when the layers of paint covering the murals were peeled away. After eight months of paint removal and cleaning, conservators began the phase called in-painting. Paint was placed only where the original pigments were missing on the surviving portions of the murals; where none of the original artwork survived, the murals were re-created. The restored murals are still susceptible to fading, so the Dallas Park and Recreation Department installed movable sunscreens that can be raised and lowered to protect the artwork. The project was funded with a $300,000 Save America's Treasures matching grant approved by the Bush administration in 2006.[26]

Dallas City Council accepted a new comprehensive development plan for Fair Park in 2003, and Dallas voters approved major bond issues in 2003 and 2006 to fund the proposed work. Some of the projects in that plan have been carried out, including restoration of the Esplanade of State reflecting basin and the Parry Avenue Gate, and the construction of a light rail station at Fair Park's main entrance that recalls the architecture of ticket and turnstile shelters from 1936. The plan also recommends two very exciting projects: constructing a modified version of the Ford Building to house a visitors center and a partial reconstruction of the Hall of Petroleum to house the Dallas Historical Society. These projects would not only re-create two significant buildings, but would also reinstate vistas along the Texas Court of Honor as they were in 1936.[27] As a result of the ongoing work, Fair Park moved from the National Trust for Historic Preservation's list of America's Eleven Most Endangered Historic Places in 1994 and 1995 to the American Planning Association's roster of the country's Top 10 Great Public Spaces in 2011.[28]

Of course, a building cannot be restored only once; the process starts over again even before the project is completed. When the 1936 murals were uncovered, they began fading anew, and weather and wear and tear from regular use are already taking a toll on some recent restorations. The reinvigoration of Fair Park is the result of an extraordinary commitment by remarkable people and organizations, but it will take an equally remarkable commitment to carry planning and restoration efforts forward.

The Magic City provided a vision of a promising future, and it stands as a monument to an exceptional past. The key to Fair Park's survival is not as a museum piece or as the backdrop for three weeks of revelry during the State Fair each fall. For decades, the fair has overshadowed the park. Dallas has done an outstanding job reclaiming the architecture and atmosphere of 1936; the challenge moving forward lies in recapturing the energy and excitement of the centennial to make Fair Park a living, breathing part of the city.

After years of work, it is once again possible to get a good sense of what it was like to walk through the Texas Centennial Exposition. The best time to experience Fair Park is not during the hurly burly of the State Fair, but during the quiet hours when it's possible to explore the grounds almost completely alone. That's when the spirit of the centennial can truly reveal itself.

Texas Centennial decal, 1936

ARCHITECTS & ARTISTS

ARCHITECTS

1 Jack Hubbell
2 Harry Overbeck
3 Bunny Hare
4 Ray Foley
5 George Dahl
6 Carr Forrest
7 Levy Wakefield
8 Lois Acker
9 Bertha Holmes
10 Donald Nelson
11 Alden R. Hawkins
12 Hans Oberhammer
13 Walter Donaldson
14 George M. Houston
15 George McLaughlin
16 Robert Buchannon
17 Norman Bucklin
18 Mac McFarland

ARTISTS

1 Pierre Biza
2 Jose Martin
3 Raoul Josset
4 H. H. Ewing
5 George Dahl
6 Hector Serbaroli
7 E. L. Amundson
8 Eugene Gilboe
9 Carlo Ciampaglia
10 Lois Lignell
11 Gozo Kawamura
12 Pierre Bourdelle
13 Jefferson Elliot Greer
14 Jack Hubbell
15 Julian Garnsey
16 G. M. Houston
17 A. J. Spence
18 Kreigh Collins
19 Thomas Stell
20 Perry Nichols
21 John Douglas
22 Harry Carnohan
23 Mac Johnson
24 George Stevens
25 Ray Siggins
26 Lawrence Tenney Stevens

Architects of the Texas Centennial Exposition

ADAMS & ADAMS, architects, was the prominent San Antonio firm that designed the interiors of the State of Texas Building at Fair Park. CARL C. ADAMS (1881-1918) and his nephew CARLETON W. ADAMS (1885-1964) established their partnership in 1909, the year Carleton received his bachelor of architecture degree from Columbia University. When Carl Adams died nine years later, MAX C. FRIEDRICH (1891-1949) became an associate architect for the firm, which kept the name Adams & Adams. The firm shared a commission with Lang & Witchell of Dallas that resulted in another of the state's best examples of Art Deco architecture, the Texas State Highway Building (1933) in Austin.[1]

DONALD BARTHELME SR. (1907-1996), architect, was brought in by Mark Lemmon to pull together the final design for the State of Texas Building when the ten firms that made up Texas Centennial Architects, Associated could not agree on a plan. Born in Galveston, Texas, Barthelme had attended Rice Institute (now Rice University) in Houston before transferring to the University of Pennsylvania, where he studied with renowned French architect Paul Cret. After the Centennial Exposition, he worked briefly for DeWitt & Washburn architects in Dallas before returning to Houston and a position with prominent architect John Staub. Barthelme established his own practice in 1939. He was hired to teach in the fledgling architecture department at the University of Houston in 1946 and remained a member of the faculty until his retirement in 1973. He chaired the architecture department at Rice University from 1959 to 1961 and was a visiting professor at Tulane University in New Orleans and the University of Pennsylvania. His sons, Frederick, Steven, and the late Donald Barthelme Jr. are noted authors.[2]

RALPH CAMERON (1892-1970), architect, designed the Masonite House at Fair Park. A San Antonio native, Cameron trained in the offices of local architects Alfred Giles and Adams & Adams. He established his own firm, but left to serve in the army during World War I. While recuperating from a war injury, he attended the École des Beaux-Arts at Fontainebleau, France. He returned to San Antonio in 1919 and resumed his practice. He was best known for his residential designs in a range of revival styles. During World War II, he served with the US Army Corps of Engineers in North Africa and Europe.[3]

ROBERT S. COOK (1907-1993), architect, was on the technical staff for the Texas Centennial Exposition. Cook was born in Evanston, Illinois, studied civil engineering at Northwestern University and received his architecture degree from the Massachusetts Institute of Technology. From 1930 to 1934, he worked for the Chicago Century of Progress exposition, where he designed and later supervised Enchanted Island, the children's area of the fair. The Kraft-Phenix Cheese exhibit in the Hall of Foods in Dallas was brought from Chicago's Enchanted Island.[4]

PAUL CRET (1876-1945), architect, drafted the master plan for the exposition site in Dallas. While attending the École des Beaux-Arts in his native Lyon, France, Cret (pronounced "Cray") won the Prix de Paris, which allowed him to study in the French capital. He moved to the United States in 1903 to teach at the University of Pennsylvania's School of Architecture; he also established a successful private practice in Philadelphia. Cret joined the French Army at the outbreak of World War I. He served with distinction, receiving the Croix de Guerre for heroism in combat and becoming a member of the Légion d'honneur, France's highest award of merit. On returning to Philadelphia, Cret resumed his architectural practice and was recognized as one of the country's leading exponents of neoclassical design. In Texas, he is best known for creating the campus master plan for the University of Texas at Austin. In 1938, the American Institute of Architects awarded Cret its Gold Medal, the highest honor an individual architect can receive.[5]

CHRISTENSEN & CHRISTENSEN, architects, collaborated with W. Scott Dunne on the Fair Park Band Shell. Dallas natives WILLIAM O. CHRISTENSEN (1903-1953) and his brother GEORGE E. CHRISTENSEN (1905-1979) were graduates of Texas A&M College (now Texas A&M University). Each worked with other architectural firms before establishing their partnership in Dallas in 1933. The brothers were known for designing houses in the city's Lakewood section. George Christensen continued his own practice after his brother's death and designed several facilities for the Dallas Zoo.[6]

GEORGE L. DAHL (1894-1987), architect, had the greatest role of any individual in creating the look of the 1936 Texas Centennial Exposition. As technical director and centennial architect, Dahl was either directly involved in or gave approval of every aspect of the fair's design. Dahl was born in Minneapolis and earned his bachelor's degree in architecture from the University of Minnesota. He returned from service in the First World War to earn a master's degree from Harvard. A Harvard fellowship enabled Dahl to study in Europe for two years; he also studied at the American Academy in Rome, which brought him into contact with many of the artists and architects who would work on the Dallas world's fair. Upon his return to the United States, Dahl worked as a designer for architectural firms in New York and Los Angeles before moving to Dallas in 1926, where he joined the firm of Herbert M. Greene. Dahl became a partner in Herbert M. Greene, LaRoche & Dahl in 1928. Six years later, the firm became involved in the efforts of a group of Dallas businessmen to locate the state's central centennial celebration in the city; as partner in charge of the centennial project, Dahl produced a series of renderings and site plans that helped the Dal-

las group win the bid for what became the Texas Centennial Exposition. In 1943, Dahl established his own firm and became one of the first Texas architects to maintain a nationwide practice. By the time he retired in 1973, Dahl had designed an estimated three thousand projects including Dallas's Titche-Goettinger department store (1929), the Dallas Morning News Building (1949), Dallas Central Library (1955), Robert F. Kennedy Memorial Stadium (1961) in Washington, DC, two dozen buildings at the University of Texas at Austin, thirty-two stores for Sears, Roebuck and Co., fifteen prisons for the Texas Department of Corrections, and the Hillcrest State Bank (1938) in University Park, Texas, the first drive-through bank in the United States.[7]

DEWITT & WASHBURN, architects, was the well-known Dallas firm responsible for the Contemporary House at the exposition and was among the associated architects for the Dallas Museum of Fine Arts in the Civic Center. The most visible member of the partnership was ROSCOE P. DeWITT (1894-1975), who received his master's degree in architecture from Harvard in 1917. After serving in World War I, he partnered with Dallas architect Mark Lemmon through most of the 1920s; by 1930, DeWitt was the business partner of G. H. Thomas Washburn. In 1937, DeWitt worked as the Dallas agent for Frank Lloyd Wright, who was then designing a house for retailer Stanley Marcus of Neiman Marcus. When Wright and Marcus had a falling out, DeWitt received the commission for the project. During World War II, DeWitt served as a lieutenant colonel in the US Army's Monuments, Fine Arts and Archives Division and was sent to France to inspect and secure historic buildings. On his return to Dallas, he formed a very successful partnership with Arch B. Swank. DeWitt later worked on the restoration of the original Senate and Supreme Court chambers in the US Capitol.[8] Less is known about G.H. THOMAS WASHBURN (1892-1972), a Kansas native and youngest son of George P. Washburn, the state's most promi-

nent architect at the turn of the twentieth century. Thomas Washburn earned his degree in architecture from the Massachusetts Institute of Technology. After serving in the Navy during the First World War, he returned to Kansas to work with his older brother Clarence, also an architect. Washburn moved to Dallas by 1922 and was in partnership with Roscoe DeWitt by 1930, when they designed Harlingen High School in South Texas. Washburn eventually joined the Fort Worth firm of architect Wyatt C. Hedrick. At the time of Washburn's death in Houston, his obituary listed his occupation as landscape architect.[9]

FRANCIS DITTRICH (1892-1973), architect, designed the Streets of Paris attraction on the Midway. Dittrich was born and studied architecture in Zlonice, Austria-Hungary (later the Czech Republic), immigrating to the United States in 1912. He moved to Chicago in 1918, and in 1922 became a designer with the prominent firm Graham, Anderson, Probst & White. Dittrich designed the Streets of Paris at the 1933 Century of Progress exposition in Chicago and reprised that job in Dallas, where he also conducted controversial life drawing classes during the Texas Centennial Exposition. He maintained an architectural practice in Chicago at least through the mid-1950s, designing stores for Sears, Roebuck and Co. and churches throughout the Midwest.[10]

W. SCOTT DUNNE (1886-1937), architect, designed the Fair Park Band Shell and amphitheater with Christensen & Christensen. The St. Louis native specialized in movie theater design; his work can still be found across Texas and Oklahoma, where he designed theaters for the region's largest film exhibitors: Interstate Theaters, Robb & Rowley Theaters, and the Jefferson Amusement and Saenger Amusement companies. Beginning in the early 1930s, Dunne designed most of his theaters in the modernistic style; he also gave many older theaters modernistic updates. Among Dunne's designs was the Texas Theater (1931), where Dallas police arrested Lee

Harvey Oswald after the assassination of President John F. Kennedy.[11]

FOOSHEE & CHEEK, architects, were among the associated architects for the Aquarium at Fair Park; James B. Cheek would also design the 1964 aquarium expansion. There were many similarities in the lives of MARION F. FOOSHEE (1888-1956) and his business partner JAMES B. CHEEK (1895-1979): both men were born in rural Texas but at an early age moved with their families to Dallas; both men trained in the office of architect H. B. Thomson, who specialized in designing large houses for wealthy clients; and both men served in the US Navy during World War I before returning to Dallas and establishing their practice. The firm was known for its residential work, but Cheek is remembered as the primary creative force in designing Highland Park Shopping Village, a milestone in shopping center development that was designated a National Historic Landmark in 2000. Now called Highland Park Village, its first section opened in 1931 in the Dallas suburb of Highland Park.[12]

HARE & HARE, landscape architects, was the Missouri-based firm that created the landscape design for the exposition grounds. SIDNEY J. HARE (1860-1938) was largely self-taught, gaining much of his early experience as superintendent of Forest Hill Cemetery in Kansas City, Missouri. He was a proponent of naturalized design and earned a reputation for his innovative ideas about cemetery and park planning. S. HERBERT HARE (1888-1960) joined his father's firm in 1910 after studying under Frederick Law Olmstead in Harvard's landscape architecture program. Through the 1920s, the firm developed a national reputation designing college campuses, subdivisions, parks, and cemeteries in twenty-eight states. In Texas, Hare & Hare created the general plan for Houston's Hermann Park (1930) and the University of Houston (1937), among many other projects. The firm is probably best known for its work on the Country Club District and Country Club Plaza

in Kansas City. The company remains in business as Ochsner Hare & Hare.[13]

BERTRAM C. HILL (1881-1977), architect, designed the Municipal Services Building at the Dallas exposition. Hill immigrated to the United States after graduating from the Merchant Venturers' Technical College in his native Bristol, England. He arrived in Dallas in 1905; his first major work was as a consultant on the Adolphus Hotel (1912). Hill returned to England during World War I, but came back to the US in 1920 and became a naturalized citizen in 1929. He is best remembered for incorporating traditional Georgian architecture into his Texas house designs of the 1920s through the 1940s.[14]

HAROLD "BUBI" JESSEN (1908-1979), architect, designed the Portland Cement House at the exposition. Jessen earned a bachelor's degree in architecture from the University of Texas in his hometown of Austin and received a master's degree in architecture from the Massachusetts Institute of Technology in 1931. On leaving MIT, he worked as a draftsman for Works Progress Administration park restoration projects. He was a founding partner of the Austin architectural firm Jessen & Jessen in 1938. He was also a talented watercolorist and illustrator, and was one of the artists of the Art Deco mural in the State Highway Building (1933) in Austin.[15]

ALBERT KAHN (1869-1942), architect, designed the now demolished Ford Motor Company Building at the Dallas fair. Kahn was born in Rhaunen, Germany, and moved to Detroit with his family at age eleven. He found work at age fifteen as an office boy in the architectural firm of Mason & Rice, where partner George D. Mason taught him drafting. By 1888, Kahn was responsible for supervising the firm's residential work; three years later he won a scholarship to study architecture in Europe. On returning to Detroit, he formed his own firm. In 1905, Kahn attracted wide attention when he designed a section of the Packard Mo-

tor Car Company plant using a reinforced concrete structural system; among his admirers was Henry Ford, who hired Kahn to design Ford automobile assembly plants. Khan's work became so popular that he is sometimes called the "architect of Detroit"; his noted designs there include General Motors' headquarters building (1923). His firm, now called Kahn, remains in business.[16]

LANG & WITCHELL, architects, designed the main entrance to the exposition grounds on Parry Avenue as well as Fair Park Auditorium (1925), which housed the General Motors exhibit during the exposition. OTTO H. LANG (1864-1947) immigrated to the United States from Germany in 1888. He settled in Dallas and worked in local architects' offices for two years until he was hired to design depots for the Texas and Pacific Railway. FRANK O. WITCHELL (1879-1958) was two years old when his family emigrated from Wales and settled in San Antonio. His professional training began at age fourteen, when he apprenticed in a local architect's office. Witchell moved to Dallas in 1898 and worked as a draftsman for Sanguinet & Staats, a prominent architectural firm. Lang and Witchell formed their partnership in 1905; they would rank among Texas's most influential architects for the next three decades.[17]

MARK LEMMON (1889-1975), architect, assisted in designing the Museum of Natural History and designed Cotton Bowl Stadium (1930) at Fair Park. Lemmon also called in Donald Barthelme to complete the plans for the State of Texas Building when Texas Centennial Architects, Associated could not agree on a design. Born in Gainesville, Texas, Lemmon moved to Dallas in 1919 after earning a degree in geology from the University of Texas at Austin and a degree in architecture and engineering from the Massachusetts Institute of Technology. Although he was best known for incorporating historical revival styles into his plans for schools and churches, Lemmon also produced important modernistic designs, including the Tower Petroleum Building (1930) in Dallas.[18]

WILLIAM LESCAZE (1896-1969), architect, designed the Magnolia Petroleum Company building, also known as the Magnolia Lounge, which is usually credited as being the first International Style building in Texas. Lescaze was born near Geneva, Switzerland, and studied at the Eidgenössische Technische Hochschule in Zurich. He moved to the United States in 1920, working for the architecture firm of Hubbell & Benes in Cleveland before opening his own firm in New York in 1923. Lescaze established himself as one of America's early modernist architects. He was said to be the only American at the first International Congress of Modern Architecture in 1928 and was one of only a few Americans whose work was included in the Museum of Modern Art's landmark 1932 *Modern Architecture: An International Exhibition*. He attracted worldwide attention for his design, with partner George Howe, of the PSFS Building (1932) in Philadelphia; shortly after that project was completed, Dallas retailer Stanley Marcus interviewed and rejected Lescaze for the job of designing his home, although Marcus later recommended Lescaze for the Magnolia Lounge project. Though Lescaze continued his career well into the 1960s, it seems that his star faded somewhat after noted modernists like Walter Gropius and Ludwig Mies van der Rohe immigrated to the United States in the late 1930s. Today, Lescaze's postwar work remains obscure.[19]

GEORGE WHEELER McLAUGHLIN (1909-1995), architect, developed special exhibit buildings for the Texas Centennial Exposition. He was born in Minnesota, studied at the University of Minnesota and earned a Paul Cret Fellowship to attend the School of Fine Arts at the University of Pennsylvania. McLaughlin spent most of the 1930s working for world's fairs. He served as assistant to the chief of design for the 1933 Chicago Century of Progress Exposition and design consultant for the Chicago fair's 1934 season; after completing his work in Dallas, he was hired as a design consultant for the 1939 New York World's Fair. In

the early 1950s, McLaughlin moved his architectural practice to Honolulu, where he published *An Architect's Sketchbook of South Seas Living.* He remained in Hawaii for the rest of his life. [20]

EDWARD MOREHEAD (b. 1904), architect, worked in the Design Department for the Texas Centennial Exposition. Although he studied at the School of the Art Institute of Chicago for four years, the Illinois native entered the University of Chicago in 1921 to study law. Morehead moved to Los Angeles the following year and enrolled at the University of Southern California, where he earned a degree in architecture in 1925. He worked for architectural firms in California and lectured on architecture and small housing at the University of California before joining the staff of the 1935 California Pacific International Exposition in San Diego as a designer and supervisor. Morehead worked closely with Juan Larrinaga on the Standard Oil Company building and its 108-foot Tower of the Sun at the San Diego fair. After the Dallas exposition, Morehead returned to San Diego, where he worked with Richard S. Requa, who had been consulting architect for the California Pacific exposition.[21]

DONALD S. NELSON (1907-1992), architect, served as the assistant to Centennial Architect George Dahl. In later interviews, Nelson specifically mentioned working on the Federal Building, Hall of Negro Life, and Hall of Petroleum. A Chicago native, Nelson earned his architecture degree at the Massachusetts Institute of Technology in 1927. As winner of the Prix de Paris scholarship, he studied at the École Normale Supérieure des Beaux Arts in Paris from 1927 to 1930. After returning to Chicago, Nelson joined the architectural firm of Bennett, Parsons, and Frost, where he played a major role in planning the 1933 Century of Progress exposition. Nelson worked on the Federal Building, States Group, and Dairy Building at the Chicago world's fair. He remained in Dallas after the Texas Centennial Exposition and opened a private practice. His better-known works include the Dallas Mercantile Bank Building and later additions (1940-1947), the passenger terminal at Love Field (1957), and the Dallas County Government Center (1969).[22]

HANS OBERHAMMER (1904-1972), architect, designed the replica of Shakespeare's Globe Theater (demolished) at the Dallas exposition. He was born in Brünn, Austria-Hungary (later Brno, Czech Republic), and trained as a bricklayer before attending the Kunstakademie in Düsseldorf, Germany. Oberhammer served on the technical staff of the semi-annual Leipzig Trade Fair and on the technical staff of Chicago's Century of Progress exposition. In 1933, New York's Museum of Modern Art included four of Oberhammer's unbuilt German projects in its exhibit *Work of Young Architects in the Middle West.* Before coming to Dallas, Oberhammer served as supervising architect for the 1934 Rochester Centennial Exhibition in upstate New York.[23]

LUTHER SADLER (1885-1965), architect, designed the streamlined Christian Science Monitor Building at the Centennial Exposition. Born in Hickory, Mississippi, Sadler moved to Dallas in 1910. He came to be recognized for his modernistic houses; one of Sadler's best-known designs stands at 6843 Lorna Lane in Lakewood. In 1946, he and John W. Armstrong formed Sadler & Armstrong, which designed and built houses in Dallas and Highland Park.[24]

E. K. SMITH, construction engineer, designed the Gulf Broadcasting Studios at the exposition with Donald Nelson. Smith was on the oil company's staff.[25]

WALTER DORWIN TEAGUE (1883-1960), industrial designer, created the now demolished buildings and exhibits for the Texas Company (Texaco) and National Cash Register Company and exhibits for the Ford Motor Company at the Dallas exposition. Teague left his native Indiana in 1903 to study painting at the Art Students League of New York. After establishing himself as an illustrator and graphic designer, he found that clients were asking for his advice on product design. In 1926, he established Teague Design in New York, a firm devoted exclusively to industrial design. Two years later, his first major client, Eastman Kodak, released Teague's iconic Brownie camera. In the 1930s he created the Texas Company's brand identity, which included updating the company's familiar star logo to read "Texaco" and creating the prototype for Texaco service stations that was used until 1964. From 1933 to 1939, Teague designed or collaborated on the Ford Motor Company's pavilions at world's fairs in Chicago, San Diego, Dallas, and New York; he also served as chairman of the board of design for the 1939 New York World's Fair. Teague is recognized as one of the pioneers of industrial design as a profession; examples of his work are in the collections of major museums around the world. The company he founded, now known as Teague, is still in business.[26]

DAVID R. WILLIAMS (1890-1962), architect, designed the now demolished Works Progress Administration Building at the Dallas exposition. A native of Childress, Texas, Williams studied architecture at the University of Texas at Austin, but left to work for the Gulf Oil Corporation in 1916 before completing his degree. Stationed in Mexico, he planned buildings, pumping stations, and other company facilities. In 1920, he left for Europe, where he traveled and studied for more than two years. On his return, Williams established an architecture practice in Dallas and began designing houses inspired by the state's indigenous architecture. In 1933, he joined the Federal Relief Administration and planned new rural communities before being named a deputy administrator with the National Youth Administration (NYA) in 1936. Through his work with the NYA, Williams was also involved in the restoration and reconstruction of La Villita, a historic neighborhood in San Antonio that was established in the 1700s.[27]

Artists of the Texas Centennial Exposition

DOROTHY AUSTIN (1911-2011), sculptor, created the cowboy statue in the West Texas Room of the State of Texas Building and the bronze grille at the lagoon entrance of the Dallas Museum of Fine Arts building in Fair Park. The Dallas native studied at the Art Students League of New York and the Pennsylvania Academy of the Fine Arts in Philadelphia. On her return to Dallas, she became known for her portrayals of the African American form; her work won local prizes in 1933 and 1934 and attracted attention from the national media. After marrying a Dallas railroad executive in 1945, Austin quit sculpting and became an accomplished photographer, angler, and skeet shooter. She remained in Dallas until her death.[28]

REVEAU BASSETT (1897-1981), artist, assisted Eugene Savage on Savage's murals in the Hall of State in the State of Texas Building. Bassett also painted the backgrounds of the dioramas that are still on display in the Dallas Museum of Natural History (later Museum of Nature & Science) in Fair Park. Bassett was a Dallas native who inherited a talent for drawing from his father, a prominent civil and mechanical engineer. Texas artist Frank Reaugh influenced Basset by introducing the young painter to landscape and wildlife art. Although Bassett was largely self-taught, his work received local and national acclaim. In 1925, two of his paintings were included in the National Academy of Design's annual exhibition in New York. Bassett worked with fellow Dallas artist Buck Winn on a mural at the Village Theatre (1935) in Highland Park, Texas, and Winn suggested Bassett assist him and Eugene Savage on the murals in the Hall of State.[29]

PIERRE BOURDELLE (1903-1966), sculptor/muralist, was one of the most prolific artists at the Texas Centennial Exposition, creating the pylon fountains flanking the west end of the Esplanade of State, murals and plaster reliefs on the Hall of Varied Industries, Communications, and Electricity, and plaster reliefs on the Hall of Transportation/Chrysler Hall. The French-born artist was the son of Émile Antoine Bourdelle, who was an assistant to the sculptor August Rodin and a successful artist in his own right. The elder Bourdelle trained his son and Raoul Josset, among many other students. Pierre Bourdelle's career would take him to three of the great expositions held in the United States in the 1930s. Organizers of the Texas exposition hired Bourdelle based on his work at the 1933 Chicago World's Fair. When he completed his work for the Dallas exposition, Bourdelle remained in Texas to collaborate with Raoul Josset on the Mier Expedition and Dawson's Men Memorial on Monument Hill in La Grange. Bourdelle continued his exposition work at the 1939 New York World's Fair, where he created a ten thousand-square-foot plaster relief on the Foods Building. He also produced murals for *SS America*, the largest ocean liner built in the United States prior to World War II, and *NS Savannah*, the world's first nuclear-powered merchant ship, launched in 1959.[30]

WILLIAMSON GERALD "JERRY" BYWATERS (1906-1989), artist, assisted Julian Garnsey in painting the murals in the lobby of the Federal Building and Pierre Bourdelle in painting the murals on the exterior of the Hall of Varied Industries, Communications, and Electricity. A native of Paris, Texas, Bywaters graduated from Southern Methodist University with a degree in comparative literature. After a lengthy tour of Europe, he studied at the Art Students League of New York. On returning to Dallas, he became a leading figure in the "Dallas Nine," a group of young regionalist artists who found inspiration in Texas landscapes. In addition to producing a significant body of work, including several Texas post office murals, Bywaters served as the art critic for *The Dallas Morning News* from 1933 to 1939 and as director of the Dallas Museum of Fine Arts from 1943 to 1964 while teaching art and art history at Southern Methodist University and continuing to create original art.[31]

CARLO CIAMPAGLIA (1891-1975), muralist, designed the allegorical murals on the Administration Building, Hall of Transportation/Chrysler Hall, Hall of Foods, and Hall of Agriculture. He painted the murals *Pollination of Nature* on the Hall of Agriculture and *Peacock and Fowl* on Livestock Building No. 1. Campaglia was born in Italy but at a young age moved with his family to New Jersey. After studying at the National Academy of Design and the Cooper Union in New York, Ciampaglia won a Prix de Rome scholarship in 1920; he returned to New York in 1924 and taught design and life drawing at the Cooper Union and Traphagen School of Fashion for the next thirty-six years. Ciampaglia also began his career as a muralist in 1924; his commissions included the Chicago Tribune Building, the Foods and Press buildings at the 1939 New York World's Fair, and frescoes at the World War II Sicily-Rome American Cemetery and Memorial in Nettuno, Italy.[32]

POMPEO COPPINI (1870-1957), sculptor, was responsible for the six sculptures in the Hall of the Heroes in the State of Texas Building. Coppini grew up in Florence, Italy, where he studied at l'Accademia di Belle Arti. He immigrated to the United States in 1896 and moved to Texas five years later when he won the commission to create the figures for the Confederate memorial on the Texas Capitol grounds in Austin. Coppini completed thirty-six public monuments during his career. Among the best known are the Littlefield Fountain on the campus of the University of Texas at Austin and the Alamo Cenotaph in San Antonio. He later headed the art department at Trinity University in San Antonio and founded the Coppini Academy of Fine Arts, also in San Antonio.[33]

C. M. CUTLER, lighting designer, was an illumination engineer for General Electric and member of the United States Illuminating Engineers Society, he designed the lighting scheme for the Texas Centennial Exposition grounds. Cutler had experience lighting theaters, among other projects.

In 1933, he served as a consulting lighting engineer at the Century of Progress International Exposition in Chicago. GE loaned Cutler to the Dallas exposition staff, apparently in exchange for many GE products being used in lighting the grounds. After the Centennial Exposition, Cutler seems to have enjoyed a long career in lighting design. He was a lighting engineer at the 1939 New York World's Fair, and in 1956, the State Fair of Texas called him back to Dallas to create the "Esplanade of Light," a light show on the Esplanade of State.[34]

GEORGE DAVIDSON (1889-1965), artist, painted the ceiling designs and decorated beams in the Hall of State in the State of Texas Building. Davidson was born in Russian Poland and moved to the United States early in his life. He studied at the National Academy of Design in New York before winning a Prix de Rome scholarship in 1913. While studying in Rome, Davidson met Eugene Savage, with whom he would develop a lifelong friendship. Davidson became a painting instructor at the Cooper Union in New York and taught with Savage at Yale University. Davidson's mural work won acclaim that included a gold medal from the Architectural League of New York in 1926. He executed murals across the country and was one of the artists who worked at the New York World's Fair of 1939.[35]

AARON DOUGLAS (1899-1979), muralist, executed a series of four murals for the Hall of Negro Life at the Dallas fair. Douglas was born in Topeka, Kansas, and went on to become one of the most important African American artists of the twentieth century. He worked for a short time in a Cadillac automobile assembly plant in Detroit to earn enough money to enroll at the University of Nebraska, where he received a bachelor of fine arts degree in 1922. He moved to New York and studied with German artist Winold Reiss, who encouraged Douglas to find inspiration in African art. By combining African visual traditions, African American cultural references, and his own abstract designs, Douglas became the leading painter of the Harlem Renaissance. In 1934, he painted a series of murals depicting African American culture and history for the New York Public Library; *Aspects of Negro Life* became his best-known work. Douglas's use of flat figures, geometric forms, and African motifs in the library murals was a clear precursor to his work at the Hall of Negro Life in Dallas. Douglas accepted a full-time teaching position at Fisk University in Nashville in 1937, but split his time between Tennessee and New York while earning a master's degree at Columbia University.[36]

OTIS DOZIER (1904-1987), artist, assisted Pierre Bourdelle with the murals and cameo reliefs on the Hall of Varied Industries, Communications, and Electricity, with the cameo reliefs on the Hall of Transportation/Chrysler Hall, and with other projects throughout the exposition grounds. Dozier was raised on a cotton farm in North Texas. After his family moved to Dallas, he took art lessons from Vivian Aunspaugh, a well-known instructor, and continued his training at the Dallas Art Institute. Dozier was a member of the "Dallas Nine," a group of regionalist artists whose work celebrated the land and people of the Southwest. The Dallas artists unsuccessfully lobbied to create the murals for the State of Texas Building at the Texas Centennial Exposition; like many of the "Dallas Nine," Dozier was hired as an assistant at the fair. In 1938, Dozier received a scholarship to study at the Colorado Springs Fine Arts Center; he later returned to Texas and painted post office murals in Arlington, Giddings, and Fredericksburg. In 1945, Dozier settled in Dallas, where he taught at Southern Methodist University and the Dallas Museum of Fine Arts School.[37]

JULIA ECKEL (1907-1988), artist, painted the murals of industrial scenes on the now demolished Works Progress Administration (WPA) Building at the Dallas exposition. A native of Washington, DC, Eckel spent most of her life in the nation's capital. During the Great Depression, Eckel was accepted into the Public Works of Art Project (PWAP), a New Deal program that paid weekly wages to qualified artists whose works were then owned by the federal government and displayed in public buildings. Some of Eckel's PWAP paintings were hung in the US Department of Labor headquarters and the Washington, DC, Public Library, and are now in the collection of the Smithsonian American Art Museum. She was later employed by the WPA, which funded her work in Dallas.[38]

LYNN FORD (1908-1978), craftsman, carved the figures representing cotton and wheat in the North Texas Room and history and romance in the South Texas Room of the State of Texas Building. Ford was born in Sherman, Texas, where his father, a railroad worker, taught him woodcarving. Ford developed into a talented craftsman and cabinetmaker. He planned to become a woodworking teacher and athletic coach, and attended North Texas State Teachers College (later University of North Texas) in Denton while supporting himself as an architectural draftsman. In the early 1930s, he moved to Dallas and lived with his brother, O'Neil Ford, who was becoming a well-known architect. Lynn opened a workshop to produce furniture and woodcarving and taught at the Dallas Art Institute. From 1938 to 1953, the Ford brothers collaborated on homebuilding. Lynn Ford and his assistants would produce the furniture, doors, and mantels and handle the carpentry work; Ford would also supervise the construction workers. After serving with distinction in World War II, he moved to San Antonio and established a new workshop that he operated until he retired in 1973.[39]

JULIAN ELLSWORTH GARNSEY (1887-1969), muralist, was responsible for designing the exterior frieze and interior decoration for the Federal Building in Fair Park. He was the son of Elmer R. Garnsey, a prominent muralist. Beginning at age fourteen, he assisted his father in decorating the Minnesota, Wisconsin, and Iowa state capitols.

Julian Garnsey earned an architecture degree from Harvard and trained at the Art Students League in New York and the Académie Julian in Paris before returning to his native New York to continue working with his father. He served in the First World War and received the French Croix de Guerre for heroism in combat. Upon his discharge from the Army, Garnsey settled in Los Angeles, where he decorated more than one hundred buildings, including the Los Angeles Central Library (1926) and the Los Angeles Stock Exchange (1929). Garnsey was responsible for the color design of the 1939 New York World's Fair and went on to teach at Princeton University and serve as director of the Beaux-Arts Institute of Design in New York.[40]

HARRY LEE GIBSON (1890-1966), sculptor, executed decorative reliefs on the State of Texas Building, including the symbolic figure of Texas at the top of the entrance niche, the century plants in front of the building, and the heads of Texas fauna on the balcony at the back of the building. Gibson was born in Arrington, Kansas. He studied at Washburn College in Topeka under well-known sculptor Robert Merrell Gage, whose statue of Abraham Lincoln on the Kansas Statehouse grounds Gibson helped cast. After serving in the First World War, Gibson attended the School of the Art Institute of Chicago and opened his own studio in the Windy City. He later moved to Milwaukee and on to New Jersey. After the Dallas exposition, he taught sculpture and clay modeling at the Dallas Art Institute, and in 1939 was commissioned to decorate the reading rooms at Southern Methodist University's Fondren Library.[41]

EUGENE GILBOE (1881-1964), artist, was in charge of decorating and painting the exposition buildings. Gilboe trained at the National Academy of Art in his native Oslo, Norway, as well as with English and German masters. After moving to the United States at the turn of the twentieth century, Gilboe built a career as an acclaimed mu-

ralist and architectural painter through his work with several prominent New York art studios. He came to Texas in 1932; his early work in the state included murals and stenciling at the Niels Esperson Building in Houston, the Stoneleigh Court Hotel in Dallas, where he lived, and at the University of Texas at Austin, where he worked on buildings designed by George Dahl. From the late 1930s through the 1940s, Gilboe found steady work as a decorative painter for the Paramount-Publix movie theater chain.[42]

JEFFERSON ELLIOT "JEFF" GREER III (1905-1958), painter/sculptor, was one of Julian Garnsey's assistants on the Federal Building frieze. Greer's is among the most colorful of the Centennial artists' stories. A director of the Texas Swine Breeder's Association and the Texas Panhandle Plains Dairy Association, Greer, at age twenty-eight, leased his three-thousand-acre ranch to tenant farmers and moved to Milwaukee to study at the Layton Art School. Greer later established a studio in El Paso, where he met renowned sculptor Gutzon Borglum, who hired Greer to work on the giant sculptures of presidents on Mount Rushmore. While employed at the Dallas exposition, Greer became familiar with the technique for creating low reliefs that required carving wet plaster after it had been applied to a wall. Greer would use the technique in later commissions including his murals at Milwaukee's Radio City (1942), the first building in the United States specifically constructed for broadcasting AM-FM radio and television.[43]

EMILE GUIDROZ (1906-2006), artist, assisted Pierre Bourdelle with the murals on the Hall of Varied Industries, Communications, and Electricity. Guidroz also painted Bourdelle's designs for seven lunettes (likely destroyed) in the Hall of Religion. Guidroz was born in Welsh, Louisiana, but spent most of his life in Fort Worth, where he graduated from Central High School and studied art at Texas Christian University. Guidroz trained under Olin Travis at the Dallas Art Institute; he

also studied at the Art Students League in New York and graduated from the School of the Art Institute of Chicago.[44]

ETHEL WILSON HARRIS (1893-1984), designer/craftswoman, created the tile murals on the walls of the West Texas Room in the State of Texas Building. At a young age Harris moved with her family from Sabinal, Texas, to San Antonio, where she became interested in Mexican handicrafts. In 1931 she organized a workshop, Mexican Arts and Crafts, to promote traditional crafts such as basket weaving, pottery making, metalwork, and tile work. Harris's art tile designs became well known. Her tiles were sold nationwide and displayed at the 1933 Century of Progress exposition in Chicago, the 1939 World's Fair in New York, and HemisFair in San Antonio in 1968. Harris eventually ran three tile factories, collectively known as the San José Workshops. She was one of the founders of the San Antonio Conservation Society and was especially interested in preserving the city's missions. She moved to the grounds of Mission San José in 1939 and lived there for more than forty years, serving as the mission's first site manager. Later in life, Harris remembered that she wrote to the Texas Centennial Exposition directors seeking the commission for the tile murals at Fair Park.[45]

WILLIAM ALEXANDRE HOGUE (1898-1994), artist, submitted unsuccessful proposals for murals in the State of Texas Building and on the Hall of Foods; he is also listed among the Dallas artists hired as assistants at the exposition. Hogue is best known for his realistic Depression-era paintings of the Dust Bowl. His family moved from Missouri to Denton, Texas, and later to Dallas, where he graduated from Bryan Street High School in 1918. He enrolled at the Minneapolis College of Art and Design, but returned to Dallas the following year to work as an illustrator for *The Dallas Morning News.* Hogue moved to New York in 1921 and was employed as a designer for advertising agencies; he spent his free time

in the city's museums. On returning to Dallas in 1925, he pursued a career in art. In 1937, *LIFE* magazine published a feature on his Dust Bowl paintings. Although largely self-taught, Hogue was hired by the University of Tulsa to head its art department in 1945. He left the university in 1963 and remained a working artist for the rest of his life, completing his final Big Bend series in the 1980s. Hogue's works are in the collections of the Dallas Museum of Art; Museum of Fine Arts, Houston; National Museum of American Art at the Smithsonian Institution; and Musée National d'Art Moderne, Centre Georges Pompidou, Paris.[46]

RAOUL JOSSET (1899-1957), sculptor, designed the statues representing France, Mexico, and the United States in front of the Hall of Varied Industries, Communications, and Electricity; *Spirit of the Centennial* and the Fish Fountain in front of the Administration Building; the eagle atop the tower of the Federal Building; and the relief on the Hall of Negro Life. Josset was born in France and studied at the École des Beaux Arts and with noted sculptor Antoine Bourdelle. After World War I, Josset received commissions to create fifteen memorials in locations across France; during this time he also won the Prix de Rome and the Prix de Paris. He immigrated to the United States and worked at the Chicago World's Fair of 1933, where he was recruited to work at the Texas exposition. Josset settled in Dallas after the fair and produced several other significant works for the Texas centennial, including memorials at Goliad, Gonzales, and La Grange. He was one of the finalists in the competition to create the statue of Thomas Jefferson for the Jefferson Memorial (1939) in Washington, DC.[47]

GOZO KAWAMURA (1884-1950), sculptor, assisted Raoul Josset and Lawrence Tenney Stevens on the six statues on the Esplanade of State. Kawamura invented a machine that helped sculptors enlarge their original models to full size statues; he continued this work in Dallas. Kawamura had emigrated from Japan to New York City in 1906. After graduating from the Na-

tional Academy of Design in 1909, Kawamura went to France, where he met and worked for the expatriate American sculptor Frederick William MacMonnies. Kawamura entered the École des Beaux Arts in 1912. After returning to New York in 1916, he worked on his own commissions and collaborated with MacMonnies on several public monuments. Kawamura's best-known sculptures were created for the Holstein-Friesian Association of America to illustrate the ideal characteristics of this breed of dairy cattle. Painted castings of the *True-Type Holstein-Friesian Cow and Bull* (1923) were sent to agricultural colleges across the country; bronze castings of the cattle are now part of the collection of the National Museum of Modern Art in Tokyo. Kawamura returned to Japan in 1940. The Gozo Kawamura Memorial Museum of Art opened in Saku, Japan, in 2010. [48]

FANITA LANIER (1903-1986), artist, was responsible for the reliefs of Texas flora interspersed between the names of Texas heroes on the State of Texas Building's frieze. Born in Miami, Florida, Lanier was an art major at North Texas State Normal College (later University of North Texas) in Denton and also studied at the Art Students League of New York and the École des Beaux Arts in Paris. In 1943, Random House hired Lanier to illustrate the book *Texas: The Land of the Tejas* by Siddie Joe Johnson; she also created illustrations for the translation of Manuel de Baca's book *Vincente Silva and His 40 Bandits* in 1947. After moving to El Paso in the mid 1950s, Lanier continued her work, which included a foray into imaginative paintings of the future of space travel.[49]

JUAN B. LARRINAGA (1885-1947), colorist/delineator, produced architectural renderings and scale models of exposition buildings, maintained the color palette for the exposition, and designed the ornamental bands near the rooflines of the exposition buildings. A native of Mexico, Larrinaga attended St. Vincent's College in Los Angeles and later traveled throughout the southwestern United States painting stage scenery for small theater companies. After joining the Flagg Scenic

Studios in Los Angeles, he helped decorate West Coast movie palaces and worked on the 1915 Panama-Pacific International Exposition in San Francisco. With his younger brother, Larrinaga formed a successful design firm that created sets, cycloramas, and miniature models for motion pictures, including Cecil B. de Mille's *King of Kings* (1927). When their company closed at the start of the Great Depression, both brothers went to work for RKO Radio Pictures, where they served as artists on *King Kong* (1933). Larrinaga left Hollywood when he was hired as art director for the 1935 California Pacific International Exposition in San Diego.[50]

TOM LEA (1907-2001), artist, painted the murals in the West Texas Room in the State of Texas Building. Born in El Paso, Lea studied painting at the School of the Art Institute of Chicago. Commissions to create murals and work as a commercial artist kept him in Illinois while he saved money to travel to Europe. After studying the works of the masters in France and Italy, Lea moved to Santa Fe, New Mexico, in 1932 and lived there for two years before returning to El Paso. He won national competitions to paint murals for the new Post Office Department headquarters (1934) and the Benjamin Franklin Post Office (1935) in Washington, DC. During World War II, Lea logged more than one hundred thousand miles in the European and Pacific theaters of operation as an illustrator/correspondent for *LIFE* magazine. He turned to writing after the war; his first novel, *The Brave Bulls* (1949), was a bestseller that was made into a movie. Lea's novel *The Wonderful Country* (1952) was also a bestseller; Robert Mitchum starred in the film version.[51]

LOIS LIGNELL (b. 1911), artist, assisted Gozo Kawamura with his work on the statues along the Esplanade of State. The youngest daughter of a prominent architect, Lignell was born in Duluth, Minnesota, and became an author and illustrator of children's books. She wrote *Three Japanese Mice and Their Whiskers*, which Farrar & Rinehart published in 1934. Lignell assisted

Kawamura in his New York studio, where she met her future husband, W. Ryerson Johnson, a well-known pulp fiction writer. In 1951, Johnson wrote and Lignell illustrated the children's book *Gozo's Wonderful Kite,* which was set in Japan.[52]

JAMES OWEN MAHONEY JR. (1907-1987), artist, painted the mural and eight cameos in the South Texas Room in the State of Texas Building. Mahoney was born in Dallas and studied with Olin Travis at the Dallas Art Institute. He went on to earn his bachelor's degree in art from Southern Methodist University and his master's degree from Yale, where he trained under Eugene Savage and won a Prix de Rome scholarship in 1932. On his return to America in 1936, Mahoney settled in New York, where he earned a variety of mural commissions including those at the Adolphus Hotel in Dallas and three at the 1939 New York World's Fair. He joined the architecture faculty at Cornell University in 1939, and in 1942 was called to wartime service in England interpreting aerial photographs of enemy territory. After the war, Mahoney returned to Cornell, where he enjoyed a long career as an art professor and chairman of the art department.[53]

JOSEPH "JOSE" MARTIN (1891-1985), sculptor, with Raoul Josset executed the *Spirit of the Centennial* statue on the Administration Building, the eagle atop the tower of the Federal Building, and the Art Deco State Fair Founders Statue (1938) in Grand Plaza. Martin (whose nickname was pronounced "Josie") was born in France, where he developed his interest in sculpture while training under his father, a woodcarver. Martin enrolled at the École Normale Supérieure des Beaux Arts, but World War I broke out before he completed his studies. He enlisted in the French Army, was wounded four times, and earned France's Croix de Guerre for heroism in combat. Martin returned to his studies, but left school in 1919 to establish his career. He enjoyed some success as a sculptor, but was hampered by the French economic depression of the mid-1920s. Martin moved to America in 1928, where he found commissions

from Marshall Field & Company in Chicago and the Cowan Pottery Studio in Ohio before being hired to create sculptures for Chicago's Century of Progress exposition. After the Texas Centennial Exposition, Martin remained in Dallas, completing centennial monuments across the state as well as projects in his adopted hometown that included decorative figures at the Lakewood Theater (1938) and the War Dead Memorial (1947) at Restland Memorial Park.[54]

MADELYN MILLER, sculptor, created the bronze doors and screen representing the arts at the Second Avenue entrance of the Dallas Museum of Fine Arts. Apart from credit for her work on the museum building, the historical record seems to contain no information about Miller's life or career.[55]

PERRY BOYD NICHOLS (1911-1992), artist, assisted Arthur Starr Niendorff in plastering and painting the fresco in the North Texas Room of the State of Texas Building. A Dallas native, Nichols's natural talent was recognized and developed by three local artists: Frank Reaugh, Nichols's first art instructor; Alexandre Hogue, who taught Nichols at a summer art camp; and Eleanor Benners, who was Nichols's art teacher at Bryan Street High School and Woodrow Wilson High School. After serving in the army, he returned to Dallas and became an active member of the local art community, exhibiting paintings in many local shows and galleries. Working with Dallas decorator Eugene Gilboe, Nichols became well known for his murals. By 1940, the two men had completed thirty murals for theaters and public buildings in five states. Nichols's work in Dallas includes the interiors of the Inwood and Lakewood theaters, five large murals in the now-demolished Sears department store on Ross Avenue and an immense mural in the lobby of the Dallas Morning News building.[56]

ARTHUR STARR NIENDORFF (1909-1975), artist, painted the fresco in the North Texas Room of the State of Texas Building. Niendorff was born

in Marshall, Texas, and moved to Dallas with his family at an early age. Though he came from a family of artists, Niendorff did not consider a career in art himself until he was studying at Stanford University. While in California, Niendorff was impressed by the work of celebrated Mexican muralist Diego Rivera, who was painting a fresco at the San Francisco Art Institute. Niendorff went to see Rivera, who took him on as an assistant. Niendorff eventually became one of the artist's chief assistants, a job that ended abruptly in 1933 when Rivera was barred from Rockefeller Center and prevented from completing his controversial mural *Man at the Crossroads.* Niendorff also traveled through Europe studying the works of the Old Masters, which he cited as an influence on his own work. Little is known about his later career.[57]

JOSEPH E. RENIER (1887–1966), sculptor, executed the *Great Medallion of Texas* for the Hall of State in the State of Texas Building. Renier specialized in architectural sculptures, reliefs, and medals, making him well qualified for the job. He grew up in New Jersey and studied at the Art Students League in New York and in Brussels in his parents' native Belgium. Renier won the Prix de Rome in 1915, but interrupted his studies to serve with the American Red Cross in Italy during World War I. After returning to the United States, he worked as an assistant professor in the art school at Yale. Alfred Eisenstadt photographed Renier's sculpture *Speed* at the 1939 New York World's Fair for *LIFE* magazine. The American Artists Professional League awarded Renier its gold medal for sculpture in 1959.[58]

G. HENRY RICHER worked with Julian Garnsey on the Federal Building frieze. Richer had served as painting foreman on Garnsey's projects in Los Angeles in the 1920s. Other than that work, details about Richer's life are not known.[59]

THOMAS "DUKE" RUSSELL (b. 1913), sculptor/painter, assisted Julian Garnsey with the frieze on the Federal Building. A native of El Paso, Rus-

sell briefly attended Texas College of Mines (later University of Texas at El Paso) before embarking on a widely varied career. He returned to his former school in 1934 as an assistant to Mexican muralist Emilio Garcia Cahero, who was creating frescoes on mining in Holliday Hall (1933) for the federal government's Public Works of Art Project. Jefferson Greer, who would work with Russell at the Dallas exposition, was another of Cahero's assistants. After completing the fresco project, Russell left El Paso to study in New York, but returned within a year. After his job on the Federal Building frieze ended, Russell earned his living by modeling wax caricatures of fairgoers at the Centennial Exposition and at the Greater Texas & Pan-American Exposition the next year. Using the skills he honed in Dallas, Russell submitted a model of the mythological figure Pan to the Walt Disney Studio, which used Russell's model for the character in the film *Fantasia*. Russell worked in the Character Model Department, which created detailed plasticine models of characters that the animators referenced. Russell assisted on Disney's *Pinocchio* before leaving the studio to work in a defense plant.[60]

EUGENE SAVAGE (1883-1978), artist, created the murals *Texas of History* and *Texas of Today* in the Hall of State at the State of Texas Building. Savage took up drawing in connection with his childhood hobby of taxidermy. Around 1899, he moved from his native Indiana to Chicago, where he studied at the Academy of Fine Arts and the School of the Art Institute of Chicago and built a successful career in commercial illustration. His interests later turned to mural painting, for which he won a Prix de Rome in 1912. In 1925, Savage became a painting professor at Yale University, and during the next decade won a number of significant mural commissions, including works at the Sterling Memorial Library at Yale (1930) and the Post Office Department headquarters (1934) in Washington, DC. At the time he was commissioned to create the Hall of State murals, Savage was serving as commissioner of painting for the United States Commission of Fine Art.[61]

HECTOR SERBAROLI (1881-1951), artist, painted the *Fecundity* and *Wheat Harvester* murals on the Hall of Agriculture from designs by Carlo Ciampaglia. Serbaroli was educated at the Instituto di San Michele in his native Rome and trained with muralist Cesare Maccari. He was hired to decorate the Teatro Nacional in Mexico City, but left at the start of the Mexican Revolution. Serbaroli moved his family to northern California and was commissioned to create six large oil paintings for San Francisco's 1915 Panama-Pacific International Exposition. While in San Francisco, Serbaroli met architect Julia Morgan, who hired him to decorate William Randolph Hearst's mansion at San Simeon. In 1927, with work at Hearst Castle winding down, Serbaroli moved to Hollywood, where he was hired by First National Pictures and began his career as a studio artist. A friend from the movie business, Juan Larringa, contacted Serbaroli when the Texas Centennial Exposition was looking for experienced muralists. On completing his work in Dallas, Serbaroli returned to California and continued his career with Paramount Pictures, 20th Century-Fox, and RKO Radio Pictures.[62]

RED SLAYTON, plasterer, worked for Pierre Bourdelle on the cameo reliefs on the Hall of Transportation and Hall of Varied Industries, Communications, and Electricity. Little is known about Slayton's life and his other work.[63]

POLLY SMITH (1908-1980), photographer, produced the photomurals that are still on display in the East Texas and North Texas rooms in the State of Texas Building. She was born Frances Sutah Smith in Ruston, Louisiana. When her father abandoned the family in Texas, Smith, her mother, and six brothers and sisters worked to support themselves and complete their educations; all seven of the Smith children attended college. Smith displayed a talent for photography and studied with Edward Steichen in New York. In 1935, the publicity department of the Texas Centennial Exposition hired her as a freelance photographer. Smith traveled around the state

with a darkroom on the back of her truck capturing images of Texas. As a result, Smith's photos appeared in national magazines, and she went to work as a freelance commercial photographer; her brother Cyrus Rowlett Smith, president and co-founder of American Airlines, was one of her clients. During World War II, Smith moved to Hollywood to work for entertainment columnist Louella Parsons. In 1944, she enrolled in the University of Texas at Austin to study art; painting and sculpture were Smith's primary interests for the rest of her life.[64]

THOMAS M. STELL JR. (1898-1981), artist, assisted Julian Garnsey on the murals in the lobby of the Federal Building and Pierre Bourdelle on the murals on the Hall of Varied Industries, Communications, and Electricity. He also created a pair of lunettes (now covered) on Livestock Building No. 1. Stell was born in Cuero, Texas. He earned a bachelor's degree from Rice Institute in Houston and a master of arts degree from Columbia University before studying at the National Academy of Design and the Art Students League of New York. He received critical acclaim as a portrait painter and was among the artists selected to exhibit works at the 1939 New York World's Fair and the 1939 Golden Gate International Exposition in San Francisco. Stell taught in the art departments of Trinity University in San Antonio and the University of Texas at Austin.[65]

LAWRENCE TENNEY STEVENS (1896-1972), sculptor, created the statues *Tenor* and *Contralto* on the Esplanade of State, the statues representing Spain, the Confederacy, and Texas in front of the Hall of Transportation/Chrysler Hall, and the *Texas Woofus* chimera in front of Livestock Building No 2. Stevens studied at the Boston Museum of Fine Arts and won a Prix de Rome scholarship in 1922. After returning to the United States, he built a national reputation as a sculptor, painter, and engraver, exhibiting at several prestigious institutions and earning prominent commissions. Stevens's work at the Texas Centennial Exposition and the New York World's Fair of 1939 suited

his preference for monumental public art, though his commissions grew smaller in scale as tastes changed after World War II. He settled in Tempe, Arizona, in the 1950s and remained there for the rest of his life.[66]

ALLIE V. TENNANT (1892-1971), sculptor, created *Tejas Warrior* above the entrance to the State of Texas Building and the seahorses and frieze on the Dallas Aquarium in Fair Park. Tennant was born in St. Louis but moved to Dallas with her family. Her talent for art emerged when she was very young; she made her first sculpture at age eight. Tennant studied in Dallas at the Aunspaugh Art School and under a German artist, Hans Kunz-Meyer, before training at the Art Students League of New York. She became associated with the "Dallas Nine" group of regionalist artists, and her portrait sculpture and architectural work was widely exhibited and praised through the 1930s. She was elected a fellow of the National Sculpture Society in 1934; in 1943, she and fellow Texan artists formed the Texas Sculptors Group. Tennant spent the rest of her life in Dallas sculpting, writing, and lecturing at the Dallas Art Institute.[67]

OLIN TRAVIS (1888-1975), artist, painted the murals *East Texas of Today, Before and After the Discovery of Oil* in the East Texas Room of the State of Texas Building. Travis, a Dallas native, had a lasting influence on the city's art community through his teaching. Encouraged by his art teacher at Bryan Street High School, Travis studied briefly in Dallas before enrolling in the School of the Art Institute of Chicago. He graduated in 1914 and spent a few years traveling the country sketching landscapes before returning to Chicago to establish a studio and teach at the Art Institute and the Commercial Arts School. Travis moved back to Dallas in 1923 and established the Dallas Art Institute and the Ozark Summer School of Painting in Arkansas. As director of the Dallas Art Institute for the next fifteen years, Travis influenced the careers of the "Dallas Nine," a group of regionalist artists, including Jerry Bywaters, Otis Dozier, Alexandre Hogue, and Buck Winn Jr., who studied at the institute.[68]

JAMES BUCHANAN "BUCK" WINN JR. (1905-1979), sculptor/muralist, designed the reliefs on the pylon and gatehouses at the exposition's Parry Avenue entrance and assisted Eugene Savage in painting the murals in the Hall of State in the State of Texas Building. Winn was born on a farm near Celina, north of Dallas. After studying at Washington University in St. Louis and the Académie Julian in Paris, he returned to Dallas and established himself as a mural painter, though he maintained interests in sculpture and architecture. He executed murals and reliefs for the Blackstone Hotel (1929) in Fort Worth, Titche-Goettinger department store (1929) in Dallas, the Dallas Power and Light Building (1931), and the Village Theatre (1935) in Highland Park, Texas, where he worked with Reveau Bassett. When Winn was hired to assist in the Hall of State, he in turn recommended Bassett as another assistant on the project. Winn painted the murals in the Gonzales Memorial Museum (1937) in Gonzales, Texas, a centennial project in the town where the first shot of the Texas Revolution was fired. Winn moved to Wimberley, Texas, in 1940 and remained active for many years lecturing, executing murals and reliefs, designing the 1946 United States postage stamp commemorating Texas statehood, and pioneering the use of fiberglass and lightweight concrete as building materials.[69]

GEORGE WITTBOLD (b. 1895), exhibit designer, was born in Chicago and began creating all of General Motors' exhibits in 1912, only four years after the company was founded. By the time he designed the GM displays at the Texas Centennial Exposition, Wittbold had been responsible for General Motors' participation in seven hundred and fifty auto shows and expositions. He would go on to build GM's celebrated "Futurama" ride at the 1939 New York World's Fair and the automaker's forty three thousand-square-foot exhibit at San Francisco's Golden Gate International Exposition in 1939.[70]

W. STUART WOOD (1903-1975), master mason, assisted Julian Garnsey on the Federal Building's frieze and helped create the replica of the Alamo (demolished) in Fair Park. He worked as a stonemason for the Dallas Park Board in the years after the exposition and later worked as an independent contractor.[71]

ACKNOWLEDGMENTS

Fair Park Deco would not have been possible without the individuals who generously and enthusiastically helped bring this project together.

We are enormously grateful to Ramona Davis, executive director of Preservation Houston, for supporting this project from the beginning and for her assistance as we worked on the books that led to this one, *Houston Deco* and *Hill Country Deco*. Thanks also to the officers and board of Preservation Houston for their encouragement through all of this work.

Fair Park Deco would not be half the book it is without the contributions of the City of Dallas Park and Recreation Department. Our sincere appreciation goes to Assistant Director Willis Cecil Winters, who generously offered his time and expertise throughout the project and whose hard work and commitment has greatly contributed to Fair Park's renaissance. The City of Dallas Fair Park Administration staff was also immeasurably helpful; thank you to Daniel Huerta, Dee Ann Bell, Sean Webb, Steve Flores, and Diana Caswell for welcoming us to the park and giving us access to many of its buildings. Thanks also to Louise Elam of the Park Department for her assistance with research materials.

Two Dallasites who care deeply about Fair Park's history and architecture were also a great help. Friends of Fair Park founder Virginia Savage McAlester, a true preservation pioneer, was gracious enough to write this book's foreword and to share her recollections of the beginning of the park's revitalization and her perspective on its future. Nancy McCoy of Quimby McCoy Preservation Architecture, who has been involved in many of the restoration projects at Fair Park, kindly opened her research files and gave us direction as we began our own work. Special thanks are due them both.

Support from The Summerlee Foundation of Dallas made this project immeasurably richer by enabling us to access historic images and materials we otherwise could not have included. Thanks also to John W. Crain for seeing the potential in the book and for his continued contributions to the study of Texas history.

North Texas is fortunate to have its history preserved in several outstanding institutions whose collections were invaluable to our research. Our thanks go to Carol Roark, Sharon Perry Martin, and Brian Collins of the Dallas Public Library Texas/Dallas History & Archives Division; Susan Richards and Samantha Dodd of Dallas Historical Society; John Slate of the Dallas Municipal Archives; Sue Gooding of the State Fair of Texas; Evelyn Barker of the University of Texas at Arlington Library; and Hillary Bober of the Mildred R. and Frederick M. Mayer Library, Dallas Museum of Art, all of whom went above and beyond in guiding us through their collections, patiently answering every question and enduring our excitement over the most obscure bits of Centennial Exposition history.

Bob Hilbun of the State Fair of Texas, Jon Rollins of Good Fulton & Farrell, Mark Knight of Mark Knight Photography, Jan Krause-Leckie of GSR Andrade Architects, Wendy Evans Joseph of Cooper Joseph Studio, Steven Butler of watermelon-kid.com, Jack Bunning and Dealey Campbell of Dallas Historical Society, and the staffs of the Museum of Nature & Science and Texas Discovery Gardens were also helpful in providing us access to, and images of, buildings that might not otherwise have been as well represented in the book. We would also like to thank researchers farther afield who provided key information: Deborah Sorensen of the National Building Museum in Washington, DC; Margaret Culbertson and Helen Lueders of the Kitty King Powell Library and Study Center, Bayou Bend, Houston; John Anderson of the Texas State Library and Archives Commission; Stephanie Coleman of the Ryerson & Burnham Libraries, The Art Institute of Chicago; Susan Earle of the Spencer Museum of Art at the University of Kansas.

Karen Hibbitt of the National Archives; Paige Plant of the National Automotive History Collection, Detroit Public Library; Danielle Szostak-Viers of the Chrysler Historical Collection; K. C. McCrory of PPG Industries, Inc.; and I. Bruce Turner of the Edith Garland Dupré Library, University of Louisiana at Lafayette, were also kind enough to field questions relating to their institutional archives, for which we are most grateful.

We would also like to thank Kathleen Murphy Skolnik of the Chicago Art Deco Society, Steven Hollowell, and Rick Pierce for assisting in research outside their usual fields, and Lisa Gray of the *Houston Chronicle* for her guidance, which helped make this a better book. Steve Lewis and Bill Pronzini contributed information from their personal archives that helped enrich this book.

David Bush would like to thank Sally Whipple, David Crawford, and Loyce Matthews for their encouragement.

And finally, our warmest gratitude goes to Melinda Esco, Dan Williams, Rileigh Sanders, Kathy Walton, Jovan Overshown, Bill Brammer, and the board of TCU Press, the people who literally made this book a reality, and Judy Alter, who saw the possibilities in our first proposal. Your enthusiasm, hard work, and friendship are always very much appreciated.

Jim Parsons and David Bush

NOTES

INTRODUCTION

[1] "Stirring Texanic Romance Inspires Force as Centennial Plant Springs Into Being," *The Dallas Morning News (DMN)*, March 16, 1936.

[2] "Official Night Opening of the Texas Centennial Exposition," radio script for NBC network, June 6, 1936 (State Fair of Texas archives).

[3] Bob Tutt, "The Centennial Revisited," *Houston Chronicle: Texas Magazine*, October 13, 1985.

[4] Frank Carter Adams, ed., *The State of Texas Building* (Austin: Steck, 1937), 7; "Centennial Suggested for 1924," *Corsicana (TX) Daily Sun*, November 6, 1923; Norman D. Brown, "Texas in the 1920s," *Handbook of Texas Online* (http://www.tsha-online.org/handbook/online/articles/npt01), accessed January 29, 2012, published by the Texas State Historical Association; Julia Cauble Smith, "East Texas Oilfield," *Handbook of Texas Online* (http://www.tshaonline.org/handbook/online/articles/doe01), accessed January 29, 2012, published by the Texas State Historical Association; United States Census data for Texas, 1940 ("Population of the State, Urban and Rural"), US Census Bureau.

[5] *Centennial News*, July 10, 1934.

[6] Kenneth B. Ragsdale, *The Year America Discovered Texas: Centennial '36* (College Station, TX: Texas A&M University Press, 1987), 46-47.

[7] "Five Texas Cities Ask Centennial," *Big Spring (TX) Daily Herald*, August 4, 1934; "Five Cities Compete For Designation Texas Centennial," *The Llano (TX) News*, August 16, 1934.

[8] "Eight Million Bid Advocated for Centennial," *(DMN)*, August 8, 1934; Ragsdale, 56-58, 82.

[9] Ragsdale, 70-74, 106-107; "Council Accepts Fair Park Contract," *DMN*, June 14, 1935.

[10] "Texas Centennial Central Exposition," Publicity Department releases, undated, TCE Buildings box, Centennial Collection, Dallas Historical Society (DHS); "Materials Used in Big Show Would Load Train Extending from Dallas to Fort Worth," *DMN*, May 3, 1936; "Brilliant Texas Oratory Is Heard as Centennial Measure Goes Before Hearing Groups," *The Galveston Daily News*, June 1, 1935.

[11] Christopher Long, "Dahl, George Leighton," *Handbook of Texas Online* (http://www.tshaonline.org/handbook/online/articles/fda86), accessed February 1, 2012, published by the Texas State Historical Association; Transcript of Sarah Hunter interview with George Dahl, February 24, 1984, in Centennial Collection, DHS; "Centennial's Stunning Beauty Due to Unique Style of Architecture," *DMN*, June 7, 1936; George Dahl biographical sketch, Centennial Collection, DHS.

[12] Ragsdale, 92; "Centennial's Stunning Beauty"; *DMN*, August 11, 1985, cited in Ragsdale, 178.

[13] Harry Benge Crozier, "Citizens to See Building Started For Centennial," *DMN*, December 1, 1935; Harry Benge Crozier, "Stirring Texanic Romance Inspires Force as Centennial Plant Springs Into Being," *DMN*, March 16, 1936.

[14] Willis Winters, "Planning the Centennial," *Texas Architect*, May/June 1999; "Architect Completes His Master Plan for Centennial Site," *Dallas Journal*, March 2, 1935; "Building Plan Adopted by Officials for Centennial," *DMN*, March 3, 1935.

[15] Maxine Holmes and Gerald D. Saxon, eds., *The WPA Dallas Guide and History* (Denton: University of North Texas Press, 1992), 370.

[16] "Innovations in Architecture Get Tryout at Fairs," *Dallas Times Herald*, March 8, 1936; Ralph Bryan, "Mark of Solidity is Outstanding in Fair Architecture," *DMN*, June 28, 1936.

[17] "Innovations in Architecture"; Buildings file, Centennial Collection, DHS; *Progress in Industrial Color and Protection at "A Century of Progress"* (Chicago: American Asphalt Paint Co.), 1933.

[18] "Innovations in Architecture." Ibid.

[19] "Heat Kills Four as New Record of 109.6 Made," *DMN*, August 11, 1936; "Cooling Plants Will Make Fair Seem Like Fall," *DMN*, April 30, 1936.

[20] "Fair Is Certain of 10,000,000 By December 1," *DMN*, July 26, 1936; Ragsdale, 118.

[21] "Famous New York Chef Tastes Texas Barbecue," *DMN*, April 14, 1936; "Rangerettes to Invite Aviators at Chicago to Attend Centennial," *DMN*, January 13, 1936; Ragsdale, 146.

[22] "An Objection from Texas," *The New York Times*, April 30, 1936.

[23] "Bluebonnet Blue Dominating Color of New Fashions," *DMN*, March 26, 1936; "Varied Industries Building To Reflect Empire on Parade," *DMN*, May 26, 1936; *Dallas Journal*, June 11, 1936; "Who Said It First?" Letter to the editor, *DMN*, January 13, 1936.

[24] Ragsdale, 249-251; "Exultant Pride of a Great Empire Is Heard as Heartbeat of Centennial's 'Cavalcade,'" *DMN*, June 21, 1936.

[25] Untitled typescript ("The Texas Centennial Central Exposition is being held in Dallas this year . . ."), Mayer Library archive, Dallas Museum of Art.

[26] *The WPA Dallas Guide and History*, 370.

ENTRANCE AND GRAND PLAZA

[1] "Thing of Beauty; Yes, Two of Them," *The Dallas Morning News (DMN)*, September 27, 1908; "Faithful Old Fair Gates Fall," *DMN*, February 13, 1936.

[2] "Stirring Texanic Romance Inspires Force as Centennial Plant Springs Into Being," *DMN*, March 16, 1936.

[3] "Building of Fair Largely Work of Community Talent," *DMN*, June 15, 1936; Memorandum from George L. Dahl to Ray A. Foley, October 5, 1935, Centennial Collection, Dallas Historical Society (DHS); C. M. Cutler, "Illumination of Texas Centennial Central Exposition," *Transactions of the Illuminating Engineering Society*, November 1936: 877.

[4] Cutler, 875.

[5] "Attention of World Turned Toward Dallas for Opening of Texas Centennial Exposition," *DMN*, June 6, 1936; "Gigantic Parade to Begin Moving Up Main at 10:30," *DMN*, June 6, 1936; "$50,000 Gold Key Will Be Used to Open Centennial," *DMN*, April 13, 1936; "Theft of Centennial Fair Key May Prove Disappointment," *DMN*, June 12, 1952.

[6] "100,000 Pack Centennial on Opening Day," *Pampa (TX) Daily News*, June 7, 1936; Kenneth B. Ragsdale, *The Year America Discovered Texas: Centennial '36* (College Station: Texas A&M University Press, 1987), 232; "Gigantic Parade."

[7] "Hall of Administration, 1910," City of Dallas Fair Park website, accessed January 23, 2012, http://www.dallascityhall.com/fairpark/architectural_guide_administration.html; "The History of The Women's Museum," accessed January 23, 2012, http://www.thewomensmuseum.org/aboutus/ABT_who_history.asp; "First Centennial Construction to Start in 5 Days," *DMN*, August 13, 1935; Ragsdale, 94.

[8] "Remodeled Fair Entrance to Form Court of Flags," *DMN*.

[9] "Fair Park Station," Dallas Area Rapid Transit, accessed January 25, 2012, http://www.dart.org/riding/stations/fairparkstation.asp.

[10] "Parry Avenue Gate and Esplanade Restoration, Fair Park," Quimby McCoy Preservation Architecture, accessed January 25, 2012, http://www.quimbymccoy.com/portfolio_parryavenue.html.

[11] Interview with Buck Winn Jr., August 23, 1978, Centennial Collection, DHS.

[12] "Street Name Passes After Yelling Match," *DMN*, April 9, 1981.

[13] "Fair Park: Yes, There is Life After Roller Coasters on the Midway," *DMN*, April 28, 1978.

[14] "Hall of Administration," Box 14, TCE Buildings File, Centen-nial Collection, DHS; Ragsdale, 94.

[15] "Blue and Gray Color Scheme for Centennial Building," *DMN*, March 29, 1936; David Dillon, "The Women's Museum, Dallas," *Architectural Record*, November 2001; Gaile Robinson, "Women's Museum in Dallas to Close Oct. 31," *Fort Worth Star-Telegram*, October 6, 2011.

[16] "Garner Favors Nation Leaving Business Arena," *DMN*, August 6, 1936.

[17] Deborah Fleck, "Georgia Carroll Kyser: Inspiration for Fair Park Statue Later Became Actress," *DMN*, January 17, 2011; Interview with Donald Nelson, Summer 1983, transcript in Centennial Collection, DHS; "Georgia Carroll Kyser Dies at 91," *Los Angeles Times*, January 20, 2011.

[18] Raoul Josset biographical sketch in Centennial Collection, DHS.

[19] Louise Elam, *Fair Park Project Summary*, Dallas Park and Recreation Department, accessed January 15, 2012, http://www.dallascityhall.com/pdf/park_and_rec/FairParkProject-Summary.pdf.

[20] *Fair Park Project Summary*.

[21] John Fies, "Electrical Features of the Texas Centennial Central Exposition," paper presented during the October 1936 meeting of the American Institute of Electrical Engineers South West District (State Fair of Texas Archive, 1936.0084); C. M. Cutler, "Illumination of Texas Centennial Central Exposition," *Transactions of the Illuminating Engineering Society*, November 1936: 883.

[22] Steven R. Butler, "Raoul Josset and Jose Martin: A Tale of Two Artists," *Legacies: A History Journal for Dallas and North Central Texas, Fall 2011* (Denton, TX: Texas State Historical Association).

[23] "93,860 Attend Fair for Opening Day of Golden Jubilee," *DMN*, October 9, 1938.

[24] "Founders' Statue & Frank P. Holland Court," Historic Fair Park, accessed January 28, 2012, http://www.watermelon-kid.com/places/FairPark/hh-tour/hh-founders.htm.

ESPLANADE OF STATE

[1] *The Official Guide Book, Texas Centennial Exposition* (Dallas: Texas Centennial Central Exposition, 1936), 19.

[2] "Marvelous Fair Lighting Display Astounds Visitors," *The Dallas Morning News (DMN)*, June 7, 1936; John Fies, "Electrical Features of the Texas Centennial Central Exposition," paper presented during the October 1936 meeting of the American Institute of Electrical Engineers South West District (State Fair of Texas Archive, 1936.0084); "Striking Lighting Effects Achieved at Centennial by Observing Laws of Physics," *DMN*, July 3, 1936.

[3] "Marvelous Fair Lighting Display"; C. M. Cutler, "Illumination of Texas Centennial Central Exposition," *Transactions of the Illuminating Engineering Society*, November 1936: 872.

[4] Willis Winters, "Planning the Centennial," *Texas Architect*, May/June 1999; "Architect Completes His Master Plan for Main Centennial Site," *The Dallas Journal*, March 2, 1935; *Official Guide Book*, 19; "Cost of the Building," *DMN*, October 8, 1935; "To Hold Drawing for Exhibit Space," *DMN*, September 3, 1922.

[5] "Magic of Science Freely Displayed at World's Fair," *DMN*, July 23, 1936; "Magic City's House of Magic Presents Eyeopening Exhibit With Aid for Erring Hubbies," *DMN*, July 7, 1936; "Exhibits at Dallas Centennial Show," *The San Antonio Light*, June 18, 1936.

[6] *Official Guide Book*, 75; Ibid., 79; Ibid., 105; "Centennial Guest Can Hear Self as Others Hear Him," *DMN*, June 7, 1936; "Texas Centennial Varied Industries Exhibits," *Dallas Daily Times-Herald*, June 11, 1936.

[7] *Official Guide Book*, 35-37; "Children Annoyed by Adults

Horning in on Train Exhibit," *DMN*, June 17, 1936.

[8]"Exhibits at Dallas Centennial Show"; "Chrysler Greets Fair Throngs in Cool, Brilliant Hall," *DMN*, June 7, 1936; "Chrysler Salon of Mirrors, Largest in World, Made With 43 Tons Blue Glass," *DMN*, June 7, 1936; "Organist of Wide Experience Presides at Electric Organ Giving Chrysler Hall Concerts," *DMN*, June 7, 1936; "At Chrysler Motors," *DMN*, June 7, 1936; *Official Guide Book*, 38-39; "New Data is Given at Chrysler Hall," *The San Antonio Light*, June 30, 1936.

[9]"Use the Television Telephone" (advertisement), *DMN*, August 20, 1936; "Catch Crooks by Television," *DMN*, July 22, 1936; "Will Wed by Television," *DMN*, August 9, 1936; "Say 'I Do' by Television," *DMN*, August 16, 1936; "First Marriage Ceremony by Television To Be Conducted at Centennial Aug. 15," *DMN*, August 8, 1936; "Farmer Asks to Use Television for Look At Prospective Bride," *DMN*, September 8, 1936.

[10]"Oil Companies Top Exhibitors at Great Fair," *DMN*, June 13, 1937; "Fire's Havoc," *DMN*, February 11, 1942; David Dillon, "Back to Fair Park," *D Magazine*, October 1985; Louise Elam, *Fair Park Project Summary*, Dallas Park and Recreation Department, accessed January 15, 2012, http://www.dallascityhall.com/pdf/park_and_rec/FairParkProjectSummary.pdf; "Murals, Murals, on These Walls," City of Dallas Park and Recreation Department Fair Park Newsletter, Fall 2005, accessed January 15, 2012, http://www.dallasparks.org/fairparknews/Fall2005/FPStory1.html.

[11]David Dillon, *Dallas Architecture 1936-1986* (Austin: Texas Monthly Press, 1985), 19.

[12]Carol Morris Little, *A Comprehensive Guide to Outdoor Sculpture in Texas* (Austin: University of Texas Press, 1996), 139.

[13]Dillon, *Dallas Architecture*, 16.

[14]"Fair Park Grounds History," Fair Park website, accessed January 15, 2012, http://www.fairpark.org/index.php?option=com_content&view=article&id=177&Itemid=31.

[15]"Oil Companies Major Exhibitors at Great Fair," *DMN*, June 13, 1937.

[16]Maxine Holmes and Gerald D. Saxon, eds., *The WPA Dallas Guide and History* (Denton: University of North Texas Press, 1992), 370; "'62 Fair Will Have International Look," *DMN*, December 18, 1961; Louise Elam, *Fair Park Project Summary*, Dallas Park and Recreation Department.

[17]Carol Morris Little, *A Comprehensive Guide to Outdoor Sculpture in Texas* (Austin: University of Texas Press, 1996), 150, 163; *Official Guide Book*, 21; George Dahl, Technical Director, letter to Gaetano Cecere, New York, January 9, 1936, Centennial Collection, Dallas Historical Society (DHS).

[18]Fine Art Conservation Laboratories Conservation (FACL) Treatment Plan for *Motion* Mural, October 31, 1999 (Dallas Municipal Archives); *Fair Park Project Summary*.

[19]*Fair Park Project Summary*; "Murals, Murals, on These Walls," Dallas's Fair Park Newsletter, accessed January 19, 2012, http://www.dallasparks.org/fairparknews/Fall2005/FPStory1.html.

[20]"Giant Fair Statue Finished," *DMN*, May 8, 1936.

[21]"Mark of Solidity is Outstanding in Fair Architecture," *DMN*, June 28, 1936.

[22]Juan B. Larrinaga, interoffice communication to George Dahl, August 13, 1935, cited in Carla Breeze, *American Art Deco: Architecture and Regionalism* (New York: W. W. Norton & Company, 2003), 189.

[23]FACL Treatment Plan for *Motion*.

[24]*Official Guide Book*, 32; "Harvester Firm Shows Types of Farm Machinery," *DMN*, June 14, 1936.

[25]Willis Cecil Winters, *Fair Park* (Chicago: Arcadia Publishing, 2010), 21.

[26]Scott M. Haskins, Fine Arts Conservation Laboratories, Inc., letter to Nancy McCoy, ARCHITEXAS, 16 December 1999, Dallas Municipal Archives; "Progress on Conservation Treatments of the Carlo Ciampaglia Murals," Fair Park Mural Conservation Project, accessed January 20, 2012, http://www.fairparkmurals.com/progress; "He Finds Dallas' Lost Art," *DMN*, January 6, 1978.

[27]*Fair Park Project Summary*; Fine Art Conservation Laboratories Conservation Treatment Summary for *Motion* mural, May 15, 2001 (Dallas Municipal Archives).

[28]Laboratory for Conservation of Fine Arts, LLC, and Conservation of Sculpture and Objects Studio, Inc., "Conservation of Four Bas-Reliefs on Centennial Building at Fair Park, Dallas, Texas," November 2000 (Dallas Municipal Archives).

[29]"At Chrysler Motors"; "Airflow Era," Chrysler Design Institute, accessed January 19, 2012, http://www.chrysler.com/design/vehicle_design/history/eras/index4.html.

[30]"Murals, Murals"; *Fair Park Project Summary*.

[31]"Historical Information on Carlo Ciampaglia and His Murals at Fair Park, Dallas, Texas," Fair Park Mural Conservation Project, accessed January 19, 2012, http://www.fairparkmurals.com/historical-information.

[32]"Esplanade Fountain Restoration" plaque at base of Great Pylon, Esplanade of State.

[33]"Begin Installing T&P Exhibit," unidentified newspaper clipping, April 29, 1936 (Dallas Public Library Texas/Dallas History & Archives Division clipping file); "Dallas-to-St. Louis Rail Trip Without Leaving Fair Grounds Thrills Visitors at Centennial," *DMN*, June 7, 1936.

[34]Correspondence and Exhibit Specification Files, Centennial Collection, DHS.

[35]"Fire's Havoc," *DMN*, February 11, 1942; "New Bridge on Fair's Lagoon," *DMN*, September 15, 1952.

[36]Dillon, "Back to Fair Park."

[37]Fies; Cutler.

[38]Correspondence file, Centennial Collection, DHS.

[39]"*Contralto* and *Countertenor* to Raise Their Voices Again," City of Dallas Park and Recreation Department Fair Park Newsletter, Spring 2007, accessed January 20, 2012, http://www.dallasparks.org/fairparknews/Spring2007/FPStory2.html; Eric Aasen, "Esplanade Fountain at Fair Park Expected to Make a Splash," *DMN*, December 4, 2009.

[40]Cutler.

[41]"Esplanade Fountain Restoration" plaque.

[42]"King Petroleum Holds Court at Exposition in Permanent Structures Costing $500,000," *DMN*, June 7, 1936.

[43]*Official Guide Book*, 43; "Humble Exhibit to Tell Story of Oil in Texas," *DMN*, May 17, 1936.

[44]*Official Guide Book*, 45; "Oil Displays at Fair to be Greatest Yet," *DMN*, May 19, 1936; "Oil Companies Top Exhibitors."

STATE OF TEXAS BUILDING

[1]"Building Plan Adopted By Officials for Centennial," *The Dallas Morning News* (*DMN*), March 3, 1935.

[2]Ragsdale, 73; "Architects Busy Completing Plans of Hall of Texas," *DMN*, October 10, 1935; Michael V. Hazel, "Building the Westminster Abbey of the New World," *Legacies*, Spring 2011; 19.

[3]Plaque on exterior of State of Texas Building; Sarah Hunter, interview with Carleton Adams, March 8, 1985, transcript in Centennial Collection, Dallas Historical Society (DHS).

[4]Kenneth B. Ragsdale, *Centennial '36: The Year America Discovered Texas* (College Station: Texas A&M University Press, 1987), 179; Sarah Hunter, interview with George Dahl, February 24, 1984, transcript in Centennial Collection, DHS.

[5]Ragsdale, 179; Hazel, 20.

[6]"488-Foot Structure to Dominate Exposition," *DMN*, July 21, 1935; "Architects Busy Completing Plans on Hall of Texas," *DMN*, October 1, 1935; Hazel, 20; Interview with Donald Barthelme, March 1984, transcript in Centennial Collection, DHS.

[7]Hazel, 21; "Work on Giant State Building Ready to Begin," *DMN*, October 12, 1935; Hazel, 21; "Centennial Hall Among 1,908 WPA Projects Refused," *DMN*, September 10, 1935; "Building Starts on Hall of State for Centennial," *DMN*, December 31, 1935.

[8]"Strike Concluded, Work is Resumed on Hall of State," *DMN*, June 10, 1936; Hill, Patricia Evridge, *Dallas: The Making of a Modern City* (Austin: University of Texas Press, 1936), 119; "Hall of State, Central Architectural Piece of Centennial, Dedi-

cated," *DMN*, September 6, 1936.

[9]"Gorgeous Shrine Westminster for Texas, Says Neff," *DMN*, September 6, 1936; Aaron Birdwell Griffing, "Inspiration to Future Ages Seen in Showy Texas Shrine, Focal Point of Centennial," *DMN*, September 26, 1936; "Majesty of State Hall Makes Visitors Instinctively Remove Their Hats and Lower Voices," *DMN*, September 20, 1936; "Heroes of '36 Would Wonder at Magnificence of Hall of State if They Could See It," *DMN*, September 28, 1936.

[10]*The Official Guide Book, Texas Centennial Exposition* (Dallas: Texas Centennial Central Exposition, 1936), 41; Buildings file, Centennial Collection, DHS.

[11]"Majesty of State Hall"; Hazel, 22, 23, 25.

[12]"State Would Despoil Shrine; City Asked to Take Charge," *DMN*, October 10, 1937.

[13]Frank Carter Adams, ed., *The State of Texas Building* (Austin: Steck, 1937), 11.

[14]Interview with Donald Barthelme, DHS.

[15]*The State of Texas Building*, 11.

[16]Ibid., 12.

[17]*The Official Guide Book,* 40.

[18]Adams interview, DHS.

[19]*The State of Texas Building*, 12.

[20]Ibid., 13.

[21]Phillip L. Fry, "Texas, Origin of Name," *Handbook of Texas Online* (http://www.tshaonline.org/handbook/online/articles/pft04), accessed February 5, 2012. Published by the Texas State Historical Association.

[22]Austin Barbosa biographical sketch, Centennial Collection, DHS.

[23]State of Texas Building description, Buildings file, Centennial Collection, DHS.

[24]Notes in Pompeo Coppini biographical file, Centennial Collection, DHS; "Coppini, Pompeo Luigi," *Handbook of Texas Online* (http://www.tshaonline.org/handbook/online/articles/fco67), accessed February 05, 2012. Published by the Texas State Historical Association; Pompeo Coppini biographical file, Centennial Collection, DHS.

[25]*The State of Texas Building*, 20.

[26]Ibid., 20.

[27]"Epic of Texas is Unfolded by Hundreds of Exhibits in Hall of State at Centennial," *DMN*, September 24, 1936.

[28]*The State of Texas Building*, 20.

[29]Adams interview, DHS.

[30]*The State of Texas Building*, 20.

[31]Adams interview, DHS.

[32]*The State of Texas Building*, 24-25.

[33]Kendall Curlee, "Dallas Nine," *Handbook of Texas Online* (http://www.tshaonline.org/handbook/online/articles/kjd01), accessed February 10, 2012, published by the Texas State Historical Association; Ragsdale, 182-183.

[34]Ragsdale, 183.

[35]Interview with Donald Barthelme, March 1984, transcript in Centennial Collection, DHS.

[36]"Medina, Battle of," state historical marker near Leming, Atascosa County, Texas.

[37]*The State of Texas Building*, 31.

[38]Ibid., 31.

[39]Julia Cauble Smith, "East Texas oilfield," *Handbook of Texas Online* (http://www.tshaonline.org/handbook/online/articles/doe01), accessed February 13, 2012, published by the Texas State Historical Association; "Dallas History," DHS, accessed February 10, 2012, http://www.dallashistory.org/history/dallas/dallas_history.htm.

[40]*The State of Texas Building*, 29.

[41]*The State of Texas Building*, 29; Dorothy Austin Webberley, letter to Dallas Historical Society, March 1, 1984, in Centennial Collection, DHS.

[42]Interview with Ethel Wilson Harris, transcript in Centennial Collection, DHS.

[43]*The State of Texas Building*, 29.

[44]Ibid., 32.

[45]Box 14, Buildings file, Centennial Collection, DHS.

46 Joan Jenkins Perez, "Knott, John Francis," *Handbook of Texas Online* (http://www.tshaonline.org/handbook/online/articles/fkn05), accessed February 12, 2012, published by the Texas State Historical Association; *The State of Texas Building*, 32.

47 *The State of Texas Building*, 32, 33.

48 "His Inflamed Tonsils Impel John Knott to Come to Texas and News Gains a Cartoonist," *DMN*, October 1, 1935.

49 *The State of Texas Building*, 34.

50 James Mahoney Jr. letter to Dallas Historical Society, November 1, 1984, in Centennial Collection, DHS.

51 *The State of Texas Building*, 34.

52 Ibid., 37.

53 Ibid., 37.

AGRARIAN PARKWAY

1 Cecil Harper Jr. and E. Dale Odom, "Farm Tenancy," Handbook of Texas Online, accessed December 30, 2011, http://www.tshaonline.org/handbook/online/articles/aefmu; Norris G. Davis, "Rural Electrification," Handbook, accessed December 30, 2011, http://www.tshaonline.org/handbook/online/articles/dpr01; "Poultry Building," Exposition Publicity Department release, undated, TCE Buildings box, Centennial Collection, Dallas Historical Society (DHS).

2 "Hall of Livestock No. 1," "Hall of Livestock No. 2," Publicity Department releases, undated, TCE Buildings box, DHS.

3 "Centennial Sidelights," *The Dallas Morning News* (*DMN*), June 17, 1936; "Meat Thermometer Displayed," *DMN*, June 19, 1936.

4 Wayne Gard, "Fair Visitors to See Debut of New Cattle," *DMN*, May 21, 1936; "Red Grapefruit Shown at Dallas," *San Antonio Express*, October 29, 1936.

5 Carl Held, "Innovations in Livestock are Feature at Centennial," *DMN*, August 23, 1936.

6 "Crippled Children Get Milk from Champion," *DMN*, October 14, 1936.

7 "The Foods Building," *The Official Guide Book, Texas Centennial Exposition* (Dallas: Texas Centennial Central Exposition, 1936), 53; "Fabulous Array of American Foods Being Displayed at Texas Centennial," *DMN*, July 24, 1936.

8 Ibid.

9 "The Midway Gazette: Yanyego Dancers in Voodoo Ritual to Appear at the Fair," *DMN*, August 3, 1936; "American Diet Is Insufficient for Yanyegos of Cuba," *DMN*, August 5, 1936.

10 Louise Elam, *Fair Park Project Summary* (Facility Development Services, Dallas Park and Recreation Department): Appendix A11.

11 "Food & Fiber Building/Fair Park, Dallas, Texas," Good Fulton & Farrell website, accessed January 1, 2012, http://www.gff.com/?p=822.

12 Louise Elam: Appendix A12.

13 Scott M. Haskins, Fine Arts Conservation Laboratories, Inc., letter to Nancy McCoy, ARCHITEXAS, 16 December 1999, Dallas Municipal Archives.

14 Louise Elam: Appendix A10.

15 Bywaters painted murals for post offices in Farmersville, Ranger, and Trinity, Texas. Dozier's post office murals are in Arlington, Fredericksburg, and Giddings. Hogue painted the post office mural in Graham.

16 "Fabulous Array of American Foods Being Displayed at Texas Centennial," *DMN*, July 24, 1936.

17 John Fies, "Electrical Features of the Texas Centennial Central Exposition," paper presented during the October 1936 meeting of the American Institute of Electrical Engineers South West District (State Fair of Texas Archive, 1936.0084), 6.

18 "Pampered Livestock to Live in Glass Houses at Centennial," *DMN*, May 7, 1936; "Shows at Fair Comply With Morals Laws," *DMN*, July 24, 1936.

19 Fine Arts Conservation Laboratories, "Final Condition Report/Conservation Treatment Plan, Resolution No. 99-2004," July 2001 and August 2002, Dallas Municipal Archives; Louise Elam: Appendix A13.

20 "Hall of Livestock No. 2," Publicity Department releases, undated, TCE Buildings box, DHS.

21 "Woofus to Quit His Lofty Post," *DMN*, October 2, 1941; Donald G. Nelson, interview transcript, Summer 1983, Architect and Artist Interviews box, DHS; David Flick, "Woofus Coming Home at Last," *DMN*, August 31, 2002.

22 "Livestock Building No. 2," The Official Guide Book, Texas Centennial Exposition (Dallas: Texas Centennial Central Exposition, 1936), 61.

FEDERAL CONCOURSE

1 "Fair Hamburger Trade Takes Five Steers Daily; Hot Dogs Would Stretch Over Grounds," *The Dallas Morning News* (*DMN*), June 17, 1936.

2 "Bill on Centennial Signed, New Type Building Projected," *DMN*, February 13, 1936; "New Face for Fair," *DMN*, November 17, 1975.

3 "Uncle Sam to Have Centennial Exhibit," *Kerrville (TX) Mountain Sun*, April 30, 1936.

4 "Brief Topics," *The Wellington (TX) Leader*, June 11, 1936.

5 "Robot to Speak in Texas for Labor Bureau; He Apologizes, Then Defends Machinery," *The New York Times*, May 31, 1936.

6 Ibid.

7 Kenneth B. Ragsdale, *The Year America Discovered Texas: Centennial '36* (College Station, TX: Texas A&M University Press, 1987): 177.

8 "New Face for Fair," *DMN*, September 17, 1975; Robert Marshall, "A Towering Achievement," The Medallion, Texas Historical Commission, July/August 2011.

9 Marshall, ibid.

10 Ibid.

11 "Description of the Mural Paintings and Exterior Friezes, United States Building, Texas Centennial Central Exposition," typed report dated 1936, Murals Box, Centennial Collection, Dallas Historical Society (DHS); Letter from George Dahl to Julian Garnsey, 9 July 1936, File X-5 Memos from Mr. Dahl, Centennial Collection, DHS.

12 "Description of the Mural Paintings and Exterior Friezes," Centennial Collection, DHS.

13 Ibid.

14 Ibid.

15 Ibid.; Margaret Swett Henson, "Long, Jane Herbert Wilkinson," *Handbook of Texas Online,* accessed February 13, 2012, http://www.tshaonline.org/handbook/online/articles/flo11.

16 "Description of the Mural Paintings and Exterior Friezes," Centennial Collection, DHS.

17 Letter from George Dahl to William B. Yeager, US Texas Centennial Commission, 8 May 1936, Box 135, Federal Building Interior file, Centennial Collection, DHS.

18 "Description of the Mural Paintings and Exterior Friezes," Centennial Collection, DHS.

19 "Memo to George Dahl from Julian Garnsey, 13 April, 1936, Box 135, Federal Building Interior file, Centennial Collection, DHS.

20 "Description of the Mural Paintings and Exterior Friezes," Centennial Collection, DHS.

21 Ibid.

22 Ibid.

23 Ibid.

24 Baker Hotel Collection, Texas/Dallas History Center, Dallas Public Library, Texas Archival Resources Online, accessed January 7, 2012, http://www.lib.utexas.edu/taro/dalpub/07905/dpub-07905.html.

25 "Description of the Mural Paintings and Exterior Friezes," Centennial Collection, DHS.

26 Willis Cecil Winters, *Fair Park* (Charleston, SC: Arcadia Publishing, 2010): 140.

27 Wool and mohair were used in upholstery; cotton in upholstery and tires; corn was used to produce solvents and butyl alcohol; soybean oil was used in paints and lacquers; sugar cane was used to produce industrial alcohol; and cowhides were tanned to produce leather.

28 Walter Dorwin Teague, "Exhibition Technique," *American Architect and Architecture*, September 1937.

29 Ibid.

30 Willis Winters, *FAIA*, "The Ford Motor Company at the Texas Centennial Exposition," *Legacies*, Spring 2011, p. 11.

31 "Machines Being Installed for Ford Exhibition," *DMN*, March 22, 1936; "The Ford Building," *The Official Guide Book, Texas Centennial Exposition* (Dallas: Texas Centennial Central Exposition, 1936), 81.

32 "Farmer Contributes Much to Present-Day Making of Ford Car," *DMN*, June 7, 1936.

33 "Machines Being Installed for Ford Exhibition," *DMN*, March 22, 1936.

34 Ibid.

35 "Court at Master Studio Makes Centennial Broadcasts Visible to Public," *DMN*, June 7, 1936; "Texas Holds Own With Broadcasting At Fair's Studios," *DMN*, June 23, 1936.

36 Ibid.; "Many Experts Make Up Radio Staff at Fair," *DMN*, June 21, 1936; Al Harting, "Centennial Fever," *Westward Magazine, Dallas Times Herald*, July 13, 1969; "Rousing Welcome Given to Modest Cactus Jack Garner," *DMN*, August 6, 1936.

37 "$75,000 Drugstore Going Into Centennial," DMN, March 22, 1936.

38 "Rio Grande Valley Exhibit," *The Official Guide Book*, 91.

CIVIC CENTER AND CENTENNIAL DRIVE

1 "Building Plan Adopted by Officials for Centennial," *The Dallas Morning News (DMN)*, March 3, 1935.

2 Patricia Everidge Hill, *Dallas: The Making of a Modern City* (Austin: University of Texas Press, 1996), 117.

3 Richard Foster Howard, 1939 radio speech, Box 1, Folder 9, Dallas Museum of Art archives; "Cooling System Draws Crowd to Art Museum," *DMN*, July 28, 1936.

4 Letter from Daniel Rich Catton, Art Institute of Chicago, to Richard Foster Howard, Dallas Museum of Fine Arts, 6 August 1936, Box 1 Folder 6, Centennial Collection, Dallas Historical Society (DHS).

5 "Peggy's Spiel at Museum Planned," *DMN*, July 16, 1936; "Museum Filled As Peggy Lets Art Have Bark," *DMN*, July 18, 1936.

6 "Fair Band Shell Declared Acme of Such Structures," *DMN*, May 3, 1936.

7 "Negroes Stage Big Juneteenth at Centennial," *DMN*, June 20, 1936.

8 John Rosenfield Jr. "Provocative Distortion of 'Macbeth' Given," *DMN*, August 14, 1936; Jesse O. Thomas, *Negro Participation in the Texas Centennial Exposition* (Boston: Christopher Publishing House, 1936), 64-65.

9 Michael Phillips, *White Metropolis: Race, Ethnicity, and Religion in Dallas, 1841-2001* (Austin, TX: University of Texas Press, 2006).

10 Kenneth B. Ragsdale, *The Year America Discovered Texas: Centennial '36* (College Station, TX: Texas A&M University Press, 1987), 177.

11 Donald G. Nelson, interview transcript, Summer 1983, Architect and Artist Interviews box, Centennial Collection, DHS.

12 "Negroes to Throng Fair in Observing Juneteenth Rites," *DMN*, June 18, 1936; "53,000 Visitors Noted at Fair's Negro Life Hall," *DMN*, June 20, 1936.

13 Thomas: 64-65; "Race Jim Crowed At Texas Centennial," *The Chicago Defender (TCD)*, June 27, 1936; "Protest Signs On Lavatories At Texas Fair," *TCD*, July 4, 1936.

14 "Motors to Show All Its Products At Fair Exhibit," *DMN*, May 31, 1936; "$50,000 Covering Will Be Built on Fair Auditorium," *DMN*, May 10, 1936.

15 "Experts Prepare Motors Show," *DMN*, May 20, 1936; "General Motors Auditorium," *The Official Guide Book, Texas Centennial Exposition* (Dallas: Texas Centennial Central Exposition, 1936), 87.

16 Thomas: 129; Buildings file, Box 14, Centennial Collection, DHS.

17"Negro Exhibits Building to Be Dedicated Formerly [sic] on June 19th, Emancipation Day," *DMN,* June 7, 1936.

18Thomas: 26, 129; "Negro Art Works Being Displayed At Fair Exhibit," *DMN,* June 28, 1936.

19Paul L. Dunbar, "A. Maceo Smith and the Hall of Negro Life," *Legacies: A History Journal for Dallas and North Central Texas Fall 2011* (Dallas: Dallas Historical Society, 2011), p. 10; Thomas, 35.

20"Hall of Religion Is Sanctuary For Visitors; Many Exhibits of Religious Nature are on View," *DMN,* June 7, 1936.

21Ibid.

22Emile Guidroz, 26 April 1984 interview transcript, Architect and Artist Interviews box, Centennial Collection, DHS.

23"Hall of Religion Exhibitors Asked To Submit Plans," *DMN,* May 5, 1936.

24Stanley Marcus, *Minding the Store* (Denton, TX: University of North Texas Press, 1997), 91.

25Unidentified newspaper article, January 10, 1936, Texas Centennial Exposition clipping file, Dallas History and Archives Division, Dallas Public Library.

26"Lounge to be Available at Dallas Show," *The Abilene (TX) Morning Reporter-News,* June 7, 1936.

27Helen Sheehy, "Jones, Margaret Virginia," *Handbook of Texas Online,* accessed January 20, 2012, http://www.tshaonline.org/handbook/online/articles/fjo59.

28Kenneth B. Ragsdale, *The Year America Discovered Texas: Centennial '36* (College Station, TX: Texas A&M University Press, 1987): 177.

29Holmes and Saxon: 374; "A Brief History of the Dallas Museum of Art," *Dallas Museum of Art,* accessed January 20, 2012, http://www.dm-art.org/AboutUs/MuseumHistory/index.htm.

30Band shell blueprints, flat file, Dallas Municipal Archives; "Fair Band Shell Declared Acme," *DMN,* May 3, 1936.

31"Band Shell Declared Acme," *DMN,* May 3, 1936.

32"Architects Sue City for Fee on Band Shell," *DMN,* July 1, 1938.

33Letter from George L. Dahl to Ray A. Foley, March 6, 1936 with March 12, 1936 reply from Foley to Dahl, Box 35, Correspondence file, Centennial Collection, DHS; Louise Elam, *Fair Park Project Summary* (Dallas: Facility Development Services, Dallas Park and Recreation Department, undated): Appendix A1.

34M. Babs Ralston, "Rare Blossoms to be Exhibited For Centennial," *DMN,* May 17, 1936; "Board Favors Giving Lee's Name to Park," *DMN,* May 27, 1936; "Texas Plants to be Placed in Fair Hall," *DMN,* August 10, 1936; "The History of Texas Discovery Gardens," *Texas Discovery Gardens,* accessed December 25, 2011, http://texasdiscoverygardens.org/history.php.

35"The History of Texas Discovery Gardens," accessed January 20, 2012.

36"Agreement to Uses of City Buildings at Centennial Made," *DMN,* May 28, 1936; "Domestic Arts Hall to House Park Offices," *DMN,* April 27, 1936; "Civic Center Hall Is Suggested for Library Building," *DMN,* July 31, 1936.

37"Aquarium Gets Big Patronage," *DMN,* September 8, 1936.

38"Aquarium in Dallas Twelfth of Kind to Be Erected in US," *DMN,* June 7, 1936.

39"Aquarium Expected to Achieve Top 4 Rank After Expansion," *DMN,* September 19, 1962; "Marine Wing Makes Debut at Aquarium," *DMN,* October 11, 1964.

40Elam, *Fair Park Project Summary*: Appendix A1.

41"Newspaper Opening Exhibit," *DMN,* May 9, 1936.

42"Park Board Bans Concessions Near City Civic Center," *DMN,* February 26, 1936; Elam, *Fair Park Project Summary*: Appendix A2.

THE MIDWAY, COTTON BOWL, AND SAN JACINTO DRIVE

1*Dictionary.com,* accessed December 26, 2011, http://dictionary.reference.com/browse/back+forty; "The Midway Gazette: Corrine's Effigy on View In Sarg's Marionette Show," *The Dallas Morning News (DMN),* July 21, 1936.

2Richard Howells, "Midget Cities: Utopia, Utopianism, and the Vor-schein of the 'Freak' Show," *Disability Studies Quarterly, Summer 2005 Vol. 25 No. 3,* The Society for Disability Studies.

3"Three Types of Marionettes Added to Centennial Shows," *DMN,* May 17, 1936. "The Midway Gazette: Nations Opens Second Revue; Corinne Stars," *DMN,* August 2, 1936.

4Rand may not have played the Texas Centennial Exposition, but she returned to Dallas almost every year as a star attraction at the State Fair of Texas through at least 1953. Rand and her ostrich feathers headlined the show at the city's Theatre Lounge into the 1960s.

5Alyce Siemens, "Girl About Town," *DMN,* July 5, 1936; "Streets of Paris Life Class Closes," *DMN,* July 31, 1936; "War on Nudity Taken by Local Board to Mayor," *DMN,* August 20, 1936; "Dallas Apparently Headed for Good Moral Scrubbing," *DMN,* August 30, 1936; "Shows at Fair Comply With Morals Laws," *DMN,* July 24, 1936; "Midway Gazette: The Midway Sings Its Own Version of 'Stormy Weather,'" *DMN,* July 22, 1936; "Girl About Town," *DMN,* July 24, 1936; "Centennial Should Be Clean Show," *DMN,* July 28, 1936.

6John Rosenfield Jr., "The Passing Show," *DMN,* June 23, 1936; "The Midway Gazette: Coast Federal Theater Folks Here to Inspect Band Shell," *DMN,* July 2, 1936; "24,534 Demand Mlle. Corrine Use Grapefruit," *Pampa (TX) Daily News,* September 11, 1936.

7Warden Lewis E. Lawes, "Crime Prevention Exhibit First of Its Kind Anywhere Says Celebrated Penologist," *DMN,* June 7, 1936.

8"Chair Victim Popular With Amorous Fans," *DMN,* July 4, 1936.

9"The President's Speech at Dallas Exposition," *The New York Times,* June 13, 1936; "Throngs Boost Fair's Total to Near 2,000,000," *DMN,* July 20, 1936; "Judge Continues Annulment Trial of Siamese Twin," *DMN,* October 15, 1936.

10Walter Dorwin Teague Album, Hagley Museum and Archive Digital Collection, accessed December 26, 2011, http://digital.hagley.org/cdm4/document.php?CISOROOT=/p268001coll4&CISOPTR=8272&REC=1.

11"Midway Shows Provide Fun for All," *The San Antonio Light,* June 30, 1936.

12"State Fair Midway to Get First Facelift," *DMN,* September 10, 1978.

13Hollywood Animal Stars advertisement, *DMN,* June 7, 1936; Hollywood Nights advertisement, *DMN,* July 28, 1936.

14"Fair Teaching Employees for Ticket Booths," *DMN,* May 7, 1936.

15"Selected Secretary for Centennial Club Formed at Exposition," *DMN,* May 22, 1936; Jay Hall, "Dallas Night Clubs Equal Nation's Best," *DMN,* June 7, 1936.

16Teague Album, Hagley Museum.

17Telegram from Walter Dorwin Teague to the Texas Centennial Exposition, February 1936, Box 80, Walter Dorwin Teague file, Centennial Collection, Dallas Historical Society (DHS).

18"National Cash Register Building," *The Official Guide Book, Texas Centennial Exposition* (Dallas: Texas Centennial Central Exposition, 1936), 91; "Midway Shows Provide Fun For All," *The San Antonio Light.*

19"Contemporary House for Use of Southwesterners to Be Dedicated Sunday," *DMN,* July 5, 1936.

20Ibid.

21"Girl Scouts to Get House," *DMN,* May 14, 1938; "Girl Scout House will be Setting for New Activity," *DMN,* January 28, 1940; "Dallas Woman Going to Girl Scout Meet," *DMN,* November 11, 1949.

22"Company Building 39 Houses," *DMN,* December 13, 1936.

23"100,000 Visit Masonite Home at Centennial," *DMN,* August 9, 1936; "Modernistic Effect Achieved in Masonite Exhibition Home Attracting Throngs at Fair," ibid.

24Sanger Bros. advertisement, *DMN,* July 19, 1936.

25"WPA Exhibit Hall to Open," *DMN,* July 28, 1936; "Centennial WPA Building Shows Work of Groups," *DMN,* August 15, 1936; "Reviewing the Reviews: What the Centennial Leaves in Auditoria," *DMN,* November 1, 1936.

26Contract between City of Dallas and Naval Reserve Association of Dallas, August 13, 1937, Box 13, Folder 4, Centennial Collection, DHS; Contract between City of Dallas and Texas Defense Guard, October 2, 1942, ibid.; "Old WPA Wrecking Started," *DMN,* February 28, 1948.

27"Biggest State Fair Ready to Receive Crowd," *DMN,* October 11, 1930; "Fair Park Stadium is Renamed Cotton Bowl by City Officials," *DMN,* January 28, 1936; "City Lets Paving and Statue Jobs," *DMN,* April 11, 1936; "Fountans [sic], Benches, Restrooms for Comfort of Fair Visitors," *DMN,* June 7, 1936.

28"Municipal Sub-Station," Box 14, TCE Buildings File, Centennial Collection, DHS.

FAIR PARK AFTER 1936

1"Fair Pay Roll Nears $300,000 Weekly, Aids Business," *The Dallas Morning News (DMN),* March 15, 1936; "6,353,827 Saw Exposition," *The New York Times,* December 1, 1936.

2Barry Bishop, "Gaiety at Fair Supplanted by Somber Hours," *DMN,* December 7, 1936.

3Corinn Lewis, "Dallas, Texas," *The Chicago Defender,* November 28, 1936; Jesse O. Thomas, *Negro Participation in the Texas Centennial Exposition* (Boston: Christopher Publishing House, 1938), 120-121; "Congress Urged To Adjourn for Exposition Day," *DMN,* March 11, 1937; "Texas To Give Back $50,000 of US Fund," *DMN,* December 10, 1937.

4"Exposition Asks Council to Spend $300,000," *DMN,* December 30, 1936; "Park Directors To Put $42,000 Into Exposition," *DMN,* February 11, 1937; "Civic Center Upkeep Gives City Problem," *DMN,* November 21, 1936; "Council Declines Bills for Museum When Fair Closes," *DMN,* November 28, 1936.

5"State Hall May Stay Closed During Fair," *DMN,* May 18, 1937; "State Would Despoil Shrine; City Asked to Take Charge," *DMN,* October 30, 1937.

6"Pan-American Beauty Being Built at Fair," *DMN,* May 10, 1937; "The Greater Texas & Pan-American Exposition," Special Section, *DMN* and *The Dallas Journal,* June 11, 1937.

7"Mexico Will Seek Friends Not Trade at Big Exposition," *DMN,* March 13, 1937.

8Jeff Davis, "Dallas and Fort Worth Shows Lavishly Staged," *The San Antonio Light (SAL),* July 13, 1937; "Fair Attendance Near Peak," *SAL,* October 24, 1938; Paul Crum, "Big D," *DMN,* June 16, 1952.

9"World's Greatest!," *DMN, Rotogravure,* October 2, 1938; "Garner Executes Deed for Federal Building at Fair," *DMN,* December 9, 1937; "Hall of State Repair Bids to Be Asked Soon," *DMN,* April 14, 1938; "Council Plans Week's Study Over Museum," *DMN,* May 14, 1938; "Texas Shrine Enters New Service Era," *DMN,* June 24, 1938; Sam Acheson, "This and That in the News," *DMN,* August 21, 1941.

10"Woofus to Quit His Lofty Post," *DMN,* October 2, 1941; "Vast Blaze Wrecks Fair's Auto Building," *DMN,* February 10, 1942;

11"Progress on the Conservation Treatments of the Carlo Ciampaglia Murals," Fair Park Mural Conservation Project, http://www.fairparkmurals.com/progress/, accessed January 29, 2012.

12"Phone Group Plans Rally For Defense," *DMN,* March 16, 1942; "Gather Scrap and Win War, is Rally Cry," *DMN,* August 30, 1942.

13"New Buildings, Beauty Area, State Fair Plan," *DMN,* June 10, 1945.

14"Fair Puts Off New Building," *DMN,* May 15, 1947; "New Auto Building Steel is Laid," *DMN,* March 22, 1948; "South's Largest Show Opens in Auto Building," *DMN,* October 10, 1948.

15Francis Raffetto, "State Fair to Get General Revamping," *DMN,* September 22, 1962; Gary Cartwright, "Doomed Cotton Bowl Symbol of a Dead Era," *DMN,* January 16, 1966; Tom Johnson, "Cullum Would Triple Park, Build Bowl," *DMN,* March 23, 1967; "Competition Hurting Fair," *DMN,* October 26, 1969; Carolyn Barta, "Fair Park Plan Being Revisited," *DMN,* Febrary 12, 1969.

16Bevis Hillier and Stephen Escritt, *Art Deco Style* (London:

Phaidon Press, 1997).

[17] Janet Kutner, "Ada Louise Huxtable: A Critic's Impressions of Area Architecture," *DMN*, November 14, 1967.

[18] Henry Tatum, "Major Renovations Planned for Fair Park," *DMN*, February 9, 1974; "New Face for Fair . . .," *DMN*, September 17, 1975.

[19] Kent Biffle, "He Finds Dallas' Lost Art," *DMN*, January 6, 1978.

[20] Henry Tatum, "$51 million Fair Park plan OK'd," *DMN*, July 17, 1981.

[21] Tatum, "Bond Supporters Fear Proposition 8 Will Fail," *DMN*, July 28, 1982; Tatum, "Groups Raise $420,000 to Back Dallas Bonds," *DMN*.

[22] Terry Maxon, "Fair Park's Art Deco Praised," *DMN*, September 23, 1983; Maxon, "Park Board OKs Fair Park Face Lift," *DMN*, November 11, 1983; *Fair Park Comprehensive Development Plan* (San Francisco: Hargreaves Associates, 2003).

[23] Virginia Savage McAlester, "Friends of Fair Park," *Texas Monthly Magazine*, October 1989.

[24] Robert Marshall, "A Towering Achievement," *The Medallion*, Texas Historical Commission, July/August 2011.

[25] "First Lady Announces $30 Million in Save America's Treasures grants," *Heritage Preservation, The National Institute for Conservation*, http://www.heritagepreservation.org/news/grants1.htm, accessed February 4, 2012; Louise Elam, *Fair Park Project Summary* (Dallas: Facility Development Services, Dallas Park and Recreation Department, undated): Appendix A1.

[26] "Progress on the Conservation Treatments of the Carlo Ciampaglia Murals," *Fair Park Mural Conservation Project*, City of Dallas, www.fairparkmurals.com/progress/, accessed February 4, 2012; "Sunscreens for Fair Park Murals Preserve Vision of Progress," *Fair Park, Talk of the Town*, Friends of Fair Park newsletter, Spring 2006.

[27] *Fair Park Comprehensive Plan*: 23, 27.

[28] Rodriguez, Alicia, "Can We Save Them?" *Historic Preservation*, July/August 1995. City of Dallas Park and Recreation Department News Advisory, "American Planning Association Designates Fair Park One of Top 10 Great Public Spaces for 2011," October 4, 2011.

ARCHITECTS AND ARTISTS

[1] Ellis A. Davis, "Carleton W. Adams," *New Encyclopedia of Texas* (Dallas: Texas Development Bureau, 1929), 755. Christopher Long, "Adams, Carleton W.," *Handbook of Texas Online*, accessed August 27, 2011, http://www.tshaonline.org/handbook/online/articles/fad25.

[2] Donald Barthelme Sr. March 1981 interview transcript, Architect and Artist Interviews box, Centennial Collection, Dallas Historical Society (DHS); "Donald Barthelme Sr. Architectural Papers, 1924-1997," *Texas Archival Resources Online*, accessed August 28, 2011, http://www.lib.utexas.edu/taro/uhsc/00040/hsc-00040.html.

[3] "Ralph Cameron: An Inventory of his Drawings and Architectural Records, 1914-1970," *Texas Archival Resources Online*, accessed December 26, 2011, http://www.lib.utexas.edu/taro/utaaa/00008/aaa-00008.html.

[4] Biographical sketch, Architects and Artists box, Centennial Collection, DHS; "Fabulous Array of American Foods Being Displayed at Texas Centennial," *The Dallas Morning News (DMN)*, July 24, 1936; US Social Security Death Index.

[5] "Architect Completes Master Plan for Main Centennial Site," *The Dallas Journal*, March 2, 1935; "Paul Phillipe Cret," *The Cultural Landscape Foundation*, accessed December 13, 2011, http://tclf.org/content/paul-cret.

[6] Band Shell blueprints, flat file, Dallas Municipal Archives; "Monday Rites Slated Here For Architect," *DMN*, July 1, 1953; "Council OK's Buildings for Zoo," *DMN*, January 27, 1960.

[7] Biographical sketch, Architects and Artists box, Centennial Collection, DHS; Christopher Long, "Dahl, George Leighton," *Handbook of Texas Online*, http://www.tshaonline.org/handbook/online/articles/fda86, accessed August 20, 2011; "George Dahl, 93, Buildings Designer," *Chicago Tribune*, July 20, 1987.

[8] Stanley Marcus, *Minding the Store: A Memoir* (Denton, TX: University of North Texas Press, 1974), 92-94; Norman Rozeff, "Harlingen History," accessed August 18, 2011, http://cameroncountyhistoricalcommission.org/Harlingen%20History.htm; "Roscoe Plimpton DeWitt (1894-1975)," *The Monuments Men*, accessed August 18, 2011, http://www.monumentsmenfoundation.org/bio.php?id=72.

[9] Ida Heacock-Baker, "Tribute to Commander George P. Washburn," *Journal of the Thirty-Eighth Annual Convention Department of Kansas Woman's Relief Corps Auxiliary to the Grand Army of the Republic* (Topeka, KS: Kansas State Printing Plant, 1922), 135-136; "G. H. Thomas Washburn," *Ottawa (Kansas) Herald*, August 9, 1972; World War II draft registration card for George Henry Thomas Washburn, Serial Number U3866; State of Texas Certificate of Death for George Henry Thomas Washburn, State File No. 59916, 8 August 1972.

[10] "Construction Starts on Streets of Paris," *DMN*, May 10, 1936; United States Census record for Francis J. Dittrich, Riverside, Cook County, Illinois, 1930; George S. Koyl, ed., *American Architects Directory, First Edition* (New York: R. R. Bowker Company, 1955), 138; US Social Security Death Index.

[11] "Theatre Designer Dies at Dallas," *The Big Spring (TX) Daily Herald*, October 20, 1937, 3; Texas State Department of Health Standard Death Certificate, State File No. 49449, 19 October 1937.

[12] "James Cheek Burial Conducted in Dallas," *DMN*, April 1, 1970; "Developers Spending $1,500,000 on Store Center," *DMN*, October 12, 1930; Highland Park Shopping Village, National Historic Landmark Nomination, Texas Historical Commission, Austin.

[13] "Hare & Hare," *The Cultural Landscape Foundation*, accessed September 14, 2011, http://tclf.org/pioneer/hare-hare.

[14] Biographical sketch, "Bertram C. Hill architectural plans, papers and other materials," *Texas Archival Resources Online*, accessed November 18, 2011, http://www.lib.utexas.edu/taro/smu/00134/smu-00134.html.

[15] "Jessen and Jessen papers, 1938-1974," *Texas Archival Resources Online*, accessed December 26, 2011, http://www.lib.utexas.edu/taro/utaaa/00109/aaa-00109.html; David Bush and Jim Parsons, *Hill Country Deco: Modernistic Architecture of Central Texas* (Fort Worth: TCU Press, 2010).

[16] W. Hawkins Ferry, *The Legacy of Albert Kahn* (Detroit: Wayne State University Press, 1987), 8-11; "Albert Kahn," *Buildings of Detroit*, accessed August 19, 2011, http://buildingsofdetroit.com/architects/kahn; "Albert Kahn, Architect," *Ford Long Beach Assembly Plant*, accessed August 19, 2011, http://fordmotorhistory.com/factories/long_beach/kahn.php.

[17] "Lang and Witchell: An Inventory of Their Collection," *Texas Archival Resources Online*, accessed November 18, 2011, http://www.lib.utexas.edu/taro/utaaa/00066/aaa-00066.html.

[18] "Architect Lemmon dies at 86," *DMN*, December 23, 1975; "Bids for Stadium Due About March 1," *DMN*, January 11, 1930; Christopher Long, "Lemmon, Mark," *The Handbook of Texas Online*, accessed December 7, 2011, http://www.tshaonline.org/handbook/online/articles/fle64.

[19] World War II draft registration card for William Lescaze, Serial Number U3727; D. J. Huppatz, "Whatever Happened to William Lescaze?" *Critical Cities*, April 29, 2010, http://djhuppatz.blogspot.com/2010/04/whatever-happened-to-william-lescaze_29.html; Marcus, *Minding the Store*, 91.

[20] George S. Koyl, ed., *American Architects Directory, Second Edition* (New York: R. R. Bowker Co., 1962), 452. Biographical sketch, Architects and Artists box, Centennial Collection, DHS; "George Wheeler McLaughlin," *The AIA Historical Directory of American Architects*, accessed August 23, 2011, http://communities.aia.org/sites/hdoaa/wiki/Wiki%20Pages/ahd1029679.aspx.

[21] Autobiographical sketch (handwritten), Architects and Artists box, Centennial Collection, DHS; Richard W. Amero, "San Diego Invites the World to Balboa Park a Second Time," *The Journal of San Diego History*, Fall 1985, Volume 31, Number 4; "Historic Landmark No. 551-Cortis and Elizabeth Hamilton/Richard S. Requa House," *Legacy 106*, accessed September 11, 2011, http://www.legacy106.com/CortisandElizabethHamiltonRichardSRequaHouse.htm.

[22] Biographical sketch, Architects and Artists box, Centennial Collection, DHS; Christopher Long, "Donald Siegfried Nelson," *Handbook of Texas Online*, accessed August 10, 2011, http://www.tshaonline.org/handbook/online/articles/fnejz.

[23] Biographical sketch, Architects and Artists box, Centennial Collection, DHS; John Elderfield, ed., *Philip Johnson and The Museum of Modern Art* (New York: The Museum of Modern Art, 1998), 52; US Social Security Death Index.

[24] State of Texas Certificate of Death for Luther Edward Sadler, State File No. 76245, 24 December 1965; World War II draft registration card for Luther Edward Sadler, Serial Number U1075; Jay C. Henry, *Architecture in Texas: 1895-1945* (Austin: University of Texas Press, 1993), 317; Harry Francis Mallgrave, *Modern Architectural Theory: A Historical Survey, 1673-1968* (New York: Cambridge University Press, 2005), 338; "Funeral Set for L. E. Sadler," *DMN*, December 26, 1965.

[25] "Court at Master Studio Makes Centennial Broadcasts Visible to Public," *DMN*, June 7, 1936.

[26] "Industrial Designer: Walter Dorwin Teague (1883-1960)," North Dakota Museum of Art, accessed August 20, 2011, http://www.ndmoa.com/WalterDorwinTeague.html; Michael DiTullo, "Last Man Standing: 80 years of Teague Design," *core77*, accessed August 19, 2011, http://core77.com/reactor/08.06_teague.asp.

[27] Muriel Quest McCarthy, *David R. Williams: Pioneer Architect* (Dallas: Southern Methodist University Press, 1984).

[28] Biographical sketch and letter to DHS, 1 March 1984, Architects and Artists box, Centennial Collection, DHS; Joe Simnacher, "Dallas Sculptor Dorothy Austin Webberley Created Noted Works," *DMN*, February 2, 2011.

[29] Biographical sketch, Architects and Artists box, Centennial Collection, DHS; Ellen Stone, "The Artist as Sportsman," *D Magazine*, April 1977.

[30] "The Texas Exposition," *Daily Capital News (Jefferson City, MO)*, November 12, 1936; "Fair Park, TX: Art and Architecture Fact Sheet," accessed October 3, 2009, http://www.dallascityhall.com/FairPark/fair_park_factsheet.html; "Pierre Bourdelle Mural," *Mural Makers*, accessed August 10, 2011, http://muralmakers.blogspot.com/2009/02/mural-by-pierre-bourdelle-actually.html; "War Restricts Use Of Largest Liner Ever Built In US," *The Port Arthur (TX) News*, May 10, 1940, p. 9; John Gaines, "Marine Log: Visitors Touring Savannah See Merchant Fleet Future," *The Galveston (TX) News*, February 8, 1963, 12.

[31] Francine Carraro, "Bywaters, Williamson Gerald [Jerry]," *Handbook of Texas Online*, accessed December 13, 2011, http://www.tshaonline.org/handbook/online/articles/fby14.

[32] Biographical sketch, Architects and Artists box, Centennial Collection, DHS.

[33] "Coppini, Pompeo Luigi," *The Handbook of Texas Online*, accessed September 29, 2009, http://www.tshaonline.org/handbook/online/index.html.

[34] "Fair Illumination Declared Foremost Item of Exposition," *DMN*, June 26, 1936; C. M. Cutler biographical sketch in Centennial Collection, DHS; *The Kentuckian*, yearbook of the University of Kentucky, 1940, 89; *The Billboard*, November 24, 1956, 68.

[35] Biographical sketch, Architects and Artists box, Centennial Collection, DHS; "The American Academy Awards," *The Architectural Record*, January 1914, 176; "George Davidson (1889-1965)," Hamilton Auction Galleries, accessed August 19, 2011, http://hamiltonauctiongalleries.com/davidson-bios.htm.

[36] Amy Helene Kirschke, *Aaron Douglas: Art, Race and the Harlem Renaissance* (Jackson, MS: University Press of Mississippi, 1995), 2-9; Susan Earle, "Harlem, Modernism, and Beyond," *Aaron Douglas: African American Modernist* (Lawrence, KS: The University of Kansas, 2007), 33, 52; "Aaron Douglas's Magisterial 'Aspects of Negro Life'," *Treasures of the New York Public Library*, accessed August 21, 2011, http://exhibitions.nypl.org/treasures/items/show/170.

37 Otis Dozier, 3 February 1984 interview transcript, Architect and Artist Interviews box, DHS; Philip Parisi, *The Texas Post Office Murals: Art for the People* (College Station, TX: Texas A&M University Press, 2004), 155-156; "The Sketchbooks of Otis Dozier: A Centennial Celebration," accessed August 18, 2011, http://smu.edu/cul/hamon/gallery/Dozier/index.htm; Kendall Curlee, "Dallas Nine," *The Handbook of Texas Online,* accessed August 18, 2011, http://www.tshaonline.org/handbook/online/articles/kjd01.

38 Stephen May, '1934: A New Deal for Artists' At Smithsonian American Art Museum," *Antiques and The Arts Online,* accessed October 16, 2011, http://antiquesandthearts.com/2009-05-12__12-44-58.html&page=2; *Smithsonian American Art Museum,* accessed October 17, 2011, http://www.americanart.si.edu/collections/search/; "WPA Exhibit Hall to Open," *DMN,* July 28, 1936, 14.

39 Frank Carter Adams, ed., *The State of Texas Building* (Austin: Steck, 1937), 32, 34; Biographical sketch, Architects and Artists box, Centennial Collection, DHS; Kendall Curlee, "Ford, Lynn," *The Handbook of Texas Online,* accessed August 28, 2011, http://www.tshaonline.org/handbook/online/articles/ffo54.

40 "Andronicus Honorary," *The Archi of Alpha Rho Chi, Vol. XI No. 6,* June 1, 1930; Biographical sketch, Architects and Artists box, Centennial Collection, DHS; "Garnsey, Julian," *Pacific Coast Architecture Database,* accessed August 19, 2011, https://digital.lib.washington.edu/architect/architects/1680/; "Julian E. Garnsey Biographical Information," *Mural Conservancy of Los Angeles,* accessed August 19, 2011, http://lamurals.org/MuralistPages/Garnsey.html; "Julian Garnsey, 82, Color Consultant," *The New York Times,* December 18, 1969.

41 Adams, ed., *The State of Texas Building,* 12; Biographical sketch, Architects and Artists box, Centennial Collection, DHS; Susan V. Craig, *Biographical Directory of Kansas Artists (Active Before 1945)* (Lawrence, KS: The University of Kansas, 2009), 138; State of Texas Certificate of Death for Harry Lee Gibson, State File No. 12618, 2 February 1966.

42 Biographical sketch, Architects and Artists box, Centennial Collection, DHS; "Centennial's Stunning Beauty Due to Unique Style of Architecture," *DMN,* June 7, 1936; Buie Harwood, *Decorating Texas: Decorative Painting in the Lone Star State from the 1850s to the 1950s* (Fort Worth: TCU Press, 1993), 68-69; State of Texas Certificate of Death for Eugene John Gilboe, State File No. 68985, 14 November 1964.

43 "Leaves His Texas Ranch to Take Up Art Study Here," *The Milwaukee Journal,* June 19, 1933; "Local Artist Served as Borglum Assistant," *The Milwaukee Sentinel,* March 7, 1941; "Colors are Skillfully Used at Radio City," *The Milwaukee Journal,* August 23, 1942.

44 Emile Guidroz, 26 April 1984 interview transcript, Architect and Artist Interviews box, Centennial Collection, DHS; Paula L. Grauer, Michael R. Grauer, *Dictionary of Texas Artists, 1800-1945* (College Station, TX: Texas A&M University Press, 1999), 41.

45 "Harris, Ethel Wilson, House," National Register of Historic Places narrative description (2001), NR reference number 1000325; Steve Bennett, "Tile Artists Captured City's Essence," *San Antonio Express-News,* September 13, 2009; Biographical sketch, Architects and Artists box, Centennial Collection, DHS.

46 Lea Rosson DeLong, "Hogue, Alexandre," *Handbook of Texas Online,* accessed August 28, 2011, http://www.tshaonline.org/handbook/online/articles/fhoad; "Alexandre Hogue: An American Visionary-Paintings and Works on Paper," *Fort Worth Museum of Science and History,* accessed August 28, 2011, http://www.fwmuseum.org/alexandre-hogue-american-visionary-%E2%80%93-paintings-and-works-paper; "Artists, Sculptors Busy at Centennial," *DMN,* March 29, 1936.

47 Jack Sheridan, Obituary of Raoul Josset, *Lubbock Avalanche-Journal,* June 1957; Biographical sketch, Architects and Artists box, Centennial Collection, DHS.

48 "Gifts of Art, From the Heart," *Blair* [Academy] *Bulletin,* Fall-Winter 2009, 24,26; W. Ryerson Johnson, *The Autobiography of W. Ryerson Johnson,* unpublished manuscript, 1995, private collection of Bill Pronzini, Petaluma, California; "Many Artists Speed Murals for Big Fair," *DMN,* March 29, 1936; "Gozo Kawamura Memorial Museum of Art," Saku City website, accessed November 21, 2011, http://www.city.saku.nagano.jp/cms/html/entry/895/277.html.

49 Adams, ed., *The State of Texas Building,* 12; *Texas, The Land of the Tejas,* WorldCat, accessed August 28, 2011, http://www.worldcat.org/title/texas-the-land-of-the-tejas/oclc/2653561&referer=brief_results; *Vincente Silva and His 40 Bandits,* WorldCat, accessed August 28, 2011, http://www.worldcat.org/search?q=vincente+silva+and+his+40+bandits&qt=results_page; "Women in the Arts," *El Paso Herald-Post,* January 2, 1963, A8; "Way Out Art," *El Paso Herald-Post,* February 12, 1964, B5.

50 Juan B. Larrinaga, autobiographical sketch, Architects and Artists box, Centennial Collection, DHS; "Señor Juan Larrinaga," *Centennial News,* Vol. 1 No. 13, November 30, 1935; Juan B. Larrinaga, interoffice communication to George Dahl, August 13, 1935, cited in Carla Breeze, *American Art Deco: Architecture and Regionalism* (New York: W. W. Norton & Company, 2003), 189.

51 Adams, ed., *The State of Texas Building,* 29; "Tom Lea Biography," *Tom Lea Institute,* accessed August 28, 2011, http://www.tomlea.net/biography_abbrev.html.

52 "Many Artists Speed Murals for Big Fair," *DMN,* March 29, 1936; John and Deborah D. Powers, "Lignell, Lois," *Texas Painters, Sculptors and Graphic Artists: A Biographical Dictionary of Artists in Texas Before 1942* (Austin: Woodmont Books, 2000); "Illinois Guest Visiting Here," *Montana Standard* (Butte), March 20, 1959; "Peace Group to Mark Jane Addams' Birthday," *Daily Herald* (Chicago), August 29, 1963; W. Ryerson Johnson, *The Autobiography of W. Ryerson Johnson,* unpublished manuscript, 1995, private collection of Bill Pronzini, Petaluma, California.

53 Adams, ed., *The State of Texas Building,* 34; Victor Colby et al., "James Owen Mahoney," Cornell University Faculty Memorial Statement, http://ecommons.library.cornell.edu/handle/1813/17813.

54 Steven R. Butler, "Raoul Josset and Jose Martin: A Tale of Two Artists," *Legacies: A History Journal for Dallas and North Central Texas, Fall 2011* (Denton, TX: Texas State Historical Association).

55 "Miller, Madelyn," *Art Inventories Catalog, Smithsonian American Art Museum,* Smithsonian Institution Research Information System, accessed December 22, 2011, http://siris-artinventories.si.edu/ipac20/ipac.jsp?&term=%22Miller,+Madelyn%22&index=.AW&limit=Lo01+%3D+ias.

56 "Perry Nichols Art Work and Papers: A Guide to the Collection," *Texas Archival Resources Online,* accessed September 11, 2011, http://www.lib.utexas.edu/taro/smu/00140/smu-00140.html.

57 Adams, ed., *The State of Texas Building,* 33; Biographical sketch, Architects and Artists box, Centennial Collection, DHS; US Social Security Death Index.

58 "Portrait of Joseph Renier's," *Smithsonian American Art Museum,* accessed August 24, 2011, http://americanart.si.edu/collections/search/artwork/?id=21378; "Joseph Renier's Sculpture 'Speed,'" *LIFE,* accessed August 23, 2011, http://www.life.com/gallery/41782/image/53372079/future-vision-ny-worlds-fair-1939#index/30.

59 US Building file, Texas Centennial Exposition-Works-Murals box, Centennial Collection, DHS.

60 "First Public Works of Art Project Fresco Completed at Mines," *El Paso Herald Post (EPHP),* April 21, 1934; Jerry Bywaters, "Lesser Known Cahero Frescoes Equal Those of Rivera," *DMN,* July 15, 1934; "Art Show to Be November 23-28, *EPHP,* November 15, 1935; "Centennial's Stunning Beauty Due to Unique Style of Architecture," *DMN,* June 14, 1936; "Duke Russell's Novel Ceroplastic Figures," *DMN,* July 12, 1937; "Mostly Personal," *DMN,* August 22, 1937; Betty Luther, "El Pasoan Creates Animals that Cavort in Odd Picture Fantasia," *EPHP,* November 13, 1940; "Miss Hortensia Salazar and Duke Russell will Marry Friday," *EPHP,* March 4, 1943; Listing for Russell, Thomas J., Fifteenth Census of the United States: 1930, Enumeration District 71-69, Sheet 9B, 10 April 1930.

61 Biographical sketch, Architects and Artists box, Centennial Collection, DHS; "Alma Mater, 1932," Public Art at Yale, accessed August 11, 2011, http://www.yale.edu/publicart/almamater.html; US General Services Administration, *Murals at Ariel Rios Federal Building 1935-2006* (Washington: US General Services Administration, 2006).

62 Biographical sketch, Architects and Artists box, Centennial Collection, DHS; Joseph A. Serbaroli Jr. "Hector Serbaroli: A Scenic Legacy," *Perspective: The Journal of the Art Directors Guild,* October-November 2008.

63 Emile Guidroz, 26 April 1984 interview transcript, Architect and Artist Interviews box, Centennial Collection, DHS.

64 Adams, ed., *The State of Texas Building,* 31, 33; "Smith, Frances Sutah [Polly]," *Handbook of Texas Online,* accessed August 28, 2011, http://www.tshaonline.org/handbook/online/articles/fsmxm.

65 Biographical sketch, Architects and Artists box, Centennial Collection, DHS.

66 Biographical sketch, Architects and Artists box, Centennial Collection, DHS; Edward Lebow, "The Amazing Colossal Sculptor," *Phoenix New Times,* October 31, 1996.

67 Biographical sketch, Architects and Artists box, Centennial Collection, DHS; Kendall Curlie, "Tennant, Allie Victoria," *Handbook of Texas Online,* accessed August 9, 2011, http://www.tshaonline.org/handbook/online/articles/fte37; State of Texas Certificate of Death for Allie Victoria Tennant, State File No. 86055, 19 December 1971.

68 Adams, ed., *The State of Texas Building,* 31; "Olin Travis," *Travis House Graphics,* accessed August 22, 2011, http://dhtravis.weblogger.com/?page_id=25; W. Russ Aikman, "Travis, Olin Herman (1888–1975)," *The Encyclopedia of Arkansas History & Culture,* accessed August 28, 2011, http://encyclopediaofarkansas.net/encyclopedia/entry-detail.aspx?entryID=3346; Susan Lee Travis, "Pilgrims of the Palette: The Artistic Legacy of Olin Herman Travis" (PhD diss., Pacifica Graduate Institute, 2009); State of Texas Certificate of Death for Olin Herman Travis, State File No. 88623, 4 December 1975.

69 Biographical sketch, Architects and Artists box, Centennial Collection, DHS; Frank Carter Adams, ed., *The State of Texas Building* (Austin: Steck, 1937), 20; Dorothy S. Schmidt, "Winn, James Buchanan, Jr.," *Handbook of Texas Online, accessed August 11, 2011,* http://www.tshaonline.org/handbook/online/articles/fwi86.

70 "Motors to Show all its Products at Fair Exhibit," *DMN,* May 31, 1936; "Experts Prepare Motors Show," *DMN,* May 20, 1936; "Progress on GM Fair Exhibit," *Oakland (CA) Tribune,* April 14, 1940.

71 "Cement Modeler Gives Work Aged Look in Alamo Replica," *DMN,* May 31,1936; "History of Texas Told in Federal Building Murals," *DMN,* June 14, 1936; William S. Wood, Obituary, *DMN,* November 15, 1975.

BIBLIOGRAPHY

Adams, Frank Carter, ed. *The State of Texas Building*. Austin: Steck, 1937.

Breeze, Carla. *American Art Deco: Architecture and Regionalism*. New York: W. W. Norton & Company, 2003.

Brettell, Richard R. and Willis Cecil Winters. *Crafting Traditions: The Architecture of Mark Lemmon*. Dallas: Meadows Museum, Southern Methodist University, 2005.

Butler, Steven R. "Raoul Josset and Jose Martin: A Tale of Two Artists," *Legacies: A History Journal for Dallas and North Central Texas, Fall 2011*. Dallas: Dallas Heritage Village, The Dallas Historical Society, The Sixth Floor Museum at Dealey Plaza.

Carraro, Francine. *Jerry Bywaters: A Life in Art*. Austin: University of Texas Press, 1994.

Chariton, Wallace O. *Texas Centennial: The Parade of an Empire*. Plano, TX: Wallace O. Chariton, 1979.

Cohen, Henry and David Lefkowitz, Ephraim Frisch. *One Hundred Years of Jewry in Texas and Description of the Jewish Exhibit in the Hall of Religion-Texas Centennial Exposition 1836-1936*. Austin: The Jewish Advisory Committee for the Texas Centennial Religious Program, 1936.

Craig, Susan V. *Biographical Directory of Kansas Artists (Active Before 1945)*. Lawrence, KS: The University of Kansas, 2009.

Cummins, Light Townsend. "From the Midway to the Hall of State at Fair Park: Two Competing Views of Women at the Dallas Centennial of 1936." *Southwestern Historical Quarterly, Vol. CXIV, No. 3, January 2011*. Denton, TX: Texas State Historical Association.

Cutler, C. M. "Illumination of Texas Centennial Central Exposition," *Transactions of the Illuminating Engineering Society*, November 1936.

Davis, Ellis A. *New Encyclopedia of Texas*. Dallas: Texas Development Bureau, 1929.

Dunbar, Paul L. "A. Maceo Smith and the Hall of Negro Life," *Legacies: A History Journal for Dallas and North Central Texas*, Fall 2011.

Earle, Susan. "Harlem, Modernism, and Beyond," *Aaron Douglas: African American Modernist*. Lawrence, KS: The University of Kansas, 2007.

Elam, Louise. *Fair Park Project Summary*. Dallas: Dallas Park and Recreation Department, undated.

Fair Park Comprehensive Development Plan. San Francisco: Hargreaves Associates, October 2003.

Ferry, W. Hawkins. *The Legacy of Albert Kahn*. Detroit: Wayne State University Press, 1987.

Fox, Stephen. *The Country Houses of John F. Staub*. College Station, TX: Texas A&M University Press, 2007.

Grauer, Paula L. and Michael R. Grauer. *Dictionary of Texas Artists, 1800-1945*. College Station, TX: Texas A&M University Press, 1999.

Harwood, Buie. *Decorating Texas: Decorative Painting in the Lone Star State from the 1850s to the 1950s*. Fort Worth: TCU Press, 1993.

Henry, Jay C. *Architecture in Texas: 1895-1945*. Austin: University of Texas Press, 1993.

Hill, Patricia Evridge. *Dallas: The Making of a Modern City*. Austin: University of Texas Press, 1996.

Hillier, Bevis and Stephen Escritt. *Art Deco Style*. London: Phaidon Press, 1997.

Holmes, Maxine and Gerald D. Saxon, eds. *The WPA Dallas Guide and History*. Denton, TX: University of North Texas Press, 1992.

Kirschke, Amy Helene. *Aaron Douglas: Art, Race and the Harlem Renaissance*. Jackson, MS: University of Mississippi Press, 1995.

Koyle, George S., ed. *American Architects Directory, Second Edition*. New York: R. R. Bowker Co., 1962.

Mallgrave, Harry Francis. *Modern Architectural Theory: A Historical Survey, 1673-1968*. New York: Cambridge University Press, 2005.

Marchand, Roland. "The Designers go to the Fair: Walter Dorwin Teague and the Professionalization of Corporate Industrial Exhibits, 1933-1940." *Design Issues, Vol. 8. No. 1, Autumn 1991*. Boston: The MIT Press.

Marcus, Stanley. *Minding the Store: A Memoir*. Boston: Little, Brown, 1974.

Marshall, Robert. "A Towering Achievement." *The Medallion, July/August 2011*. Austin: Texas Historical Commission.

McCarthy, Muriel Quest. *David R. Williams: Pioneer Architect*. Dallas: Southern Methodist University Press, 1984.

McGregor, Stewart, ed. *The Texas Almanac and State Industrial Guide*. Dallas: A. H. Belo Corporation, 1936.

The Official Guide Book, Texas Centennial. Dallas: Texas Centennial Central Exposition, 1936.

Parisi, Philip. *The Texas Post Office Murals: Art for the People*. College Station, TX: Texas A&M University Press, 2004.

Powers, John and Deborah D. Powers. *Texas Painters, Sculptors and Graphic Artists: A Biographical Dictionary of Artists in Texas Before 1942*. Austin: Woodmont Books, 2000.

Ragsdale, Kenneth B. *The Year America Discovered Texas: Centennial '36*. College Station, TX: Texas A&M University Press, 1987.

Rydell, Robert W. *World of Fairs: The Century of Progress Expositions*. Chicago: The University of Chicago Press, 1993.

Rydell, Robert W. and Laura Burd Schiavo, eds. *Designing Tomorrow: America's World's Fairs of the 1930s*. New Haven: Yale University Press, 2010.

Schenck, Lisa D. *Building A Century of Progress: Architecture of Chicago's 1933-1934 World's Fair*. Minneapolis: University of Minnesota Press, 2007.

Schoen, Harold, compiler. *Monuments Erected by the State of Texas to Commemorate the Centenary of Texas Independence*. Austin: Commission of Control for Texas Centennial Celebrations, 1938.

Serbaroli, Joseph, Jr. "H. E. Serbaroli and the Mysterious Muralists of Fair Park," *Legacies: A History Journal for Dallas and North Central Texas, Fall 2011*. Dallas: Dallas Heritage Village, The Dallas Historical Society, The Sixth Floor Museum at Dealey Plaza.

Teague, Walter Dorwin. "Exhibition Technique." *American Architect and Architecture, September 1937*. New York: Hearst Magazines, Inc.

Thomas, Jesse O. *Negro Participation in the Texas Centennial Exposition*. Boston: Christopher Publishing House, 1938. Winters, Willis. "Planning the Centennial," *Texas Architect*, May/June 1999.

Winters, Willis Cecil. *Fair Park*. Chicago: Arcadia Publishing, 2010.

Winters, Willis, FAIA. "The Ford Motor Company at the Texas Centennial Exposition," *Legacies: A History Journal for Dallas and North Central Texas*, Spring 2011.

The digital newspaper archives on three websites proved invaluable in researching this book: *www.dallasnews.com/historicalarchives* for *The Dallas Morning News*; *www.newspaperarchive.com* for newspapers in the rest of Texas and across the United States; and *www.nytimes.com* for *The New York Times*.

Texas Historical Association's *Handbook of Texas Online*, *www.tshaonline.org/handbook/online*, remains an outstanding source of information on Texas and Texans.

ILLUSTRATION CREDITS

HISTORIC IMAGES

Corcoran Gallery of Art
Hall of Negro Life mural, *Into Bondage*

Dallas Historical Society
Architects and artists group photographs
Contemporary House
Federal Building rotunda (color)
Federal Building rotunda murals, *North, South, East, West*
Food & Fiber Pavilion, 1970s
Hall of Agriculture mural sketch (Jerry Bywaters)
Hall of Foods exterior (color)
Hall of Foods west portico mural
Hall of Foods mural sketch (Alexandre Hogue)
Hall of Foods mural sketch (Otis Dozier)
Hall of Foods north portico mural
Hall of Varied Industries mural, *Builders*
Hall of Varied Industries relief, *Texan Youth*
Livestock Building No. 1 mural, *Peacock and Fowl*
Midget City
National Cash Register Building
Spirit of the Centennial, 1980s
Texas & Pacific Railway Company exhibit,
 Hall of Transportation
Texas Court of Honor planters
Masonite House
WPA Building

Dallas Municipal Archives
Cotton Bowl and Stadium Plaza
Traction and *Aeroplane Transportation* murals before
 restoration

Dallas Public Library
Texas/Dallas History & Archives Division
83-1/5, Midway at night
MA94-5/252, State Fair Auditorium and Exposition Building
MA94-5/269, Fair Park Coliseum
MA94-5/278, Esplanade Winged Horse/Siren pylons at night
MA94-5/283, Hall of Religion
MA94-5/335, Skillern's Better Service Drugstore
MA94-5/350, Midway
PA2000-3/1298, Hall of Transportation (WRR studio), c. 1960
PA2003-3/9, Hall of Transportation under construction
PA2008-5/19, Ford Building V-Eight Hall
PA2008-5/22, Ford Building Industrial Hall
PA2008-5/37, Ford Building Diorama Hall
PA2008-5/39, Ford Building showroom
PA2008-5/77, Ford Building Executive Lounge
PA2008-5/98, Ford Building Entrance Hall
PA83-1/4, Parry Avenue Gate
PA83-1/10, Esplanade reflecting basin at night
PA84-16/2, Gulf Broadcasting Studios
PA85-11/16, Hall of Foods west portico mural
PA87-1/19-59-315, Aerial view of Cotton Bowl Stadium
PA99-2/4, Gulf Singing Tower
PA92-20/5, Hall of Negro Life Tuskegee Institute exhibit

Fine Arts Museums of San Francisco
Hall of Negro Life mural, *Aspiration*

Hagley Museum and Library
1977242_04, Texas Company Building interior
1977242_05, Texas Company Building exterior

Ryerson and Burnham Archives,
The Art Institute of Chicago
52527, Museum of Fine Arts interior
52553, *Tenor, Contralto,* and Great Pylon at night
52560, Band Shell
52564, Grand Plaza looking toward Administration Building

State Fair of Texas Archives
1936.0084, Interior views, Halls of Transportation and Varied
 Industries (Hall of Transportation corridor; General Electric
 exhibit; Swift & Co. exhibit)
1936.0004, General Motors Auditorium interior
1936.00041, Midway aerial
1936.00049, Livestock Building No. 2
1936.00056, Esplanade reflecting basin from
 Great Pylon
1936.00057, *Confederacy* statue before completion
1936.00061, Aerial view of Fair Park
1936.00085, Federal Building Reception Room
1936.00085, Interior view, Hall of Agriculture
1936kc.00119, State of Texas Building Lecture
 Hall Lobby
1936kc.00135, State of Texas Building rendering
1936kc.00145, State of Texas Building front doors
1936kc.00342, Ford Building exterior
1936kc.00360, Ford Building exterior at night
1936kc.00360, General Motors Auditorium exterior
1936kc.00360, Hall of Agriculture
1936kc.00360, Hall of Negro Life exterior
1936kc.00360, Hall of Petroleum
1936kc.00360, Midway, Ripley's Odditorium
1936kc.00360, Midway, Streets of Paris
1936kc.00360, Museum of Fine Arts lagoon façade
1936kc.00360-34, Midway, Hollywood concession
1936kc.00427, Texas Centennial Exposition ticket
1936kc.00360, Texas Company Building exterior
 at night
1936kc.00429, Esplanade of State at night
1939.0003, Esplanade of State
1941.00004, Hall of Agriculture, 1940s
1948.00006, Automobile Building with *Spain* statue
1948.00029, Automobile Building from east
1948.00031, Esplanade of State aerial view
1950.00005, Hall of Horticulture
Texas Centennial Exposition poster

Texas State Library and Archives Commission
1972/11-29, "Esplanade and Reflection Basin at Night"
 postcard
4-16/117, Centennial Exposition decals
AC1/163-21, "Mural on Hall of Electricity" (*Prometheus*)

ORIGINAL PHOTOGRAPHS

GSR Andrade Architects
Band Shell at night

Mark Knight
Gebhardt Chili exhibit, Hall of Foods

All other original photography by
Jim Parsons and David Bush

INDEX

Acker, Lois 196
Adams & Adams 58, 59, 60, 62, 76, 197
Adams, Carleton 60, 70, 76, 78, 86, 197
Administration Building 14, 20, 21, 22, 23, 190, 192-193, 201, 204, 205
African American participation in Texas Centennial Exposition 140-141, 145, 146, 185, 202
Agrarian Parkway 90, 92, 96, 103, 105
Ahlschlager, Walter 52
Air conditioning 10, 14, 28, 90, 92, 132, 140, 146, 149, 173, 177
Alexander, Blake 192
Allred, James V 14, 185
American Planning Assn. 193
Amphitheater, see Fair Park Band Shell
Amundson, E. L. 196
Apple dance 168, 185
Aquarium vii, 140, 164, 170, 198, 207
ARCHITEXAS 34, 94, 97, 118
Arthur A. Everts Co. 14
Austin, Dorothy 83, 153, 201
Austin, Texas 5, 9, 10, 11, 60, 197, 198, 199, 200, 201, 203, 206
Automobile and Manufacturers Building (1922) 28, 136
Automobile Building (1948) 29, 52, 53, 186, 187, 192, 193

Band shell, see Fair Park Band Shell
Barbosa, Austin 71
Barthelme, Donald 59, 60, 62, 66, 73, 79, 197, 199
Bassett, Reveau 150, 201, 207
Biza, Pierre 196
Bogard, Guthrie & Partners 53
Bourdelle, Pierre 5, 8, 30, 31, 35, 43, 44, 45, 46, 47, 48, 106, 107, 108, 146, 187, 188, 193, 196, 201, 202, 203, 206
Bryan, Ralph 10, 37, 152
Buchannon, Robert 196
Bucklin, Norman 196
Bywaters, Williamson Gerald ("Jerry") 79, 100, 123, 201, 207

California Pacific International Exposition (1935) 37, 117, 135, 166, 168, 200, 204
Cameron, Ralph 178, 197
Carnohan, Harry 196
Carroll, Georgia 21
Cavalcade of Texas 9, 10
Centennial Building, see Hall of Transportation
Centennial Model Homes 169, 177, 178, 179
Century of Progress International Exposition (1933) 5, 8, 9, 117, 146, 166, 168, 173, 197, 198, 199, 200, 201, 202, 203, 204, 205
Cheek, James B. 164, 198
Chicago World's Fair (1893), see World's Columbian Exposition
Chicago World's Fair (1933), see Century of Progress International Exposition
Christensen & Christensen 139, 158, 197, 198

Christian Science Monitor Building 165, 200
Chrysler Hall 10, 28, 44, 57, 116, 201, 202, 206
Ciampaglia, Carlo 5, 21, 35, 38, 40-42, 46, 94, 97, 99, 100, 184, 191, 196, 201
Civic Center 2, 8, 9, 10, 131, 138, 140, 146, 150, 152, 159, 163, 164, 165, 170, 185, 189, 198
Collins, Kreigh 196
Conley Design Group 106, 164
Contemporary House 177, 178, 198
Contralto 54, 55, 56, 206
Cook, Robert S. 197
Coppini, Pompeo 73, 201
Cotton Bowl Stadium 11, 68, 90, 134, 169, 180, 181, 182, 187, 189, 191, 199
Coulter, Robert 10
Cret, Paul 8, 26, 58, 90, 138, 197
Crozier, Harry Benge 8
Cutler, C. M. 3, 5, 14, 26, 55, 201-202

Dahl, George L. 5, 8, 9-10, 12, 26, 35, 58, 60, 114, 118, 120, 122, 141, 152, 159, 166, 176, 182, 185, 192, 196, 197-198, 200, 203
Dallas Historical Society 61, 73, 79, 176, 185, 187, 193
Dallas Historic Preservation League, see Preservation Dallas
The Dallas Morning News 5, 8, 10, 11, 24, 26, 28, 61, 74, 86, 92, 141, 145, 168, 169, 182, 198, 201, 203, 205
Dallas Museum of Fine Arts 140, 152-156, 198, 201, 202, 205
Dallas Museum of Natural History 140, 150-151, 152, 199
"Dallas Nine" 8, 79, 100, 201, 202, 207
Dallas Park Board 8, 140, 152, 159, 160, 163, 179, 185, 187, 192, 207
Dallas Park & Recreation Department ix, 192, 193
Danna, John B. 150
Davidson, George 77, 202
Demolished buildings/demolition 29, 55, 57, 117, 127, 134, 135, 136-137, 144, 146, 169, 171, 172, 173, 174, 176, 177, 179, 185, 187, 189, 199, 200, 207
Dennis, John 22, 193
DeWitt & Washburn 152, 177, 197, 198
Dillon, David 8, 29, 32
Dittrich, Francis 173, 198
Donaldson, Walter 196
Douglas, Aaron 145, 202
Douglas, John 196
Dozier, Otis 100, 202, 207
Drinking fountains 75, 159
Dunne, W. Scott 139, 140, 156, 158, 197, 198

Eckel, Julia 179, 202
Electricity Building, see Federal Building
Embarcadero Building, see Hall of Foods
Entertainers: Cab Calloway, 138, 140; Carroll, Della, 168; Mademoiselle Corinne, apple dancer, 168; Jan Garber, 138; Daisy and Violet Hilton, 169; Dolly Kramer, The Midg-
et Sophie Tucker, 168; Mona Lleslie, The Diving Venus, 168; Paris Peggy, 140; Punch & Judy, 179; Roy Rogers, 135; Eleanor Stubitz, The Miniature Mae West, 168; Sons of the Pioneers, 135; Orson Welles, 140; Floyd Woolsey, 169; Yanyego dancers, 92
Esplanade of State ix, x, 2, 3, 10, 11, 12, 14, 26-57, 60, 138, 166, 185, 187, 189, 192, 193, 201, 202, 204, 206
Everts, Myron 14
Ewing, H. H. 196
Exhibitors: Ball Bros., 92; Beech-Nut Co., 92; Carnation Co., 92; Chrysler, 28, 44, 57, 116; Christian Science Monitor, 165, 200; Coca-Cola, 28; Dr Pepper, 92; Eastman Kodak, 28, 200; Ford Motor Co., 116, 117, 127-132, 199, 200; Gebhardt Chili Powder Co., 101; General Electric, 28, 51, 201; General Motors, 11, 116, 138, 142-143, 199, 207; Gulf Refining Co., 54, 134, 135, 200; Humble Oil & Refining Co., 57; International Harvester Co., 40; Kellogg Co., 92; Kraft-Phenix Cheese Co., 92, 197; Lone Star Gas Co., 146; Magnolia Petroleum Co., 149, 199; Mrs. Tucker's Shortening Co., 92; National Cash Register Co., 169, 176, 185, 200; Owens-Illinois Glass Co., 28; Pennzoil, 57; Sinclair Oil & Refining Corp., 138; The Texas Co. (Texaco), 174-175, 200; Westinghouse, 28; see also Railroads

FACL, Inc. 94, 97, 106
Fair Park Auditorium, see General Motors Auditorium
Fair Park Band Shell 138, 139, 140, 156, 157-158, 187, 192, 197, 198
Fair Park Stadium, see Cotton Bowl Stadium
Federal Building 114, 115, 116, 117, 118-126, 179, 183, 185, 187, 191, 192, 200, 201, 202, 203, 204, 205, 206, 207
Fish Fountain 22, 193, 204
Foley, Ray A. 159, 196
Food & Fiber Building, see Hall of Agriculture
Fooshee & Cheek 164, 198
Ford Motor Co. Building 2, 8, 10, 117, 127-132, 175, 185, 187, 193, 199, 200
Ford, Lynn 85, 202
Forrest, Carr 196
Fort Worth, Texas 5, 50, 86, 136
Founders Statue 24-25, 205
Fountains x, 22, 26, 30, 50, 54, 55, 62, 193, 201, 204, see also drinking fountains
Fowler, W. Brown 140
Frankenstein, H. A. 114
French, David S. 28
Friends of Fair Park ix, 110, 149, 192

Gambrell, Herbert 61, 79
Garner, John 20, 185, 187
Garnsey, Julian 8, 120, 121, 122, 124-125, 196, 201, 202-203, 205, 206, 207
General Exhibits Building, see Hall of Transportation
Gibson, Harry Lee 66, 69, 70, 203

Gilboe, Eugene 196, 203, 206
Greater Texas & Pan-American Exposition 11, 24, 29, 57, 106, 117, 169, 177, 178, 179, 182, 185, 187, 206
Greer, Jefferson Elliot ("Jeff") 120, 196, 203, 206
General Motors Auditorium 14, 116, 138, 142-143, 144, 185, 199, 207
Goldberg, Brad and Diana 15
Good Fulton & Farrell 93, 98, 101
Goodwin & Tatum 159
Grand Plaza 12, 14, 23, 205
Great Medallion of Texas 73, 74, 76, 205
Great Pylon 54-56
Griesenbeck, Clyde 150
GSR Andrade Architects 157, 165
Guidroz, Emile 146, 203
Gulf Broadcasting Studios 134, 136, 187, 200

Hall of Agriculture 90-97, 100, 105, 183, 186, 187, 191, 193, 201, 206
Hall of Domestic Arts 140, 163, 187
Hall of Foods 10, 90, 92, 98-104, 105, 184, 187, 197, 201, 203
Hall of Horticulture 160-162, 169, 178, 187, 191
Hall of Negro Life 2, 114, 140-141, 144-146, 179, 185, 200, 202, 204
Hall of Petroleum 29, 33, 57, 62, 117, 187, 193, 200
Hall of Religion 10, 146-148, 185, 203
Hall of State, see State of Texas Building
Hall of Transportation 26, 27, 28, 29, 32-44, 46, 49, 50, 51, 52, 53, 57, 187, 188, 189, 191, 192, 193, 201, 202, 206
Hall of Varied Industries, Communications, and Electricity 28-29, 30, 32, 35 38, 45-48, 49, 51, 52, 136, 186, 187, 201, 202, 203, 204, 206
Hare, Bunny 196
Hare & Hare 5, 187, 198
Harris, Ethel Wilson 84, 203
Hawkins, Alden R. 196
Herbert M. Greene, LaRoche & Dahl 5, 152, 197
Herman Miller 122
Herold, Otto 24
Hill, Bertram C. 181, 199
Hogue, J. D. 28
Hogue, William Alexandre 100, 203-204, 205, 207
Holmes, Bertha 196
Houston, George M. 196
Houston, Texas 5, 60, 141, 185, 197, 198, 203, 204
Howard, Richard Foster 140
Hubbell, Jack 196
Humble Hall of History, see Hall of Petroleum

Jessen, Harold ("Bubi") 178, 199
Jewish participation in Texas Centennial Exposition 146
John Garner Hall, see Administration Building

Johnson, Mac 196
Joseph, Wendy Evans 20
Josset, Raoul 5, 8, 21, 22, 24, 35, 38-39, 52, 118, 144, 187, 190, 192, 196, 201, 204, 205

Kahn, Albert 8, 117, 127, 199
Kawamura, Gozo 196, 204, 205
Kean, Frank D. 150
Keune, Russell viii, 192
Kleuser, M. C. 160
Korn, Anton F. 163
Kyte, W. O. 28

Laboratory for Conservation of Fine Arts 43
Lang & Witchell 12, 13, 18, 19, 142, 197, 199
Lang, Otto H. 32, 199
Lanier, Fanita 66, 204
Larrinaga, Juan B. 37, 200, 204
Lea, Tom 84, 204
Lemmon, Mark 60, 150, 180, 197, 198, 199
Lescaze, William 8, 149, 199
Life Class 168, 173
Lignell, Lois 196, 204
Linkletter, Art 14, 135
Livestock buildings 90, 92, 98, 106-113, 206
Lone Star Gas Co. Building, see Hall of Religion

Magnolia Lounge 10, 138, 149-150, 192, 199
Main entrance, see Parry Avenue Gate
Management Resources 192
Marcus, Stanley 149, 198, 199
Masonite House 178, 197
Martin, Joseph ("Jose") 8, 21, 22, 24, 36, 118, 190, 196, 205
McCraw, William 11
McLaughlin, George Wheeler 196, 199-200
Mechanical man, see Robots
Midget City 166, 168, 170, 171
Midway 2, 10, 114, 116, 140, 166-173, 174, 185, 189, 198
Miller, Madelyn 154-155, 205
Morehead, Edward 200
Municipal Services Building 181, 199
Murals ix, x, 8, 16, 21, 29, 35, 37, 38-39, 40-42, 45-48, 74, 79-80, 82, 83, 84, 86, 87, 94, 97-98, 99, 100, 102, 103, 109, 123-126, 145, 179, 184, 187, 189, 191, 193, 201, 202, 203, 204, 205, 206, 207
Museum of Fine Arts, see Dallas Museum of Fine Arts
Museum of Natural History, see Dallas Museum of Natural History
Museum of Nature & Science, see Dallas Museum of Natural History
Music Hall at Fair Park, see General Motors Auditorium
Myers, Noyes & Forrest 8

National Cash Register Building 117, 169, 170, 176, 182, 185, 200
National Park Service ix
National Trust for Historic Preservation viii,

ix, x, 193
Neiman Marcus 5, 149, 177, 198
Nelson, Donald S. 5, 8, 14, 21, 24, 58, 60, 110, 115, 118, 134, 141, 144, 196, 200
Newton, David 54, 55, 110
New York World's Fair (1939) 8, 10, 176, 200, 201, 202, 203, 205, 206, 207
Nichols, Perry Boyd 86, 196, 205
Niendorff, Arthur Starr 86, 205
Normandie, S. S. 170, 173
Nudes/nudity 21, 140, 168

Oberhammer, Hans 196, 200
Oglesby Greene 162
Overbeck, Harry 196

Pan-American Arena 106
Pan-American Exposition, see Greater Texas & Pan American Exposition
Parry Avenue Gate 12-17, 18, 26, 193, 199, 207
Performers, see Entertainers
Pittsburgh Plate Glass Co. 28
Pitzinger, J. A. 163
Portland Cement House 178, 199
Poultry Building 90, 98, 106, 186
Preservation Dallas 192

Quimby McCoy Preservation Architecture 15, 55, 89

R. Alden Marshall & Associates 119
Railroads: Atchison, Topeka and Santa Fe Railway, 28; Chicago, Burlington and Quincy Railroad, 28; Missouri Pacific Railroad, 28; St. Louis-San Francisco Railway, 28; Texas and Pacific Railway, 28, 50, 199
Rangerettes 11
Renier, Joseph E. 76, 205
Reliefs x, 12, 16, 18, 26, 29, 30, 31, 35, 43, 44, 48, 57, 66, 69, 70, 76, 88, 119, 126, 144, 162, 164, 187, 188, 192, 201, 202, 203, 204, 206, 207
Restoration ix-x, 14, 15, 20, 21, 22, 29, 34, 35, 42, 45-46, 49, 50, 54-55, 61, 89, 93, 94, 97, 98, 101, 106, 118, 119, 157, 164, 165, 190, 192-193
Richer, G. Henry 123, 205
Robots 2, 40, 116, 117
Rogers, Betty Turner 2
Roosevelt, Franklin D. 11, 134, 141, 169, 185
Roper, Daniel C. 14
Russell, Thomas ("Duke") 120, 205-206

Sadler, Luther 165, 200
San Antonio, Texas 5, 58, 60, 73, 80, 84, 178, 191, 197, 199, 200, 201, 202, 203, 206
San Diego World's Fair (1935), see California Pacific International Exposition
Sanger Bros. 178
Savage, Eugene 16, 79, 80, 201, 202, 205, 206
Sculpture x, 11, 21, 22, 24-25, 27, 35, 36, 38-39, 52, 54-55, 61, 71, 73, 83, 110, 153-155,

187, 192, 193, 201, 204, 205, 206, 207
Segregation 140, 141
Serbaroli, Hector 94, 196, 206
Sheep and Goat Building, see Livestock buildings
Siggins, Ray 196
Singing towers 54, 135
Skillern's Better Service Drugstore 136-137, 187
Slayton, Red 206
Smith, E. K. 134, 200
Smith, A. Maceo 140-141
Smith, Polly 81, 85, 206
Spence, A. J. 196
Spirit of the Centennial 21, 190, 193, 204, 205
Star, Stashka 21, 193
State Fair Association ix
State Fair Coliseum, see Administration Building
State Fair of Texas viii, 5, 8, 10, 11, 12, 14, 24, 46, 52, 83, 90, 101, 117, 118, 125, 136, 138, 146, 160, 165, 174, 181, 182, 185, 187, 189, 192, 193, 202
State Fair of Texas Administrative Offices, see Municipal Services Building
State of Texas Building viii, 2, 8, 9, 26, 32, 58-89, 185, 186, 187, 189, 192, 197, 199, 201, 202, 203, 204, 205, 206, 207
Statues, see Sculpture
Stell, Thomas M. 123, 196, 206
Stevens, George 196
Stevens, Lawrence Tenney 8, 27, 35, 36, 38-39, 54-56, 110, 187, 196, 204, 206-207
Streets of Paris 140, 166, 168, 170, 173, 185, 198
Streets of All Nations 168, 169
Swine Building, see Livestock buildings

Teague, Walter Dorwin 117, 127-130, 132, 169, 174-175, 176, 200
Television telephone 28-29, 141
Tennant, Allie V. 71, 164, 207
Tenor 54-56, 206
Tejas Warrior 71, 207
Texas Court of Honor 26, 33, 62, 65, 66, 90, 114, 117, 166, 185, 193
Texas Centennial Commission 2, 4, 5
Texas Co. (Texaco) Building 117, 169, 174-175, 200
Texas Discovery Gardens, see Hall of Horticulture
Texas State Fair, see State Fair of Texas
Texas Woofus 110, 187, 206
Thomas, Arthur E. 160
Thomas, Cullen F. 2, 5
Thomas, Jesse O. 140, 141
Thornton, Robert Lee 5
Titche-Goettinger 5, 198, 207
Tony Sarg's Marionette Theater 168
Towle, H. Ledyard 28
Tower Building, see Federal Building
Travis, Olin 82, 203, 205, 207

United States government participation in Texas Centennial Exposition 5, 60, 114-126, 140, 141, 179, 185, 192
University of Texas at Austin ix, 9, 197, 198, 199, 200, 201, 203, 206
University of North Texas 202, 204

Wakefield, Levy 196
Warden Lawes' Crime Prevention Exposition 168
Wayt, Sylvia 28
White, Henry Coke 152
Williams, David R. 179, 200
Winn, James Buchanan ("Buck") 16, 201, 207
Winters, Willis Cecil ix
Wittbold, George 143, 207
Women's Museum, see Administration Building
World Exhibits Building, see Hall of Transportation
Wood, W. Stuart 120, 207
Woofus, see Texas Woofus
World's Columbian Exposition (1893) 9, 168
Works Progress Administration (WPA) Building 169, 179, 187, 200, 202
Works Progress/Work Projects Administration 11, 60, 100, 140, 169, 179, 199, 202

Yale University 79, 202, 205, 206
Yeager, William 122

Zeiske, A.E. 11

TEXAS CENTENNIAL CENTRAL EXPOS

DALLAS 1936 TEX

MASTER PLOT PLAN

DEPARTMENT OF WORKS
APPROVED BY *Ray C. Foley*

GEO. L. DAHL - CENTENNIA
APPROVED BY *Geo. L. D*

ALPHABETICAL LISTING OF PRINCIPAL FEATURES
TEXAS CENTENNIAL EXPOSITION

The listing below, both alphabetical and numerical, is given as of May 9, 1936. Changes occurring since that date are not shown, as it was necessary to send this map to press on May 10.

A
- 41 Administration Building
- 43 Agriculture
- 93 Alamo
- 61b Amusements
- 87 Anthropoid Ape Show
- 22 Aquarium
- 55 Army Camp
- 95 Asiatic Store
- 96 Asiatic Store No. 2
- 40 Auditorium
- 64 Auto Skooter

B
- 102 Baby Incubator
- 82 Barn
- 86 Believe It or Not
- 35a Better Homes, Inc.
- 92 Black Forest
- 6b Building Site
- 16 Building Site
- 18 Building Site
- 19 Building Site
- 25 Building Site
- 26 Building Site
- 32a Building Site
- 34 Building Site
- 51 Building Site
- 98 Building Site
- 101 Building Site
- 108 Building Site
- 111 Building Site
- 112 Building Site
- 115 Building Site
- 124 Bundling Show
- 61a Byrd's Little America

C
- 24 Catholic Mission Site
- 119 Cavalcade
- 113 Centennial Colored City
- 35c, f Centennial Model Home Sites
- 21 Christian Science Monitor
- 2 Chrysler Building
- 123 Chrysler Garden Theater
- 88 Chuck Wagon
- 66 Continental Oil Co.
- 63 Crime & Snake Show & Cafe
- 103 Crystal Maze

D
- 30 Dreyfuss & Son

E
- 8 Electrical & Communications
- 9 English Concessions
- 58 Entrance Gates

F
- 83 Ferris Wheels
- 52 Fire, Police, Hospital & WRR
- 81 Flour Milling Industry Building
- 100 Flying Skooter
- 4 Foods
- 5 Foods
- 36 Forbidden City Site
- 13 Ford Motor Company
- 39 Ford Motor Co. Theater
- 14 Ford—Roads of the Southwest
- 79 Frog Farm

G
- 47 Grandstand
- 70a Gulf Refining Co.

H
- 56 Hall of Religion Site
- 27 Hollywood Animal Show
- 61c Holy City
- 31 Horticulture
- 114 Hostess House
- 106 Hunt's Relic House

I
- 48 Incinerator
- 23 Island

J
- 50 Jockey Club Restaurant
- 84 Judge Bean's Court

L
- 62 Life Show
- 45a, b, e Live Stock No. 1
- 46 Live Stock No. 2
- 57 Live Stock Coliseum

M
- 90 Magnolia Petroleum Co.
- 42 Maintenance Shops
- 35c Masonite
- 77 Mayflower Doughnut Shop
- 75 Midget City
- 99 Miss X Attraction
- 107 Moonshine Still (The)
- 94 Movie of U
- 29 Museum of Domestic Arts
- 38 Museum of Fine Arts
- 17 Museum of Natural History

N
- 28 National Cash Register Co.
- 32b National Park Service
- 60 Negro Exhibit
- 73 Nuremberg Restaurant

O
- 37 Open Air Amphitheater
- 68 Outdoor Transportation Exhibit

P
- 54 Paddock
- 3 Petroleum
- 35d Portland Cement Assn.
- 45c, d Poultry

R
- 72 Race Track
- 61d Racing Coaster
- 120 Radio Rehearsal
- 69 Reflecting Basin
- 6a Restaurant—C. J. Muller
- 80 Reviewing Stand
- 89 Rio Grande Valley
- 65 Rocket Speedway

S
- 85 Screeno
- 97 Screeno No. 2
- 110 Search-Light Battery
- 67 Service Building
- 59 Service Gates
- 91 Shooting Gallery No. 1
- 116 Shooting Gallery
- 76 Show Boat
- 10 Sinclair Oil Company
- 104 Skee Roll
- 118 Skee Roll
- 70b Skillern's Drug Store
- 35b Southern Pine Association
- 11 Sports Show
- 49 Stables
- 74 Stadium
- 109 State of New Mexico
- 44 State of Texas
- 105 Streets of All Nations
- 78 Streets of Paris

T
- 33 Texas Ranger Station
- 20 The Texas Company
- 53 Toilets
- 15 Tony Sarg's Marionette Theater
- 1 Transportation Building

U
- 12 U. S. Government (also 71)
- 71 U. S. Government (also 12)

V
- 7 Varied Industries

W
- 117 War Relics
- 121 Will Roger's Steer
- 122 W. P. A. House

1 TRANSPORTATION BUILDING
2 CHRYSLER BUILDING
3 PETROLEUM
4 FOODS
5 FOODS
6a RESTAURANT-C.J. MULLER 6b BLDG. SITE
7 VARIED INDUSTRIES
8 ELECTRICAL & COMMUNICATIONS
9 ENGLISH CONCESSIONS
10 SINCLAIR OIL COMPANY
11 SPORTS SHOW
12 U.S. GOVERNMENT (ALSO 71)
13 FORD MOTOR COMPANY
14 FORD-ROADS OF THE SOUTHWEST
15 TONY SARG'S MARIONETTE THEATER
16 BUILDING SITE
17 MUSEUM OF NATURAL HISTORY
18 BUILDING SITE
19 BUILDING SITE
20 THE TEXAS COMPANY
21 CHRISTIAN SCIENCE MONITOR
22 AQUARIUM
23 ISLAND
24 CATHOLIC MISSION SITE
25 BUILDING SITE
26 BUILDING SITE
27 HOLLYWOOD ANIMAL SHOW
28 NATIONAL CASH REGISTER CO.
29 MUSEUM OF DOMESTIC ARTS
30 DREYFUSS & SONS
31 HORTICULTURE
32a BLDG. SITE
32b NATIONAL PARK SERVICE
33 TEXAS RANGER STATION
34 BUILDING SITE
35a BETTER HOMES, INC.
35b SOUTHERN PINE ASS'N.
35c MASONITE
35d PORTLAND CEMENT ASS'N.
35c,f CENTENNIAL MODEL HOME SITES
36 FORBIDDEN CITY SITE
37 OPEN AIR AMPHITHEATER

38 MUSEUM OF FINE ARTS
39 FORD MOTOR CO. THEATER
40 AUDITORIUM
41 ADMINISTRATION BUILDING
42 MAINTENANCE SHOPS
43 AGRICULTURE
44 STATE OF TEXAS
45a,b,e LIVE STOCK NO.1
45c,d POULTRY
46 LIVE STOCK NO. 2
47 GRANDSTAND
48 INCINERATOR
49 STABLES
50 JOCKEY CLUB RESTAURANT
51 BUILDING SITE
52 FIRE, POLICE, HOSPITAL & W.R.R.
53 TOILETS
54 PADDOCK
55 ARMY CAMP
56 HALL OF RELIGION SITE
57 LIVE STOCK COLISEUM
58 ENTRANCE GATES
59 SERVICE GATES
60 NEGRO EXHIBIT
61a BYRD'S LITTLE AMERICA
61b AMUSEMENTS
61c HOLY CITY
61d RACING COASTER
62 LIFE SHOW
63 CRIME & SNAKE SHOW & CAFE
64 AUTO SKOOTER
65 ROCKET SPEEDWAY
66 CONTINENTAL OIL CO.
67 SERVICE BLDG.
68 OUTDOOR TRANSPORTATION EXHIBIT
69 REFLECTING BASIN

70a GULF REFINING CO.
70b SKILLERN'S DRUG STORE
71 U.S. GOVERNMENT (ALSO 12)
72 RACE-TRACK
73 NUREMBERG RESTAURANT
74 STADIUM
75 MIDGET CITY
76 SHOW BOAT
77 MAYFLOWER DOUGHNUT SHOP
78 STREETS OF PARIS
79 FROG FARM
80 REVIEWING STAND
81 FLOUR MILLING INDUSTRY
82 BARN
83 FERRIS WHEELS
84 JUDGE BEAN'S COURT
85 SCREENO
86 BELIEVE IT OR NOT
87 ANTHROPOID APE SHOW
88 CHUCK WAGON
89 RIO GRANDE VALLEY
90 MAGNOLIA PETROLEUM CO.
91 SHOOTING GALLERY NO I.
92 BLACK FOREST
93 ALAMO
94 MOVIE OF U
95 ASIATIC STORE

95 ASIATIC S
96 SCREENO
99 BUILDIN
99 AMUSEM
100 FLYING
101 BUILDIN
102 BABY IN
103 CRYSTAL
104 SKEE RO
105 STREETS
106 HUNT'S
107 THE MOO
108 BUILDIN
102 STATE O
110 SEARCH-
111 BUILDIN
113 BUILDIN
CENTENNI

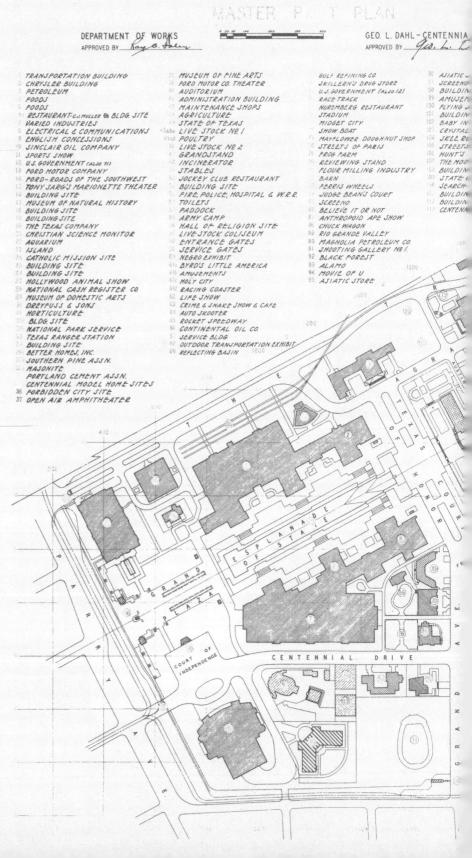